Watercolours

a step-by-step guide

This Edition published in 2002 for Index Books Ltd
Henson Way
Kettering
Northants NN16 8PX

This material was previously published as part of the reference set *The Step-by-Step Art Course*.

ISBN:1-897884-88-5

Produced by
Amber Books Ltd
Bradley's Close
74–77 White Lion Street
London N1 9PF
www.amberbooks.co.uk

Editor: Deborah Hercun

Printed in Singapore

Watercolours

a step-by-step guide

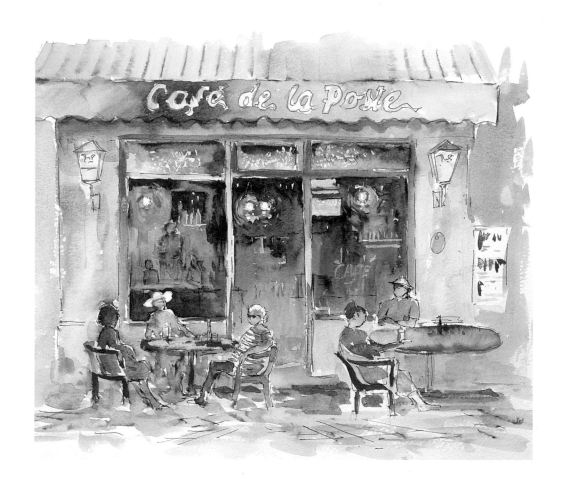

INDEX

CONTENTS

Blueprint for a painting

Like a play or film, a picture must be put together so that its component parts make a balanced, harmonious whole to hold the attention of the viewer. This important skill is called 'composition'.

Traditionally, artists have used the rectangle as the framework for paintings. When used horizontally, it is referred to as having a 'landscape' format, and when used upright as having a 'portrait' format (although, of course, you could paint a landscape in the 'portrait' format or use other shapes instead).

Getting the right fit

The shape and size of the rectangle has to be right for what you want to fit into it. If it is too small, the image looks squashed and this makes the viewer want to see past the edges; too large, and the eye wanders about trying to find something to hold its interest. Good composition is achieved when all the elements of the picture (colours, shapes, tones, textures and, vitally, the spaces between them) relate to each other in a balanced way.

The focal point

Imagine that you have just moved into an empty house and you are arranging the furniture in the living room. You will probably set out the armchairs and sofa so that they face the television, or perhaps a fireplace. These are 'focal points', and the angles and relative distances that you create in positioning the furniture is an important consideration.

Alternatively, the chairs might be arranged to face each other for conversation, in which case the focal point is actually a space.

In a painting, the focal point is the point to which the viewer's eye tends to be drawn most strongly. This is usually the main subject of the work – for example, the face in a portrait, or the

THE GEOMETRY OF COMPOSITION

This information is by no means essential to composing a successful picture, but you may find it interesting. Absorb as much, or as little, of it as you like.

Euclid noted that a sequence of numbers (3, 5, 8, 13, 21, etc) gave a series of ratios which Renaissance artists called the 'divine proportion', otherwise the 'Golden Section' or 'Golden Mean'. If a line is drawn by combining any two successive numbers (say 5 and 8, making 13), and divided into the two component lengths (i.e. one of 5 and one of 8), then the ratio of the smaller part to the larger (5:8) is the same as the ratio of the larger part to the whole (8:13).

▶ **The Golden Section**
The diagram shows how a focal point within a rectangle is created by using the 'Golden' proportions. Giovacchino Toma (1838-91) used this principle for the main focal point in his painting *Luisa San Felice In Prison*, **below.**

This principle was used as the basis for many Classical buildings because the balance created by these divisions, either vertically or horizontally (or both), is very satisfying. In paintings, the points where the verticals and horizontals of the 'Golden Mean' intersect within the rectangle are often used as the focal point (or points) of the image. This is about a third of the way in and a third of the way up (or down).

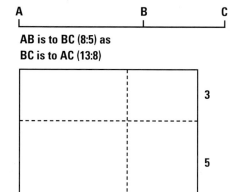

AB is to BC (8:5) as
BC is to AC (13:8)

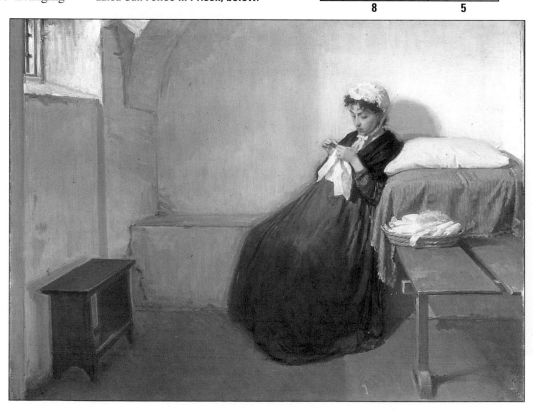

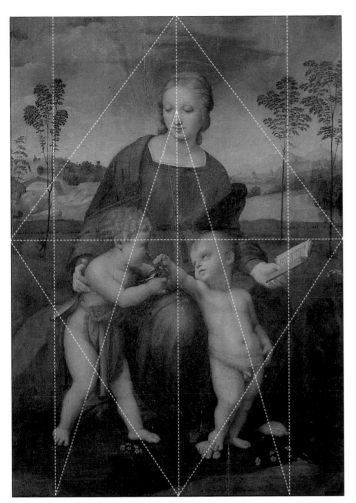

▲ Renaissance painters used the formal geometry of vertical, horizontal and diagonal lines to form triangular compositions within the rectangle. The portrait shown here, the *Madonna of the Goldfinch* by Raphael Sanzio (1483-1520), shows the principle clearly.

Composition in practice

To understand the importance of composition, you will need to explore a little, observing how different elements relate to each other. Try these exercises.

1 Take a sheet of white paper and some coloured papers (say red and green). Cut up the colours into rectangular shapes of various sizes and practise arranging them in different ways on the white sheet, overlapping some of them if you like. Try to organise a focal point and to achieve a good balance between shapes, spaces and colours. Look at how your arrangements visually affect the rectangle. Is there a sense of space; are there 'busy' areas and 'quiet' ones; is there any sense of 'movement' or 'tension' between shapes? Try the same exercise with other colours, or with black and grey.

2 Find a reproduction of a well-known painting for this exercise. Using tracing paper, draw lines to connect up the main directions formed by the various objects, light, shadows and forms within the painting. Notice how diagonals are used to hold together different areas and create 'routes' for the eye to follow.

3 From a sheet of white paper measuring 8 x 5cm (3 x 2in), cut out a rectangle from the centre to leave a frame about 1cm (⅜in) wide all round. Hold this at arm's length and move it slowly around the room or the garden. The view you see inside the frame is your composition. Notice how a very small shift of the frame can make for a much more balanced composition.

church tower in a village scene. In more complex images, where no one element is more important than another, the artist has to guide the viewer's eye around the picture by the way the various elements are arranged. As in the living room, the balance of these and the 'dynamic' that is set up within the rectangle are what composition is all about.

Things to avoid

There are no firm rules, but some things are best avoided. Dividing the surface in half by placing a tall object in the centre, or positioning the horizon line exactly half-way up, makes the picture 'boring'.

Similarly, same-size objects equidistant on either side of the centre line, or a continuous row of trees running right across the middle of the picture, make for dull compositions. As a rule of thumb, remember to compose 'through' the picture as well as across the surface.

▼ The compositions of Pieter Brueghel (the Elder) (*c.* 1515-69) are full of incident and usually contain lots of different focal points with plenty of space for the eye to wander about in. Notice the position of the flying bird in his painting *Hunters in the Snow*. Is it the first thing that caught your eye?

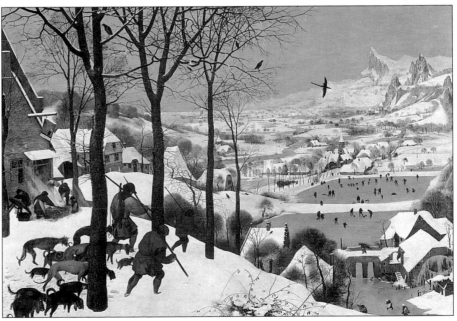

The power of colour

Colour is the painter's most versatile tool. It has the power to excite, control space, create atmosphere, express emotion and represent the illusion of reality.

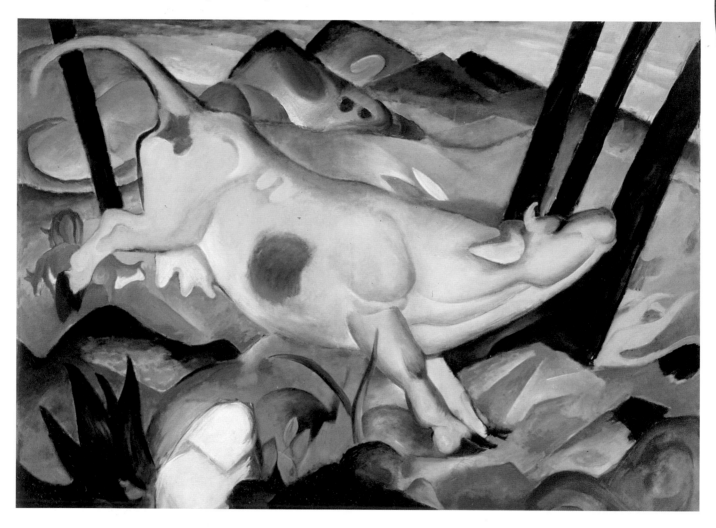

It was not until after the invention of the camera in the mid 19th century that artists recognised light as the prime factor in the way we see colour in the world around us. Before then, the 'local' colour was most often taken as the first consideration: sky is blue, grass is green – but is it that simple? If you look at the sky on a sunny day, it's much bluer overhead than it is on the horizon, where not only is it paler, it also has some yellow in it. Colour is dependent upon light, and we need to understand how it works.

The theory of colour

White light (sunlight), passing through a raindrop, splits into the colours of the rainbow spectrum. When these are fanned into a circle to make the colour wheel (see above, right), the principles of colour mixing can be seen. Red, yellow and blue are known as the primary colours: they are pure colours and cannot be mixed from any others. The other three (orange, green and violet), are called secondary colours because they are formed by an even mixture of their two immedi-

▲ Franz Marc's (1880-1916) *The Yellow Cow*, **complete with blue patches and red foreground, makes the point that colour can be used to great effect expressively, as well as realistically.**

ate primary neighbours in the circle.

This can be extended to make tertiary colours by mixing any of the primaries with either of its secondary neighbours. For example, blue and green will produce a colour generally called turquoise. In fact mixed colours are often named

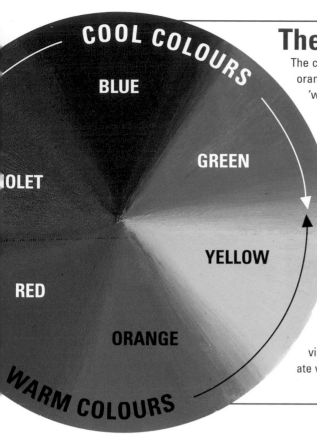

COOL COLOURS

BLUE

GREEN

IOLET

YELLOW

RED

ORANGE

WARM COLOURS

The colour wheel

The colours in one half of the wheel (red, orange, yellow) are specified as 'warm' and appear to advance from the page, while those in the other half (blue, violet and green) are 'cool' and seem to recede. This factor can be used in landscape painting for example, where trees in the distance can be made to recede by making them more blue-green than those in the foreground.

Colours opposite each other in the circle are described as complementary. Placed side by side they react against each other and fight to dominate the visual space. Artists use this to create vibrancy and contrast in pictures.

A BASIC PALETTE

There are certain colours which, when mixed together, can form the backbone of your art. The colours listed below are all good 'mixers' in any medium. If you have viridian, two blues and two yellows, you can mix most greens you are likely to need. Practise mixing pairs of all the colours without white.

Be careful when using black on its own, since it can 'deaden' a painting if overdone (remember, it is not really a colour!). Raw umber mixed with ultramarine is a good substitute.

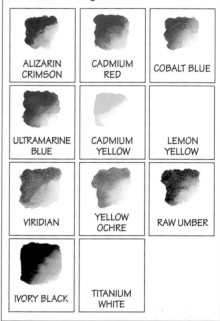

ALIZARIN CRIMSON	CADMIUM RED	COBALT BLUE
ULTRAMARINE BLUE	CADMIUM YELLOW	LEMON YELLOW
VIRIDIAN	YELLOW OCHRE	RAW UMBER
IVORY BLACK	TITANIUM WHITE	

after the gemstones or flowers which they resemble and these are the sort of labels you will see on tubes of paint in an art shop.

Black and white

You will notice that the circle does not contain either black or white. When light falls on an object, the object will absorb some of its wavelengths and bounce back others which make up the colour we see. Black soaks them all up and white bounces them all back, so black is the absence of any colour and white is all the colours rolled into one.

Brown

And what of brown? An object seen as brown is absorbing very few of the spectrum of light wavelengths (just those at each end of the rainbow) and bouncing all the others back. By mixing the three primaries together or the three secondaries in different proportions, a whole range of browns can be made.

▶ Claude Monet (1840-1926) used colour to convey passing impressions of light and atmosphere – in this case a group of waterlilies which seem to dissolve into the water around them.

Warm versus cool

Colour temperature is also part of the equation (see the colour wheel), while colour can also be said to be opaque or transparent, dark or light, translucent or impasto, flat or textured, matt or gloss, vibrant or dull.

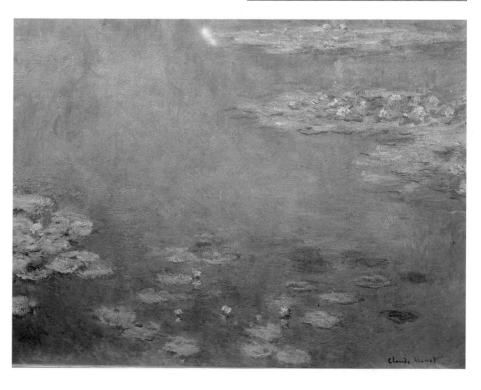

Midsummer landscape

You only need two watercolours to create this simple summer landscape. The blue and yellow are mixed together to make green.

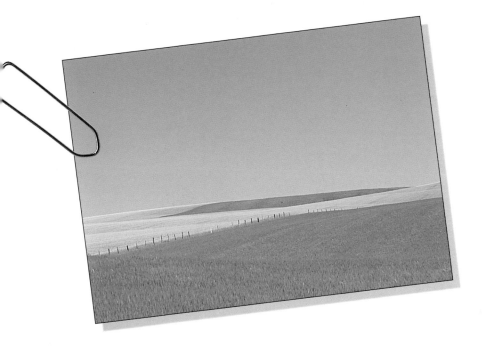

Watercolour landscapes are one of the real joys of art. And you only need two colours to achieve this inspiring summer scene: the green is made by simply mixing the cobalt blue and cadmium yellow together.

The main thing to remember when painting a watercolour like this is that there are no rights or wrongs. You can interpret the view how you want. Because the paint will be wet on the board, where colours meet or where paint is laid directly on top of water, the colours will bleed. This lends individuality, but how much you use this technique is up to you.

Go as far as you like
How far you take the picture is also up to you. Step 11 provides a good place to stop, or you can develop the picture a bit more by following the stages shown in 'A Few Steps Further'. Take care not to keep on applying layers of paint and to overwork the picture though. Also remember to change your water often, so the colours you are mixing do not become too muddied.

Laying a graded wash
An important technique featured in this project is laying a graded wash, which is explained more fully on page 16. The block (see the 'Expert Advice' box on page 12) helps to ease the flow of the paint downward when applying the wash. This can be made by covering a piece of wood with paper – or you could just use an old book.

Finally, remember to paint onto watercolour board or paper weighing more than 140lb, since the water will cause lighter papers to wrinkle – or 'cockle' – spoiling your work (see page 17).

▲ **You can achieve a lot by using just two watercolours and by mixing them in different quantities.**

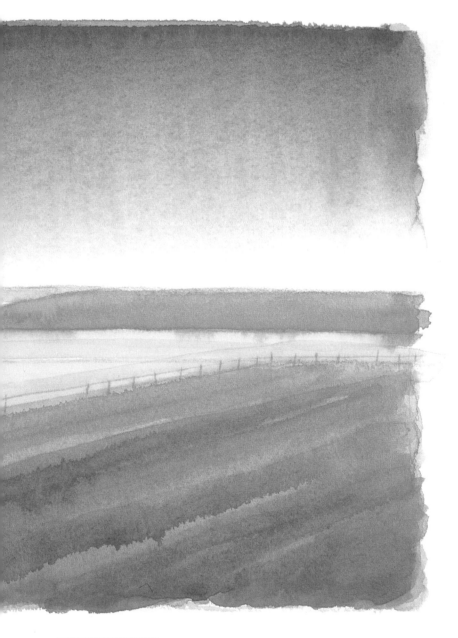

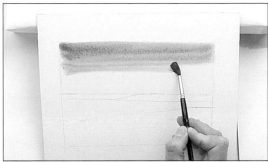

2▲ **Lay the wash for the sky** Following the instructions on page 16, lay a graduated wash over the sky area. Use the cobalt blue watercolour and a No.6 brush (rather than a flat brush, which is too large for this scale of painting). Prop the watercolour board against a block to help the paint flow smoothly down the board, and use more water in your paint mix as you move downwards to achieve the graduated effect.

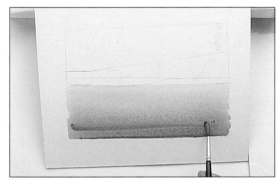

3▲ **Intensify the colour** Turn the board upside down and again prop it against the block. Work more of the cobalt blue mix into the top area of the sky. The angle of the board stops the paint running down into the lower sky, leaving a more intense colour at the top. Leave to dry.

FIRST STROKES

1▲ **Roughly mark out the main areas of the painting** Using a 2B pencil, lightly draw a rectangle for the frame of the picture. Study the photograph, and again using light strokes, draw in the horizon. Lightly divide the foreground to mark the areas of green and yellow field.

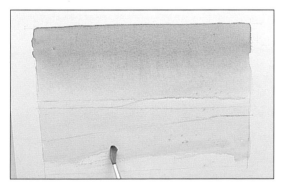

4▲ **Paint in the base colour for the foreground** Clean the No.6 brush, pour a little clean water into a separate palette well or saucer, and mix in some of the cadmium yellow that comes with this issue. Make sure that you mix enough paint to cover the foreground. Turn the board the right way up and work downwards, using large strokes. Leave to dry, then repeat and leave to dry again.

DEVELOPING THE PICTURE

Now you can start adding in the areas of green. First mix your colours. Pour a little clean water into a palette well or saucer, make up some cadmium yellow, then add cobalt blue, bit by bit, until you reach a shade of green you are happy with. The more blue you add, the darker the green will become.

5 ▶ Start to add in the areas of green

Remove the block and clean the No.6 brush. Then paint a thin layer of clean water around the outer edge of what will become the most distant strip of green field (shown right). Using the green mix, paint in the green strip itself, so that the paint bleeds into the adjacent area of 'wet' yellow.

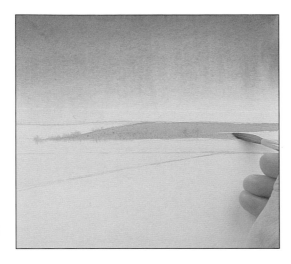

▶ **The more blue that is added to the yellow, the darker the resulting green will become.**

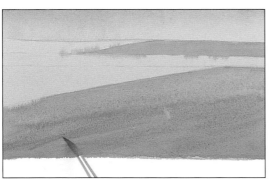

6 ▲ Paint in the foreground Move on to the foreground area, using the same mix of green paint and working from right to left across the board. Load the brush with plenty of paint and use wide, uneven strokes, working fairly quickly.

7 ▶ Darken the background colour

Before the strip of green field on the horizon has a chance to dry thoroughly, add a touch of cobalt blue to the green mix to make it slightly darker. Then paint over the strip again to give it more depth of colour.

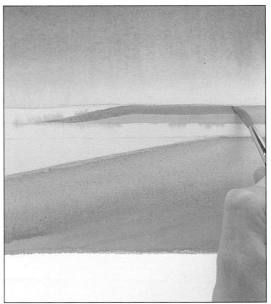

EXPERT ADVICE
Using a block

Watercolour board can be propped up against a block as you work, to make the paint run more easily down the page. This helps when laying washes. Once the wash has been laid from top to bottom, the board can then be turned upside down. Working this time from bottom to top, the paint will again flow in a downward direction (towards the top of the painting in reality), creating greater intensity of colour as it dries.

8 ▶ Add perspective to the foreground

Using plenty of the darker green mix and working quickly so that the paint does not dry, add bold, diagonal lines to the foreground area. Move right to left and top to bottom to mimic the sloping lie of the land. This helps to emphasise the perspective.

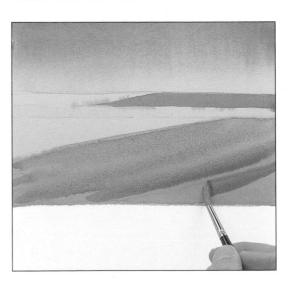

LIFTING OFF EXCESS PAINT WITH A TISSUE

Watercolour is a flexible medium to work with, and it needn't be a problem if you make a mistake: it's easy just to blot wet paint off the paper using an absorbent material such as a tissue or kitchen towel. Even dry paint can be lifted off, with varying degrees of success, using a dampened tissue or cotton bud. The stronger the staining properties of the paint used, the more chance there is of it leaving a faint residue behind, even after lifting.

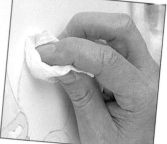

9 ▶ Add definition to the yellow field Paint over the yellow field again to intensify the colour, and leave to dry. Then paint a few rough 'stripes' of yellow horizontally across the field to add definition. Leave the painting to dry.

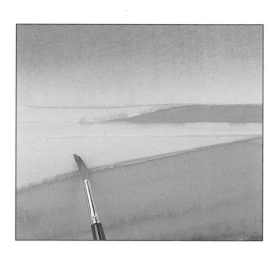

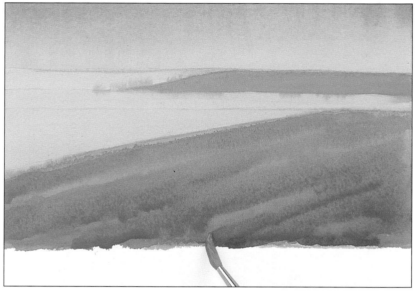

10 ▶ Emphasise the slope of the foreground Paint a thin layer of clean water over the entire green foreground area. Then, using the dark green mix, again paint strong, irregular diagonal lines over the foreground area, moving right to left and allowing the paint to bleed.

Master Strokes

Jacob van Ruisdael (1628/9-1682) *Landscape with a Ruined Castle and a Church*

A landscape specialist, Ruisdael is known for the sense of atmosphere he instilled in his paintings – largely through dramatic use of light and shade. In striking contrast to the project above, he was never known to paint a cloudless sky (we'll be tackling clouds in later projects), and in this example, a mass of towering grey cumulus threatens the serenity of the scene. Although the windmill in the centre of the painting is bathed in an almost idyllic shaft of golden light, and a sense of stillness is conveyed as in the 'Midsummer landscape', there is a suggestion that what we are actually witnessing is the calm before the storm. The shepherds to the left of the picture take a break from their work regardless.

The clouds take on a more menacing feel as they rush into the foreground, towering upwards at the same time. The shadow they cast darkens much of the foreground of the picture.

The eye is immediately drawn to this streak of pale yellow, used to depict the remaining sunlight seeping through the clouds and washing over the scene.

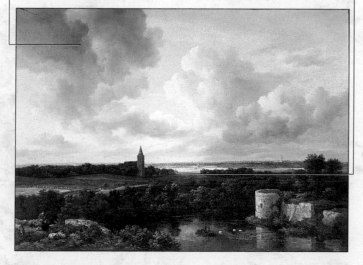

11 ▸ **Add the finishing touches** Load the brush with dark green mix and drag it across the bottom half of the green field on the horizon to again intensify the colour. Make sure the area of yellow field is dry, then add a touch of cobalt blue to the cadmium yellow mix to create a slightly 'dirty' yellow. Paint a few streaks of this colour across the yellow field to give an impression of shadows falling across the land. Leave the painting to dry.

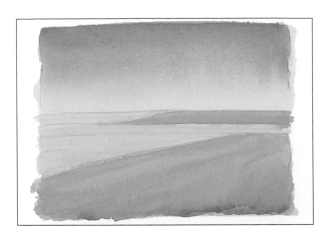

A FEW STEPS FURTHER

Step 11 is a good place to stop, since you may well be entirely satisfied with the picture as it stands. However, if you want to take your work on a little further, you can add in a fence and some more foreground detail. This helps to emphasise the perspective in the scene.

12 ▸ **Paint in the fence** Make up a new mix using cobalt blue and just a dash of cadmium yellow. Then, using the fine No.2 brush and starting from the centre of the picture and working outwards, paint in the fence posts, using small, downward strokes. Space them as in the photograph, with the most distant posts appearing shorter and closer together.

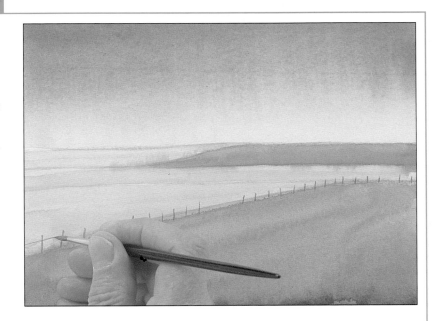

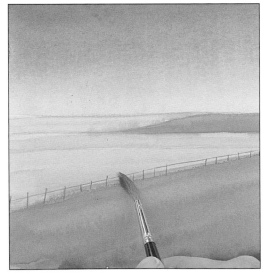

13 ▴ **Add the wire and blend in** Again using the No.2 brush and this time working left to right, add a very fine line across the upper part of the posts to depict the wire joining them together. Press the brush only lightly on the paper and try to keep your hand steady. Leave to dry, then brush a thin layer of clean water across the fencing to blend the colours and soften any harsh lines.

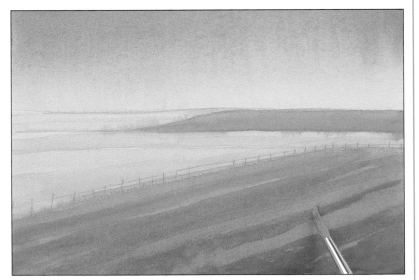

14 ▴ **Reinforce the perspective** Add a bit more cobalt blue to the existing green mix to darken the colour further. Then make bold, diagonal strokes across the foreground area, moving right to left with the brush. Add the most intense patch of colour in the bottom right-hand corner of the field, to reinforce the perspective of the scene. The picture is now finished and can be left to dry.

THE FINISHED PICTURE

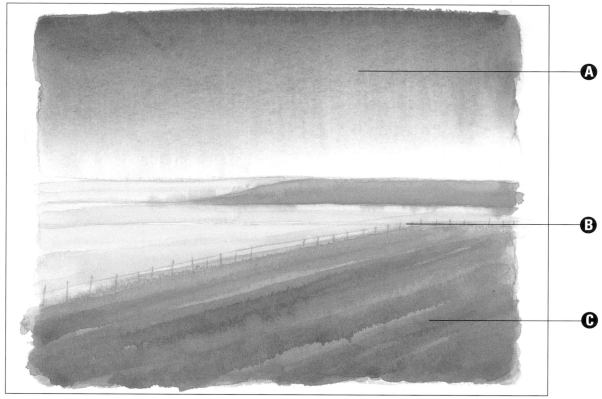

A

B

C

A Area of graded wash
Using a graded, rather than flat wash, means that the blue of the sky is at its most intense at its highest point, and palest on the horizon – as it would be in a real landscape.

B Blended fencing
Brushing water over the fence softened the hard lines created by using a very fine brush. This brought the fence more into line with what is happening in the rest of the picture.

C Built up foreground
The foreground was built up by adding successive layers of green paint. The final, darkest application was allowed to bleed freely, to create a range of interesting and random effects.

Express yourself Intensified colour

In this version of the same view, the artist has intensified the colours by using more concentrated paint mixes. Complementary colours were also used – red over green and violet over yellow – to give the scene some extra zing (see the 'colour wheel' box on page 9 for more information on this).

Another change is the omission of the fence to give a more open view, and the use of stronger lines in the foreground to exaggerate the perspective. The time of day is also different: the pink haze on the horizon suggests early morning – a complete departure from the midday light suggested in the photograph.

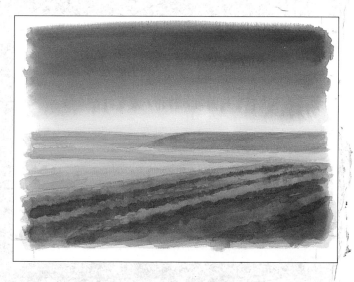

Washing onto watercolour paper

Laying a flat wash onto paper is the first step that most artists

take when working with watercolours. Here's how to do it.

Laying a wash onto paper is the starting point for most watercolour paintings. The wash can be flat or graduated (fading in colour towards the top or bottom of the picture) and then serves as the base colour onto which other colours can be applied.

Test the wash first

The wash technique is often used in landscape painting or for large areas of plain sky. Two good tips are to make sure that you mix enough paint to complete the wash, and to test its strength on a piece of scrap paper before you start painting. This is because watercolour dries lighter than it appears when initially applied.

The type of watercolour paper used is important as most lightweight papers require stretching to avoid cockling (see the 'Expert Advice' box). The stronger and heavier papers, however, will withstand the wettest of washes and still remain fairly flat. The texture of the paper will also affect the quality of the wash. So the best option for practising laying washes is to use a sheet of cold pressed (or Not) paper heavier than 140lb. See the box on 'Types of paper' below right for more information on this.

Equipment

Any painting project will only benefit from good organisation, so the starting point will always be to lay out your equipment. For this exercise, make sure that you have a flat (or chisel ended) brush, a jar of clean water with a wide enough neck to accommodate the brush,

Laying a flat wash

YOU WILL NEED

Sheet of 140lb+ NOT water-colour paper

Jar of water

Mixing palette or dish

Flat brush

Watercolour: Cobalt blue

1 ▲ Lightly wet the paper Dip the brush into a jar of clean water and, holding it at arm's length, wet the paper using a series of horizontal and vertical brush strokes. Ensure that all the paper is covered. This allows the paint to flow freely when applied.

2 ▶ Drag the brush across the paper Leave a minute or two for the water to be absorbed. In the meantime, pour some water into a palette or white saucer and, using a wet brush, mix in some of the cobalt blue paint.

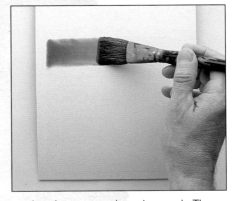

Make sure you mix enough paint to complete the wash. Then drag the loaded brush over the top of the paper in a single, smooth, even stroke, applying even pressure all the way along.

3 ▶ Continue moving downwards At the end of the stroke, lift the brush and repeat the procedure directly underneath – reloading your brush with paint if required and making sure that

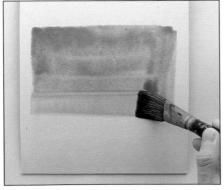

you leave no gaps between the new brushstroke and the one above. Continue moving down the paper in the same way, maintaining even pressure throughout.

4 ▶ Leave to dry Despite its initial appearance, the paint will dry to a smooth, even finish. Resist the temptation to work on the wash further.

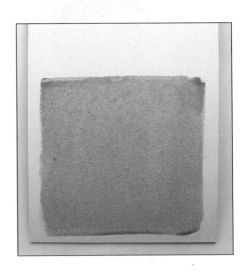

EXPERT ADVICE
Preventing cockling

Paper lighter than 140lb should generally be 'stretched' before a wash is laid onto it. Otherwise, the wetness on the paper will cause it to contract as it dries, leaving a buckled surface. When this happens, the paper is said to be 'cockled', like the painting shown right.

Full step-by-step instructions for stretching paper will appear later in the book. Until then, use board or paper heavier than 140lb for your watercolour projects, since these are heavy enough not to need stretching, and will not cockle.

and your paint all laid out together on one side of the paper. If they are on opposite sides, you will inevitably end up reaching across the paper with a water- or paint-laden brush, which may then drip onto your work. So being prepared pays dividends.

Washing

This wash technique is best practised at arm's length to achieve fluid movement and an even result. You can also use a block (see the first project which begins on page 10, and Expert Advice on page 12) to ease the flow of paint down the paper and to allow the wash to flow smoothly

downward without dripping. The resulting wash will initially look rather patchy and untidy, but resist the temptation to fiddle with it, or attempt to re-work it. Just allow the paper to dry naturally and the result will be an even wash.

What next?

Having mastered the basic skills of laying a flat wash, you can try your hand at a graduated wash. This involves increasing or decreasing the intensity of colour towards the top or bottom of the wash, to give a fading effect.

This can be achieved either by adding more water to the paint mixture each time you drag the brush across the paper – or by starting off with a very watery mixture and then adding more paint with each successive application.

▲ **A palette is the ideal tool for mixing washes. Clean water is placed in the round wells and colours are then mixed in the flat, slightly sloping sections below.**

TYPES OF PAPER

Watercolour paper comes in three main types:

Hot-pressed or Smooth	A textureless paper which is good for pen and ink and for line work
Cold-pressed or Not	A slightly textured general purpose paper, ideal for beginners
Rough	A highly textured paper best suited to vigorous painting techniques

▼ **A single streak of watercolour paint running through ten different weights and textures of paper shows clearly how the various paper types react with the paint, and how this affects its appearance.**

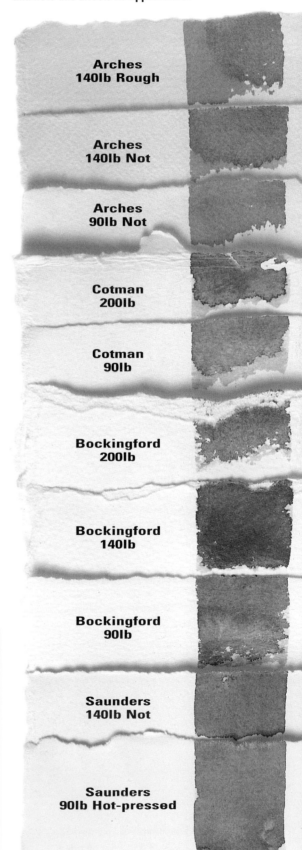

Arches 140lb Rough

Arches 140lb Not

Arches 90lb Not

Cotman 200lb

Cotman 90lb

Bockingford 200lb

Bockingford 140lb

Bockingford 90lb

Saunders 140lb Not

Saunders 90lb Hot-pressed

Still life with oranges and a pepperpot

You learned the basics of watercolour painting in our first project. Take the skills you developed a step further and create this simple kitchen scene using cadmium red and yellow, and cobalt blue watercolour paint.

With the right paper (140lb+ to prevent cockling – see page 17) and just a few colours, you can achieve some impressive results with watercolours. This project uses only three: the cobalt blue and cadmium yellow used in the first project, and cadmium red. These paints are simply mixed in varying quantities to provide all the colours you need.

Adopt a flexible approach

There's something very satisfying about mixing up watercolours, then pushing them around on the paper with your brush. You can never anticipate exactly where the paint is going to flow into thicker or thinner areas of wash. This makes watercolour an exciting medium to work with and means it's always best to retain a certain amount of flexibility in your approach.

The paint's interaction with the paper counts for a great deal because watercolours can be either opaque or translucent, depending on how much water you add. In fact the water and the paper are just as much part of an artwork as the paint itself. Irregular, grainy paper surfaces, for example, will influence the whole appearance of a picture. Paint gathers in and around the paper's peaks and troughs, mimicking the way that light plays across the surface of your subject matter.

Keep the colours thin

Remember that it's the wateriness of watercolours that gives them their delicacy, so it is important to keep colours thin and build them up stage by stage. This is one of the characteristics of watercolour painting, and part of its attraction for many people. Stick to this rule and you should be satisfied with the results you obtain.

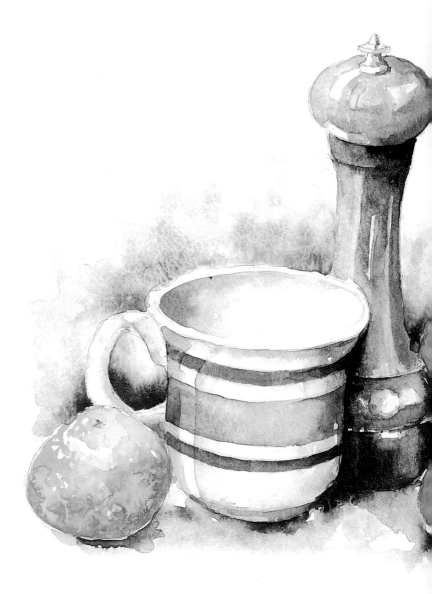

▶ **Even everyday objects are satisfying to paint. You can compose them in any number of ways to make the most of contrasts in colour and texture.**

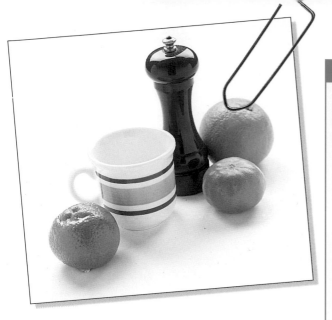

YOU WILL NEED

Sheet of 140lb+ watercolour paper

Palette or small saucer

2B pencil

Brushes: No.1; No.8

Jar of water

Kitchen towel

3 watercolours: Cobalt blue; Cadmium yellow; Cadmium red

3 ▲ Paint in the mug and oranges Use the pale blue wash to paint in the mug, leaving only a trace of colour. This should be heavier along the mug's right-hand side and inside the rim. Create the base tone for the oranges with a thin layer of cadmium yellow, leaving the highlights untouched. Dab off any excess paint with kitchen towel.

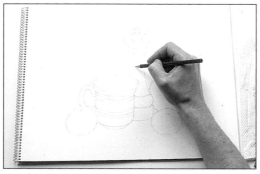

FIRST STROKES

1 ▲ Sketch in the objects Using a 2B pencil, make a simple line drawing of the objects. If you prefer, you can use a grid – although our artist drew freehand. There's no need to worry about detail at this stage – just study how the items in the group relate to each other and draw in the outline of the shapes. Keep the pencil line quite fine and use a rubber to tidy up any lines that become too thick and rough. Also sketch in the main highlights.

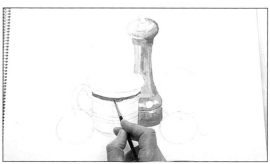

4 ▲ Add some detail Once the first layer of paint has dried, you can apply stronger blue tones to the pepperpot using the No.1 brush and a less watery wash of cobalt blue. Lay the paint most heavily along the pepperpot's right-hand edge, around the bottom and under its rounded top to define the shape. Take care to work around the areas of highlight. Also make two dark lines along the side of the cup to mark the stripes, using a firm stroke.

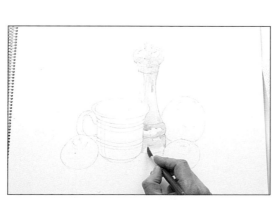

2 ▲ Give shape to the pepperpot Mix up a fairly thin wash of cobalt blue in your palette and use the No.8 brush to apply this to the main area of the pepperpot. Leave the highlights blank. Then dilute the wash some more so it is translucent, and paint in the highlights so that they are a paler blue.

**EXPERT ADVICE
Preventing muddy colours**

When working with watercolours, you should remember to refill your jar with clean water on a regular basis. Murky water makes for dull colours and this tends to give your picture a lifeless appearance.

DEVELOPING THE PICTURE

Now that the objects are sketched in and roughly defined, it's time to add some detail. This is achieved by building up layers of colour on top of each other to create areas of light and shade and to add form. Don't be afraid to add lots of water to the page if you want to. The paper may wrinkle up as you do this, but it will become smooth again when dry.

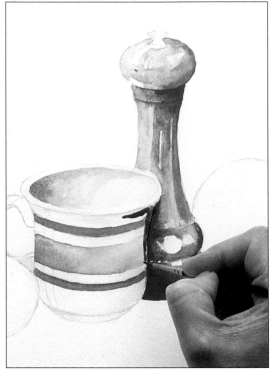

5 ▶ Add the pepperpot's shadows Again using the fine brush, use a darker, more concentrated tone of cobalt blue to build up the layers and create the shadow that the cup casts against the bottom of the pepperpot. Also define its bottom right edge and add in the shadow under the rim of the pepperpot's round top.

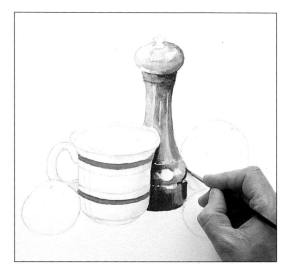

6 ▶ Give form to the cup Mix the cadmium yellow, cobalt blue and cadmium red together until you achieve a violet/grey colour. Then use the fine brush to paint inside the rim of the cup. Make the application of paint heaviest around the edge, to define the shape, and fade out the wash as you move towards the cup's centre. Also use this colour to add in the cup's wide central stripe.

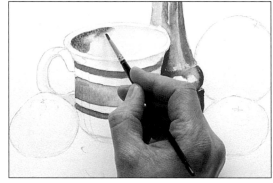

7 ▲ Work on the shadows Add more paint to the mix to create a deeper shade of violet/grey. Use this to create the shadow along the cup's right-hand and bottom edges by painting a fine line as shown. Then dab the paint with kitchen roll to spread it and remove the majority of the fluid. This creates a 'ghostly' shadow effect. Also add some colour to the cup's handle and add a strip of more dilute wash to create the vertical highlight (see Step 8).

Master Strokes

Paul Gauguin (1848-1903)
Teapot, Jug and Fruit

Gourds rather than oranges are the principal fruit in this still life by Gauguin, and this points to the fact that although a Frenchman by birth, he spent several years living in Tahiti in the South Seas.

The composition has obvious similarities to the above project in that there is the same contrast between the polished surfaces of the man-made pottery objects and the 'living' fruits. The real difference is in the media used and the way the paint is applied. Gauguin uses oils and applies the paint in flat slabs of colour – unlike the built up washes of watercolour above.

The shape of the gourd is defined by the way the fruit has been painted almost in two 'halves' – one vibrant red and the other orange.

Gauguin suggests the light source comes from the right in this scene by lightening the dull background towards the right-hand corner.

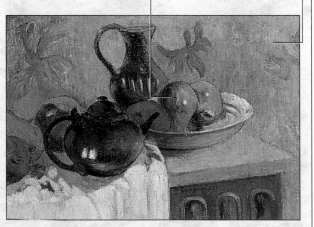

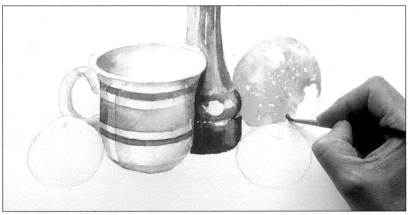

8 ▲ Give surface texture to the oranges Mix together cadmium red and cadmium yellow to produce orange. Then apply the paint to the oranges loosely and roughly, using the fine brush and allowing the lighter wash underneath to show through in places. This gives an impression of the fruits' pitted skin. Gradually increase the content of red in the paint as you move into the lower half of each orange. This helps to define their rounded shape and gives them a sense of weight.

9 ▶ Create the reflection Add the reflection of the orange in the pepperpot by dabbing a touch of the orange mix on to the highlight you created earlier. Drip a little extra water on to the orange dab to soften its edges and to blend it into the surrounding colour.

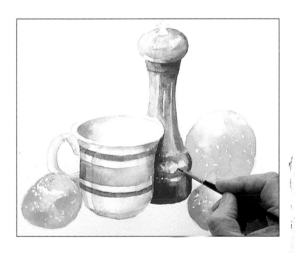

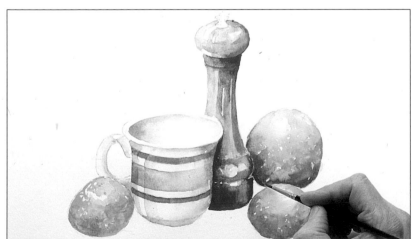

10 ▲ Sharpen up the shadows Add some more cadmium red to the mix and again build up the colour in the lower half of each orange, following the shape of each fruit round and using dabs of paint. Then mix a new colour using cadmium red with a touch of cobalt blue to produce a deep shade of blue. Load the No.1 brush with this new colour and sharpen up the edges between the pepperpot and the cup. You have now completed the work on the objects, and the painting can be left to dry.

EXPERT ADVICE
Watercolour brushes

A watercolour brush needs to come to a good point, so make sure yours does this. This will give you more control over where the paint goes on the paper. When you wash the brush after use, reshape it by pinching the bristles lightly between your fingertips. If you find any straggly hairs, these should traditionally be singed off, but a snip with a pair of scissors will do.

Express yourself
Adding a fourth colour

By adding a fourth colour, purple, the artist has heightened the sense of contrast in the scene. The effect is to create a less realistic final picture but to increase its impact. This is because the purple resonates against the blue of the pepperpot and cup (blue and violet sit next to each other on the colour wheel, so will always fight to dominate the visual space). The artist used plenty of water and allowed the purple wash to bleed extensively on the paper.

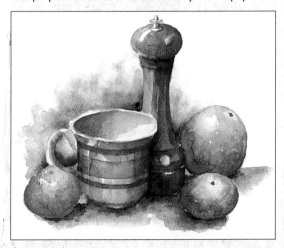

Add some foreground shadows then set your still life objects against a mottled background by daubing grey paint onto wet paper. Simply follow the steps.

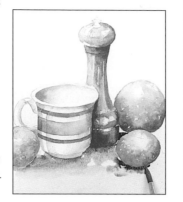

11 ▶ Add the shadows below the group
Use the thicker brush and random, short strokes to daub a strong patch of violet/grey mix beneath the group. Then drop water on to it so that the colour spreads out. Dab with kitchen roll to lighten and blend.

BLOTTING OUT

TROUBLE SHOOTER

Kitchen towel is a useful ally in watercolour painting. Too much water in the paint can cause it to bleed into other colours. This can quickly be remedied by using kitchen towel to soak up the excess.

12 ▶ Prepare the background
Paint a thin layer of clean water in a random arc shape around and above the group of objects. Take care not to drop water from the brush on to the rest of the picture, or to brush water over any areas that are by now dry.

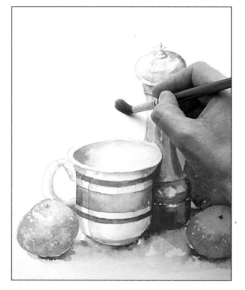

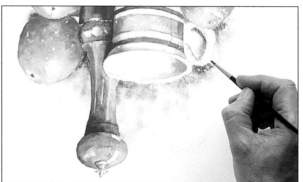

13 ▲ Add the colour Turn the painting upside down and daub the violet/grey mix around the edges of the group with the fine brush. Encourage the paint to move into the background and to bleed into the area you painted with water. Dab the paint with kitchen towel to prevent it from running back into the central objects.

THE FINISHED PICTURE

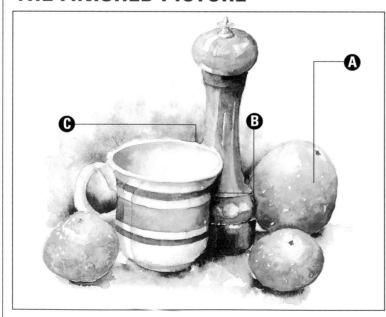

A Surface texture
The texture of the oranges was built up by varying the intensity of paint and allowing the underlying wash to show through in places.

B Defined images
Sharp lines were allowed to bleed into shadows. These define the pepperpot and make it stand out from the cup.

C Curved shape
Light falling on the china cup was painted in as a pale blue wash and strengthened in key areas to mimic the object's curved shape.

Pen and wash

You don't need expensive materials to create effective pictures. Even the humble fibre-tipped pen will produce lively line drawings, which you can enhance with a coloured wash.

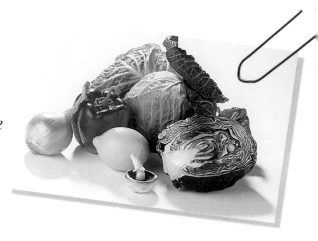

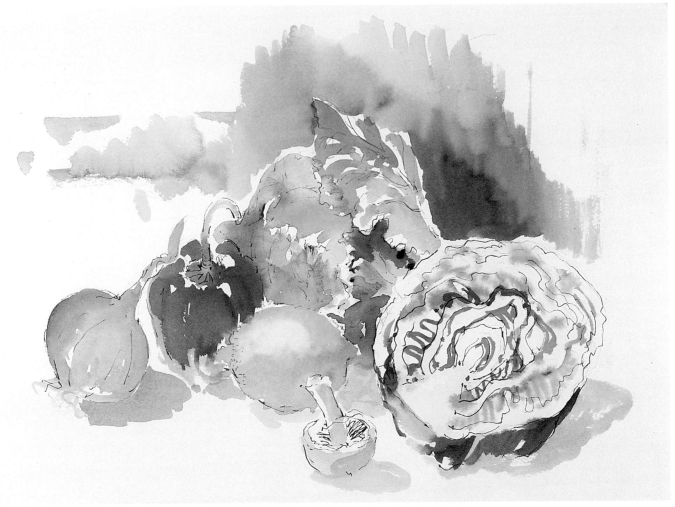

The next time you write out a shopping list, or do a crossword puzzle with a black fibre-tipped pen, take a second look at it. Even an inexpensive, throw-away pen such as this, readily available from stationers and art shops, can be a perfect medium for creating art. These pens are not only extremely portable, they can produce an amazing variety of strokes.

Take this group of vegetables (above), for example. Depending on whether you press the nib hard or quite lightly, you can portray the leafy veins of the cabbage, the solidity of the onion, or the smooth skin of the pepper. Other

good subjects to practise drawing with a fibre-tipped pen are small objects like shells, eggs, feathers, pebbles or stones.

Creating texture and form

Dots, dashes and lines of different lengths and intensities can have a very potent effect. The closer together the marks, the darker the area will appear. Very dark areas can be defined by first drawing one set of lines and then adding another set in a different direction across the top of them. This is known as cross-hatching.

A sense of roundness is achieved by making

▲ **Thin washes of watercolour allow the light tone of the paper to show through, while the water soluble line ink seeps into the colour wash, creating a soft effect.**

objects darker in the dips of their curves and lighter as they curve out, because this is where they catch the most light.

Adding a wash

Once a pen drawing is complete, a coloured wash can be applied on top of it. The washes used in this project are made from block watercolour paints diluted with water.

These washes have to be kept thin, so as not to hide the contours of the drawing and the 'light' that reflects from the white paper beneath. The artist used a water soluble pen for the line drawing, to encourage the pen lines to dissolve slightly and to seep into the washes, creating an interesting effect.

The first part of this exercise shows you how to draw the vegetables in considerable detail, using the fibre-tipped pen. Then, as washes work best on simple drawings, 'A Few Steps Further' asks you to start afresh and draw the vegetables once more – this time without using so many intricate lines.

EXPERT ADVICE
Using different papers

Pen and wash works well with various types of paper. Those with smooth, shiny surfaces allow the pen to move unhindered over the page, making line drawing easier. Heavier, grainy papers look especially good with washes brushed over; however, a surface that is too rough can mean that pen marks fall into the crevices. This can make drafting an image unnecessarily complicated for anyone other than an expert. The softer nature of highly grained paper also means that the pen might sometimes catch on it and clog up.

1 ▲ **Make a rough outline sketch** Pressing lightly with the 2B pencil, draw the main vegetable shapes. Make them quite large and bold. No detail is necessary yet, just draw a circle for the main part of the red cabbage and an oval for the lemon. It is more important to try and sketch the correct positions and relationships of the vegetable shapes. Don't worry if you have to go over the outlines more than once to achieve the correct size.

▼ **YOU WILL NEED**

Two large sheets of 140lb Not paper

2B pencil

Black water-soluble fibre-tipped pen, size 0.5

No.8 brush

Palette or saucer

Jar of water

Six watercolours: Cadmium red; Cadmium yellow; Cobalt violet; Cobalt blue; Monestial green; Burnt sienna

2 ▶ **Begin to add detail in pen** Having completed your rough pencil sketch, use the fibre-tipped pen to trace over the delicate frayed edges of the green cabbage leaves. Follow the outlines of the leaves. The veins in these leaves are thick, so press hard with the pen and go over them more than once if necessary.

3 ▶ **Create the first shadows** Draw a series of short pen lines close together at the bottom of each of the cabbage leaves, behind the main ball of the red cabbage and the lemon. This will create the shadows that silhouette the shapes of the vegetables in front.

DEVELOPING THE PICTURE

Depending on how hard you press with your pen, objects can look close to, or further away. Vibrantly-coloured vegetables nearer the front of the still life need to have stronger lines.

4 ▶ Draw in the contours of the red cabbage The lines of the red cabbage are dramatic and very thick in places. They have an irregular, twisting pattern, so it doesn't matter if you make an error. Make the outside, purple part of the cabbage darker by drawing the pen lines close together.

5 ▲ Work on the outline and surface of the lemon Press quite hard with the pen to draw a heavy outline around the lemon. The lemon has a dotted surface. Draw your dots close together near the bottom of the lemon, but put fewer dots at the top, where the light hits it.

6 ▲ Shape and shade the mushroom Draw the outline of the mushroom. Make some strong lines under the mushroom umbrella, starting from the central stem outwards. The dark shadows under the mushroom are created by drawing lines close together.

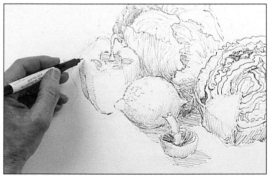

7 ▲ Build up the pepper To define the pepper, go over its outline and stem more than once. Outline the highlighted areas around the top. Draw small, tightly-packed lines in the dips of the pepper curves, but allow these to thin out as you approach the more bulbous parts that catch the light. Draw more small, tightly-packed lines in the shady area behind the lemon to create the shade.

Master Strokes

Floris van Schooten (1605-55)
Still Life with Brass Pot

The Dutch masters of the 17th century were famed for their still life studies, which were meticulous in every detail. The Dutch, with their Calvinist beliefs, were keen moralists, and their still life paintings often show the simple things in life – the message being that these are more important than sensual pleasures.

The fruit in the foreground of this painting by Floris van Schooten glows with vitality, while the cabbage and artichoke behind them are painted in heavier colours, to give an impression of solidity. The neutral earth-coloured wall is a perfect backdrop to this skilfully arranged composition.

The earthy tones of the backdrop to this composition have the effect of thrusting forward the timeless objects chosen as the centrepiece.

The exquisite use of tone, colour and shade on the polished fruit and gleaming brass pot bring an unusual degree of reality to the painting.

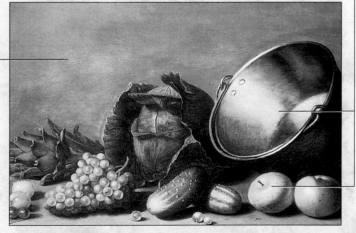

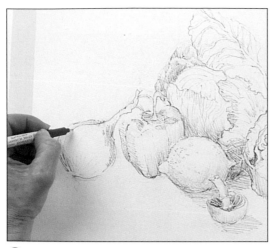

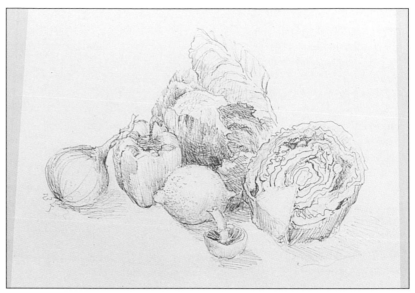

8 ▲ Add detail to the onion Follow the curved lines of the skin segments around the onion. Thicken up the lines at each end, not forgetting the root and stem. Now continue to darken and reinforce the lines and shapes of the vegetables where you think it necessary.

9 ▲ Complete the pen drawing The finished drawing should clearly show the differences in the subjects' size, shape, solidity and shadow. Keep practising your pen strokes until creating depth becomes easier.

A FEW STEPS FURTHER

Once you are satisfied with your pen drawing, put it aside and start with a clean sheet of paper. Draw the vegetables again, but without such detailed lines and shade. Then the colour washes can be applied. These can be very loose – the main thing is to enjoy moving the colours over the surface of the page. Washes don't need to be terribly accurate – if a colour runs from one vegetable to the next, so much the better. This kind of 'accident' often looks terrific. Use a saucer or palette to mix the combination and consistency of colours before applying them.

EXPERT ADVICE
Watercolour blocks

Watercolour comes in two varieties – blocks and tubes – and blocks have many plus points. First they can be bought separately and slotted into a suitably sized palette, like this one for square blocks. The beauty of this is that, when one block is used up, it can be replaced by another of the same or a different colour. Such palettes are ideal for a technique like pen and wash, where you are required to work fairly quickly, with all the paints to hand.

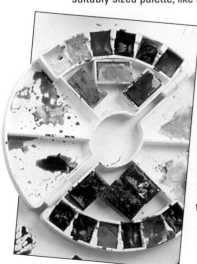

10 ▲ Begin adding the wash Draw the rough outlines of the vegetables. Load your brush with monestial green then dip just the end into some clean water. Trace it over the green cabbage. The paint does not have to be all one consistency – it will actually work better with thick and thin patches. Mix more monestial green with cobalt violet. Use this darker blue-green to define the cabbage with a few dark lines.

11 ▶ **Colour the lemon and mushroom** Clean the brush. Mix together cadmium yellow and monestial green. This will make a lime green colour. Then dip the brush in water and wash it over the top part of the lemon. Without cleaning the brush, dip the end of it into the cadmium red. Use this deeper yellow tone to colour the bottom part of the lemon. Add more water to the colour so that it looks very light and wash it over the mushroom.

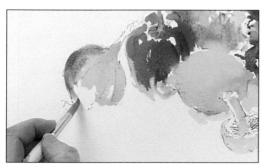

13 ▲ **Mix a wash for the onion** Clean the brush. Mix together cadmium red and cadmium yellow, then add enough water to make a fine orange wash to cover the onion. Load the brush with burnt sienna and put a line of this along the right edge of the onion, blending it into the rest of the colour.

Express yourself
Monochrome effect

Pen and wash are again used in this alternative version of a vegetable still life, but the overall effect is completely different. The line work is done in sepia coloured ink, which gives a softer effect than the black fibre-tipped pen used for the main exercise. The ink was applied with a water soluble cartridge art pen, which runs in water.

To create the wash effect, a brush was simply dipped in pure water (no added colour) and run over the top of the line work. The water splits the sepia into pink and green and spreads, creating contrast.

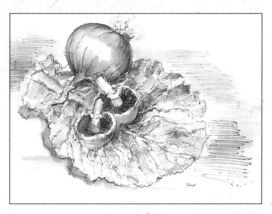

12 ◀ **Add a red wash to the pepper** Clean the brush with water, then load it with lots of cadmium red and just a dab of water. Wash it over the pepper, leaving white gaps at the top for the highlights. Then, without cleaning it, dip the tip of your brush into the monestial green. Apply this darker red tone to the most bulbous areas of the pepper.

USING AN INK RUBBER

TROUBLE SHOOTER

Mistakes made with pen and wash are difficult to hide. The paint is translucent, so you cannot cover up errors by putting new layers of paint on top. Some mistakes, however, can be remedied with a grainy-textured ink rubber, so long as it is used correctly. It is important to wait until the paint is dry first. Then just rub over the problem area as lightly and evenly as possible. A heavy hand will take away the surface of the paper along with the ink and paint and create an area that does not blend in.

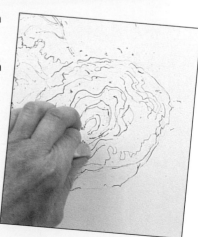

14 ▶ **Paint the contours of the red cabbage** Clean the brush and dab dry. Mix cadmium yellow with water to paint in the lighter areas of the red cabbage. Clean the brush, then load it with a mixture of cobalt violet and cadmium red with just a little water. Use this vivid colour to follow the general line pattern of the red cabbage.

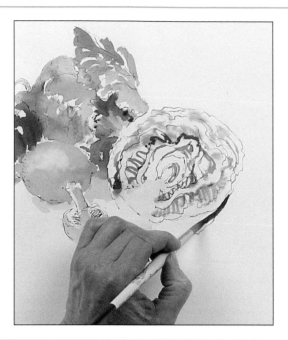

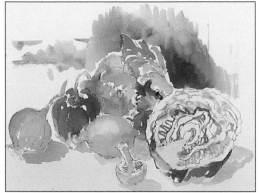

15 ▲ **Fill in the background shadow** Clean the brush and mix cobalt blue with cobalt violet for the shadowed area in the background. Make this deep violet tone strongest directly behind the vegetables, then fade it out as you move away from the group by continually adding more water.

THE FINISHED PICTURE

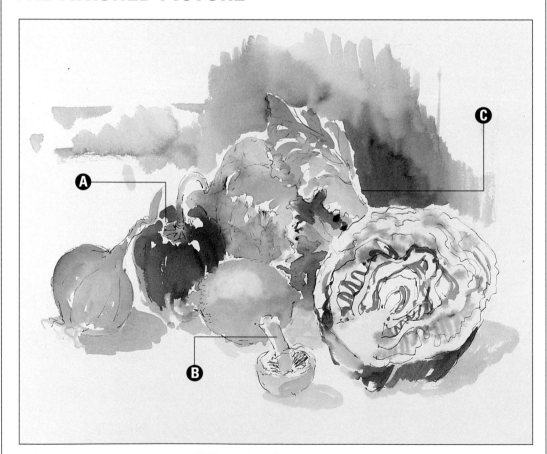

A Bright colours
Less water is added to the more densely coloured objects, like the red pepper, to make the colour stronger and brighter.

B Line and wash contrast
The sharpness of the lines complements the flowing, loose applications of paint that overlap the edges.

C Unpainted areas
White unpainted areas are left, allowing the paper to show through. This gives a neutral contrast to the paint.

Sunlit café scene

Lively town scenes like this one needn't be difficult to paint. Learn how to focus attention on your main subject by simplifying the background.

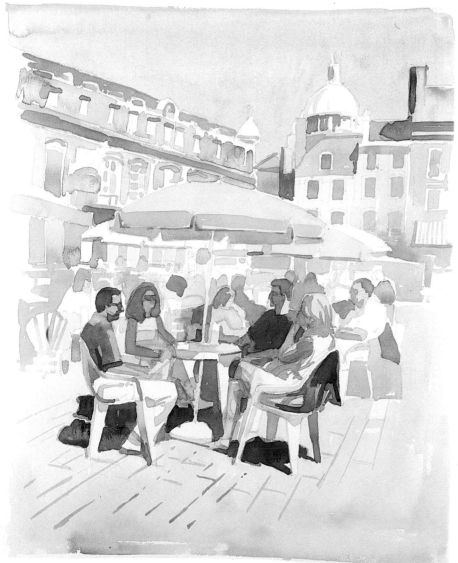

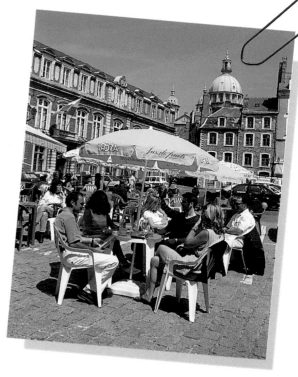

▲ **By using a contrasting combination of bright colours and deep shadow, the artist has created a convincing outdoor scene, bathed in summer sunshine.**

Artists do not always paint exactly what is in front of them. Part of being a good painter is being able to select the features of a scene that will work well together. A lively café setting like this one might, at first glance, seem rather complicated to paint. It is possible, however, to simplify it by picking out certain shapes and colours and disregarding others.

Simplified background

There is no need, for example, to be put off by the prospect of tackling the busy area behind the main table and chairs. You don't have to make the people and buildings in the background graphically clear, as long as a few of the more obvious shapes are left in and the paint tones blend in with the rest of the picture. The main

point to remember is that the elements in the background should not overpower the clearer images of the four most important figures and their umbrella in the foreground.

Strong shadows

One of the most interesting qualities of a bright daytime setting is the role that shadows play. In the scene chosen for this exercise, the shadows are cast by the umbrellas, the café tables and chairs, and the people themselves. Watercolour is an ideal medium for conveying both light and shade. By mixing paints together, layering one colour on top of one another and using ample water, you can create very subtle tones with traces of different colours showing through (see 'Expert Advice' on page 31 for how to mix colours for shadows).

Large sheet of
140lb+ white
watercolour paper

2B pencil

Round brush No.6
with a good point

Mixing palette or
dish

9 watercolour
paints:
Titanium white;
Cadmium orange;
Cadmium red;
Chrome yellow;
Burnt umber; Burnt
sienna; Yellow
ochre; Cobalt blue;
Ultramarine

FIRST STROKES

1 ▶ Make a sketch and begin adding colour Use
the 2B pencil to sketch the scene. Then mix
titanium white with water and add just a touch
of cadmium red and chrome yellow. Test this
colour on a separate sheet of paper until it
makes a suitable flesh tone and paint the four
main figures at the front of the scene. Clean the
brush. Mix up a strong chrome yellow and paint
in the large umbrella. Wipe the brush with a
tissue, then use cadmium orange to paint in the
T-shirt of the man on the far left. Put another
patch of cadmium orange behind the man in
the background on the far right.

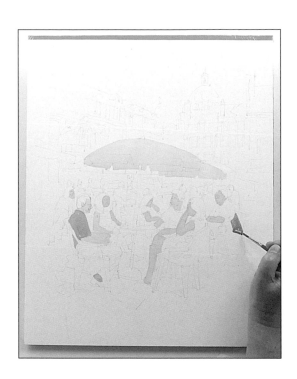

**2 ▶ Fill in the dark hair
and T-shirt** Clean
the brush. Use burnt
umber to paint the
hair of three of the
main figures. Vary the
tone by gradually
adding more water.
Then mix cobalt blue
with burnt sienna and
paint in the blue
T-shirt of the man on
the right. Add more
water to the mix to
make the colour less
intense and use this
new shade of blue to
define the chair on
the far left, and the
shadowy areas in
the centre.

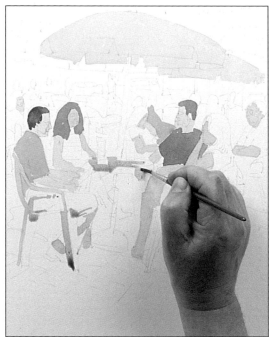

3 ▲ Paint the woman on the right Use yellow
ochre to fill in the blonde hair and dress of
the woman on the right. Clean the brush. Then
mix cobalt blue with a little water and paint the
legs of the chair she is sitting on. Also use cobalt
blue to dab in the shady areas behind the chair
on the far right.

**4 ▶ Deepen the skin
tones** Mix up some
cadmium orange and
paint in the hair of the
woman in the centre
background. Then
use a mix of burnt
sienna and a little
yellow ochre to paint
the tanned faces and
bodies of the people
in the foreground.

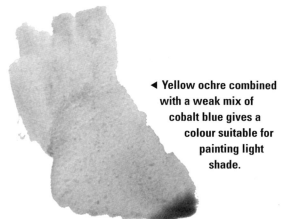

◀ **Yellow ochre combined
with a weak mix of
cobalt blue gives a
colour suitable for
painting light
shade.**

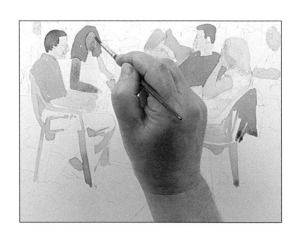

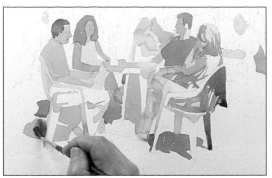

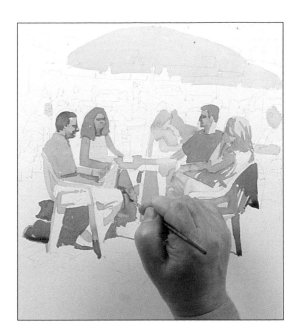

6 ► **Add detail to the figures** Now make a mix of ultramarine and burnt sienna and use it to reinforce the shadows under the left-hand chair some more. Also use this colour to paint patches and lines of shade on the faces, arms and legs of the four main figures. Add a little more detail to their facial features, too. Clean the brush.

5 ▲ **Develop the main group** Paint the dress of the woman on the left with a mix of cobalt blue and titanium white. Define darker shadows under the furniture using cobalt blue alone mixed with a little water. Use burnt sienna to create dark streaks on the hair and dress of the woman on the right. Add a little burnt sienna to the cobalt blue mix and use it to intensify the shadow under the left-hand chair.

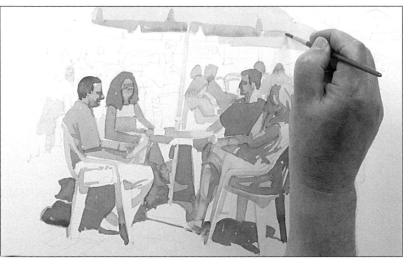

7 ▲ **Continue to develop the picture** Mix ultramarine with a little water and paint in the shadow under the central table. Clean the brush. Deepen the colour of the left-hand woman's blue dress using cobalt blue. Then mix burnt umber with water and paint in the faces of the people in the background. Also use this colour to reinforce the shade under the umbrella.

8 ► **Fill in more shaded areas** Make a mix of cobalt blue and a touch of burnt umber. Use it to paint in the areas of shade in the background. Add more cobalt blue to the mix and darken the T-shirt of the man at centre right. Use this colour also to fill in the shadow under the far right-hand chair and the area behind the man on the left.

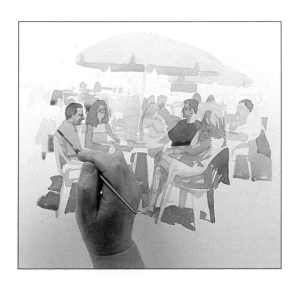

EXPERT ADVICE
Creating dark colours

Watercolour painters often avoid using black paint, because it can appear too stark next to the delicate, wispy quality of other watercolours. There are many other interesting ways of arriving at dark colours using this medium. The very dark patch of shadow under the chair (below) is created with a mix of two strong colours – cobalt blue and burnt sienna. While this gives a darker tone than the others around it, the effect is not too stark. As an experiment, try to see how many different dark greys and 'blacks' you can achieve by mixing combinations of watercolours. There are many possibilities. For example, with chrome yellow, cobalt blue and cobalt green you can mix a very dark combination, almost black but with lots of interesting tones throughout.

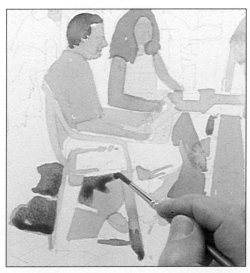

DEVELOPING THE PICTURE

Now that you have dealt with the tables, chairs and figures in the foreground, it is time to tackle the sky and the buildings in the background. Despite their grand appearance, it is quite easy to add a few uncomplicated details to buildings such as these, as long as you have sketched the basic proportions and angles correctly.

9 ▶ Make a wash for the sky Turn the painting upside down and place it on a block (see page 12). Mix ultramarine with a little water, load the brush with colour and paint in the sky area. Allow the watery paint to flow to the top of the picture. Leave to dry for a few minutes, then turn the picture the right way up again.

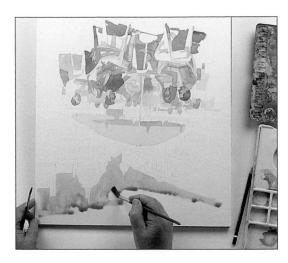

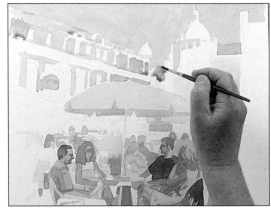

10 ▲ Begin painting the buildings Paint in the pale walls of the right-hand buildings with a watery mix of burnt umber and cobalt blue. Clean the brush. Mix cadmium orange with water and a little yellow ochre. Paint the roof on the right and the building on the left, leaving gaps for all the windows. Mix a strong cobalt blue with a touch of water and paint in a dark patch of colour between the buildings, just above the main umbrella.

11 ▲ Develop the left-hand building Use the same mix of cobalt blue to paint in the roof and the window tops of the building on the left. Dilute the mix with slightly more water and paint in the windows themselves.

Master Strokes

Raoul Dufy (1877-1953)
The Terrace of the Café San Martigues

Although painted in a different medium – oils – from the café scene featured in the above watercolour exercise, this painting by Raoul Dufy has certain similarities. The emphasis is placed on the group of people set right at the front of the picture, while the rest of the outlook forms a less clearly defined backdrop to the scene. In fact, the main figures are placed so much in the foreground that the viewer feels almost part of the group around the table. As in our café scene, the detail and shading in the picture is restricted largely to the main figures. The people and the buildings in the background are painted comparatively loosely. Dufy's painting is strongly lit and shows effective contrasts between the various areas of light and shade.

The buildings are simple blocks of colour with grey rectangles for the windows. Note how the juxtaposition of the red wall and the green café front prevents the background from becoming bland.

Thick, textural brush strokes have been used to describe the figure in the foreground, creating a lively picture surface.

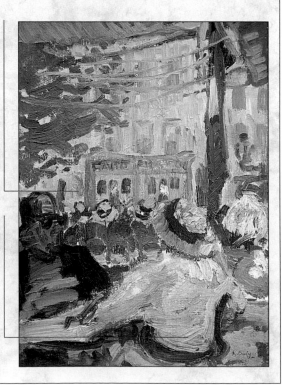

12 ▶ **Complete the buildings** Still using the watery cobalt blue, paint the remaining wall, the windows and the roofs of the buildings on the right, as well as the shaded area below them. Add the detail behind the man on the left. Mix ultramarine with only a little water and add touches of dark blue to the dome and to the roof of the right-hand building.

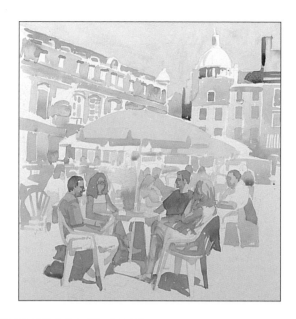

▶ A mix of undiluted cadmium red and cobalt blue gives a deep grey colour suitable for the darkest areas of shadow in a watercolour painting.

A FEW STEPS FURTHER

Although the main part of the painting is now complete, a further option is to work up the foreground area in front of the tables in greater detail. You can achieve this by adding some shading and a few lines to indicate the paving. With loose areas such as this, you can use plenty of water to allow colours to mingle. Don't be afraid of enjoying yourself and experimenting here. The wet areas can always be soaked up with a tissue afterwards.

13 ▶ **Add washes to the foreground** Wash over the foreground on the right-hand side using a mix made from lots of water and a touch of ultramarine and burnt sienna. Clean the brush. Use yellow ochre, again mixed with plenty of water, to wash over the foreground at centre left. Allow the two washes to seep into one another.

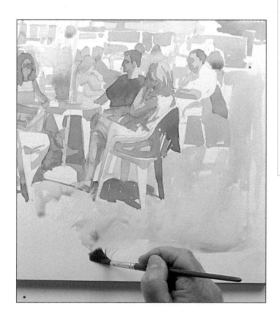

14 ▶ **Strengthen some of the colours** While the foreground is drying, go back to the rest of the picture. Reinforce some of the existing colours if you would like to emphasise them. Here, more cadmium orange has been added to the back of the man on the far left. The hair of the people in the background could also be made a stronger shade of orange.

TROUBLE SHOOTER

THE CORRECTING POWER OF WATER

If you make a mistake while you are painting with watercolours, wash over the problem area with a brush dipped in water. This will reactivate the paint, so that it is easy to dab it off with a tissue. It is usually possible to do this even if the paint has been drying for a while.

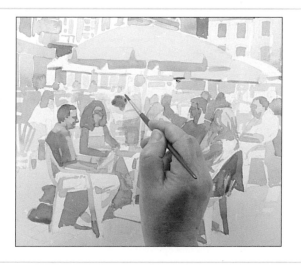

15 ► **Darken the shadows and paint the paving** Darken the shadows under the table using a mix of cobalt blue and a touch of burnt sienna. Mix cadmium orange with burnt sienna and define the bottom edge of two of the yellow umbrellas with a fine line. Finally, once the paint in the foreground has dried sufficiently, use burnt umber mixed with a little water to paint in the lines of the paving stones. Paint these at an angle to convey the perspective.

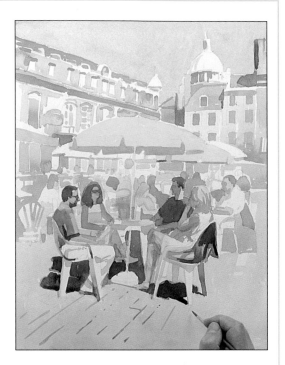

THE FINISHED PICTURE

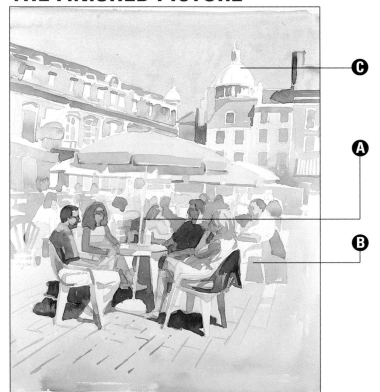

A **Strong focal point**
The picture is dominated by the strong shapes and tones in the centre: the large umbrella, the four people round the table and the dark shadows.

B **Simple background**
The scene behind the main table was left very loose and, apart from a few patches of dark colour here and there, the paint was highly diluted with water.

C **Unpainted areas**
Some parts, such as the church dome and the small dome on the left, were left unpainted to allow the white paper underneath to show through.

Express yourself
A tonal approach

You can emphasise the effect of strong sunshine on the café scene by simplifying the colours and relying more on the tones created by light and shade. In the version of the exercise shown here, the people around the table are sketched in without adding too much detail. Once the flat orange wash has been brushed over the drawing, the light areas are taken out by brushing on more water and dabbing the paint off with a tissue. The orange tone is deepened by adding more paint in shaded areas such as the underside of the umbrella. The deep shadows on the ground are painted in a solid dark colour to offer maximum contrast (see 'Expert Advice' on page 31 for how to mix grey and 'black' with watercolours), while mid-tone areas, such as the hair and clothing, are created with a dilute mix of the dark colour.

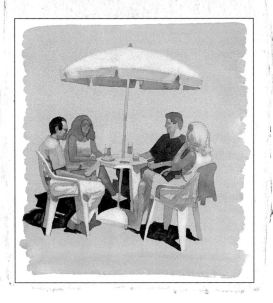

Brushes

It's worth building up a collection of different brushes as they will help you achieve a wide range of exciting paint effects.

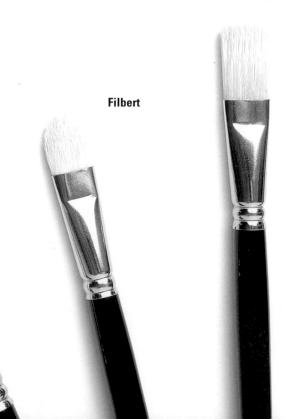

▲ **Brushes are available in many sizes. These sable rounds range in size from the finest No.0000 to the much larger No.20.**

Artists' brushes come in an enormous range of shapes and sizes, corresponding to the various purposes they are intended for. They may be made from several different kinds of natural bristles or from synthetic fibre, and the difference in price between the different types of bristle can be considerable. The choice is wide, but in the end the decision as to which to buy and use is a personal one, often depending on trial and error. Initially, it is a good idea to experiment with one or two brushes at a time to see how you get on.

WHAT TO LOOK FOR

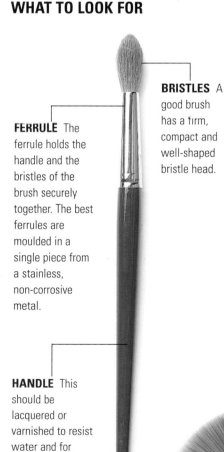

BRISTLES A good brush has a firm, compact and well-shaped bristle head.

FERRULE The ferrule holds the handle and the bristles of the brush securely together. The best ferrules are moulded in a single piece from a stainless, non-corrosive metal.

HANDLE This should be lacquered or varnished to resist water and for ease of cleaning.

Small and large

Most artists' brushes are available in a range of sizes, usually numbered. For example, a standard watercolour brush range can start with a tiny No.0000, used only for the very finest work, going up to No.20 and even larger. However, it is worth remembering that each brush manufacturer has a slightly different system. Hence a No.2 brush made by one manufacturer is not necessarily exactly the same size as a No.2 brush produced by another. The size of some flat brushes may be expressed in terms of total bristle width instead of numbers – 25mm (1in), 51mm (2in) and so on.

Types of brush

Each type of brush is designed to make a specific kind of mark. Choosing a brush depends very much on the effect you want to achieve, but if you have one or two of the following basic brush types they will be all you need to begin with.

Round This is a brush with a rounded ferrule. It is a popular, general-purpose brush with a full bristle head that holds a lot of paint. Large rounds are useful for laying washes and wide expanses of colour. The point can be used for painting lines and detail.

Flat or chisel headed This brush has a flattened ferrule with a square-cut bristle head. The wide bristles are good for applying paint in short dabs and for laying flat areas of colour, while the narrow edge of the bristles is useful for making thinner lines. A flat with very short bristles is sometimes referred to as a 'bright'.

Filbert Somewhere between a flat and a round, a filbert has a flattened ferrule but with tapered bristles. It is a popular and versatile brush, combining the functions of other brush types.

Fan The attractively shaped fan brush, or blender, as it is also sometimes known, has widely splayed-out bristles and is used primarily for blending colours together smoothly.

Flat

Filbert

Round

Fan

Watercolour brushes

Watercolour brushes are usually softer than those used with oil and acrylics. The very best-quality watercolour brushes available are sable brushes. These are made only from the tail-end hairs of the sable, a small, fur-bearing animal that is found in certain regions in Siberia. This is why pure sable brushes are so expensive. To reduce the cost, manufacturers sometimes mix sable with other natural hair. This is usually ox or squirrel hair, but occasionally goat, camel or even mongoose hair is used.

Why are sable brushes so good to work with? For a start, they combine strength with suppleness, and this allows you to paint in a lively yet controlled way. They also wear well, and will keep their shape. If properly cared for, a sable brush can last a lifetime.

However, manufactured bristles have improved enormously in quality in recent years. They fall into two main categories. Soft brushes are made especially for water-colour paints and have a texture and pliancy which aims to match the qualities of natural hair. Stiffer, general-purpose nylon brushes are made mainly for use with oil and acrylics, but are occasionally used by watercolourists to give a textured surface.

Caring for watercolour brushes

Each time you use a brush, rinse it in water. Either hold your brushes in your free hand while you work, or lay them down on a flat surface. Never leave them standing head down in water, because this will bend the bristles. Once this has happened, it can be difficult to restore a brush to its proper state.

At the end of a painting session, wash each brush thoroughly in warm soapy water, then rinse well under running water. Gently shake the bristle head back into its natural shape. If necessary, reshape the bristles with your thumb and index finger. Store brushes upright with the handle end downwards.

Special brushes

You may come across various eye-catching and exotic-looking brushes in the art shop. Though they may appear unusual and have intriguing names – rigger, oriental, mop and spotter – these brushes are very practical and invaluable for creating specific effects.

Rigger So-called because it was originally used to paint fine ship's rigging in marine paintings, the rigger has long, tapering bristles. Today it is used more generally for all linear work, but especially for lettering, poster writing and also calligraphy.

Oriental brushes Recognisable by their cane or bamboo handles, these brushes produce the characteristic, flowing lines which give Japanese and Chinese paintings their distinctive quality. The bristles taper to a fine point and the brushes can be used for painting fine lines as well as for creating broad strokes and laying washes.

Spotter Miniature paintings and all fine detail can be executed with a retouching brush, or spotter. This is a small round brush with short bristles, good for all precise work.

Wash brushes There are several large brushes that are designed specifically for laying flat washes. Most artists use a soft, flat brush; others prefer a large round, or a mop. The mop brush has a large, rounded head and is especially good for laying textured washes such as sea and sky.

Brushes for oil and acrylic

Brushes made for oil and acrylic paints are stiffer than those used for water-colour painting. However, watercolour

Rigger

Sable rounds

Synthetic brushes

Mop

WATERCOLOUR BRUSH MARKS

Rigger

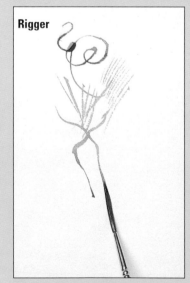

The long bristles of a rigger are designed for linear work.

Flat or chisel headed

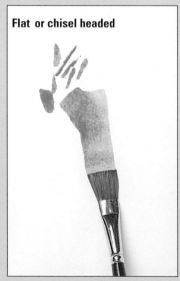

A flat brush can give broad or narrow lines of paint.

Round

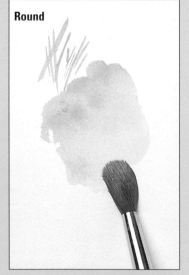

Use the whole brush for painting large areas, and the tip for details.

ACRYLIC BRUSHMARKS

Round

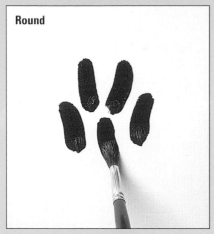

The oval marks made by a round brush echo the shape of the bristle head.

Flat or chisel headed

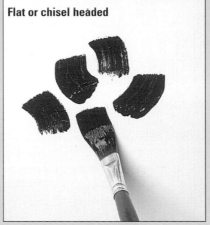

The rectangular profile of a flat brush produces regular dabs of acrylic colour.

Filbert

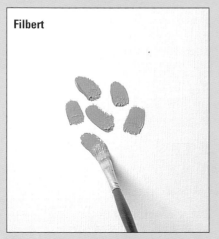

Filbert bristles curve gently to a point and give strong, tapering strokes.

Fan

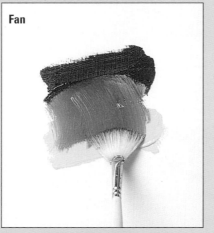

Use a fan-shaped brush for delicate blending effects with acrylics.

brushes can also be used with oils and acrylics, especially if you are painting areas of thin colour or painting detail.

Oil painting brushes are traditionally made from a natural bristle, usually hog's hair. There are also excellent synthetic brushes now available and some artists actually prefer these, finding them easier to clean and harder-wearing.

Certain synthetic brushes have been specially developed for use with acrylic paints, but as a general rule, both natural bristle and synthetic brushes can be used with either oil or acrylic paints. One word of warning, however: oil and water do not mix. Brushes which you have already used with oil paints should be carefully cleaned before you go on to use them with acrylics, which are water soluble.

Care and cleaning

Whether you are using oils or acrylics, paint should never be allowed to dry on the brush. At the end of every painting session, clean your brushes carefully by first wiping off excess paint with paper or kitchen roll. Brushes used with oil paint should then be rinsed in turpentine or white spirit, wiped clean and washed in warm water and household soap. Rub the soapy brush in the palm of your hand to loosen the paint that has accumulated round the ferrule. Rinse the brush well, then shake it to remove the water. If necessary,

carefully reshape the bristles then leave the brush to dry in a jar, with the bristle end up.

Acrylic brushes should only be cleaned in warm water and soap. Because acrylic paint dries so quickly, it is a good idea to keep brushes moist during the painting session when you are not using them. Do this by laying brushes in a dish of water with the handles resting on the side of the dish.

If you let acrylic paint dry on the brush accidentally, you can rescue it by soaking the bristles overnight in methylated spirits. This will soften the paint, which can then usually be washed off with soap and warm water.

Other handy brushes

Once you have experimented with the range of recognised artists' brushes, you might like to try other kinds. Small house decorating brushes are excellent for painting flat areas of colour and can save time if you like working on a large scale. Avoid very cheap ones – they tend to moult and you may waste any time you would have saved picking loose bristles off your painting. The very best decorating brush is still much cheaper than the equivalent artists' brush. Other useful brushes include a stencilling brush with a flat end to create stippled colour; a sash brush for painting large areas; and an old toothbrush for spattered effects. A fitch is a cheaper alternative to a sash brush.

Synthetic

Hog's hair

Sash

Stencilling

Decorating

Fitch

37

Gnarled tree in a storm

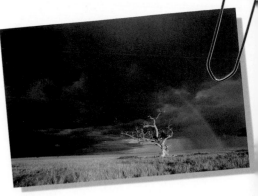

This dramatic watercolour landscape is easy to paint with the help of a trick of the watercolourist's trade – masking fluid.

Apart from the dramatically lit, gnarled tree, the most stunning aspect of this landscape is the stormy sky represented behind it. However, painting the dark areas of colour between the lighter, intricate branches and twigs of the tree represents something of a challenge. The answer is to use a favourite tool from the watercolourist's box of tricks – masking fluid.

Using masking fluid

Masking fluid is always the ideal choice if you want to combine large expanses of colour with more detailed work (see page 44 for more information). It is a rubber-like substance that seals the paper wherever it is painted, repelling any paint applied over the top and creating a negative image underneath. The image can then be left white or painted in with paler colours to provide a contrast with the background.

Painting the sky

Here, the tree and its branches are first coated with masking fluid so it becomes possible to wash paint over the paper without fear of obliterating even the finest lines. The transparent qualities of watercolours can then be used to the full to create the glowering sky. It is built up by layering several different shades of blue over one another, so that all the layers remains visible or at least have a presence.

The sealed image of the tree remain highly defined throughout this process. When you have finished painting the sky, you can simply peel off the masking fluid with your fingers.

▼ Without the use of masking fluid, it would not be possible to show the intricate shapes of the tree's branches in anything like the detail required.

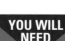

YOU WILL NEED

Piece of watercolour board about 28 x 41cm (11 x 16in)

2B pencil Rubber

Round brushes: Fine No.00; No.6

Fine, old No.00 brush for applying the masking fluid (one that you do not wish to paint with again)

Masking fluid

11 watercolours: Cadmium yellow; Lemon yellow; Yellow ochre; Burnt sienna; Raw sienna; Cadmium red; Prussian blue; Indigo blue; Ivory black; Viridian; Cobalt green

FIRST STROKES

1 ▶ Draw the tree and horizon Using the 2B pencil, draw the basic lines of the image. Draw the line of the horizon about two-thirds of the way down the page. The tree should be small and positioned to the centre right. Draw the trunk first, then add the gnarled branches, narrowing these off to little twigs at the top.

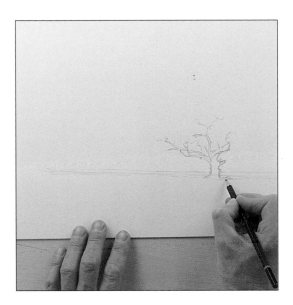

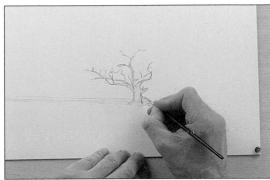

2 ▲ Paint the tree with masking fluid Use a No.00 brush to paint masking fluid on to the tree. Start with the trunk and work up to the branches. Take small amounts on the brush each time. Remember that all areas covered with masking fluid will remain free of paint. Clean the brush in warm, soapy water immediately.

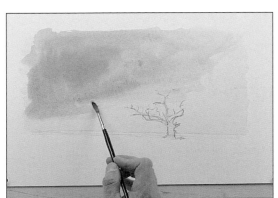

3 ▲ Lay a wash for the sky Change to the No.6 brush. Mix together Prussian blue with a tiny amount of yellow ochre and plenty of water to make a duck egg blue colour. Then apply a fine wash over the whole sky down to the horizon. Apply a more concentrated patch of Prussian blue to the top left side of the sky. Load the brush with water and spread it out across the sky.

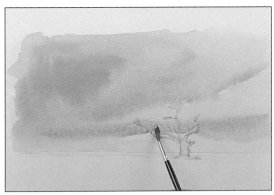

4 ▲ Create a cloud Paint a streak of more concentrated Prussian blue out from the left side of the landscape across the tree. Keep this streaky to denote a layer of cloud floating. Leave the areas around it relatively free of paint so that there is a contrast with the deeper colour.

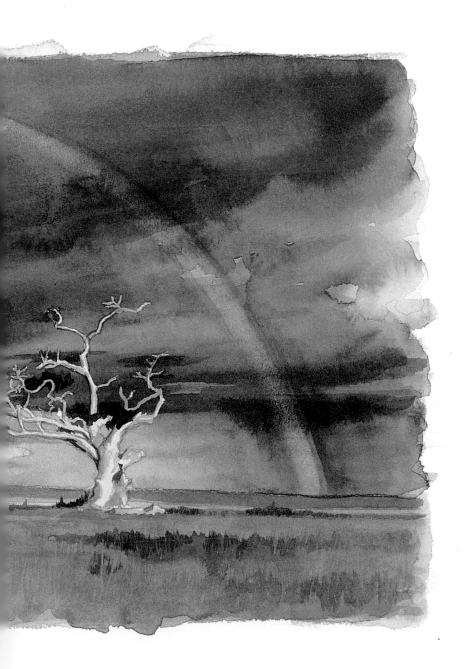

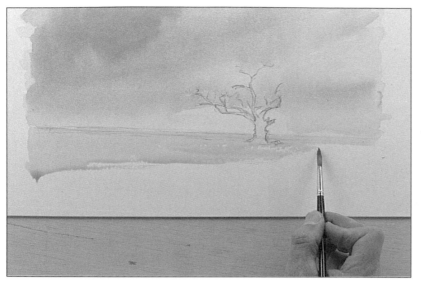

5 ▲ Lay the base tone for the foreground Clean the brush. Mix together yellow ochre with a touch of cadmium red and water. Starting under the horizon on the left-hand side of the picture, work this colour down and across the foreground to represent the area of grass.

Express yourself
Dramatic skies

Once you have mastered the masking fluid technique to paint the gnarled tree, you can devise different skyscapes to set behind it. Be as extravagant with colour as you like – the scene is meant to be dramatic. Lay one colour over another and see what shades and forms they take on.

In the variation of the step-by-step painting shown here, the artist has created storm clouds in indigos, purples and violets. As before, there are strong highlights on the tree trunk, suggesting rays of sunlight falling on it through gaps in the clouds and creating a theatrical effect. The foreground, too, is built up as before, with grass stalks painted as details over a wash. However, in this picture the green shades suggest a more temperate landscape than the dry plains depicted in the step-by-step painting.

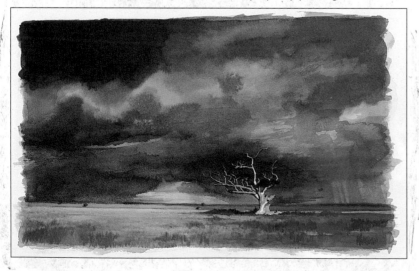

DEVELOPING THE PICTURE

Now that the main shapes and areas have been drawn and blocked in, the painting is developed by working them up some more. The same colours, or just slightly different ones, are used again and again to create the dramatic contrasts. Don't worry if some of the shades start to look dark; remember that watercolours usually dry lighter. Neither is there any need to be too precise when painting the sky. The stormy look will be achieved more successfully if you take a 'loose' approach. Keep the paint watery and uneven for the best effects.

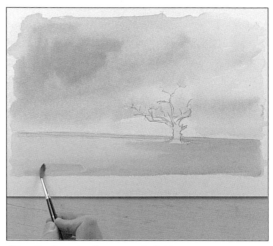

6 ▲ Darken the foreground Still using the No.6 brush, mix yellow ochre with water. Start under the horizon on the right-hand side of the paper and paint this colour all the way from top to bottom of the foreground area, and about halfway across. Take the colour right the way across the picture at the top and bottom of the foreground.

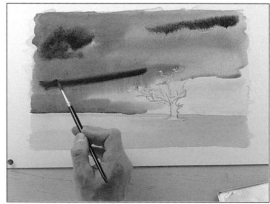

7 ▲ Begin to paint darker clouds Clean the brush and add indigo blue to the sky from the left. Use enough water to spread the colour across the paper, but keep it strong. Mix another strong tone of indigo and apply streaks of clouds here and there across the sky. Blend with a little water. Allow the paint to dry.

8 ► Deepen the sky on the right

Continue to reinforce the colour of the sky on the right-hand side. Mix Prussian blue with ivory black and make the area behind the branches darker to emphasise the dark cloud behind them. Wait until this dries. You can use a hair-dryer to speed up the process.

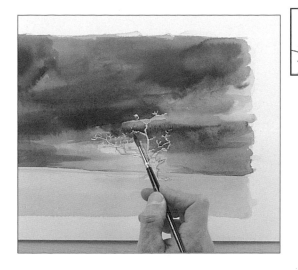

EXPERT ADVICE
Handling watercolours

Water can be used for more than just mixing colours when painting with watercolours. If you paint a patch of colour on the paper and then spread a trail of water away from it, the paint will bleed into the water by itself. This really helps if you are trying to create a 'cloudy' atmosphere.

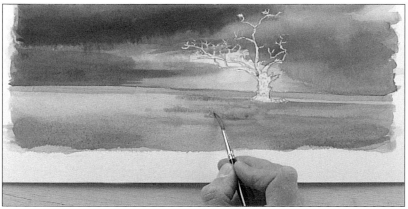

9 ▲ Add texture to the foreground
Clean the brush. Make a mix of raw sienna and yellow ochre and paint in a line under the horizon. Add viridian to this colour and add a line under the tree, then continue in short horizontal streaks across the landscape right down to the bottom of the paper. Add enough water to allow the streaks to bleed slightly.

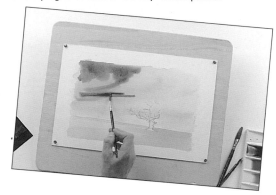

10 ► Develop the stormy sky
Now make the sky really stormy by mixing indigo blue with water and quite a lot of ivory black, so that the colour becomes more intense. Paint a patch in the left corner and spread it out across the sky. Load the brush with water so that the colour thins out as

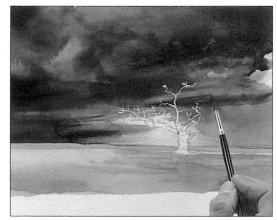

you drag it across the page. Put further washes of indigo on the left, just above the horizon, thinning with water and painting across. Use Prussian blue and black for the dark area behind the top of the tree.

11 ▲ Give definition to the grass
Mix cobalt green, ivory black and yellow ochre with a little water. Paint short vertical lines of different lengths across the right side of the page. Start under the tree and work down and across the bottom of the page. Again, allow to bleed. Also work some rough strokes at bottom left.

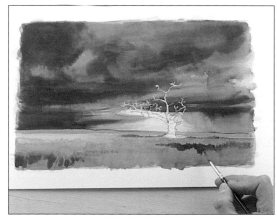

12 ► Remove the masking fluid and paint the tree
When the paint is dry, peel the masking fluid off with your fingers. You will be left with a negative image of the tree, showing all the details of the branches and twigs. Mix lemon yellow and cadmium yellow with a touch of cadmium red and water. Paint in the tree with this colour, using the No.00 brush.

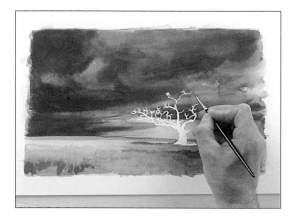

13▲ **Add fine details** Clean the brush. Mix a pure burnt sienna and apply fine lines around the edges of some of the twigs and branches to denote areas of shade. Add a little yellow ochre to the mix and paint in the grass details across the bottom left-hand side of the picture.

Master Strokes

Camille Pissarro (1830-1903)
Chestnut Trees at Louveciennes

These bare trees stand out dramatically from the sky behind them. However, as Pissarro's painting was worked in oils rather than watercolours, he would have had no difficulty in adding the finer lines of the branches once the sky had been painted in. Pissarro was concerned with how light affected outdoor scenes. He shows the play of sunlight on the trees by using colours with strong tonal contrasts for the trunks.

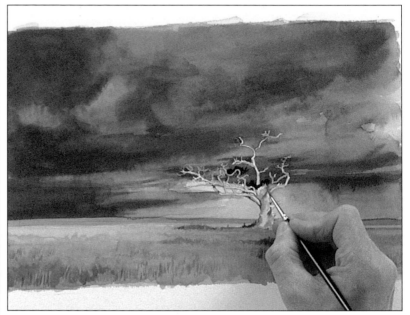

The tiny figures on the left give a sense of scale to the picture.

The gnarled and intricate branches and twigs make a filigree pattern against the background of the sky.

The long shadows cast on the ground by the tree trunks and branches add to the impression of low directional light in the scene and add interest to the foreground.

A FEW STEPS FURTHER

The rainbow gives a final, almost formal touch to the painting. Its sweeping arc, bursting from the horizon, unites the ground and sky. If you don't think you've made the sky dark enough, then mix more indigo or Prussian blue with ivory black and darken the clouds wherever you think it would look effective.

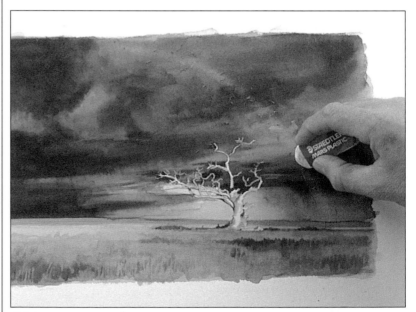

14▲ **Further darken the sky behind the tree** Clean the brush. Make a dense mix of Prussian blue and ivory black. Put this dark shade behind some of the branches to emphasise their form and shape. Clean the brush again.

15▲ **Define the rainbow** Using a rubber, erase a curve from the centre of the sky to the ground. This will lighten the sky slightly, so that the rainbow colours will show better in the next stage.

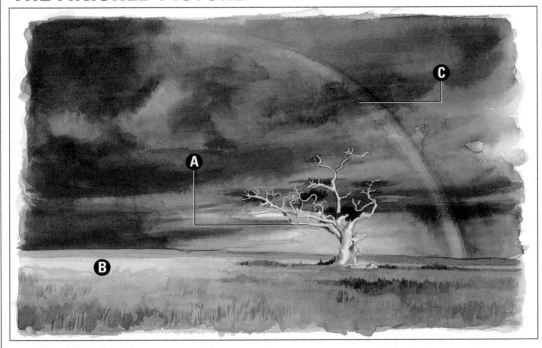

16 ▲ **Paint the rainbow** Fill in the rainbow with curved lines of cadmium red mixed with water, and then cadmium yellow.

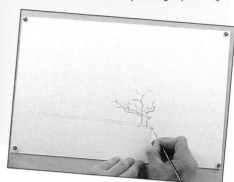
THE FINISHED PICTURE

A Well-defined details

Because the artist used masking fluid, the lines of the tree are very clear cut. Even fine details like the delicate twigs stand out sharply against the dark background of the stormy sky.

B Impression of space

Several areas, such as the sky just behind the tree trunk and the grass on the left, are left relatively devoid of colour to form an interesting contrast with the overall dark feel of the painting. They also help to create a feeling of space.

C Misty rainbow

Where the curve of the rainbow has been lightly erased, some of the darker paint remains visible on the paper underneath, giving an impression of swirling, low-lying cloud and mist.

Masking techniques

Fluffy white clouds in a blue sky, falling snowflakes or a bare tree on the horizon – all these images are easy to create using the masking technique.

▶ To create the effect of falling snowflakes in this picture, dots of masking fluid were applied to the paper with a brush before any paint was put on. Once the picture was finished and the paint had dried, the masking fluid was rubbed off.

Masking is the technique used for covering specific areas of a picture so that they are protected while paint is being applied. It is a simple but very creative technique that will enable you to produce effects that might otherwise seem quite impossible.

For example, how do you fill in the background area behind a complicated flower arrangement? And how do you paint a flat blue watercolour sky whilst leaving the white clouds untouched?

You could, of course, paint around every flower and cloud in the pictures, but this would be very time-consuming. Besides which, the new colour would almost certainly be patchy and uneven because of the tight, precise brush-strokes you would be obliged to use.

The solution is masking. It is very much quicker and more effective to mask out the flowers or clouds first, so that you can simply paint over them to achieve a flat, even background or sky. When the mask is taken away, the areas underneath will be revealed untouched as well-defined shapes.

Depending on your paints and materials, masking can produce shapes that are sharp and clear, soft and subtle, or even patterned and textured. To start with, try making a simple mask from torn or cut paper. For this exercise you will need to use quite thick paper and acrylic or oil paints (watercolour is too fluid).

All kinds of lines

To paint a straight line, hold the sheet you have chosen as your mask in position on your paper, and take the colour boldly over its straight edge. Then, for a jagged effect, experiment by tearing the masking sheet into pieces and painting over the ragged torn edges.

Experimental masking

More unusual and decorative effects can be created by painting over doilies, lace, mesh and netting. It is well worth experimenting to discover for yourself a few of the possibilities. For example, instead of applying paint with conventional brushstrokes, you might also try stippling the colour. Blue paint stippled over pieces of cotton wool on watercolour paper, for instance, will create a realistic sky with some convincing white clouds.

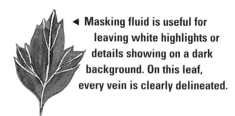

◀ Masking fluid is useful for leaving white highlights or details showing on a dark background. On this leaf, every vein is clearly delineated.

Using masking fluid

YOU WILL NEED

Small piece of watercolour paper

2B pencil

Masking fluid

Fine round brush for applying masking fluid (use an old one)

Fine round brush for applying paint

Watercolours

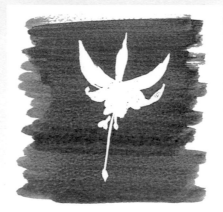

1 Mask out the flower Draw the outline of the fuchsia and paint inside it with masking fluid. Then add a turquoise watercolour wash over the top and leave to dry. Remove the masking fluid by rubbing gently. A distinct white image of the flower will be left showing.

2 Paint the flower To complete the fuchsia, paint the masked-out image in pink and purple. Using this masking technique, none of the paint bleeds and the edges of the flower remain clear and sharp.

Masking tape

For rigidly straight lines and geometric shapes, use masking tape – a tough, self-adhesive tape which comes in different widths and which adheres firmly to the paper or canvas. More important, it is also easy to remove. Press the tape down firmly to prevent paint from seeping underneath and use thick colour. Tapes leave hard edges, but by tearing and cutting you can introduce a softer effect.

It is safer to let the paint dry before removing the tape, but this is not always practicable, especially if you are using oils, which take a long time to dry. In this case, remove the tape carefully by lifting one end and holding the tape clear of the painting to avoid smudging.

Masking fluid

Masking fluid can be applied with a brush, a pen, a cocktail stick or even a twig, and dries to a thin, rubbery, easily-removed film. It is excellent for masking out specific areas of white for highlights and reflections, and for picking out detail. The fluid is also useful if you want to preserve selected painted areas from a surrounding wash.

Although masking fluid can achieve unexpected and attractive results, it is wise to experiment before using it on an actual painting. First try a few brush-strokes on a piece of scrap paper. Wait till the fluid is dry, then paint over the masked marks. Allow the paint to dry completely before removing the rubbery mask using a soft rubber or a clean finger. You will normally find that the mask comes away like magic, leaving areas of pure white, although on rare occasions it can damage the surface of the paper, spoiling further applications of paint (especially watercolour).

Use an old brush

A word of caution. Masking fluid will ruin good paintbrushes. If you use a brush to apply it, make sure it is an old one. In any case, wash the brush thoroughly after use, otherwise the bristles will become like solid rubber.

Masking fluid can be used with any paints, but you should always work on a smooth paper. The fluid tends to sink into the pitted surface of a rough paper and can be tough to remove. Also, remember to take off the fluid as soon as possible after the paint has dried – if you leave it overnight or longer, this can prove difficult.

Masking fluid is excellent for certain watercolour landscape techniques. For example, you may find it easier to depict the bare branches of trees by first masking out the shapes in masking fluid with a fine-pointed brush (see the project on page 38).

Snowflakes

Snowflakes can be dotted in with masking fluid in the early stages of a painting. For a realistic effect, mask the foreground flakes with the tip of a brush, then add smaller, distant flakes with a pen. When the masking fluid is eventually removed, the snowflakes will stand out as brilliant white flecks of paper.

Similarly, it is simple to depict water by masking out any white spray and reflections with masking fluid (the spray can be spattered on with an old toothbrush). When the fluid is removed, the white shapes stand out to create a realistic impression of moving water.

◀ **A selection of effects you can achieve with masking fluid.**

Seascape with clouds

A cloudy sky is the main focus of this seascape.

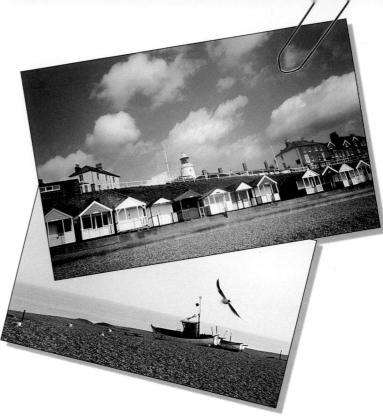

Painting skies is easy – once you know how! Watercolour can be wonderfully unpredictable to work with, especially if you apply the paint quickly and freely. You'll find that the resulting wet washes and spontaneous runs of colour will do some of the job for you and will help you to capture the mood of the sky you are painting. You'll need a range of brushes to achieve the best effects – see page 35 to find out what various brushes are used for.

Graded washes

Look at the sky, at any time of the day, and notice how it changes colour towards the horizon. This seaside sky becomes gradually paler and cooler – an effect you can obtain with a graded wash. To achieve this, dilute the ultramarine, the main sky colour, with water as you work downwards from the top of the paper. (See the feature on page 16 and the project on page 10 to refresh your memory.) The coolness is emphasised by introducing a little cobalt, a particularly cold blue, into the diluted ultramarine.

Sponged clouds

Don't forget to leave patches of white paper to represent the clouds. A continual process of dampening and dabbing with tissue and a small sponge ensures that these white shapes take on the soft-edged, fluffy appearance of real clouds.

Composing from photographs

Clouds can move so quickly that there may be no time to draw and paint them. The solution is to take photographs so that you can paint the scene at leisure later. Another advantage of working from photographs is that you are not confined to painting a single scene. You can pick the best elements from several different photos and combine them in your picture, as the artist has done here.

▶ **The summer sky with its fluffy white and grey clouds forms a lively backdrop to the otherwise simple and tranquil beach scene.**

YOU WILL NEED

Sheet of 600gsm (300lb) Not watercolour paper

2B pencil

Watercolour brushes: Nos.3, 7 and 10 round; rigger; 25mm (1in) flat

Mixing dish or palette

Jar of water

Tissue or kitchen towel

Small natural sponge

6 watercolour paints: Ultramarine; Cobalt blue; Yellow ochre; Ivory black; Alizarin crimson; Cadmium red

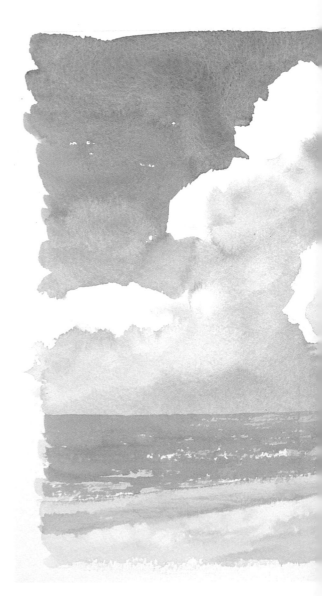

FIRST STROKES

1 ▶ Start with a drawing Using your chosen photographs for reference, make a light pencil drawing of the subject with a 2B pencil. The drawing need not be detailed – just put in a few accurate lines as a guide to show you where to apply the colour when you start painting. However, because the large expanse of sky is such an important element in this composition, you should position the horizon line with care. Note that the sky takes up about two-thirds of the picture area.

2 ▲ Dampen the clouds Take the flat brush and dampen the cloud areas with clean water so that when you apply the blue paint below the clouds it will bleed into them. Make your strokes as light as possible by moving the brush from the wrist in short, flicking strokes.

3 ▲ Start painting the sky Now for the graded wash on the sky. Mix a small quantity of ultramarine and water in a small dish. Working from the top, use the No.10 round brush and begin to wash in the sky with rapid, loose strokes of colour. Take the blue up to the top edge of the cloud shapes without touching the dampened area. This preserves a clear outline.

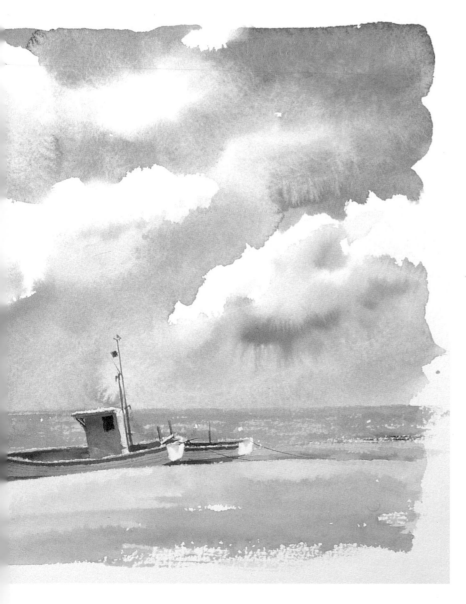

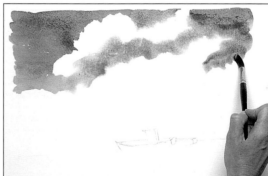

4 ▲ Dilute the blue wash Lighten the ultramarine colour by adding a little more water to the mix as you move downwards, and continue to spread the wash freely across the sky area. On the underside of the clouds, take the blue wash slightly over the edge of the previously dampened cloud areas. This will cause the blue to run slightly, giving the bottom edges of the clouds a realistic soft edge.

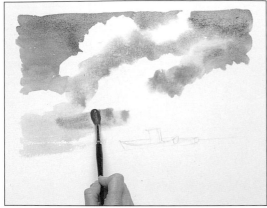

5 ▲ **Lighten the horizon** Finish the sky as quickly as possible – ideally before the dampened clouds start to dry (although you can give the clouds an occasional stroke of clean water if necessary). Make the sky paler and cooler at the horizon by adding more water to the ultramarine mix. At the same time, gradually add a little cobalt blue to the wash. Paint the sea in the same pale blue, using even strokes.

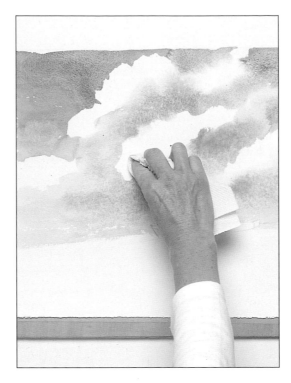

6 ◄ **Remove excess moisture** When the sky is complete, dab off excess paint and water with a tissue or kitchen towel. This creates lighter areas and also 'fixes' the runs and explosions of colour which are an essential part of the sky. Further soften the underside of the clouds by dabbing the edges with a clean, damp sponge.

Master Strokes

John Constable (1776-1837)
Weymouth Bay with Jordan Hill

Constable is the master of wide open spaces with large dramatic skies. In this seascape, painted in oils on canvas, the sky takes up more than half the picture area and is full of movement. Unlike the clouds in the watercolour project above, which are left unpainted so that the white paper can show through, Constable's clouds are made up of many colours ranging from cream to dark grey. Together, these colours create strong contrasts, suggesting a mixture of sunshine and storm.

The pinkish-brown and grey colours of the clouds are reflected in the turbulent sea.

Strongly applied strokes of cream oil paint highlight the clouds where the sun is falling on them.

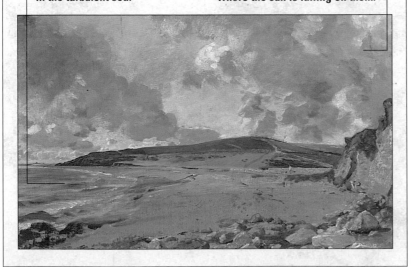

DEVELOPING THE PICTURE

Once you have completed the basic shapes of the clouds, you can develop them by adding shadows to their undersides. Avoid hard edges around the shadows by sponging, as before. If the paint has already dried, you will need to press and rub quite hard with the damp sponge to remove any unwanted edges.

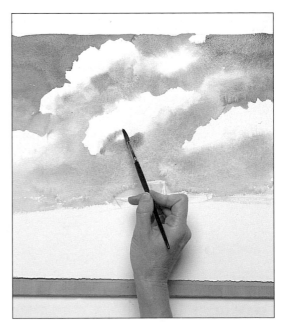

7 ▲ **Add cloud shadows** Into the underside of the damp clouds add a few shadows in diluted ivory black with an extra touch of alizarin crimson. Use a No.7 round brush, applying the colour in loose, broad strokes. Allow spontaneous runs of colour to remain.

8 ▶ Soften the shadows Blot the shadows with a piece of tissue to remove excess paint and lighten the tones. Leave some darker patches along the bottom of each shadow area to help give the clouds a three-dimensional appearance. Then give the clouds a final sponging to get rid of any hard edges which may have formed.

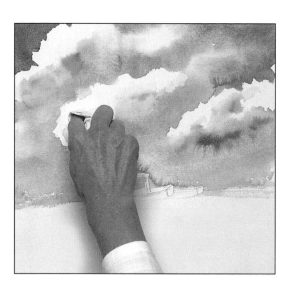

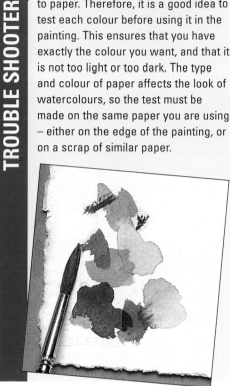

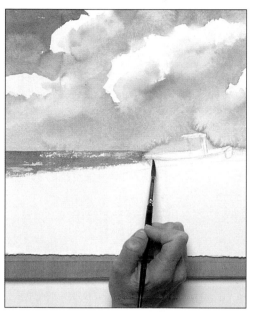

9 ◀ Paint the sea Change to a No.3 round brush and paint over the existing sea colour with ultramarine mixed with a little black. Like the sky, the sea is paler towards the horizon. But for the sea, you start at the bottom with strong colour and a loaded brush, then gradually add more water as you move upwards. Paint horizontal strokes to show the waves, leaving flecks of the underpainting showing through to represent foam.

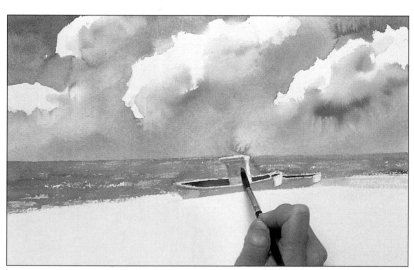

10 ▲ Add the boat shadows Still using the No.3 brush, paint the dark interiors of the boats in ivory black. Use the sea colour – a mixture of ivory black and ultramarine – for the main parts of the boat which are in shadow, leaving the rims, cabin edges and tail-ends of each boat unpainted so that the white paper shows through.

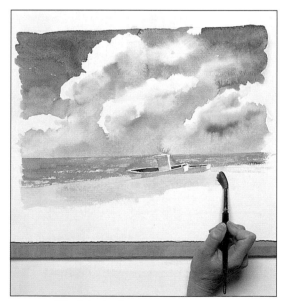

11 ▲ Block in the foreground For the sweeping shore and the sand dunes you need a bigger brush – the No.10 round. Paint the sand in broad horizontal strokes of yellow ochre mixed with a touch of alizarin crimson. Try to leave flecks of white paper showing between the brush strokes. This will give a sparkle to the sand and help to give the impression of a realistic, sunny beach.

A FEW STEPS FURTHER

The basic blocks of colour in the painting – the sky, the sea and the beach – have now been filled in. But if you want to work the picture up some more, you can give the foreground more form and enhance the sunny atmosphere of the scene. The final touch is to finish painting the two boats, which are the focal point of the picture, by adding fine details such as the mast and the ropes. These are depicted using a rigger brush (see page 36).

EXPERT ADVICE
Graded wash

The sky here is painted with a graded wash, which, unlike the flat wash shown on pages 16-17, becomes gradually paler. Start with a strong colour, then add increasing amounts of water to achieve the graded effect. This helps give a sense of distance, as pale colours seem to recede, while strong ones seem nearer.

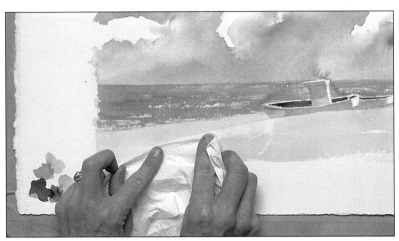

12 ▲ Lighten the sand Before the paint has had a chance to dry, use the straight edge of the tissue to soak up some of the sand colour along the top of the dune. This will create wedge-like shapes of light, giving the effect of sunlight falling on the undulating beach.

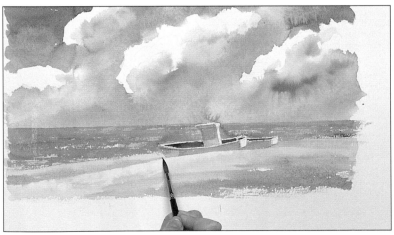

13 ▲ Add shadows to the beach Switch to the No.7 brush and paint the shadows in the sand using a warm-toned mixture of yellow ochre with touches of alizarin crimson and ultramarine.

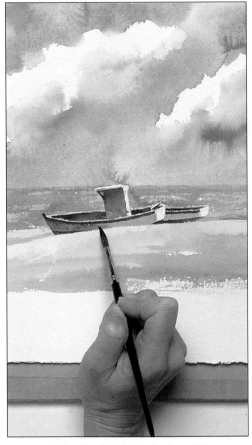

14 ▲ Paint the details on the boat The wheelhouse and bands on the boat are painted in using cadmium red, toned down with a touch of ivory black. The fine details, such as the mast, painted in black, should be completed using a rigger brush. Finally, strengthen the shadows on the side of the boat in a purplish mixture of ultramarine and alizarin crimson.

THE FINISHED PICTURE

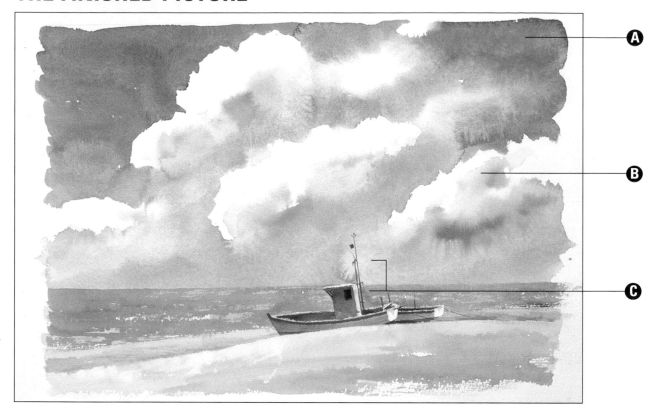

A Two blues
The wash for the sky was created using strong ultramarine at the top of the picture, becoming lighter and cooler with the addition of water and cool cobalt blue towards the horizon.

B Realistic clouds
Clouds must look softly rounded, with no hard edges – a constant process of dampening and gentle dabbing with a sponge and tissue was used to achieve this effect.

C Verticals and horizontals
The vertical shapes of the wheelhouse and mast, painted with a fine rigger brush, help break up the effect of the strong horizontal lines created by the beach and the horizon.

Express yourself Sunset silhouette

The same scene at sunset makes a dramatic picture. First, the artist washed the whole area with orange, mixed from equal quantities of Indian yellow, cadmium red and yellow ochre. Then, working quickly, she plunged mauve into the wet sky, letting the colours merge – a technique called 'wet on wet' – to create soft-edged clouds. When the picture was dry, she painted the beach in the sky colour mixed with mauve and the boat in solid black.

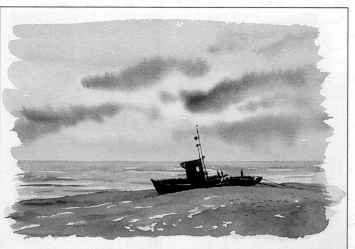

Stretching paper

Nothing is more frustrating than getting a watercolour painting just right, only for the paper to wrinkle up. Avoid disappointment with a little preparation.

Wrinkles appear in watercolour paper because it stretches when it is wet and shrinks as it dries. But it rarely dries evenly, creating wrinkles and cockles.

The degree of cockling depends on a paper's weight and quality. Paper weight is expressed in terms of grammes per square metre for metric measurements and weight per ream (500 A4 sheets) for imperial measures. With heavier papers, those of 300gsm (140lb) and over, the paper should be sturdy enough to stand all but the heaviest soaking. Light papers will almost certainly cockle.

With light- and medium-weight papers, and those meant to take heavy washes, the answer is to soak the paper with water and dry it flat before starting work.

Stretching paper may seem a chore, but it saves time and disappointment in the long run. You can stretch a few sheets at a time so that you have a ready supply and do not have to repeat the performance every time you want to paint.

Stretching on a board

The most usual method of paper stretching is to stick the wet sheet on to a board with gummed tape. Use a drawing board, blockboard, sturdy ply or fibreboard. Hardboard is unsuitable because it will bend as the paper dries. Nor

Using a board

YOU WILL NEED

- Light- or medium-weight paper
- Scissors
- Drawing board or other rigid board
- Sponge
- Bowl of water
- Gummed paper tape
- Four drawing pins

1 ▼ Wet the paper Cut the paper so that it fits on the drawing board, leaving at least 1cm (½in) all round. Soak the sponge in water and thoroughly wet the paper all over.

2 ▼ Remove excess water When the paper has absorbed the water, squeeze the sponge dry and use it to soak up any excess moisture with long, firm strokes.

3 ▶ Tape the edges Cut the gummed tape into strips slightly longer than the sides of the paper. Wet the tape and stick down the paper, half the tape on the paper, half on the board.

4 ▶ Reinforce with drawing pins Put a drawing pin at each corner of the paper to prevent the paper from tearing or pulling off the tape. Leave the paper to dry naturally away from direct heat.

▲ **Avoid the disappointment of wrinkled paper by stretching it first.**

Using a stretcher

should you use a plastic or laminated board because the tape will not stick properly. Make sure there are no bumps or flaws on the board's surface, because these will show on the stretched paper. Also, any ink or paint marks may dissolve and stain the paper.

Most papers contain size to create a receptive painting surface. Lightly sized paper takes only a minute or two to absorb water. Heavily sized paper takes longer and should be thoroughly wet. Over-soaking will eventually weaken paper and it may tear. Too little water, and the paper will not expand properly.

Use gummed brown paper tape to stick the dampened paper to the board. As the paper dries, it will often contract with a surprising force and may pull away the tape. For extra strength, cut the paper almost to the size of the board so the tape goes over the edges of the board. Always allow the paper to dry completely.

Using a stapler

A speedy method of paper-stretching is to staple the sheet to the board instead of using gummed paper. The same method can be used with a wooden canvas stretcher, in which case the stretched paper stays on the frame when you paint.

Short cuts

To avoid having to stretch paper, try using a watercolour block. This is made up of sheets of watercolour paper gummed together at the edges and mounted on cardboard to form a rigid block. Each painting is removed as it is completed. Alternatively, try watercolour boards – individual sheets of watercolour paper mounted on rigid card. These are slightly more expensive but can save a lot of time.

1 ▲ **Staple one side** Cut the paper to fit the stretcher, leaving about 4cm (2in) all round. Centre the stretcher on the paper and staple the paper to the edge of the stretcher at the centre of the longest side.

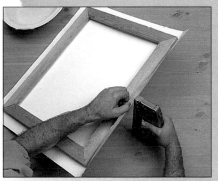

2 ▲ **Staple the second side** Staple the paper to the edge of the stretcher at the centre of the opposite side. The paper should not be slack, but do not try to stretch it too much at this stage otherwise it may tear.

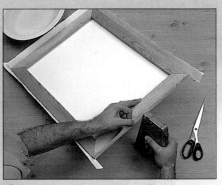

3 ▲ **Cut the corners** Cut a slot at each corner of the paper, from the corner of the stretcher and at a right angle to the edge of the paper. Staple the paper at the centre of the two remaining shorter sides.

4 ▲ **Wet the paper** Finish stapling the paper to the stretcher. Wet the paper thoroughly and evenly with a sponge and allow to soak until the paper has absorbed the moisture.

5 ▲ **Remove excess moisture** Wipe any remaining water from the surface of the paper using the squeezed-out sponge in long, even strokes, and allow the paper to dry naturally.

Still life with books

Watercolour is a flexible medium which can create many different effects. The 'one-stroke' wet-on-dry method gives crisp, clean images.

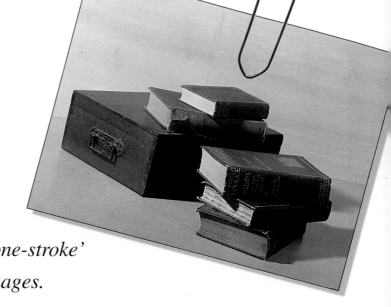

◄ The simple geometric shapes of the books and box are brightly lit from one side to give emphatic shadows.

The true beauty of watercolour painting is seen when it is applied layer upon layer as areas of pure colour. The building up of layers of translucent washes gives the painting a lovely, luminous brilliance.

The key to producing clear, vibrant watercolours is to keep the washes fresh and clean, and to allow each wash to dry thoroughly before you lay the next. This is called the wet-on-dry technique. Working in this way you can build up layers of fresh, jewel-like colour.

Working light to dark

When using pure watercolour, you do not have the option of adding a lighter tone over a dark tone, so the lightest tone available is the white of the paper. Plan the way you will work before you start. Look for the brightest highlights on your objects and make sure you retain these as white paper. You need to work 'light to dark' in the classic watercolour way, laying down the lightest tones of the local colours first, then gradually building up the tones by overlaying successive washes of colour.

Keep your colours fresh

Choose a large palette with many recesses, or use several saucers, so that you can keep each wash separate. Have two jars of water, one for rinsing your brushes and the other for diluting the paint for the wash, and change the water fairly frequently.

FIRST STROKES

1 ▼ **Locate the main elements** Using a 4B pencil, locate the objects on the sheet, starting in the middle and working outwards. Use very light lines to provide a guide for the rest of the drawing. Refine the drawing, checking vertical and horizontal alignments, angles and 'negative shapes'. Include the outlines of the cast shadows.

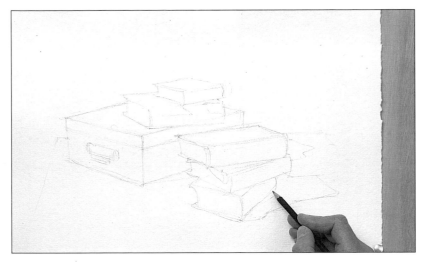

2 ▶ **Lay the first pale pink washes** Make a pale wash of permanent rose toned down with a touch of Payne's grey. Test the wash on scrap paper and add more water if the colour is too intense. Apply to the top book with a No.6 brush. Add scarlet to the wash to produce a warmer red for the second book. Leave to dry.

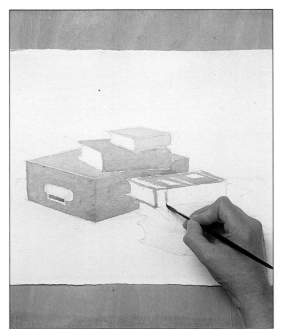

3 ◀ **Establish the box and blue books** Mix a wash of burnt umber with a touch of scarlet and Payne's grey. Using the No.6 brush, apply the paint to the front and sides of the box. Add a little cobalt blue to create a cooler brown for the top. Make a dilute cobalt blue wash with a touch of Payne's grey to paint the book on the top of the pile. Using the very tip of the brush, take the wash around the golden lettering.

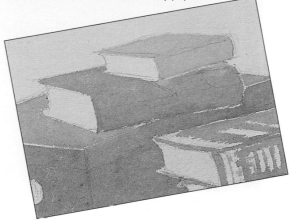

▶ **A cool red (permanent rose) and a warm red (scarlet) will give you just the right colour for the reddest books.**

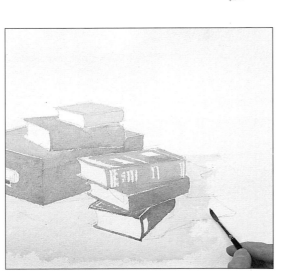

4 ▲ **Begin to paint the surface** Continue blocking in the blue books with a slightly more intense version of the colour. Leave the painting to dry. Mix a wash of raw sienna with a touch of cadmium yellow and light red. Block in the golden colour of the supporting surface, then leave it to dry.

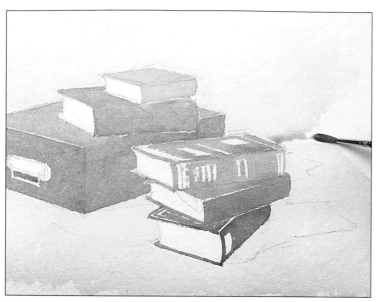

5 ▲ **Paint the background** Mix a very pale greenish-yellow for the background. Use lemon yellow with a little cobalt blue and raw sienna. Lay this on as a single flat wash. Leave to dry.

DEVELOPING THE PICTURE

At this point all the elements of the picture have been established. Now you need to build up the darker tones with more intense versions of the initial washes. This will give the image a three-dimensional quality.

6 ▼ **Add dark tones** Mix a wash of permanent rose with a touch of burnt umber for the shaded spine of the top red book. Use the tip of the brush to lay a thin line of colour along the top edge of the cover. Add a touch of burnt umber to a wash of scarlet for the shaded parts of the second book. Notice the soft edge where the shaded area meets the light area – dip your brush in water and run it along the edge of the wash. For the shaded side of the box, use burnt sienna darkened with Payne's grey.

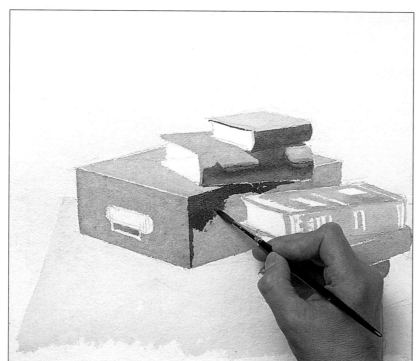

USE A HAIR-DRYER TO SPEED UP DRYING

TROUBLE SHOOTER

To retain the integrity of each layer of wash, it is important that the painting is thoroughly dry before you apply successive washes. This can take time. A hair-dryer will speed things up. Don't use a dryer if there are puddles of wash, and choose a low setting – this avoids runnels of paint being blown across the support.

7 ▲ **Add more dark tones to the spines** Darken cobalt blue with Payne's grey. Using this wash, apply colour to the spine of the blue books, working carefully around the golden lettering on the spine.

◄ **Use permanent rose with a touch of Payne's grey for the cooler of the red books.**

▶ **Mix Payne's grey, burnt umber and raw sienna to create a dark but warm tone for the cast shadows.**

8 ▼ **Add the cast shadows** The shadows that fall on the supporting surface are important to establish the horizontal plane on which the objects are resting. Paint them with a wash of Payne's grey with burnt umber and raw sienna, using the No.6 brush. Work carefully to create crisp edges. Leave to dry.

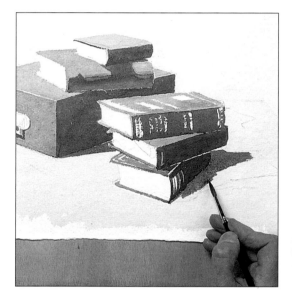

9 ▼ **Erase pencil lines** Using the previous wash, lay bands of shadow along the edge of the book covers. Leave to dry. Erase any distracting pencil lines with a kneadable rubber.

10 ▲ **Add details to the box handle** Use a Payne's grey/burnt umber mix to paint the brass handle, leaving the white of the paper for the highlights. Use the tip of the brush and don't worry about precise details – a simplified version will be very convincing.

Express yourself
Editing and simplifying

The colours, shapes and textures in a subject are merely a jumping-off point for the artist. The 'picture-making' process involves manipulating, editing and emphasising to create an image that is effective and unique. Here the subject has been simplified, which emphasises the shapes of the objects, the pattern made by the light tone on the ends of the books, and the way this is echoed by the areas of shade and shadow. Try stripping your still-life subject down to its bare essentials and see what emerges.

11 ▶ **Start to add the darker tones to the books** Apply a mix of permanent rose with Payne's grey to the cover of the top book, leaving a sliver of underlying colour along the edge, where light catches it. For the second book cover, apply permanent rose with scarlet.

12 ▲ **Work up details** At this point, decide which areas need to be emphasised. Warm up the side of the box that is turned to the light with a wash of burnt sienna and use the tip of the brush to add a few details to the handle. Mix cobalt blue and Payne's grey and add dark tones to the tops of the blue books, using the tip of the brush to work around the lettering.

A FEW STEPS FURTHER

The two most difficult stages in creating a picture are getting started and deciding when it is finished. The painting is complete and entirely convincing, but you might want to take it further, adding emphasis and detail.

13 ▲ **Developing the surface** The contrast between the objects and the supporting surface is a little stark. Rectify this with a flat wash of raw sienna and burnt sienna. Leave to dry. Intensifying this area pulls the entire image together. Add a wash of raw sienna with Payne's grey to the end of the bottom blue book.

Master Strokes

François Bonvin (1817-87)
Still Life with Books, Papers and Inkwell

Although painted in the nineteenth century, this still life has a similar feel to the one in the project. It has a pleasing simplicity and captures in the same way a seemingly casual pile of interesting old books and papers, which look as though they have been left ready to be picked up and used.

Bonvin's composition is lit from the left, creating different areas of tone on the book. The difference in technique between oils and watercolour means that the highlights could be added after the dark tones were placed. With watercolours, the artist must work from light to dark shades.

The separate sheets of paper are defined by varying degrees of shadow.

Note how the light catches the edge of the top cover, creating a pale band along the edge.

14 ▲ **Adding gold lettering** The covers of the books are blocked with gold lettering. You can suggest this simply by going over the white lettered areas with raw sienna toned down with a tiny touch of Payne's grey.

15 ▶ **Warm the top of the box** Add warmth to the top of the wooden box by adding a final wash of burnt umber and burnt sienna. This final layer of colour will add depth and warmth.

16 ◀ **Enrich the handle** Develop the brass handle further by working into it with Payne's grey warmed with burnt umber. A few touches will be surprisingly effective. Use this mix to add details and lettering on the covers of the red books.

THE FINISHED PICTURE

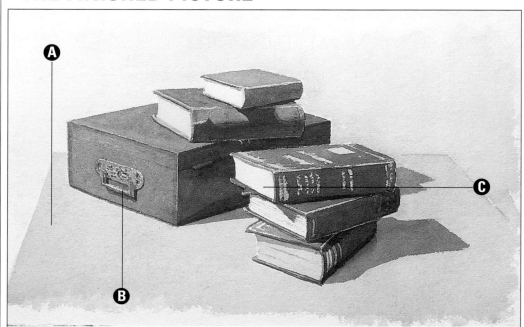

A Layers of crisp colour
Dry each application of water-colour before you apply the next — watercolour applied wet on dry is much easier to control.

B Small details are important
Small, generalised details, such as the scrollwork on the handle of the box, can add character and richness to a painting.

C Working light to dark
With pure watercolour you do not have a white to create light tones. The white of the paper is the lightest local colour — here, the pages of the book.

Tinted papers

If you have used only white paper in your work up to now, why not try some of the temptingly coloured papers available in art shops and see how they can change the character of a drawing or painting?

If you use yellow paint or coloured pencil on a red paper, you are likely to end up with orange or with a yellow that has a distinctly orange tinge. Similarly, if you use blue on yellow paper, the result will be green.

In other words, the colour of the paper you are using will show through and directly affect the marks you make. This is why watercolours and other transparent materials are traditionally

painted on white paper; the bright whiteness shows through, making the transparent colours clear and vivid.

Only with very opaque materials, such as undiluted gouache or acrylic, will the colour be thick enough to obliterate the effect of the underlying paper.

Mix and match

A huge selection of coloured papers is available, ranging from the lurid and luminous to the sombre and muted. The only way to discover the effect of each type of paper on the various media and different colours is by trial and error.

Have a look at some of the pastel papers, including the popular Canson Ingres, Mi-Teintes and Fabriano Ingres. These papers are just as good for coloured pencil and mixed media work as they are for pastels. Also consider sugar paper, which, although fairly flimsy, is good for charcoal or chalk drawings. Coloured tissue paper, while not suitable for drawing and painting on, is excellent for collages and mixed media.

Bear in mind that watercolour and other wet media require sturdy papers, and that pencils and pastels tend not to work as well on very smooth papers as

▼ **Different coloured papers can subtly alter the colours of the marks you make on them. The illustration below shows how a yellow shade in various media changes character depending on the paper used.**

Coloured pencil

Soft pastel

Watercolour

Gouache

CHOOSING A PAPER COLOUR

Landscape

▶ A warm, pinkish paper contrasts effectively with the blue sky and green grass of this landscape.

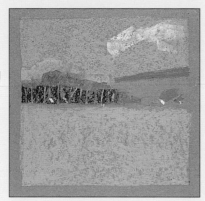

▶ The same landscape on a cool, blue paper is less dramatic. Instead, the mood is more tranquil.

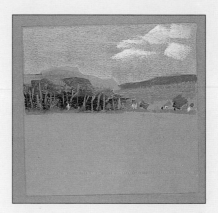

Still life

▶ Flecks of a mid brown paper show through the pastel marks in this drawing of an orange. The effect is to enhance the overall warm tones of the picture.

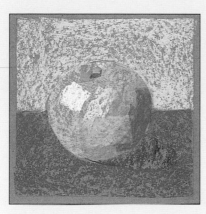

▶ Blue paper gives the subject a different, though equally effective character. It cools the warm orange shades, at the same time toning with the dark shadow and foreground.

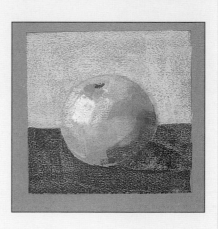

they do on those with some texture. But apart from these practical considerations, the best idea is to buy a few samples of different types of coloured paper and have fun experimenting!

Choosing a coloured paper

Whichever medium you are using, the colour of the paper you choose should play a positive role in the picture, complementing the subject. If you have only white paper, you can easily tint it before beginning your painting with a wash of watercolour or gouache, or by lightly applying a layer of pastel colour with the broad edge of the stick. However, a pastel tint is not ideal for detailed work.

A landscape worked mainly in cool shades of green can look good on a cool paper such as blue or grey. However, exactly the same subject will often work equally successfully on a warm orange or brown paper, though the resulting picture will be very different in mood. As you can see from the group of illustrations on this page, the character of a subject is fundamentally affected by your choice of background colour.

Lights and darks

Light colours show up well on dark paper, whereas darker colours are accentuated by a lighter paper. If your subject is mainly dark, with just a few pale areas or highlights, then it makes sense to start off with a dark-toned paper. A moonlit landscape, for example, looks wonderfully dramatic on black or dark blue.

Most of us are familiar with grey sugar paper, which is still standard issue for art classes in many schools and colleges because it is inexpensive. It may have seemed dull at the time, but this shade of paper provides an excellent medium-toned background colour for many drawing and painting materials.

Grey sugar paper is particularly effective for drawings made in chalk and charcoal used together. By starting with a mid-toned background, you can immediately begin work on the tonal aspects of the drawing by establishing the extreme lights and darks, relating each of these to the tone of the grey paper. Use black charcoal for the shadow areas and white chalk for the highlights and other paler areas.

▶ This selection of papers shows a range of light and dark colours, some warm and others cool. A, B and D are examples of Fabriano Ingres paper; C is a white watercolour paper that has been tinted with a layer of pastel, while E is the same paper colour-washed to give an interesting tone.

A

B

C

D

E

Landscape with hills

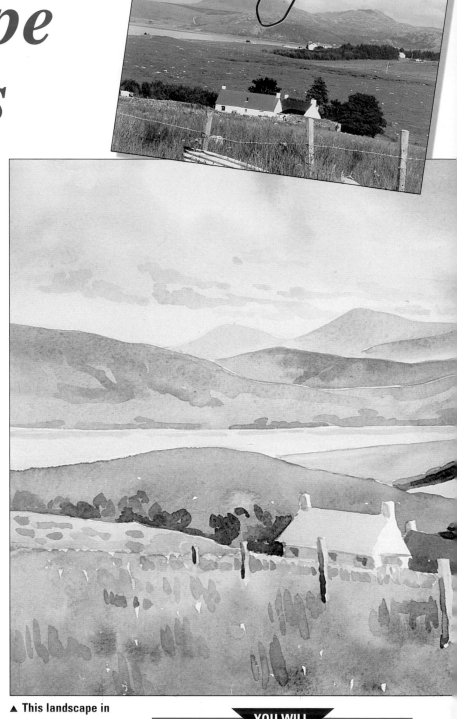

Using cool shades of blue for the distant hills gives this summer landscape a sense of perspective.

A little touch of blue can work wonders in a landscape painting, not only in the sky, but also in the fields, trees and hills. Although the lovely watercolour shown here is a summer landscape, painted when everything is at its greenest, only the grass in the foreground can be described as bright green. The rest of the scene becomes bluer as it recedes into the distance. In fact, the hills are not green at all, but are painted in pure ultramarine.

Atmospheric perspective

Distant colours in a landscape are affected by the intervening atmosphere, which makes them appear hazy. This natural phenomenon, sometimes called atmospheric or aerial perspective, is the reason why hills in the distance appear to get progressively bluer and paler.

Watercolour is the perfect medium in which to capture this gradually fading effect. Because the colours are translucent, hills will appear to get fainter if you add increasing amounts of water to the blue. Remember, watercolour dries paler and duller than its wet colour suggests, so be bold with the blue. It is better to exaggerate the blueness than to lose the effect of the atmospheric perspective.

Perspective with brushstrokes

Another effective way of suggesting distance is not only to make the foreground colours brighter, but also to apply the colour in larger, more distinctive brushstrokes. For example, the tufts of grass at the front of the picture are painted in bold strokes of bright colour which bring the foreground into focus. They also contrast with the smoothly washed colours of the distance, emphasising the difference between the two.

▲ **This landscape in watercolour was painted from a limited palette. Most of the colour mixtures come from the same three basic colours – cadmium orange, ultramarine and burnt sienna.**

FIRST STROKES

1 ▶ **Flood in the sky** Start with a light outline drawing in 2B pencil. Using a No.10 round brush, dampen the sky and clouds, then flood the wet area with Winsor blue. Leave fluffy white unpainted shapes for the clouds. Mix equal quantities of ultramarine and alizarin crimson and paint shadows on the underside of the clouds, letting the colour run into the wet paper.

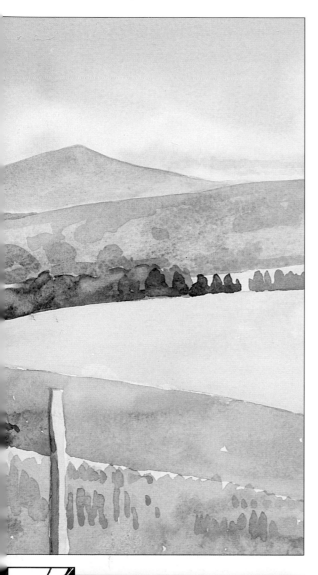

2 ◀ **Soften the clouds** Wash and squeeze the moisture from the No.10 brush and soften the edges along the top of the clouds by lifting the colour off with the damp brush.

3 ▶ **Develop the landscape** While the sky dries, start work on the rest of the painting. Change to a No.7 round brush and paint the small rooftop in burnt sienna. Use a diluted mixture of the same colour on the second roof and the fence posts. Start painting the water with a single streak of diluted Winsor blue to reflect the colour of the sky.

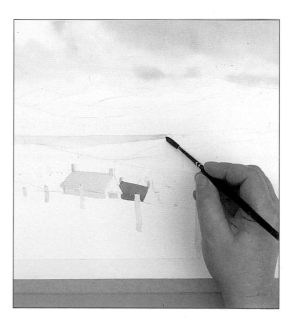

EXPERT ADVICE
Using a pen rubber

Use a pen rubber for correcting line drawings. This handy tool has a narrow, angled tip which allows you to erase a fine line without rubbing away the surrounding drawing.

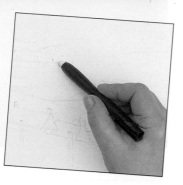

DEVELOPING THE PICTURE

Now the sky and foreground are in place, it is time to establish the blue distant hills, then introduce a few warmer tones. Do this last by adding a little cadmium orange to the other landscape colours.

4 ▼ Create a sense of distance Paint the three palest distant hills using diluted ultramarine. The furthest hill is by far the palest of the three, so it should be painted with the thinnest mixture. Add a little more blue to the mixture for each of the other two hills.

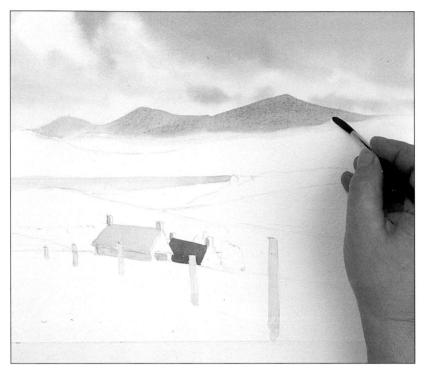

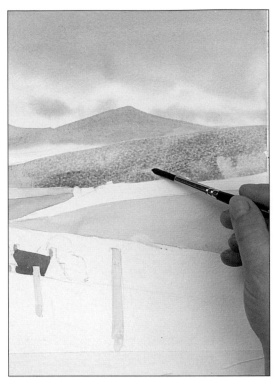

5 ▲ Block in the middle distance Paint the greenest fields in Hooker's green mixed with a little cadmium orange. Brighten this mixture with a little cadmium yellow and apply a little of the new colour to the first colour while it is still wet. For the darker hills, use ultramarine toned down with a little cadmium orange. Vary this by painting a few strokes of burnt sienna into the wet colour.

6 ▶ Start the foreground grass For the warm-toned foreground grass, mix cadmium orange and burnt sienna with a touch of ultramarine. Suggest the grass texture by applying the colour in short, vertical strokes.

TROUBLE SHOOTER

REMOVING WET PAINT

Working on a tilted board causes very wet colour to run and collect at the bottom of the painted area. If this reservoir of paint is not removed, it can dry to a much darker tone than the surrounding colour. To prevent this, soak up the unwanted paint using a dry brush or a piece of tissue.

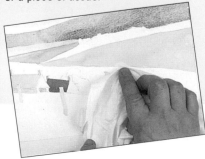

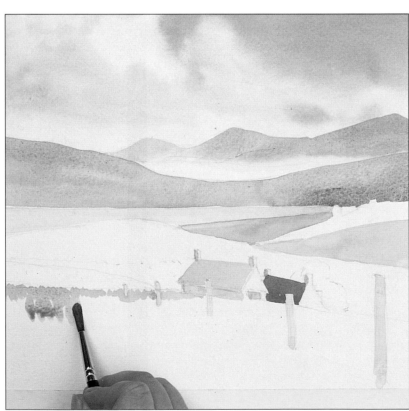

7 ▼ Indicate the grass texture Mix a second grass colour from equal parts of ultramarine and cadmium orange. Change to the No.10 brush and continue with the foreground, alternating between the two grass mixtures and allowing the colours to run together. Increase the size of the vertical strokes as they get nearer to the lower edge of the picture.

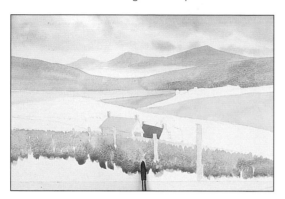

8 ▶ Develop the background Paint the wall in a diluted mixture of burnt umber and burnt sienna. Change to the No.7 brush and move on to develop the background. The hills should become progressively stronger and warmer as they come forward, so paint the remaining hill in ultramarine with a little added orange.

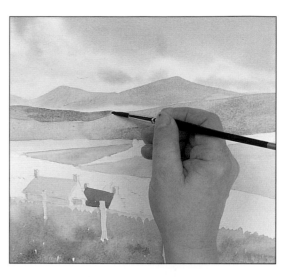

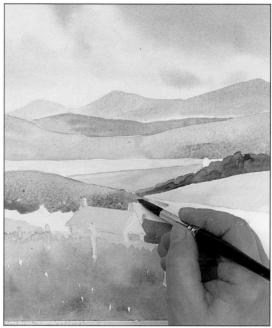

Express yourself
A simple sketch

A rapid watercolour sketch of the same subject is similar in colour to the finished painting. As in the painting, the hills are painted in ultramarine. However, in the sketch the artist is less concerned with the subtle gradation of tones than in creating a lively, instant impression of the landscape colours.

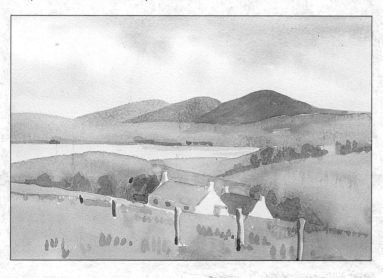

9 ▲ Continue with the hills and trees Paint the trees – initially as one continuous shape – using a dark bluish-green mixed from ultramarine and a little cadmium orange. Wait for the tree shape to dry, then paint into it, adding texture and a few tree shapes in varying mixtures of ultramarine and cadmium orange. Go back to the No.10 brush for painting the hill behind the house; this is mainly cadmium orange softened with touches of burnt sienna and ultramarine.

▶ **Experiment with different tones of ultramarine to discover its full potential. Start with three or four equal amounts of blue and add increasing amounts of water to each. Try the results on scrap paper.**

10 ▼ **Develop the trees** Before the orange hill is quite dry, paint the tree shapes in ultramarine with touches of cadmium orange and burnt sienna. The damp background gives these a nice soft edge.

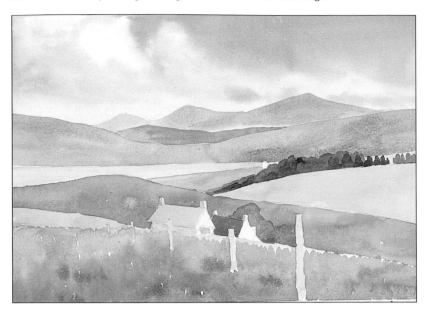

Master Strokes

Jan Brueghel the Elder (1568-1625) and Joos de Momper (1564-1635)
Mountain Landscape with a Lake

These two Flemish painters regularly collaborated with each other and other artists; figures in Momper's landscapes were often painted by Brueghel. This mountain scene exemplifies aerial perspective, with the furthest mountains painted in cool blue tones so that they recede into the distance, while warm shades of reddish-brown are used to make the foreground advance.

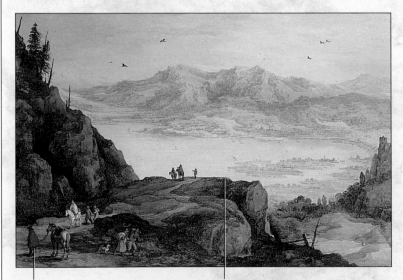

Little touches of red in the foreground are a favourite device used by artists to help create convincing perspective.

The small figures silhouetted against the pale background of the lake provide dramatic focus and a sense of scale.

Most of the main landscape features are now blocked in. The painting is not quite finished, but already the pale blue distance and the strong foreground have created a sense of space in the picture.

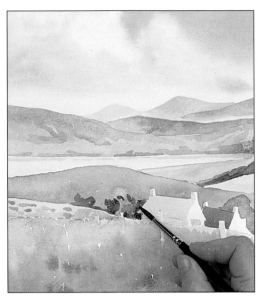

11 ▲ **Define the hill, wall and trees** Now for a few details. Use a No.7 brush to emphasise the edge of the hill. Add a few flecks for the individual wall stones in burnt umber. Paint a few sharp shadows into the distant trees in ultramarine; do the same to the trees behind the house in Hooker's green with a touch of burnt umber.

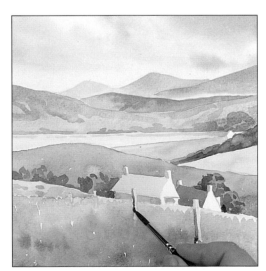

12 ▲ **Complete the house and fence** Paint the shaded side of the houses in ultramarine with a tiny touch of burnt umber. Define the fence by painting the shaded side of each post in a mixture of equal parts of burnt umber and ultramarine.

13 ▾ **Add shape to the clouds** To add a few more cloud shadows, first wet the area with clean water, then dot in a few shadows in ultramarine darkened with a little burnt umber.

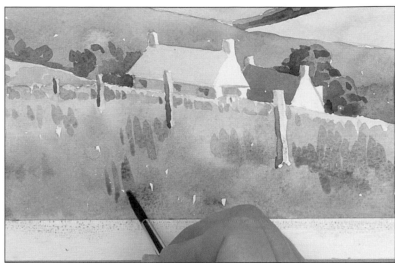

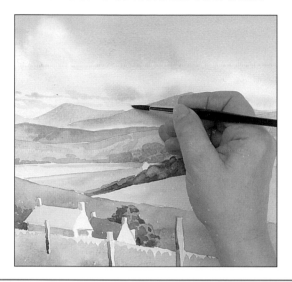

14 ▴ **Complete the foreground** Finally, bring the foreground into focus by painting a few crisp blades of glass and leaves on to the existing dry colour. Do this in varying mixtures of cadmium orange, ultramarine and burnt sienna.

THE FINISHED PICTURE

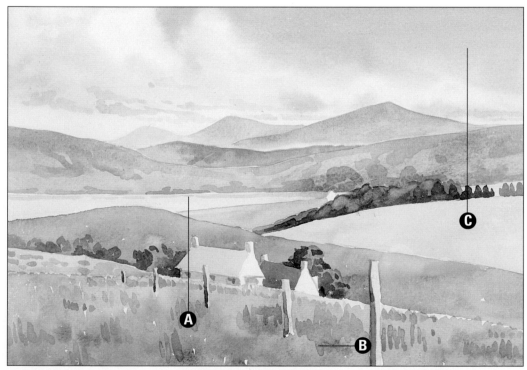

A Reflection of the sky
The water in the lake is practically colourless, so it was indicated only by a pale streak of Winsor blue to reflect the colour of the sky.

B Texture in the foreground
Foreground grass texture was added in the final stages and painted on to dry colour. This creates sharp shapes which bring the foreground clearly into focus. In comparison, the background scenery appears indistinct.

C Different blues
The sky was painted in Winsor blue, making a subtle distinction between the sky area and the distant blue hills, which were painted in ultramarine.

Placing the horizon

Think carefully about where you place the horizon in your landscape painting – it has an enormous effect on the atmosphere of your composition.

The location of the horizon defines the proportion of sky to land, and has a crucial effect on the mood and sense of space within a landscape picture. Without really thinking about it, we know that the horizon line is probably the most important element in a landscape painting. In fact, if a single horizontal line is drawn anywhere on a rectangular support, most people will 'read' it as the horizon.

A low horizon

Flat, open landscapes such as plains and fenland have a broad, spacious feeling. The horizon is far away and wide, and the sky is large and important. Seascapes have a similarly open feeling. In these regions you can see weather fronts approaching and watch the shadows of clouds crossing the landscape. To recreate these conditions in a picture, place the horizon line low.

The shape of the canvas also affects the mood of the composition. A wide landscape format allows the eye to travel slowly from side to side, so it is ideal for broad, open panoramas. For his painting *Deauville, 1893*, Eugène Boudin chose a landscape format and placed the horizon low in the picture area. There is a large sky, and the clouds and the people on the beach diminish in scale towards the horizon, creating an airy, spacious feel.

Contrast this with *Poplars on the Banks of the Epte* (right) by Claude Monet (1840-1926). Here the artist has combined a very low horizon with an upright format. The tall, slender columns of the poplars and the sinuous zig-zag line of their canopy draw the eyes upwards. The viewpoint (that is, the viewer's eye-level) is an important aspect of landscape composition. If you are high up – standing on a wall, for example – you can see further than if you are sitting down, and the horizon will

▲ *Poplars on the Banks of the Epte* (1891) was painted by Claude Monet in the autumn, so the warm colours of the turning leaves emphasise the sinuous curve created as the trees follow the river bank, and increase the illusion of depth in the picture.

appear to be further away. This work was painted from a boat, and the low viewpoint means it is dominated by the sky and the towering, silhouetted trees. Although the trees get smaller as they recede into the distance, they and their reflections break the edges of the picture, drawing attention to the picture plane.

A high horizon

By contrast, a high horizon leaves little room for the sky and produces a contained and rather intimate landscape. In nature you can experience this effect in mountain valleys; towering crags crowd in upon you, casting deep shadows and limiting your view of the sky. Wooded landscapes and forests can also produce this slightly claustrophobic atmosphere.

In *Red Vineyards at Arles* (below), Vincent Van Gogh (1853-90) has taken an exaggeratedly high viewpoint, so we can see all the activity in the vineyard. A high horizon tends to flatten the picture, and the artist exploits this quality to create a graphic, almost decorative painting. Van Gogh has also created a rather ambiguous sense of space – the trees and human figures diminishing in the distance contrast with devices which emphasise the picture plane; bright colours, strong outlines and vigorous brushmarks which do not change in scale.

Experimenting with horizon lines

The horizon is just one aspect of the internal geometry (organisation) of a landscape painting. The final impact of the composition will depend on how you organise the other elements such as space, tone, colour and format. Choose a landscape and make thumbnail sketches of it, placing the horizon at different levels. You will find that each treatment demands a different internal geometry.

● If you place the horizon low in the picture area and create a thunderous sky, the painting will have a dramatic, threatening mood.

● Introduce trees on either side of the scene and the image will feel more enclosed.

● Place the horizon high within an upright format – the landscape will advance towards the viewer.

● Introduce a sweeping path or a river to lead the eye towards the horizon and you immediately create a sense of recession.

● Try placing the horizon right in the middle – you may have been told that this is 'wrong', because an even, symmetrical image can be boring, but it can work very well.

A high horizon creates an enclosed, intimate feeling and allows the artist to show greater detail in the foreground.

A central horizon can be unnaturally stable, but the right tonal balance between the areas adds dynamism.

A low horizon is ideal for showing dramatic skies to their best advantage, and to create a sense of spaciousness.

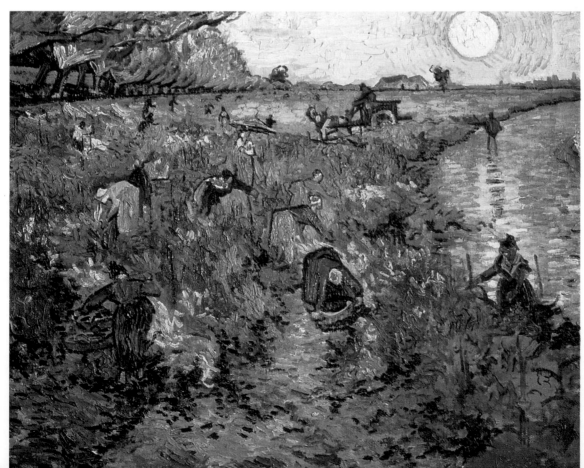

◀ Vincent Van Gogh used a high horizon in *Red Vineyards at Arles* (1888) to give him the space to show a landscape drenched in the red, orange and golden tones of a glorious sunset.

Creating foliage in watercolours

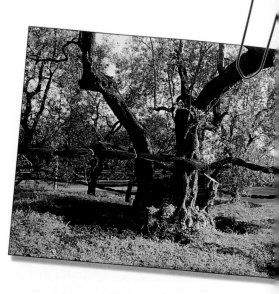

Trees, with their enormous variations in shape, colour and patterns of growth, are an important source of colour and texture in landscape paintings.

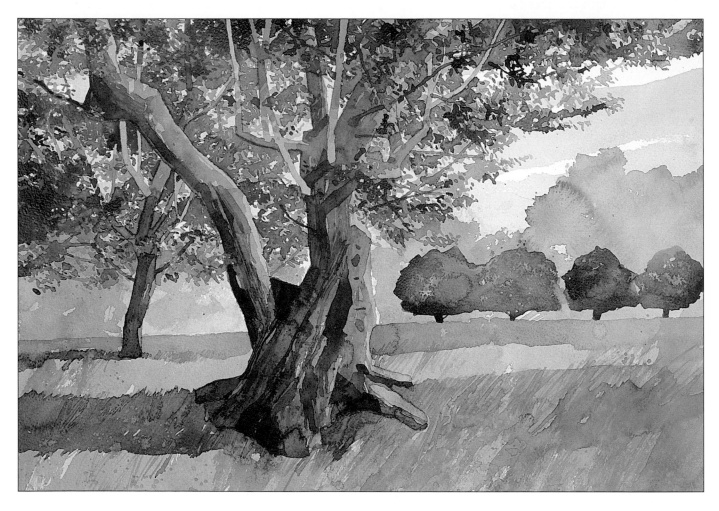

T he flutter of leaves in a passing breeze is one of the most important elements in a convincing landscape painting. Using a few simple watercolour techniques, you'll soon be creating truly naturalistic effects.

When trees are in the foreground, you can make out the pattern made by the foliage and the shapes of some individual leaves. But you won't see every part of a scene with pinpoint accuracy, so don't paint every leaf. Instead, find a mark that describes the distinctive character of the foliage.

Study the subject carefully through half-closed eyes and put down the areas of tone. Gradually, a leaf-like pattern will begin to emerge. If you paint just a few leaves in detail, the viewer's brain will understand that the rest of the foliage follows the same pattern and will 'fill in the blanks'.

When a tree is further away, you can see only generalised leaf forms and the leaf masses around the boughs. And when trees are seen from even further away, only a broad silhouette of the leaves and trunk is discernible.

▲ **The grey-green foliage of this gnarled olive tree is shown in enough detail to suggest the leaves without being too precise. The trees in the distance are treated as silhouettes.**

FIRST STROKES

1 ▼ Draw the outlines Using a 2B pencil, establish the broad areas of the landscape. The branches and leaves of trees look complicated, so ignore the detail and concentrate on the underlying forms. Think about the composition – whether you are working directly from the subject or from references, adjust the drawing to create a pleasing arrangement.

YOU WILL NEED

Large piece of 300gsm (140lb) Not watercolour paper

2B pencil

Brushes: Nos.10, 6, 3 soft rounds

7 watercolours: Cobalt blue; Sap green; Sepia; Yellow ochre; Payne's grey; Cerulean blue; Black

Mixing palette or dish

Natural sponge

▼ A mix of sepia, sap green and yellow ochre makes a good foliage colour.

2 ▶ Block in the sky Using a No.10 brush, mix a wash of cobalt blue and lay it in for the sky. Remember that, in watercolour, the paper is the lightest colour available, so leave patches of paper unpainted as clouds. Leave to dry.

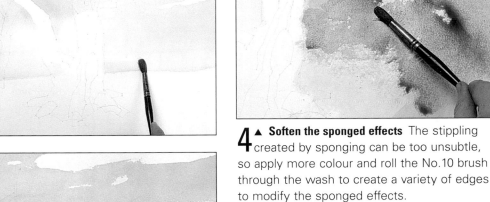

4 ▲ Soften the sponged effects The stippling created by sponging can be too unsubtle, so apply more colour and roll the No.10 brush through the wash to create a variety of edges to modify the sponged effects.

3 ▲ Apply background greens Make a wash of sap green and, using a natural sponge, apply this broadly and loosely in the grassy foreground area. Use sweeping, diagonal marks that suggest swaying grasses. Mix sap green and sepia to create a lighter green for the trees in the distance, and dab it on with a sponge.

5 ▲ Add texture to the foreground Mix sap green, sepia and yellow ochre to give a vivid grass green colour. Using a No.6 brush and making vigorous diagonal strokes, add more colour to the grassy area in the foreground. Leave the painting to dry.

6 ▼ **Paint the trunks and branches** Make a wash of sepia and Payne's grey for the tree trunks. Using the No.6 brush, apply flat colour, thinking about the way a tree grows: the boughs come out of the main trunk, and the branches and twigs grow out of each other in a logical pattern, becoming gradually thinner towards the edge of the tree. Allow to dry.

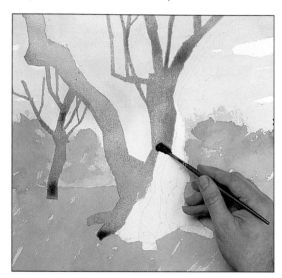

DEVELOPING THE PICTURE

The background and the main silhouette of the tree are established, so it is now time to create the foliage. The patches of leaves are built up gradually in three stages by layering a light, middle and dark tone of the same basic colour. This technique creates a sense of movement, suggesting light catching fluttering leaves.

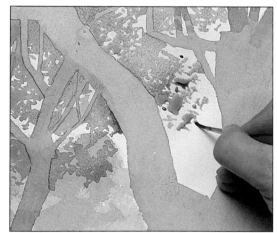

7 ▲ **Start to apply foliage to the olive trees** Mix Payne's grey, sap green and cerulean blue to make a pale blue-green for the first foliage tone. Use a small No.3 brush to apply this wash, pushing and pulling the colour with the tip of the bristles to create random clusters of leaves. Try not to space the marks too evenly, and vary the tone of the wash by adding differing amounts of water.

Gum arabic is the medium that carries the pigment in watercolour paint. Adding extra medium intensifies the colour and gives a slight sheen, as in the darkest foliage colour shown below. You can buy gum arabic in bottles from most art supply shops.

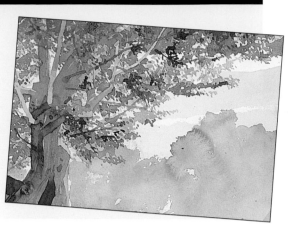

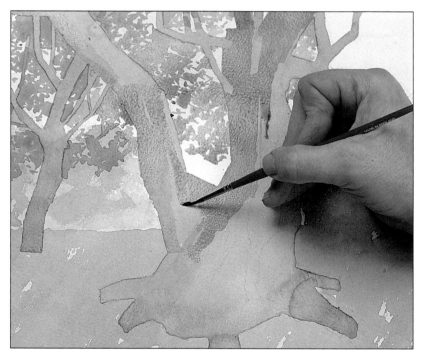

8 ▲ **Add shadows on the tree trunk** Using a more concentrated wash of the sepia/Payne's grey mix and the No.3 brush, lay in the shadows on the trunk and branches of the main olive tree. These shadows give form and solidity to the tree, and also help to describe its gnarled surface.

9 ▶ **Finish adding the first tone** Using the Payne's grey, sap green and cerulean blue wash and the No.3 brush, complete the first application of tone to the foliage. Take care to keep the marks a similar size as you work across the painting. Leave the paint to dry thoroughly.

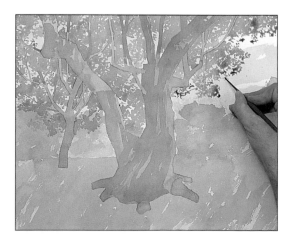

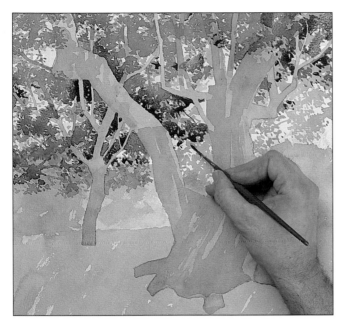

10 ▲ **Add a second tone to the foliage** Mix a darker tone of the foliage colour and use the No.3 brush to apply another layer of leaves. Screw up your eyes to isolate the main masses of foliage. Notice that the tops of each mass, especially those on the side from which the light is coming, are lighter than the undersides. Work as before, creating patches of wash and then painting detailed leaf shapes around the edges. Leave to dry.

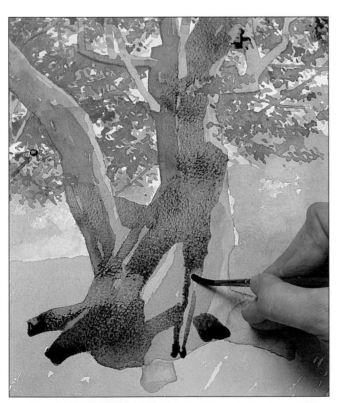

11 ▲ **Paint shadows on the trunk** Mix a darker tone of the sepia/Payne's grey wash and apply dark shadows to the left side of the trunk and the branches that are turned away from the light. Use the same wash to 'draw' some thin branches and twigs amongst the foliage. Allow to dry thoroughly.

Master Strokes

Gustav Klimt (1862-1918)
Roses under the Trees

The Austrian painter Gustav Klimt developed a highly decorative style. In his treatment of these trees in an orchard, the foliage is painstakingly built up dab by dab using a pointillist technique, until the surface glows with hundreds of different shades.

The painting is dominated by the vibrant foliage of the tree which fills the picture area, creating a decorative, almost abstract effect.

The ridged texture of the tree trunks is described in detail, using broken, curved lines. Patches of green lichen enliven the grey surface.

12 ▶ **Give texture to the bark** Prepare a third, dark tone of the basic foliage wash used in step 7. Add gum arabic to intensify the colour (see Expert Advice on the opposite page). Apply a final layer of this colour, painting clusters of leaves as before. Mix a wash of black and, using the No.3 brush, apply dark tone on the darkest side of the trunk. Use the same wash to describe fissures and textures in the bark of the tree.

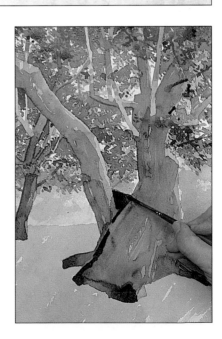

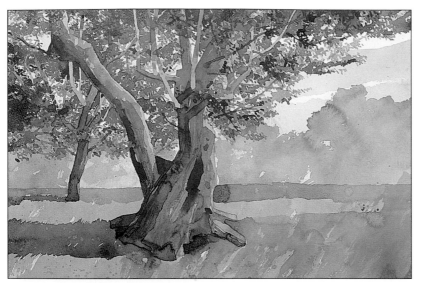

13 ▲ **Apply texture and shadows** Using a wash of sap green and the No.3 brush, apply wide brush marks to the grassy area in the foreground. Allow this to dry thoroughly and then use sepia with a little sap green to paint the shadows cast by both olive trees. These attached shadows help to 'fix' the trees to the horizontal surface of the ground.

Express yourself

Band of gold

The same olive tree has been given an arresting treatment here with the addition of bright orange and green bands dividing the composition in two. These are applied as a collage of coloured paper and represent the nets used to catch the harvested olives, which have been rolled up and tied. This unusual device not only adds a splash of almost fluorescent colour to the neutral grey-green background, but also acts as a counterbalance to the vertical trunks and branches that predominate in the painting.

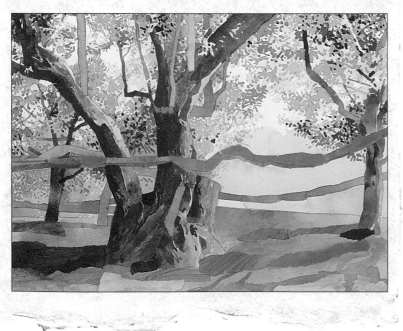

Applying the foliage as layers of washes gives the tree canopy depth and form. This area of the painting can be considered complete – it is convincing and has textural interest. You could, however, add more texture to the foreground – this will add eye-catching detail and increase the sense of recession. Consider adding to the background by painting in a line of simple silhouetted trees.

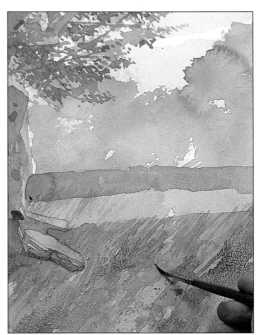

14 ▲ **Add texture to the grass** Mix sap green with sepia and paint vigorous diagonal marks with the No.3 brush to create grassy textures in the foreground. Spatter the wash over the area for varied textures.

▼ **Use increasingly concentrated mixes of sepia and Payne's grey for the bark.**

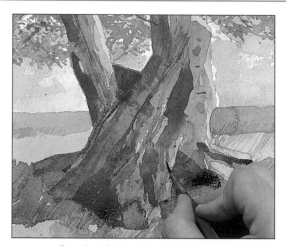

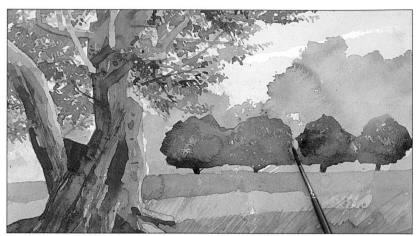

15 ▲ **Develop the textures in the bark** Mix black and sepia and, using the No.3 brush, work across the trunk adding a variety of textures. The bark of this ancient olive tree is twisted and gnarled, so you can use a range of brush marks to describe its surface.

16 ▲ **Add trees in the background** Mix Payne's grey and sap green to create a dark green. Use the No.3 brush to paint a row of trees in the middle distance. These trees add interest to the composition and create a sense of recession. However, at this distance you cannot see details of the foliage, so reduce the trees to simple silhouetted shapes.

THE FINISHED PICTURE

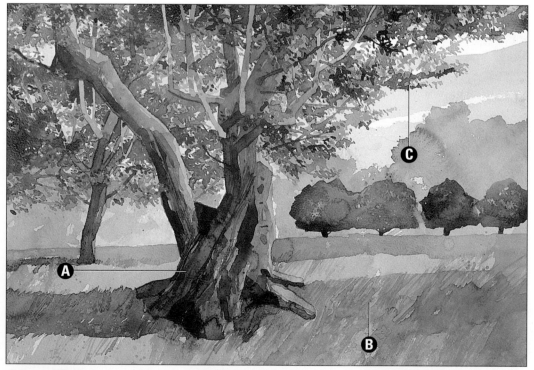

A Textured bark
The rough texture and fissured surface of the tree trunk is one of the interesting features of this subject. The textures were applied gradually, working light to dark.

B Foreground textures
Vigorous brush marks in the foreground capture the appearance of wild grasses. The foreground texture also helps to create a sense of space and recession.

C Simple leaf shapes
Simplified, shorthand marks capture the character of the foliage. These have been applied in layers to build up the volume and depth of the tree's canopy.

Choosing the best easel

A stable easel, which holds your work rigidly in one position, will avoid the frustration of trying to work with your picture precariously propped up on a table or on your lap. You'll soon find it's a necessity rather than a luxury.

A good easel is an artist's best friend. It will last a lifetime and is one of the most important and permanent pieces of studio equipment, so take time to look around and buy a model that meets all your requirements. Your choice of easel depends on various factors – the available space in your working area, whether you like to work standing up or sitting down, and whether you tend to work mostly indoors or out-doors. It also depends on the medium you generally use and on the scale of your work. For example, watercolours are much easier to use with an easel that can be tilted to the horizontal, so your washes won't run down the paper.

Outdoor easels

Lugging a heavy easel on painting expeditions is no fun at all, so choose a compact, portable model for outdoor work. A sketching easel (see easels E-H opposite) could be the answer, being both lightweight and foldable. These are made in wood or aluminium, are fully adjustable and can usually be positioned for both watercolour and vertical painting.

Sketching easels can accommodate surprisingly large boards and canvases, but this depends on the make and type. Check the distance between the top and bottom easel grips to make sure that the easel will take the size of support you prefer.

A box easel (see right, below and easel N) is more stable, though slightly heavier than an ordinary sketching easel. However, it is easy to fold up and carry, and also incorporates a box or drawer for holding paints, brushes and other materials.

Easels for indoor work

For large or heavy canvases, a traditional upright studio easel (easels I-L opposite) is probably your best bet. These can be bulky – some even have castors, so that they can be moved around more easily – but they are reassuringly solid.

If your work space is limited, a radial easel (J) is a versatile alternative. This consists of an upright spine with tripod-type legs. The whole easel can be adjusted, so you can angle your work to suit the light, though not to the horizontal position necessary for watercolour painting. When it is not in use, the radial easel can be folded for easy storage.

A tilting radial easel is also known as a 'combination' easel (K), because it brings together features of both the radial and the sketching easel. It has a central joint, so

◀ **The versatile box easel is ideal for the artist who likes to work both in the studio and out-of-doors. For storage and carrying, the easel folds down to a box shape with a handle for easy carrying (right).**

that it can be adjusted to any position from upright to completely horizontal, and it is therefore an ideal choice for the artist who works in a variety of media.

If your studio space or work area is limited, a sketching easel or a box easel will be just as versatile indoors as outdoors. Alternatively, if you work on a fairly small scale, a table-top easel in wood or aluminium (see easels A-D) might be all you need.

Looking after your easel

Apart from the lightweight sketching easels made from aluminium, most artists' easels are robustly constructed from hardwood, traditionally beechwood. They require little regular maintenance, although the wood benefits from an occasional coat of wax polish, especially when an easel is used outside or in damp conditions. Also, the metal adjusting nuts can get stiff and should be kept lubricated with oil.

THE RIGHT EASEL FOR THE JOB

TABLE EASELS

A Sturdy wooden easel with an 'H' frame, which can be tilted to provide the ideal working angle.

B Light, portable tripod-type wooden easel with rubber-tipped non-slip feet.

C Extremely light aluminium easel with adjustable telescopic back leg and rubber-tipped feet.

D Wooden easel, which can be set at four different angles and folds flat when not in use.

SKETCHING EASELS

E Lightweight easel with an adjustable tilting facility, making it suitable for all media, including watercolour.

F Substantial tilting, sketching easel appropriate for all media.

G Folding, tilting metal easel with telescopic legs and adjustable canvas grip.

H Fully adjustable metal easel with a camera mount fixing, so that it can be used as a photographic tripod.

STUDIO EASELS

I Sturdy studio easel with an adjustable lower shelf for the canvas or board, allowing simple adjustment of the working height.

J Rigid, adjustable radial easel, which can be tilted backwards and forwards, but not horizontally for watercolour work.

K Combination easel, which can be secured in any position and is suitable for use with all media.

L Artist's 'donkey' or platform easel – a comfortable sitting easel which takes up very little space when folded.

M Simple, popular 'A' frame easel with a metal ratchet on the lower support for adjusting the working height.

N Box easel with a container for paints, brushes and other art materials. Ideal for studio or outdoor work.

Coffee and croissants

All the necessities for a continental breakfast are arrayed in this still life. You might find a similar scene in any French café if you want to paint on location.

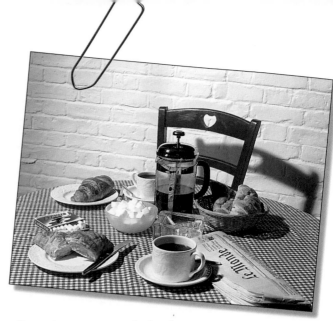

▼ A spontaneous, economical style gives this watercolour painting a pleasing freshness.

Think of the painting opportunities that France has to offer and beautiful landscapes, picturesque villages and golden beaches might come to mind. But there are also paintings waiting to be made in the corner of every café. With a few cups of coffee, a newspaper and a croissant or two, you have the makings of an attractive and evocative still life. Of course, you don't have to go abroad to create the ambience of the French café – you can easily do it in your own kitchen.

Arranging the composition

Take some time over the arrangement of the objects. In the painting shown here, a newspaper, a knife and a cigarette packet are positioned at an angle in the foreground to help lead the eye into the composition. The cafetière at the centre of the table provides a focal point, and the red chair helps to give depth as well as a bold contrast to the blue of the table-cloth.

A simple approach

This type of subject matter lends itself to a simple, spontaneous approach – a rough pencil sketch, then a bold application of watercolour. In fact, the painting shouldn't take that much longer than the breakfast itself. Don't over-labour the colours by laying wash upon wash. And be selective about where you apply the paint. To register the brightest highlights in the scene, simply leave the paper exposed.

As far as the watercolour paint is concerned, it is best to use the solid blocks that come in pans rather than the semi-liquid variety in tubes. A selection of pans in a box is easier to transport if you are working on location. Watercolour paints in this form also allow you to work quickly, as each colour is on hand, ready to be mixed.

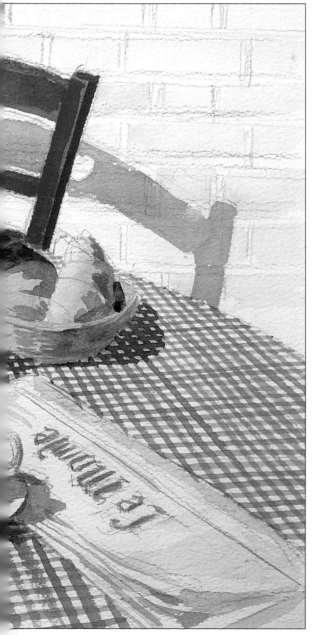

FIRST STROKES

1 ▲ Begin the pencil sketch With a 4B pencil, softly outline the shape of the table and chair. Then concentrate on establishing the breakfast objects. Pay particular attention to the series of ellipses formed by the cups, bowl and cafetière and their relationship to the ellipse of the table.

2 ◄ Re-emphasise the outlines Give further definition to your pencil sketch. Pay attention to the perspective, especially to that of the lettering on the newspaper. Draw two converging lines and then add the letters between them. Put a minimum of detail on the sugar cubes, as this area will be left largely as exposed paper.

3 ► Establish the table-cloth You don't have to draw all the squares, but you need enough lines to help with the perspective. The lines going away from you should converge slightly towards an imaginary vanishing point, while the horizontal lines should be parallel.

4 ▲ **Start on the background of bricks** The bricks will eventually be given only a pale wash of watercolour, so you need to put in quite a lot of detail with pencil to convey their texture. Then sit back and re-evaluate your drawing.

5 ▲ **Put the finishing touches on your drawing** Look over your picture and add the final details, including some definition on the edges of the sugar cubes. Remember, don't commit yourself to irreversible watercolour washes before you're totally happy with your drawing.

DEVELOPING THE PICTURE

Start the painting by putting initial washes of watercolour on the main objects on the table. Then move on to the table-cloth. (If the table-cloth has small checks or an intricate pattern, be prepared to spend quite a lot of time on it – or simplify it.) Finally, go back to the objects, enhancing their colour and modelling with further washes.

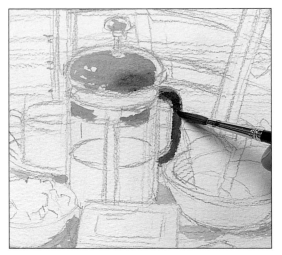

6 ◀ **Begin with the dark tones** Use a weak mix of cobalt blue and Payne's grey with a No.6 brush to render the shadows cast on the cloth. Use the same wash for the lid of the cafetière and, while it is still wet, use a strong Payne's grey to show the shadow on the right of the lid and to define the handle.

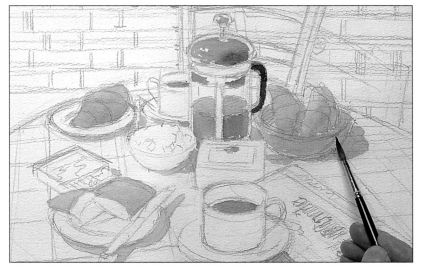

7 ▲ **Turn to the warmer colours** Add water and burnt umber to your Payne's grey mix to render the coffee in the cafetière and cups. Add more burnt umber for the coffee on the left side of the cafetière and more Payne's grey on the shadowed side on the right. Then use a mix of burnt umber, yellow ochre and alizarin scarlet for the croissants and basket.

8 ◀ **Paint the chair** Clean your brush thoroughly and mix together some alizarin scarlet and alizarin crimson. Use this bright red colour to paint the chair.

9 ▲ **Fill in the table-cloth pattern** Switch to a No.3 brush and use a dark mix of Payne's grey and cobalt blue for the lettering on the newspaper and for the darker cast shadows. Dilute the mix for the mid tones on the cups. Clean the brush and, with a dilute mix of ultramarine, start defining the checks on the table-cloth. Use bold, long brush strokes. You need a steady hand and a degree of patience here.

10 ▲ **Continue with the table-cloth** To get the perspective right on the vertical lines of the checked pattern, follow the guidelines you established in pencil. Use a paper napkin or a piece of kitchen paper under your hand to avoid smudging any of the lines already painted.

Master Strokes

Otto Dix (1891-1969)
Sylvia von Harden (1926)

Otto Dix was a German painter and graphic artist whose earlier work is characterised by his satirical depiction of the horrors of the First World War and the decadence of German society after it. The scene in this painting is far removed from the cosy setting of the café table shown in our step-by-step. It illustrates Dix's skill at capturing the seedier side of life and at portraying the personalities of his subjects, warts and all. Notice the nicotine-stained teeth and fingers, and the chipped nail varnish of the woman in this portrait. The simple items on the table – the drink, cigarettes and matches – act as props, setting the scene around the central character and reflecting her immediate concerns.

As well as being superbly executed, the portrait of the woman has elements of caricature in it. Her facial features and hands are exaggerated and her distinguishing qualities are emphasised.

The marbled top of the café table provides an area of light colour in contrast to the deep red tones in the rest of the picture. The pattern of the marble adds interest to the sparse arrangement of items on the table.

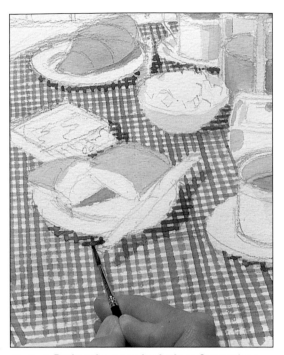

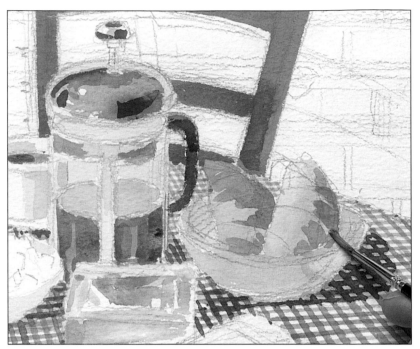

11 ▲ **Darken the areas in shadow** Strengthen your ultramarine mix and, using the grey washes you put in earlier as a guideline, rework the areas of the table-cloth in shadow.

12 ▲ **Overlay washes** Add a lot of water and some Payne's grey to your ultramarine mix to put in the watery colours captured in the glass ashtray. Then start building up the darker tones. Use a deep burnt umber to render the areas of coffee in shadow in the cups and cafetière. Mix up alizarin scarlet, yellow ochre and cadmium yellow for the dark glaze on the croissants. Darken the tone on the cafetière lid with Payne's grey.

Express yourself
Erasing the pencil lines

Simply by erasing the pencil marks on the painting, you will give the whole picture a fresher, more vibrant look. Much of the tone and detail of the wall was drawn in pencil. Once this is removed, the chair and table appear to leap forward towards the viewer. The bright colours seem to float and play against each other with a greater vigour. The viewer's eye is drawn across the blue table-cloth towards the areas of warmer colour.

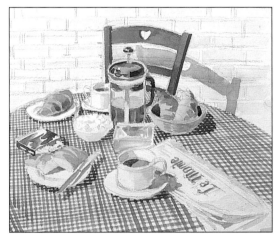

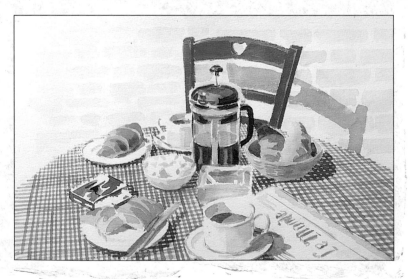

13 ▲ **Work on the light tones** Paint in the swirling pattern on the cigarette packet using the strengthened ultramarine mix from step 11. Then add a touch of burnt umber to a mix of alizarin scarlet and alizarin crimson to put in the shaded sides of the chair. Clean your brush and use a weak mix of Payne's grey and ultramarine to paint the whitewashed wall and some of the shadows among the sugar cubes. Then add a little viridian to this mix to render the printed areas of the newspaper. Darken the mix with more Payne's grey and paint the cast shadow of the chair.

Squint at the set-up through half-closed eyes to check that you've got the tonal range right. Then give the picture greater punch by adding the darkest tones. Remember, as there is no going back with watercolour, don't add these tones until the end. Try not to spend too long tightening up the picture or you'll lose the freshness and spontaneity which are part of its appeal.

14 ▶ Add some detail
Use a strong mix of Payne's grey for the dark tone on the knife; deepen it further for the detail on the cigarette packet. Mix burnt umber and alizarin crimson to show the red chair through the cafetière.

15 ▲ Put in the final washes Now mix up burnt umber with a touch of yellow ochre to darken the end of the left-hand croissant in the basket (where it is caught in shadow behind the cafetière). Use the same mix for the shaded side of the basket.

THE FINISHED PICTURE

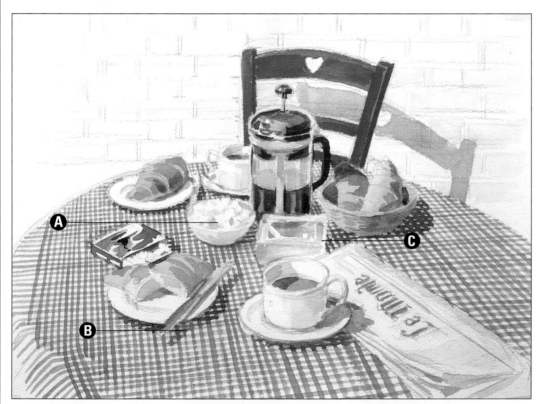

A Less is more
A few dabs of grey for some shadowed sides of the sugar cubes was all that was needed to suggest their shape. The same technique was used for the cigarettes.

B Cast shadows
The artist used a considerably darker blue in the shadow areas of the table-cloth to prevent the objects from appearing to float above the table.

C Delicate touches
Changes of tone and colour were subtly applied to the ash-tray to capture the reflections of the table-cloth and the cafetière in the glass.

Watercolour landscape

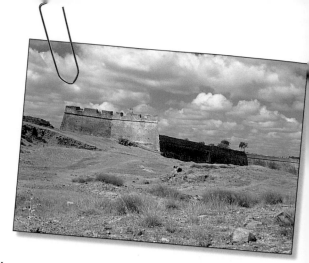

By masking out areas of your watercolour painting, you can create some wonderful effects. In this image, masking fluid and tape were used to create realistic clouds and grass.

Like many landscape subjects, this striking Mediterranean view has such rich and varied surface patterns and textures that brush and paints alone might not be versatile enough to capture the full effect. The scene combines fluffy clouds, layers of earth-coloured washes and the graphic, cut-out quality of dry, spiky grasses.

Quite simply, you must look for ways to create the exact equivalents of what you see. The following are useful tips for painting two of the most common landscape features – sky and grass. Both involve masking and washes of colour which must be allowed to dry between stages. As this takes time, you can speed up the process with a hairdryer – the rivulets of colour this sometimes creates can add to the effect.

Fluffy clouds using masking fluid

The cloudy sky is painted in two straightforward stages, and the technique can be adapted to depict any type of clouds. First, paint the cloud shapes with masking fluid, then brush a wash of blue over the entire sky. Remove the masking fluid and you are left with a flat, picture-book sky complete with white, cut-out clouds.

Next, apply a second coat of fluid across the top of the cloud shapes, slightly overlapping into the sky. Paint over the sky area with a different blue, remove the fluid and you have a realistic sky with subtle veils of overlaid colour and three-dimensional clouds which reflect the sunlight.

Spiky grass using masking tape

Rather than simply painting blades of grass on top of a background colour, try masking out the grass with sticky tape before overlaying the colour. This leaves a white silhouette for each blade. Overpaint some of the blades with a streak of green while leaving others white to convey the heat and reflected sunlight of the Mediterranean landscape.

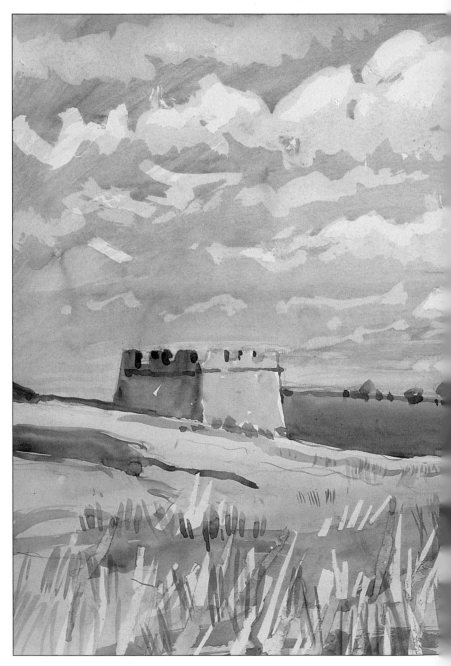

▲ If you want to paint a scene on location, protect your brushes in a tube like the one above.

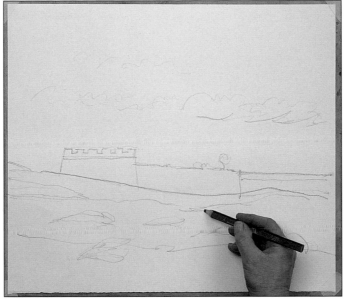

YOU WILL NEED

Piece of 300 gsm (140lb) watercolour paper 42 x 45cm (17 x 18in)

Chisel-ended carpenter's pencil or soft drawing pencil

Masking fluid and old brush

Brushes: 38mm (1½in) flat; No.6 soft round

8 watercolours: Cobalt blue; Ultramarine; Raw sienna; Ivory black; Alizarin crimson; Vandyke brown; Viridian; Cadmium yellow

Masking tape

Scissors

FIRST STROKES

1 ▲ **Start with a drawing** Make a simple drawing of the subject, sketching in the outline of the clouds. To get a bold, chunky line, use a soft drawing pencil or a chisel-ended carpenter's pencil like the one used here.

2 ▶ **Mask the clouds** Using an old brush, block out the cloud area with masking fluid. Apply the fluid thickly, scrubbing it over the top half of the larger clouds. Then dab in the lower half of the larger clouds, twisting the bristles occasionally to create swirling brush marks. Pick out the distant clouds with thin slithers of fluid. Allow the masking fluid to dry.

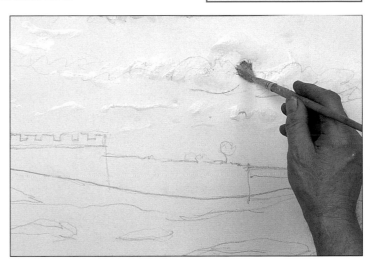

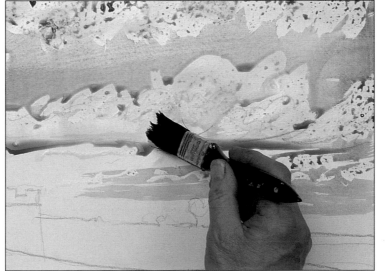

3 ◀ **Apply the first wash** Using the 38mm (1½in) brush, paint a light wash over the whole sky area in diluted cobalt blue. Load the brush generously and pull the colour in overlapping, horizontal strokes. When the wash is dry, remove the masking fluid. Rub from the centre of each shape to avoid lifting the surface of the paper.

4 ▼ **Mask out new areas** Apply a second coat of masking fluid over the sky – painting a highlight along the top side of the clouds and on selected blue areas. Let the fluid dry.

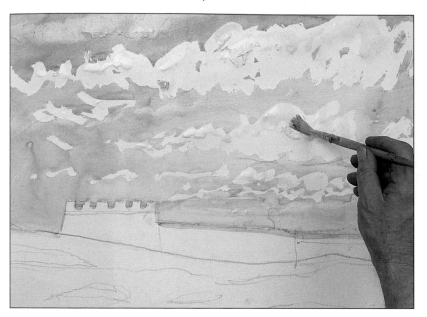

Express yourself

Impressionistic image

A similar scene, but this time executed with no masking techniques, produces a softer, more impressionistic image. Here the emphasis is on colour and atmosphere rather than texture and shape. The paint is applied wet-in-wet, with the colours running into each other. Although no attempt has been made to render the scene realistically, the viewer can still discern sand, grass, hills and sky, as well as the fort.

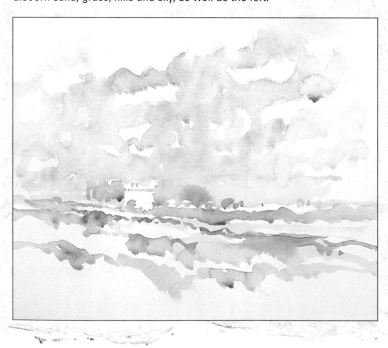

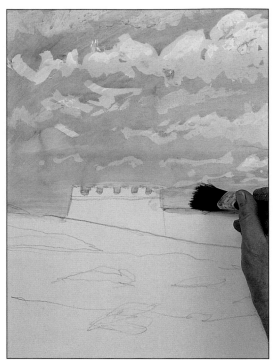

5 ▲ **Apply a second wash** Paint a dilute wash of ultramarine over the entire sky area, taking the colour over both the masked and the painted areas in broad, horizontal strokes.

DEVELOPING THE PICTURE

Allow the wash to dry, remove the masking fluid and the sky is complete. It is now time to move on to the rest of the composition, and for this you will need some masking tape and a pair of scissors.

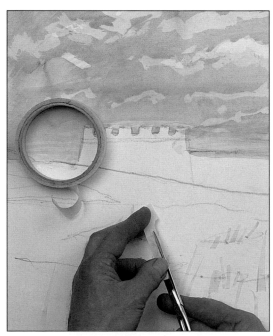

6 ▲ **Mask out the grass** Cut short, irregular strips of masking tape and stick them down to represent clumps of grass. Make the distant tufts smaller than those in the foreground.

7 ▼ **Paint the sand** Mix an earthy wash from raw sienna and plenty of water and paint this over the masking tape, using broad, criss-cross strokes.

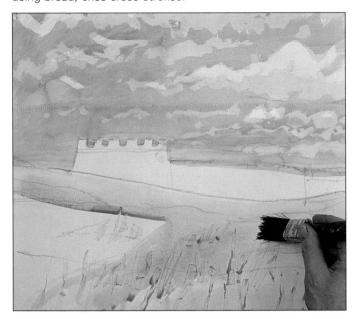

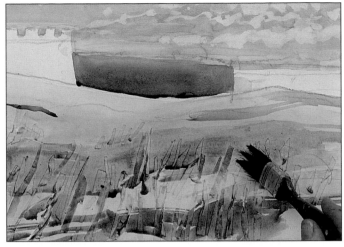

8 ▲ **Repeat the process** Allow the wash to dry. Then, without removing the first ones, apply a few more masking tape strips in the foreground. Make the new strips larger than those further away to help create a sense of depth. Paint the wall of the fort in a mix of ivory black and alizarin crimson. Add a little Vandyke brown to the fort colour and apply this in a few broad strokes to indicate the shadows on the sand dunes.

Master Strokes

Robert Adam (1728-92)
Rocky Landscape with Castle

One of the finest architects of the eighteenth century, Robert Adam was also a skilled landscape artist. He came from the 'topographical' tradition, in which landscape was represented in an accurate, realistic way. Note how every last tree and shrub is rendered in detail in this image.

The sweeping, slanted brush strokes used for the clouds echo the strong diagonals of the path.

The eye is led up the path to the castle and on ultimately to the patch of blue sky.

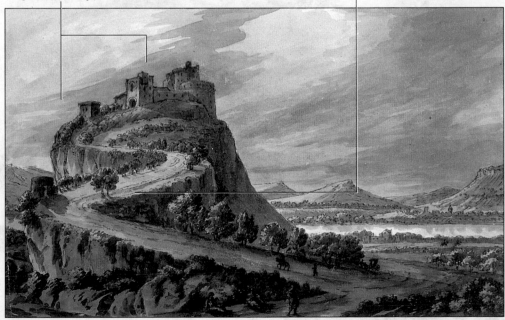

▲ **The coolest tones in the composition are ultramarine (left) and cobalt (top) in the sky, and the viridian (bottom) used for the grass.**

▲ **The warmer, landscape colours are Vandyke brown (left) and raw sienna (top). A mix of ivory black and alizarin (bottom) describes the fort and distant hills.**

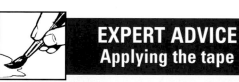

9 ▲ Remove the tape When the paint is quite dry, remove the masking tape to reveal the spiky clumps of grass. Remove stubborn bits of tape by rubbing with your finger.

10 ▶ Paint the background Using a No.6 round brush, paint the rest of the fort in the black and alizarin mix. Use a dark mix for the shadows and a paler wash of the same colour for the light areas. Take the same colour into the distant hills.

EXPERT ADVICE Applying the tape

Cutting up masking tape with scissors is a sticky business. Don't worry if the strips adhere to each other and get crumpled as a result – this reflects the grass in its natural state and looks more realistic. Just press the strips down as firmly as possible, as shown here, to stop the paint from running underneath.

A FEW STEPS FURTHER

At this stage the painting is almost complete. You have established the rolling sky and the background scenery, as well as the textured scrub and grasses of the foreground. You can now go on to add a little local colour to the foreground and a few background details.

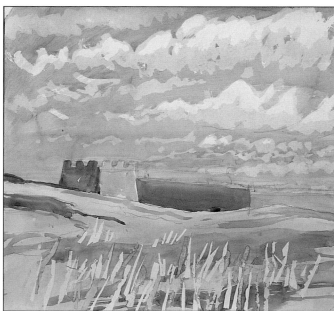

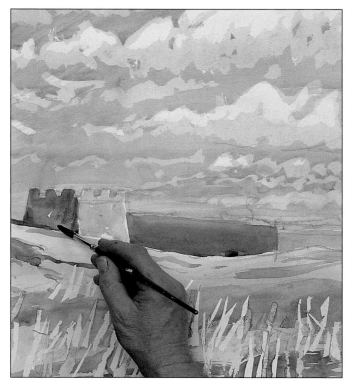

11 ▲ Complete the background Finish painting the distant hills in a weak wash of alizarin and black, then allow the paint to dry before moving on to the next stage.

12 ▲ Add blades of green grass Still using the No.6 round brush, paint a few blades of grass in viridian, cadmium yellow, and a mix of the two. Use short, narrow strokes for the background grass. Add more yellow to the mix and paint the foreground grass in stronger strokes.

13 ▶ Develop the background Finally, define the fort, using a light, broken line of ivory black and alizarin. Paint the trees in viridian mixed with a little ivory black.

THE FINISHED PICTURE

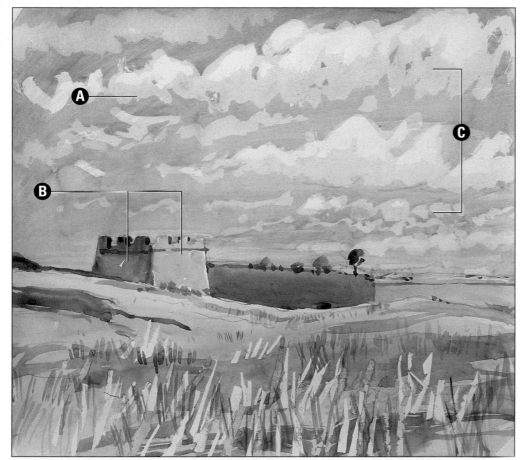

A Three-dimensional clouds
The undersides of the clouds are shaded by the second coat of blue – this helps the viewer to appreciate their volume.

B Two-toned fort
The whole fort is painted in a mix of black and alizarin, with a weak wash for the sunlit areas and a deep one for the shadows.

C Size matters
Small brush strokes in the background of the sky and much larger ones in the foreground give a sense of depth.

Painting with two colours

Restricting your palette has two great advantages: it makes paint mixing easier and results in paintings with wonderfully harmonious colour.

Successful watercolour painting depends to a large extent on knowing how to mix the colours you need. Experienced artists do this automatically with an ease and speed that makes the process appear almost effortless. Their secret lies in using as few colours as possible – the more limited the palette, the more harmonious and integrated the composition will appear.

The two-colour palette

As an introduction to working with a restricted palette, try painting a picture using just two colours. This sounds drastic, but you will be astonished at how much can be achieved with a pair of carefully selected colours and at how realistic the result can be.

The selection is personal and depends very much on what you are painting, but a blue combined with a warm colour provides the maximum scope for most subjects. For the watercolour seascape on the far right, our artist chose ultramarine and burnt umber which provided a varied range of browns and greys. Combinations of the two colours created the dark neutral tone of the beach behind the breakwater; the subtle warm colours of the beach and rock face; and the cool blue-greys of the sea and sky.

Alternative pairs

To continue the two-colour experiment, try painting with different pairs of colours. Apart from burnt umber and ultramarine, other effective two-colour palettes are Prussian blue, cerulean blue or indigo with any of the warm earth colours – such as Indian red, Venetian red or burnt sienna.

For flowers, still-life arrangements and other subjects that contain bright colours, try working with a pair of complementaries – two colours that fall opposite each other on the colour wheel. It is surprising how many paintings are based on the use of opposites, and how effective the colours appear as a result. Depending on the subject, choose red with green, blue with orange, or yellow with violet.

The use of opposites produces a particularly brilliant colour reaction, and artists have long made use of this visual property. By laying a colour next to its opposite, the effect is to make both appear more vibrant and bright than when viewed separately. In addition, complementary colours produce a neutral tone when mixed in equal quantities, so greys, browns and other muted colours present no problem.

Black and white

Often the addition of black to two colours gives not only an additional repertoire of dark tones, but also extends the range of greys and neutrals.

TWO-COLOUR COMBINATIONS

The range of colours and tones that you can obtain from ultramarine and burnt umber are shown here. The limited range of colours available should help you think much more carefully about tone.

	Dark	Medium	Light	Very light
Ultramarine				
Ultramarine + a little burnt umber				
Burnt umber + a little ultramarine				
Burnt umber				

A TWO-COLOUR COASTAL SCENE

This coastal landscape was completed using only burnt umber and ultramarine. A wide range of the possible mixes is shown left. Six of these mixes – together with their exact position on the painting – are shown here.

As with any landscape, think about creating an illusion of distance through aerial perspective. Objects appear cooler in colour and lighter in tone in the distance. For instance, note how a dark mix of mainly burnt umber is used for the large cliff top in the middle ground, while the small cliff top in the far distance is rendered in a very pale mix of mainly ultramarine.

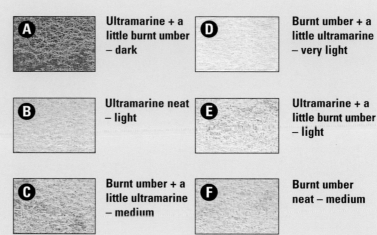

A Ultramarine + a little burnt umber – dark

B Ultramarine neat – light

C Burnt umber + a little ultramarine – medium

D Burnt umber + a little ultramarine – very light

E Ultramarine + a little burnt umber – light

F Burnt umber neat – medium

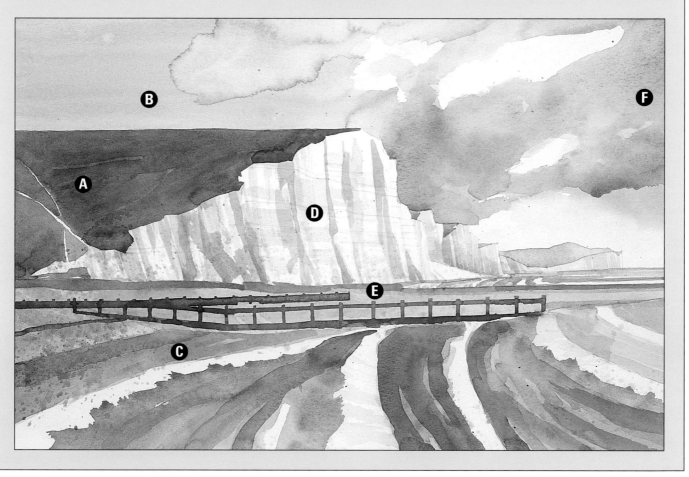

However, by choosing colours that are dark in tone, like the burnt umber and ultramarine used here, it is not really necessary to use black at all. You can create a near-black with a strong mix of the two palette colours – look at the breakwater in the painting above. For a paler shade of any colour, simply add water to the mixture. Areas of pure white are created by leaving the paper unpainted.

Using a limited palette is, in a sense, a return to the origins of the watercolour tradition. In the eighteenth century, watercolour was considered primarily a sketching medium – useful for making studies for oil paintings. One of the main aims of these sketches was working out the tonal arrangement of the final composition. To do this, you didn't need a full range of colours. Thus a limited palette was established early as one of the traditions of watercolour painting.

Paul Sandby (1725-1809), known as the father of watercolour painting, often worked in just two or three colours. He used this palette with great success to capture the diverse effects of sunlight and atmosphere.

A little improvisation

And if Sandby ever came unstuck with his limited range of paints, he was very imaginative in his use of other materials. For example, he once mixed a 'warm' black by combining the burnt edges of his breakfast toast with gum water!

Headland in Dorset

Apply watery mixes of paint with large brushes and loose strokes to convey the exhilarating sweep of this English coastal landscape.

Although this beautiful panoramic landscape looks spontaneous, it is, in fact, an organised patchwork of loosely worked areas. The secret is to be expressive – using big brushes and bold splashes of watercolour – but, at the same time, to make sure you keep control of the overall image.

Loose – but logical

You can achieve this by working freely and loosely within clearly defined areas of the composition. As each area is completed, allow it to dry thoroughly before moving on and treating another part of the painting in the same manner.

For example, in this landscape the turbulent sky was painted wet-on-wet, one colour being allowed to flow freely into another. When the sky was dry, the headland was worked in a similar manner, with accidental runs of paint forming shadows and grassy texture.

This way of painting not only results in a realistic view, but also gives it a real sense of animation. You almost feel as if you are standing in the exposed landscape with clouds racing across the sky and the solitary tree bending in the wind.

A masked track

One area of the painting that was kept relatively crisply defined was the track. This was protected with masking fluid at the beginning of the painting to prevent the washes on the headland from accidentally running over it. Tinted masking fluid is easier to see on white paper – you can buy it ready-tinted or you can tint colourless fluid yourself by adding a little watercolour.

The artist worked from photographs to create his painting. He realised that no single snapshot could capture the sweeping panorama of this subject, so he took a series of photographs and then joined them with transparent tape to get an extra-wide view. To photograph a panorama, stand in one place and turn slightly to take each shot. The pictures should overlap with no gaps.

Do this by choosing an object on one side of the frame and making sure the same object is in view on the other side of the frame before taking the next photograph.

Remember, you don't have to copy your photographs slavishly. For example, in this series of photos the tree is an isolated, rather distracting shape on the edge of the picture. However, in the painting it is moved inwards and thereby helps lead the eye down the track and into the centre of the picture.

▼ **Don't be afraid of the unpredictable qualities of watercolour. The wet-on-wet technique produces unexpected rivulets of colour that add to the lively style of this painting.**

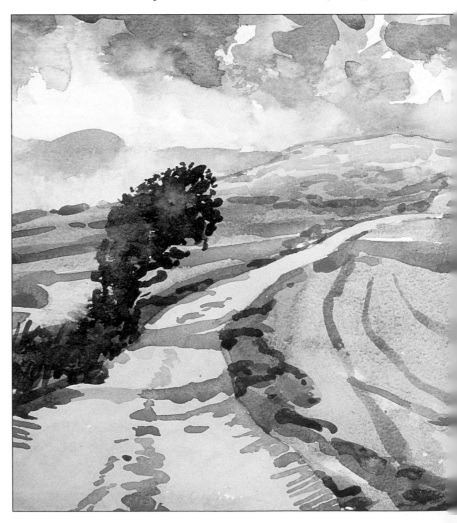

FIRST STROKES

1 ▶ Mask out the track With a 4B pencil, sketch in the horizon and one or two of the main lines in the composition, including the track. Using an old brush, paint out the track with tinted masking fluid.

2 ▶ Wash in the sky Using a large mop or wash brush, paint the sky in a very dilute mixture of cobalt blue and cerulean. Use lots of water, applying the colour in broad horizontal strokes. Add a little yellow ochre wash at the point where the sky meets the horizon, and try to paint the horizon as a crisp line.

3 ▼ Dab in the clouds Get rid of any residue of paint along the bottom edge of the wash by dabbing with a paper tissue. Use the tissue to dab the sky, so creating a few white cloud shapes.

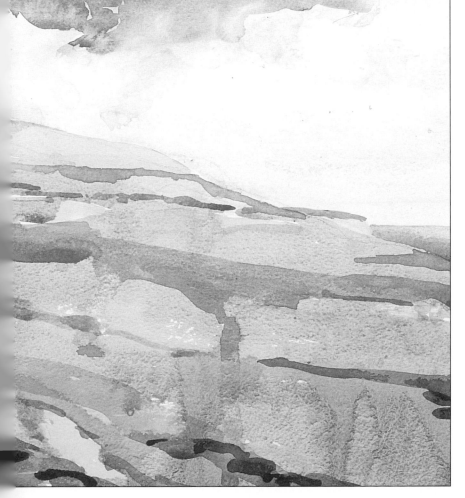

4 ▼ **Add dark sky tones** Allow the blue sky wash to dry completely, using a hair-dryer if necessary. Darken the sky mix by adding a little ivory black and indigo to it. Change to a No.20 round brush and paint the clouds in this darker mixture as broad brush strokes of colour.

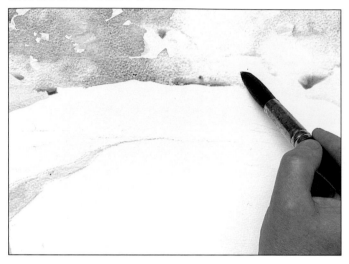

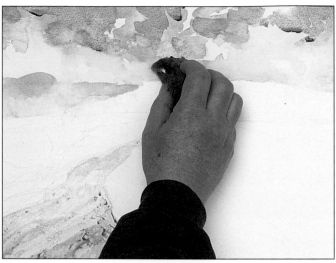

5 ▲ **Build up the sky** While the paint is still wet, splash clean water on to the underside of the dark clouds, then dab with a sponge to soften the edges of the shapes. Allow the paint to dry, then repeat the process – painting, wetting and dabbing – to build up another layer of dark clouds.

DEVELOP THE PICTURE

The sky is now complete. Allow it to dry thoroughly, then move on to paint the rest of the landscape. Try to retain the horizon line as a definite division between the sky and the land.

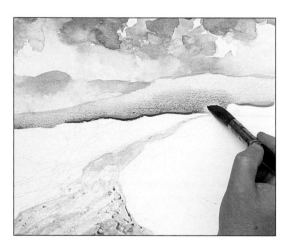

6 ◄ **Block in the background** Paint the background hill in yellow ochre. Using the tip of the No.20 brush, paint a slight shadow along the base of the hill by dropping a little burnt sienna into the wet yellow ochre.

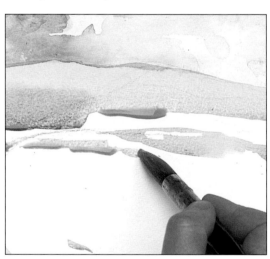

7 ▲ **Extend the sandy areas** Bring the yellow ochre colour into the foreground of the composition by painting the sandy patches at the foot of the hill and in the foreground field.

◄ **Brown and ochre shades convey the colour of the sandy soil, while a range of greens suggest the grass tones.**

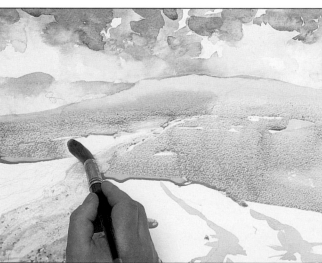

8 ◄ **Paint the grass** Mix a light green from yellow ochre and ultramarine, with a touch of lemon yellow to sharpen the colour. Paint this freely across the unpainted areas, allowing the green to mix and run with the patches of yellow ochre. Leave a few flecks of white paper showing between the loose brush strokes.

9 ▼ **Build up the greens** Add a little raw umber to the green mixture and paint a few horizontal stripes across the wet grass. The new colour will run down the paper, blending into the paler green to form soft shadows.

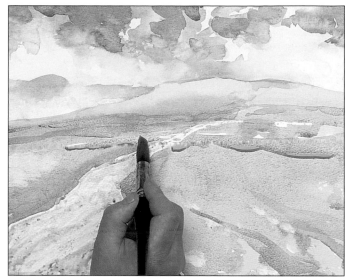

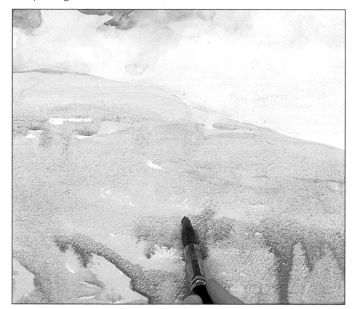

10 ▲ **Add shadows and dark tones** Paint the shadow on the left side of the track in a dark, dull green mixed from yellow ochre and ultramarine with added touches of indigo and ivory black. Mix a bright bluish-green from ultramarine and lemon yellow, and apply this in narrow bands, following the contours of the landscape.

Master Strokes

Alfred Sisley (1840-1926)
Path Leading to Ville d'Avray

With its luminous sky and short, broken brush strokes, this painting is typical of Alfred Sisley's landscapes. A member of the Impressionist school, Sisley painted mainly around Paris and had a skill at making seemingly ordinary scenes appear inspirational. In this landscape, he uses a path to help guide the eye into the distance – just as in our step-by-step demonstration.

The light-toned path catches the eye and drags it up the picture. Note how the bend in the path is echoed throughout the painting – for instance, by the curves of the hedge on the left and the brow of the hill.

Exposed earth is rendered with a lively area of broken colour – including the complementaries, red and green.

Short, curved strokes of white and green capture the effect of wind blowing through grass, enlivening the image.

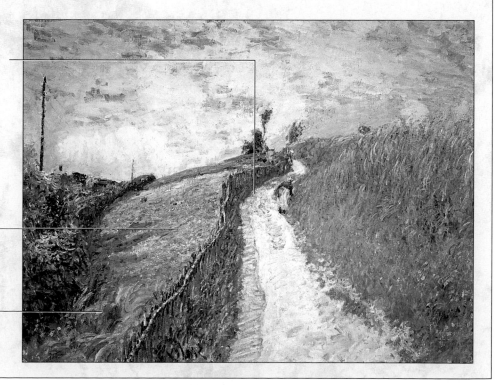

11 ▼ **Develop background shadows** Changing to a No.12 round brush, add burnt sienna to the bright bluish-green until you get a cool grey. Use this to dot in a few linear shadows along the horizon and the base of the hill.

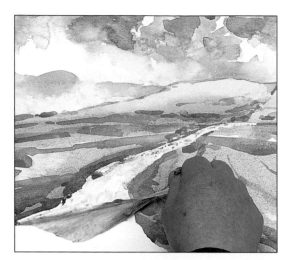

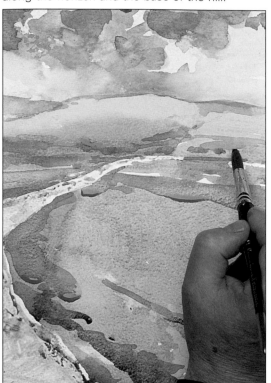

12 ◄ **Remove the masking fluid** Reveal the unpainted track by lifting one end of the dry masking fluid. This should come away intact with a clean pull. If it doesn't, rub any remaining bits off with your finger or an eraser.

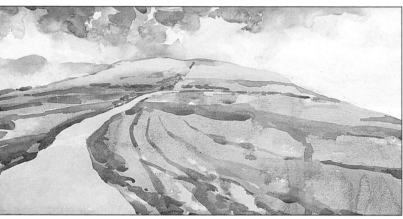

13 ▲ **Apply a wash to the track** Once the masking fluid is removed, the track is revealed as bright white paper. Tone this down with a dilute mixture of raw sienna and ultramarine.

Express yourself
Change to acrylics

Try painting this subject in a similar unrestrained manner, but using acrylics instead of watercolour. With this opaque paint, the landscape appears chunky and three-dimensional. Brush marks retain their shape and texture, and the accent is on solid form rather than light and colour.

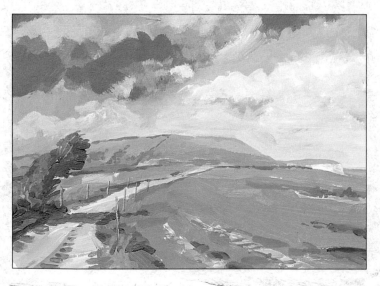

JUST A TOUCH OF BLACK

A little black goes a long way. If you add too much, your palette will soon turn dark and muddy. You can avoid this by keeping the black watercolour in a separate container, adding it in small quantities to other colours only when needed.

TROUBLE SHOOTER

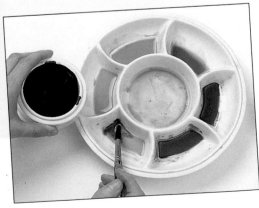

Now that the track is painted, you have established all the main areas of the landscape. However, to complete the painting you need to add a few shadows to break up the path and put in the tree bent over by the wind.

14 ▼ **Add shadows to the track** Mix a cool, neutral tone from Payne's grey and yellow ochre and use this to paint the shadows on the track with irregular, horizontal strokes.

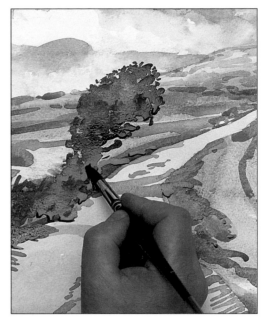

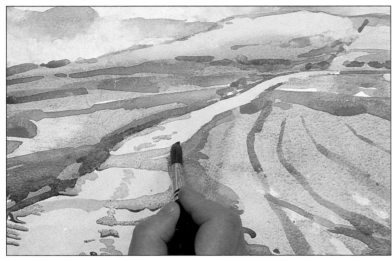

15 ▲ **Paint the tree** Establish the tree in burnt sienna with a little ivory black. Paint the branches in short strokes, using the tip of the bristles. Finally, dab the wet colour with a sponge or tissue to create paler patches at the centre of the tree.

THE FINISHED PICTURE

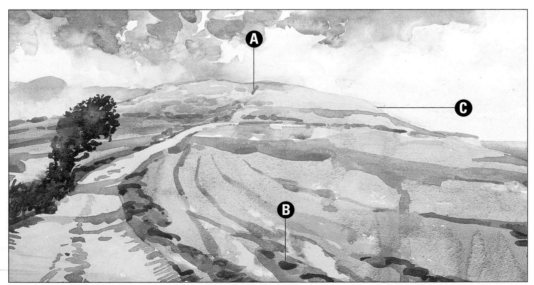

A Vanishing point
The sandy track is a crucial element in the composition. The converging lines lead the eye of the viewer into the centre of the painting, before disappearing at a vanishing point on the horizon.

B Runs of colour
Accidental runs of green wash look like shadows and tufts of grass in the fields. These spontaneous marks become an integral part of the composition, describing the texture and contours of the landscape.

C Hard edge
The horizon forms a sharp division between the land and the sky. It provides a crisp separation between two areas of very loose washes of colour – the green and ochre fields and the bluish-grey clouds.

Creating highlights

To give a realistic impression of the sheen and tints of a sitter's hair in watercolours, try 'masking out' areas with an ordinary household candle.

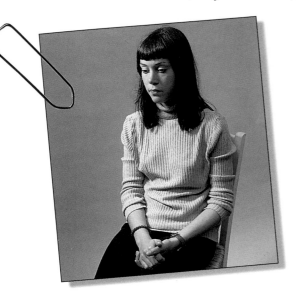

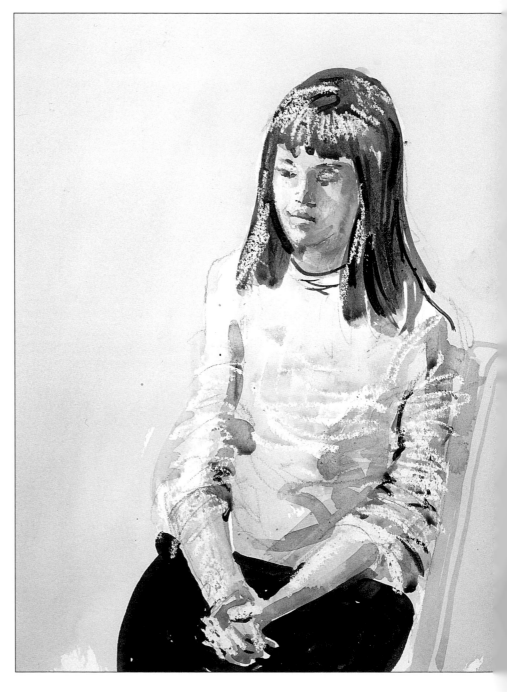

One thing you learn pretty quickly when painting portraits is that a mass of hair is never one single colour. The light will always bring out unexpected tints and highlights. The model in this painting has dark brown hair, but the sun shining through the window also brought out strong glints of gold and copper in it.

Masking highlights

In watercolour, you can capture this effect by painting the hair in two or more washes of colour and masking parts of each layer with the wax of an ordinary household candle – a technique known as wax resist.

In this portrait, our artist started on the hair by masking out streaks of white paper with a wax candle to create white highlights. The waxy candle marks were then overpainted with yellow ochre, causing the masked white highlights to show through the paint. The same technique was used again to mask out a few streaks of yellow ochre before applying a wash of burnt umber. The result is pale and golden highlights in a mass of deep brown hair.

As well as the colour of the hair, pay attention to its overall shape. Try to ignore the thousands of individual hairs that spring from the skull – instead, treat the hair as a solid mass. Paint it in broad strokes exactly as you would render the face and body. In short, simplify what you see.

▲ Notice how the candle has been applied not only to create highlights in the hair – but also across the body and around the arms. This helps give the whole picture a lively, textural surface.

FIRST STEPS

1 ▼ **Start with a basic drawing** Make a simple outline drawing of your subject. Keep pencil lines to a minimum as they are only a guide to the subsequent watercolour painting. Establish the main shapes – the head, body and arms – and indicate the position of the facial features. A carpenter's pencil, available from hardware stores, has a wide, flat lead and will encourage you to concentrate on the essentials and ignore superficial details.

2 ▲ **Mask the wax highlights** Before you start painting, take a white household candle and block in any areas that you want to be white in the finished picture. These include all the light areas on the illuminated side of the face and the highlights on the face and hair.

YOU WILL NEED

Piece of 300gsm (140lb) Not watercolour paper 40 x 46cm (16in x 18in)

Carpenter's pencil

White household candle

6 watercolours: Yellow ochre; Indian red; Raw sienna; Ultramarine; Ivory black; Burnt umber

Brushes: Nos.6 and 5 round brushes; 38mm (1½in) flat brush

Cotton buds

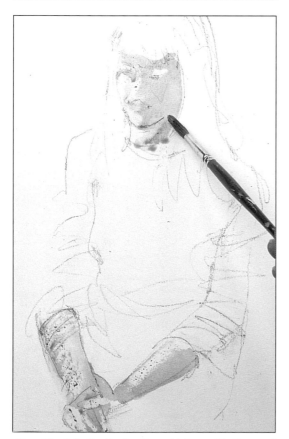

3 ▲ **Block in the flesh colour** Using a No.6 round brush, paint the arms and face in a mixture of yellow ochre and Indian red. The waxy candle marks will show through the watercolour, emerging as bright white highlights.

4 ▲ **Paint the sweater** Changing to a 38mm (1½in) flat brush, paint the sweater in raw sienna. The candle wax will again show through the paint and help to indicate the rounded, solid form of the body.

DEVELOPING THE PICTURE

It is now time to work on the hair with layers of paint and more wax. Also, block in the background around the figure with a large brush, taking the opportunity to improve and redefine the outline of the figure where necessary.

5 ▼ Paint highlights in the hair Using a No.5 round brush, loosely block in the lightest hair tones in a wash of yellow ochre. There is no need to be too precise about this, because much of the yellow will eventually be covered with brown.

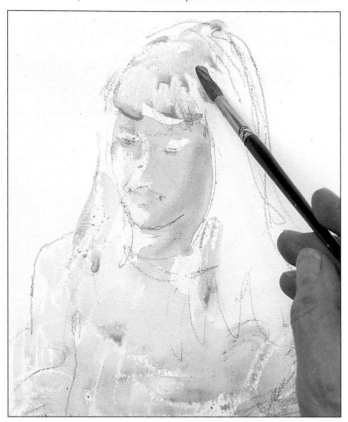

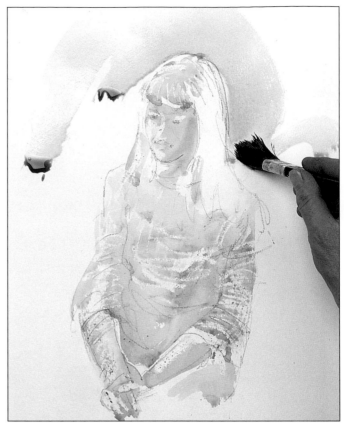

6 ▲ Add the background Change to the 38mm (1½in) flat brush and block in the background loosely in a mixture of ultramarine and ivory black.

EXPERT ADVICE
Removing dried paint

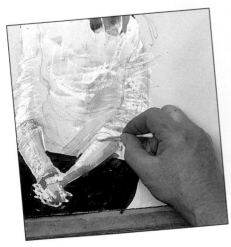

Tiny blobs of paint may collect and dry on top of the candle wax. You can remove these by lifting them carefully with a cotton bud. If the blobs have dried, try dampening the cotton bud first. Go carefully – if you press too hard you might actually rub the colour in more.

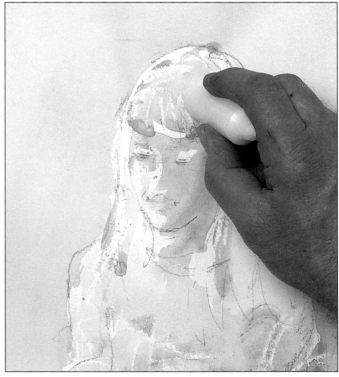

7 ▲ Use wax resist on hair highlights Make sure the yellow ochre on the hair is completely dry, then add a few strokes of candle wax to protect some yellow areas before applying the final wash of paint over the hair. Make the candle marks in the same direction as the fall of the hair.

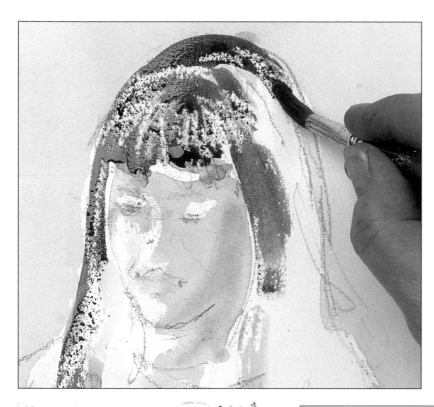

8 ◄ **Block in the brown hair** Using the No.6 round brush, paint burnt umber over the entire hair area. Again, let the brush strokes follow the direction of the hair. The protected areas of yellow ochre will emerge as golden glints through the dark brown wash.

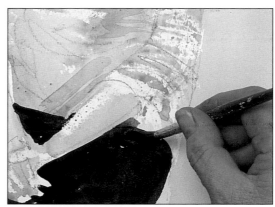

9 ▲ **Paint the trousers** Still using the No.6 round brush, start to block in the trousers as a flat area of ivory black with only the occasional highlight left showing.

Express yourself

A portrait sketch

This portrait sketch in black and white shows how highlights in the hair can be achieved quickly and effectively by leaving patches of the paper untouched. Shadows are blocked in as broad areas of hatched pencil tone.

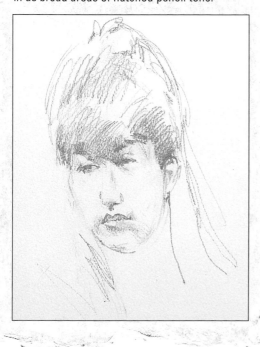

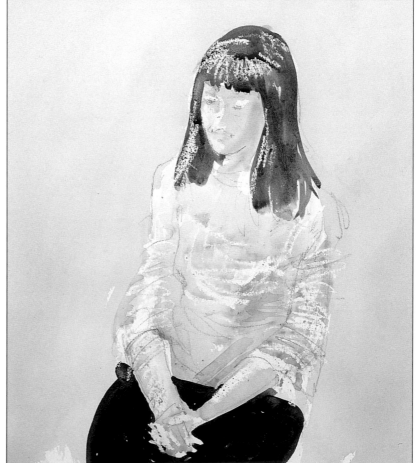

10 ▲ **Define the figure** Complete the trousers, taking the black up to the bottom edge of the sweater. Note that the trousers, which are painted as a flat area, do not really convey the form of the figure. It is the changes of tone in the sweater that give the impression of the three-dimensional figure beneath the clothing.

You have now painted all the main areas of the composition, but the figure still needs a few finishing touches. Some darker shadows, particularly on the face and hair, will help bring your portrait to life without sacrificing the freshness of the paint. However, it is important not to overdo the detail or to overwork the painting at this stage.

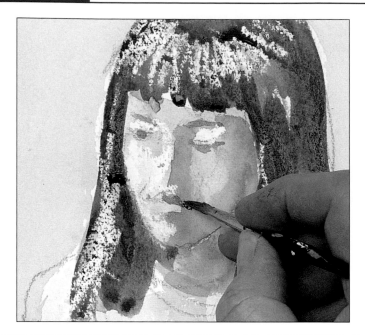

11 ◄ **Develop the face**
Still using the No.6 brush, add darker tones to the face in a mixture of Indian red and yellow ochre. The mixture must be stronger than the initial wash colour so that these darker areas show up. Leave the light patch on the far cheek unpainted. Using the No.5 round brush, define the facial features by painting grey shadows under the eyes, on the upper lip and along the eyebrows with a mixture of ultramarine and burnt umber.

Master Strokes

Valentin Serov (1865-1911)
Girl with Peaches

A renowned Russian artist, Serov is best known as a portraitist and, as his reputation grew, he painted many celebrities, particularly from the world of the arts in Russia. This beautiful, informal portrait is one of Serov's early works, painted when he was only 22 years old. It has a fresh, luminous quality that perfectly captures the dappled effect of gentle sunshine filtering into the room, highlighting the girl's hair, face and clothing.

The girl has a radiant, peachy complexion, the colours on her rosy cheeks echoing those of the fruit on the table.

The casual pose, with the arms propped up on the table, lends the portrait an air of informality.

12 ▶ **Paint in the shadows** With the same fleshy shadow mixture of ultramarine and burnt umber, paint broad strokes along the shaded side of the body and arms. Then paint the back of the chair in long smooth strokes of pale grey, achieved by mixing a little ivory black with plenty of water.

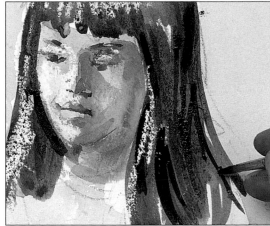

13 ▲ **Add hair shadows** Still using the No.5 brush, add a few dark streaks of shadow to the hair in ivory black. Start each streak at the crown of the head. Lift the brush to achieve a tapering effect at the end of each stroke.

THE FINISHED PICTURE

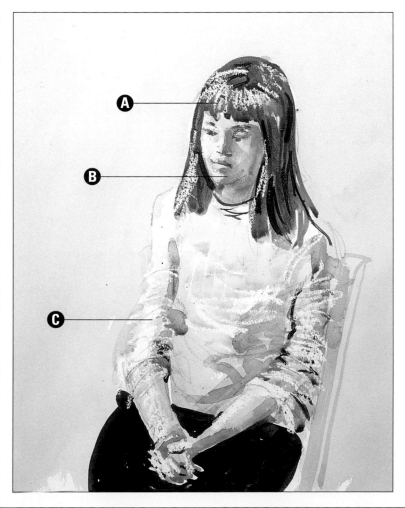

A Adding highlights to the hair
Reflections and highlights in the hair were built up gradually, using a candle wax resist. Reflected light was represented by the whiteness of the paper.

B Simplifying the flesh tones
The face was painted in a mixture of Indian red and yellow ochre. This was first applied as an overall pale wash. Shadows were then painted on top of the wash using a stronger mix of the same colours.

C Following the form
On the body, the direction of the wax highlights follows the form of the subject — helping describe the rounded arms and the torso underneath the clothing.

Enlarging your work

Producing a larger-scale version of the subject you are trying to paint or draw can be easier than you think – just follow the simple step-by-step techniques described here.

The following scenario is a familiar one to many artists. You are about to start work on a painting. You know what you want to paint and you have some reference – perhaps a drawing, photograph or small colour sketch of the subject. However, the reference is much smaller than the picture you want to paint. The problem is this: how do you transfer the small image on to a large paper or canvas without altering the shapes or losing the composition?

A freehand copy is one possibility. Draw directly on to the large support, referring to the sketch as you progress. For the experienced artist, with confidence and drawing skills to match the challenge, this is fine. However, for the beginner, freehand copying is not always as simple as it seems and can turn the very first stage of a painting into a frustrating stumbling block. For example, an over-cautious approach often leads to the enlarged drawing being too small, resulting in a lot of empty space around the subject. An easier and more accurate way of transferring and enlarging the image is to use a grid.

PROPORTIONATE RECTANGLES

The grid method of enlarging only works if both the small and large rectangles have the same proportions. To construct a proportionate large rectangle (B in the diagram) from a smaller one (A in the diagram), draw a diagonal from the bottom left-hand corner and through the top right-hand corner of rectangle A. Extend the bottom and left-hand sides of the small rectangle to form rectangle B, making sure that the top right-hand corner of rectangle B falls on the diagonal line and that each corner of the rectangle is drawn at a right angle.

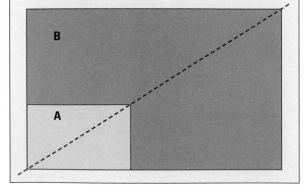

Enlarging a watercolour sketch

A small watercolour landscape is enlarged here using the grid method to provide an outline drawing for a larger watercolour. No detail is necessary, simply enough information to act as a guide for the paint. The grid is divided into twelve sections – use tracing paper to avoid drawing grid lines directly on to the colour sketch.

1 ▲ Rule up a grid Take a sheet of tracing paper and draw a rectangle the same size as the watercolour sketch. Use a ruler to divide the rectangle into twelve equal sections.

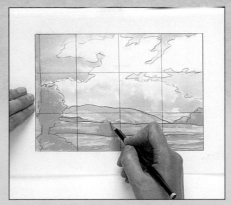

2 ▲ Trace the main outlines Use a soft pencil to trace the outlines of the landscape – the hills, trees and clouds – keeping the lines light and unfussy.

3 ▲ Enlarge the grid On watercolour paper, draw a large rectangle of the same proportions as the small sketch. Rule up a proportionately larger grid inside the large rectangle.

4 ▶ Copy the image Using the small tracing as your reference, copy the picture on to the watercolour paper section by section. Each section will be accurately reproduced on the larger-scale grid, creating an enlarged image in the correct proportions.

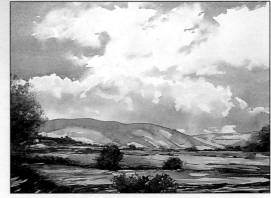

5 ◀ Paint the finished picture Erase the grid lines before you begin to paint. You can now use the enlarged outlines as a guide while you work on the various stages of the painting.

Enlarging with a grid

The grid should divide the reference sketch or photograph into a number of equal rectangles or squares. Either draw these directly on to the reference or, if you would prefer not to mark the photo or sketch, draw a grid on a piece of tracing paper and trace the reference picture on to it (see above).

The next stage is to draw a bigger grid on the large piece of paper or canvas, using the same number of squares or rectangles. It is important that the grid on the large support has exactly the same proportions as the smaller one, otherwise you will end up with a distorted image. You can now copy the smaller image section by section on to the larger support.

Confident strokes

For the enlarged drawing, try to keep your lines free and flowing. Indicate only the main shapes rather than attempting to include every detail. Avoid a cramped-looking image by drawing from the elbow rather than the wrist and by holding your drawing tool as far from the drawing tip as possible.

It helps to work with a chunky medium such as carbon pencil or graphite stick when reproducing the larger image. These tools produce thick lines which will encourage you to draw boldly, creating a drawing with a fresh, spontaneous appearance.

Photocopier method

Using a photocopier is another way of creating a larger image, enabling you to increase the size of a small sketch or photograph up to an A3 format. If you want anything bigger, you may have to enlarge your reference picture in sections, in two or more stages. However, the photocopied image still needs to be transferred by tracing, and for this you will need a lightbox.

Details and textures in watercolour

Although watercolours can be used in a free and loose manner, they can also be used to create intricate, highly finished paintings.

Using a simple pocket set of water-colour paints, the artist for this step-by-step created a sweeping rendition of a Scottish landscape – full of subtle variations of colour and texture.

In the foreground, features, such as the tree branches and intricate shadows, are brought into sharp focus using care-fully controlled lines made with a fine brush. In contrast to these lines, lively elements have been created by applying the paint in unconventional ways.

Flicking paint

Sprays of seeded grasses, for example, were added in the foreground by gently flicking paint on to the paper. And out-stretched, leafy branches have been implied by blowing small pools of wet paint across the paper. These details give the impression of wind blowing across the scene, playing on the grass and foliage as it passes.

In the background, however, little detail has been added. Instead, broad strokes have been used to create the smooth surface of the mountain in a harmonious range of greens, browns and blues. To create these colours, you need constantly to mix small amounts of different colours into your main washes.

It is, therefore, vital to wash your brush often to avoid muddy colours. Dry off the brush on a wad of tissues, or flick the spare water out on to a newspaper positioned on the floor.

▶ **The artist has used aerial perspective to create a sense of depth. The distant mountain is rendered in cool blues and greens, while the grassy areas are painted in warm browns. Note also that the figure in the reference photo (top right) has been omitted to create an unsullied scene.**

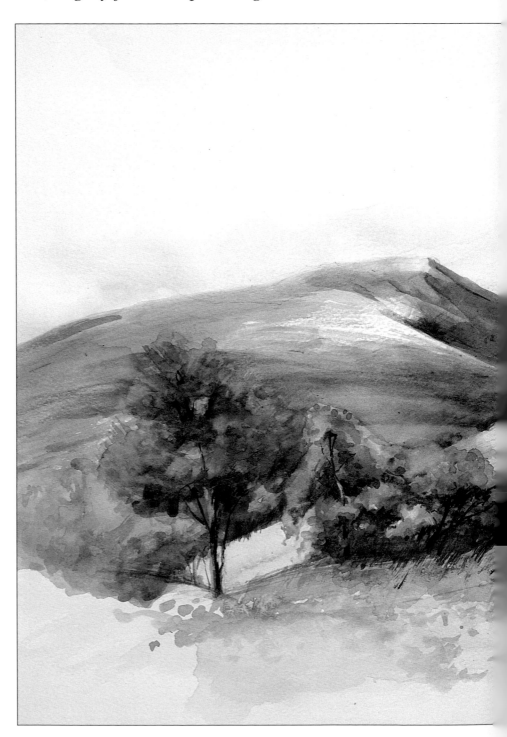

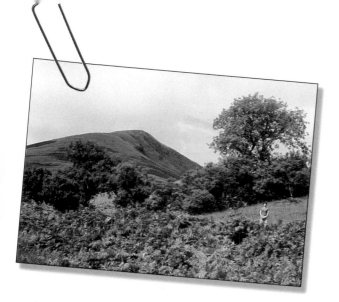

YOU WILL NEED

Piece of 300gsm (140lb)
Not watercolour paper
40 x 60cm (16 x 24in)

HB pencil

Brushes: Nos.8, 6 and 2
flats; Nos.4 and 00 rounds

Large jar of water

10 watercolours:
Ultramarine; Cobalt blue;
Crimson; Burnt umber;
Emerald green; Ochre;
Orange; Forest green;
Cadmium yellow; Black

Large flat mixing dish

Paper tissues

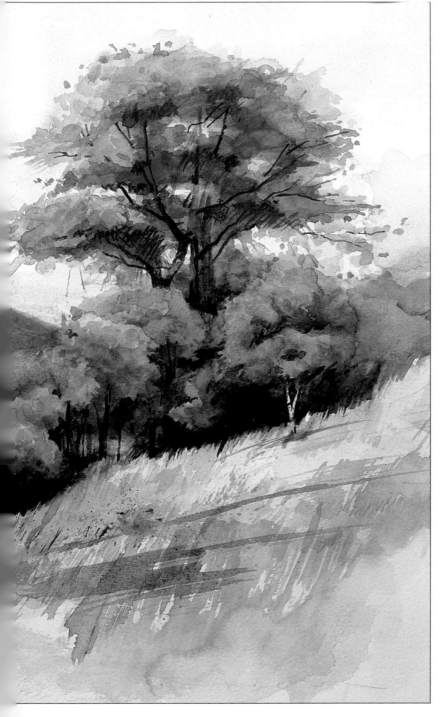

FIRST STROKES

1 ▼ Sketch out the scene With an HB pencil, sketch out the main features of your scene. In the palest areas, press only lightly with the pencil, capturing the faintest impression of the ragged outlines of the foliage. In darker areas, you can block in the shadows with a firmer scribbling action. These pencil marks are an important foundation on which to build your detailed composition.

2 ▲ Prepare the sky Use a No.8 flat brush and clean water to wet the sky area, making a neat edge along the line of the mountain. Do not let the area get too wet, or the paper might become wrinkled – but put on enough water to make the paper surface glisten.

3 ▶ Wash in the sky colours Put touches of ultramarine and cobalt blue into a pool of clean water on your mixing dish. Working quickly on the wet paper, boldly mark in the blue sky above the mountain. The water on the paper will make the edges of the colour blend into the white areas. Clean the brush. With tiny spots of crimson and burnt umber, colour a second pool of water and wash in the undersides of the clouds.

DEVELOPING THE PICTURE

Now that you have established the basic outlines and washed in the sky, you can begin work on the landscape itself. To achieve a range of lively textural effects, use various methods of applying the paint, from dabbing and hatching to spattering.

4 ▶ Block in the foliage With clean water, wet the paper in the main areas of foliage. Mix a wash of emerald green with touches of burnt umber and ultramarine. With a No.4 round brush, block in the foliage, using a dabbing action. Let the patches of colour overlap and run into one another, leaving patches of plain white paper in between.

5 ◀ Establish the foreground Wash the paper in the foreground with clean water. Mix a wash of ochre and burnt umber with a touch of orange, then use the flattened tip of the No.8 flat brush to sketch in the grass. Create strong, textural strokes to make these foreground features stand out. As you work, pull touches of other colours into your wash – emerald green, forest green, burnt umber, ochre and cadmium yellow.

6 ▲ Work into the shadows With a strong wash of ultramarine, forest green and a tiny touch of black, use a No.8 flat brush to work in the deep shadows under the bushes. Visually, this makes a strong line to draw the eye across the painting. Use tight hatching marks along the edge of the grassy area to give the impression of grasses growing up across the shadows.

Master Strokes

Robert Adam (1728-92)
Landscape with Bridge over a Stream

In this landscape, Scottish artist and architect Robert Adam has used a palette of colours similar to that of the step-by-step project, combining warm browns and ochres with a range of subtle greens and cool blue-greys. As in the step-by-step, the textures are varied – dabs and washes of colour contrast with meticulously painted details, such as the tree branches and the bridge.

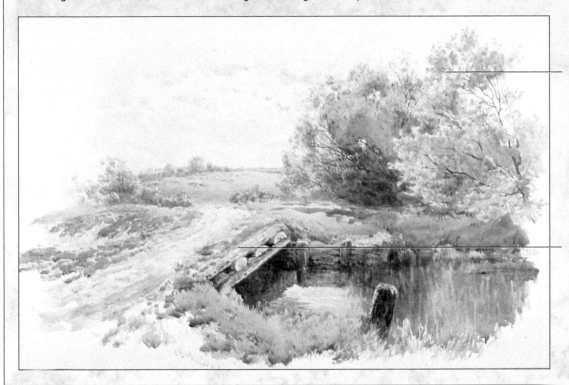

The warm-toned bush on the right catches the viewer's attention. It offers a strong contrast to the more muted greens in the other areas of the landscape.

Cutting diagonally across the picture, the bridge leads the eye into the middle distance of the painting.

7 ▼ Establish the mountain Wait until the sky area is dry so that the edge of the mountain will remain crisp. The mountain is worked on dry paper with a wash of burnt umber, plus touches of cobalt blue and ultramarine to give it a cold, distant appearance. Use long, flat strokes of the No.8 flat brush following the contours of the mountain. Draw a touch more ultramarine into the mix for the darker (right) side of the mountain.

8 ▲ Develop the foliage Using a No.6 flat brush, dab emerald green with a little ochre and burnt umber on to the leafy areas. For a lively effect, identify pools of green paint around the edge of the tree. With your face close to the paper, blow sharply across the surface to throw spurts of paint outwards from the tree. Remove unwanted spots of paint with a tissue.

9 ▶ Mark in the twigs
Use a No.00 round brush and burnt umber paint to mark in the trunk and main branches of the tree. Some are visible between the green patchy areas. Others stretch out sideways to support external foliage. Refer back to your subject to ensure that your marks remain characteristic of the tree. To mark out the finest twigs, see Expert Advice.

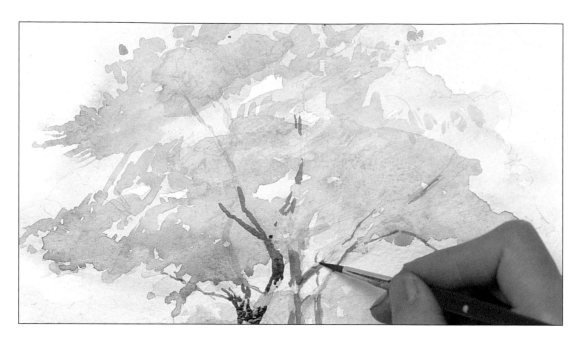

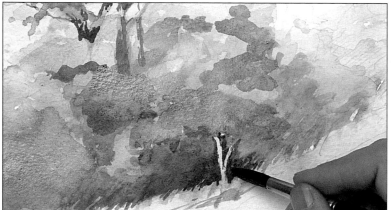

10 ▲ Work a foreground tree To create a light area, draw a wet brush along the line of the trunk. Dry the brush on a tissue, then draw it down the same line to leach out the colour. Use a mix of forest green, ultramarine and a little black for the shadows around the tree. Develop the foliage of the large tree and bushes, using the same colours as in step 8. Add ochre to help the foreground tree stand out.

TROUBLE SHOOTER

REMOVING PAINT SPOTS

If paint splashes on to a plain area such as the sky, it can be removed with some quick action. While the paint is still wet, press a clean paper tissue on top of the mark. Add a drop of clean water to the mark, blot with tissue and repeat until the mark disappears.

11 ▲ Enliven the foreground grass Add touches of orange and emerald green to ochre and use a No.6 flat brush to paint in coarse, grassy marks in the foreground of the composition. For a lively texture, make some flicking marks upwards from the base of the grass stems. To do this, load the brush with paint, then hold it in one hand close to the paper and pull the bristles back with the fingers of your other hand. Release with a flick upwards to spatter paint across the picture. Remove unwanted spots of paint quickly with a tissue.

12 ▼ **Develop the middle distance** Using a No.6 flat brush, mix a wash of cadmium yellow with a tiny touch of burnt umber to block in the field in the middle distance, behind the bushes. Put more burnt umber and a touch of orange into the wash, then use a stiff-bristled toothbrush to scrub the colour across the middle range of the grassy area. Mimic the textural lines of the grasses with your strokes.

13 ▼ **Deepen the tree shadows** Add a touch of black to burnt umber and, using the tip of a No.4 round brush, work in the deepest shadows on the trunk and branches of the tree. Use the black paint very sparingly, saving it for really striking details such as these.

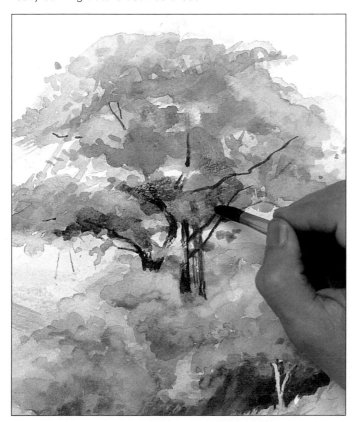

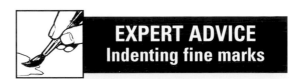

EXPERT ADVICE
Indenting fine marks

Before you paint the finest twig lines in the tree structure, use the pointed wooden end of a paint brush to press indentations into the surface of the watercolour paper. These will make tiny 'rivulets', which will hold the dark paint neatly in delicate twig shapes.

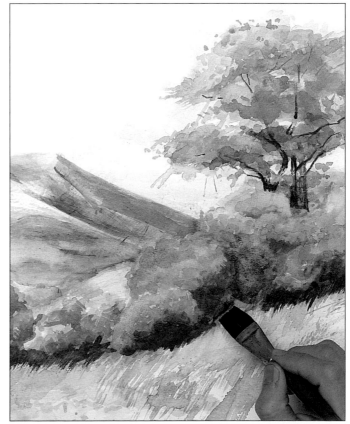

14 ▲ **Strengthen the features** Stand back from the picture and judge the tonal balance between the different areas. Using the No.8 flat brush, strengthen the main features. Use a wash of ultramarine with touches of black and crimson to deepen the shadow areas on the mountain. Draw more ultramarine into the mix to establish the deepest shadows. Add ochre to emerald green in varying proportions to enliven the upper parts of the bushes.

15 ▼ **Add distance detail** Use the technique from step 10 to leach out colour from under one of the bushes. With a No.00 round brush, wash in a mix of cadmium yellow with a touch of burnt umber. Once dry, paint black trunk details.

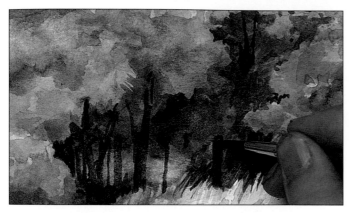

The composition is now complete, but you might wish to draw out some of the character of the scene with more work on fine detail, such as the grass and branches.

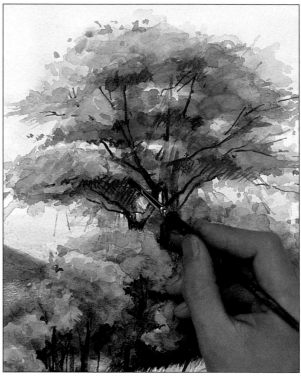

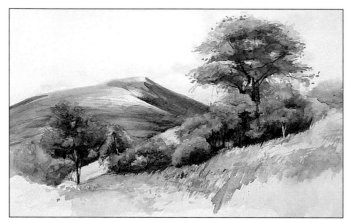

16 ▲ **Finalise the balance** Using the No.8 flat brush and a mix of cobalt blue, ultramarine and emerald green, wash in the lower area of the mountain behind the distant trees. Add trunks and branches to the small tree on the left using the techniques from step 13. With the No.6 flat brush and a mix of forest green and ultramarine, use a dabbing action to develop the leaf detail of both the small and large trees.

17 ▲ **Develop the detail** With a strong mix of burnt umber and black, and using a No.2 flat brush, paint in more branches and twigs on the largest tree. Strengthen existing branches to the front of the tree, but leave the ones nearer the back more washed out, to give a sense of three dimensions.

Express yourself

Focus on texture

The chosen scene is characterised by contrasting areas of smooth sky, sculpted mountain surface and detailed foliage areas. To focus on these textures rather than the colours, discard your paints and take up a piece of charcoal or, as here, a burnt umber soft pastel. Working with a loose style on Not watercolour paper, capture the textures with a variety of strokes. Use soft, scribbling motions for the shadows, flowing marks for the contours of the mountain, and a hatching action for the grass. Use the charcoal or pastel on its side to block in larger areas of smooth shadow.

18 ▶ Add sweeps of colour
As a finishing touch, you could convey the impression of the sweeping movements of a strong wind. Make up a strong mix of burnt umber and ochre. With a No.4 round brush, make bold, slanting marks across the foreground area to suggest the blown and tumbled grasses.

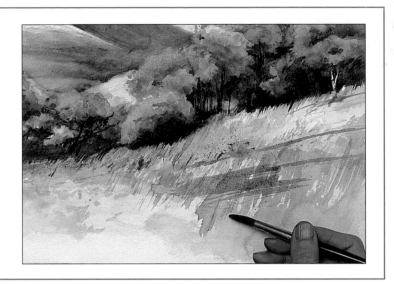

THE FINISHED PICTURE

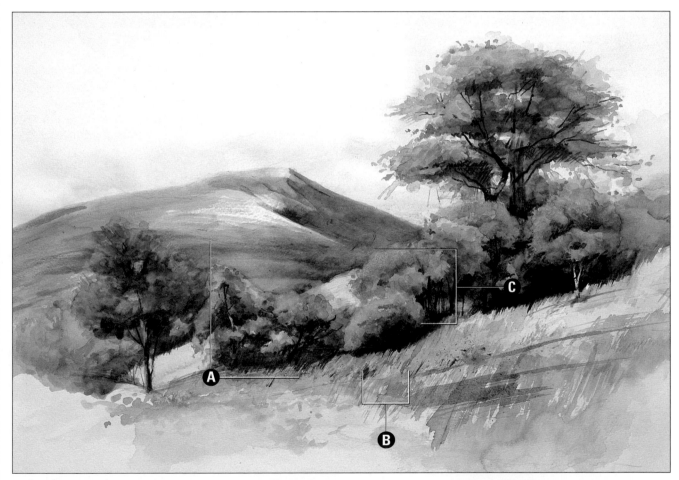

A Sense of distance
The cool blues and greens of the distant mountain recede, helping create a sense of depth. They contrast with the warmer ochres, oranges and browns in the foreground.

B Contrasting textures
Hatched brush strokes and spattered paint created a lively texture for the scrubby grass-land. This contrasts with the smooth sky and sculpted surface of the mountain.

C Strong diagonal
The line of trees and the slope in the middle distance helps create dynamic diagonals that cut across the picture. They provide a pleasing echo of the sloped profile of the mountain.

Trout in watercolour

Use a combination of pure watercolour and water-soluble pencils to capture the shimmering colours of these rainbow trout.

The streamlined body shapes and iridescent colours of rainbow trout make them an absorbing subject. Arrange the pair of fish on a white plate – the austere background highlights their simple shapes and delicate hues. A more dramatic background would be distracting. If necessary, tilt the plate to provide you with a high viewpoint, as this will give a strong composition. Spray the fish with water from time to time, using a plant mister, to keep them looking fresh and glossy.

Organise the lighting carefully – you should be able to see the details clearly, but strong shadows add impact.

Combining media

This is an ideal subject for a mixed media technique. Wet-in-wet washes of watercolour are ideal for the delicate blushes of colour on the skin of the fish. Wet the paper with clean water first and then flow in very pale washes to begin with. Increase the intensity of the colour in the subsequent layers. This

method of working gives you the control that you need to achieve a realistic look for the reflective bodies of the trout. When the basic forms are established, you can apply detail and texture with water-soluble pencils. In this project, the artist exploits an unusual technique to depict the characteristic speckling.

▼ **You will need a delicate touch and a subtle palette of watercolours to convey the iridescent effect on the bodies of these rainbow trout.**

Piece of 555gsm (260lb) Not watercolour paper

HB pencil

Masking fluid plus old brush and soap

Brushes: Nos.10 and 7 rounds

8 watercolours: Winsor blue (if unavailable, use Phthalo blue); Permanent rose; Viridian; Ultramarine blue; Burnt umber; Cadmium yellow; Cadmium red; Permanent violet

Tissue paper

Craft knife

7 water-soluble coloured pencils: Dark blue; Soft green; Grey; Light blue; Bright blue; Dark brown; Red

FIRST STROKES

1 ▶ Draw the subject Start by making a careful drawing of the fish and the plate, using an HB pencil. Notice how the artist has arranged the fish on a slight diagonal to produce a dynamic composition. If they had been horizontal, the image would have been quite static.

2 ▶ Mask the highlights The silvery highlights of the fish scales are represented by the white of the paper. Protect these areas with masking fluid while you lay on washes of colour. Use an old brush and rub a bit of soap into it before you dip it into the masking fluid – it will be easier to clean later. Place masking fluid over all the brightest parts of the fish. Wash the brush. Leave the mask to dry thoroughly.

3 ▲ Apply the first washes Wet a No.10 brush and dampen the two fish. Lay a very pale wash of Winsor blue along the back of the top fish. While this is still wet, lay a wash of permanent rose below it. Wash viridian along the back of the lower fish, overlapping the rose to make grey. Place a band of rose along the middle of the lower fish, then mix ultramarine blue and rose for the pale violet on its belly.

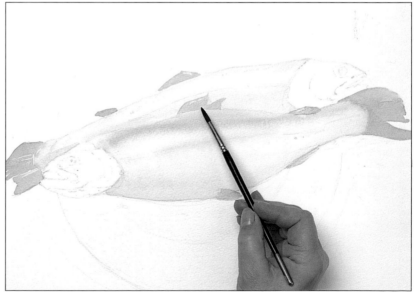

4 ▲ Paint the tail and fins Allow the first washes to dry completely. Mix Winsor blue and burnt umber to give an intense, warm grey for the tails and fins. Apply the colour carefully, using the tip of the No.10 brush. Leave to dry.

5 ▼ **Paint the plate** The white, glazed surface of the plate picks up colours reflected from the adjacent surfaces, including the fish. Apply very pale washes of permanent rose, cadmium yellow and Winsor blue, allowing the washes to blend and bleed into one another to create a delicate, pearly effect. Allow these washes to dry.

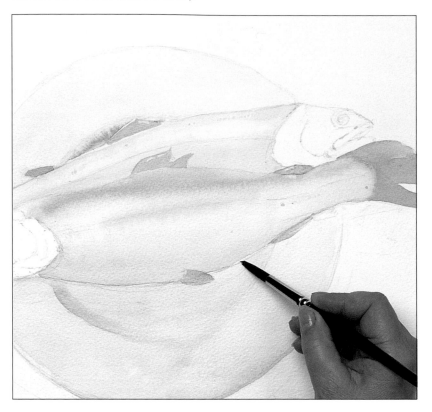

6 ▲ **Strengthen the colours** Moisten the fish with water, avoiding the overlap where you need a crisp edge. Wash a mix of Winsor blue and permanent rose along the back of the top fish, adding viridian beneath it. Flood bands of cadmium yellow on each side of the rose stripe on the lower fish. Paint a little of the pale violet mix from step 3 on the belly. Deepen the rose stripe on the side of the fish and darken its back with a mix of Winsor blue and burnt umber.

Express yourself

A new composition

Experiment with composition whenever you can. Very small adjustments can entirely change the character and impact of an image. Here, a single fish is displayed on a plain white plate. By arranging it so that it fills the picture area from corner to corner, the artist has given the image energy and has emphasised the graphic qualities of the subject.

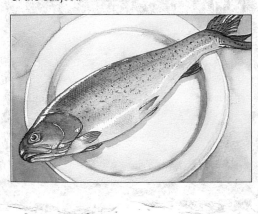

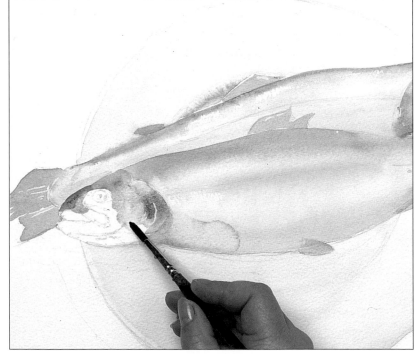

7 ▲ **Paint the heads** Add a touch of burnt umber to Winsor blue and use this for the dark areas on the right-hand fish's head. Working wet-in-wet, apply cadmium yellow and permanent rose. Develop the head on the left in the same way, using the mixed grey, permanent rose, burnt umber and a little cadmium red. Allow to dry thoroughly.

DEVELOPING THE PICTURE

The image has been established using a series of wet-in-wet washes. Now, the water-soluble pencils will come into their own. You can use them to draw details such as the eyes, to add small areas of intense colour and to develop textures using a variety of techniques.

8 ▲ Apply texture Re-wet the fish, then blot the surface with a tissue so that it is just damp. Using a craft knife, scrape specks of pigment from a dark blue pencil tip over the backs of both fish, dusting them with·granules of colour. Repeat with soft green and grey pencils.

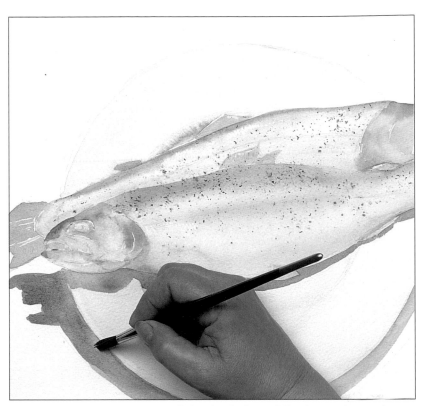

9 ▲ Paint the shadows Mix ultramarine and permanent rose to create a cool violet for the cast shadows. Apply this wash with the No.10 brush, working underneath the lower fish and around the outside of the plate and crisping up the outlines at the same time. Using the same wash, add the shadows cast by the tails. Notice how the shadows give the image a three-dimensional feeling and establish the horizontal surface on which the plate is resting.

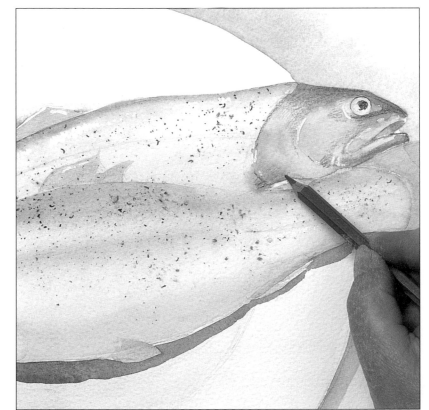

10 ▲ Add details in water-soluble coloured pencil Lay a very pale wash of Winsor blue over the background at the top of the image. While it is still wet, introduce touches of cadmium yellow and permanent violet to create a delicately variegated wash. Use a dark blue water-soluble pencil to create the dark pupil of the eye and the shading on the head of each fish. Go over these with grey pencil. Use this pencil to draw the details of the mouth and the eye socket. Take a light blue pencil and apply hatched shading within the mouth, along the cheek and under the head.

EXPERT ADVICE
Customise your palette

If you want to build up intense colours using water-soluble coloured pencils, make a palette on a piece of scrap paper. Hatch patches of the shades you want to use. You can dissolve the colours with a brush dipped in water and then transfer them to the image. This method allows you to control the intensity of the wash.

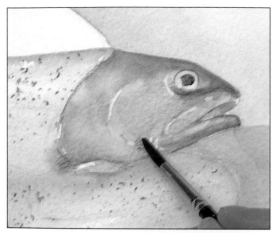

11 ▲ **Blend the pencil colours** Using a No.7 brush dipped in water, start to blend the water-soluble pencil colours. Work carefully, as the pigment in some water-soluble pencils is very intense and might overwhelm the subject. If the washes you create are too saturated, blot the surface gently with a tissue.

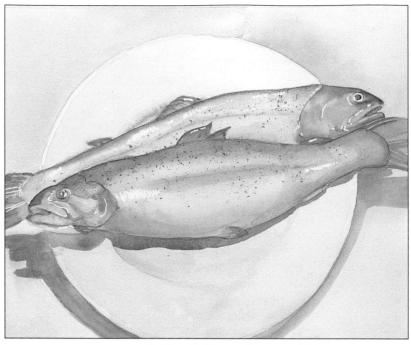

12 ▲ **Tighten up the image** Using the paper palette method (see Expert Advice, page 117), define the back of the top fish with bright blue pigment picked up on a brush, and paint the fins with dark brown. When the painting is dry, remove the film of masking fluid.

A FEW STEPS FURTHER

Deciding when your painting is finished is one of the most difficult decisions you have to make. The trick is to add a touch more detail and texture without jeopardising the spontaneity of the image.

13 ▲ **Refine the outlines** With the dark blue water-soluble pencil, redraw the backs of the fish and the outlines of the fins. Using the blue and grey water-soluble pencils, draw spots along the back of the fish to suggest the larger dappled marks on their backs.

Master Strokes

Isaac van Duynen (1628-88)
Still Life of Fish on a Table

This highly realistic still life is typical of the Dutch School of painting. Van Duynen, whose family was in the fish trade, takes an almost anatomical interest in the sea creatures in the arrangement. The picture is beautifully composed, making the most of the diverse shapes and harmonious colours.

Painted highlights capture the reflective surfaces of the different sea creatures, such as the glistening scales of the fish.

The pinky-orange colour of the salmon and the lobster's claws provides a contrast to the mainly neutral shades in the painting.

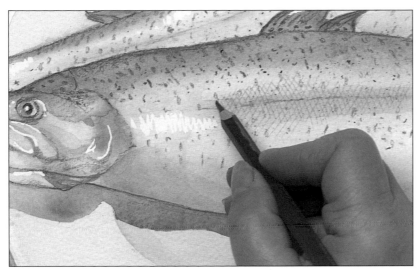

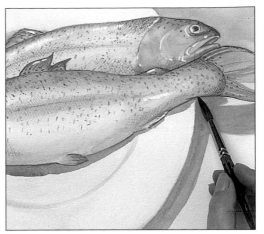

14 ▲ **Draw the scales** With a red pencil, draw a regular cross-hatched pattern along the side of the fish to suggest its scaly surface. If you create just a small area of detail, the eye will fill in the rest.

15 ▲ **Darken the cast shadow** Hatch in more scales in shades of blue and grey. Using the No.7 brush and ultramarine blue with a touch of permanent rose, intensify the colour of the shadow cast by the plate.

THE FINISHED PICTURE

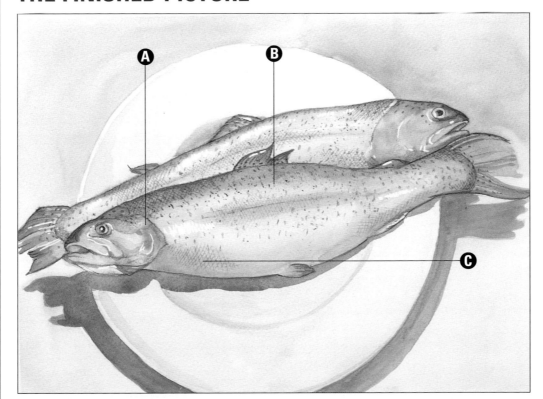

A Delicate wet-in-wet washes
By applying the washes to damp paper, the artist allowed the colours to flow into each other to create subtle colour blends. These perfectly captured the iridescence of the skin of the trout.

B Speckled pattern
The dots of colour on the fish were created by scraping water-soluble pencil on to damp paper, and by drawing dots on to dry paper. Combining both techniques produced visual interest and an accurate description.

C Scaly texture
Small areas of light, regular cross-hatching with the water soluble pencils suggest the scaly bodies of the fish. If this texture had been applied more extensively, it would have looked too mechanical.

Choosing your palette

Painting on holiday is great fun and a good way to capture the atmosphere of the places you have visited. Make sure you take the right colours for the job.

A holiday often means the chance to pack up a few colours and brushes and take time out to do what you enjoy best – painting. If your destination is hot and sunny, you need to think in terms of bright colours and strong tonal contrasts. However, if you are visiting a cool, damp place, your colour schemes will almost certainly be more subdued and muted.

Your holiday palette

The two holiday subjects here could not be more different. One is a sunny harbour on the Greek island of Halki. The other is a windswept beach under a cloudy sky in the north of England.

However, whether you favour a sunny island or a windy coast, it is important to take the right colours for the job. For example, a palette of twelve watercolours was needed to capture the sea, sky and sunshine of Greece. The mixtures are bright with predominantly clear, pure colours. Conversely, only eight watercolours were used to describe the wet, windy atmosphere of the isolated beach and these were generally cool and more subdued.

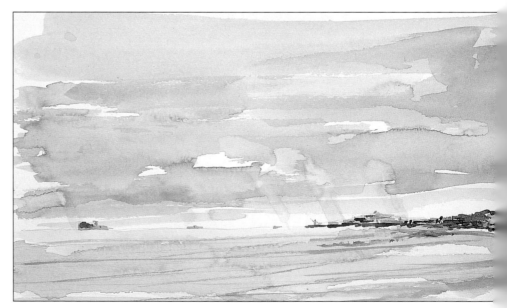

▲ **The bright Mediterranean sun helps create a colourful, sharply defined scene (top). By contrast, the cloudy, damp British climate produces a moody landscape, full of subtle colours and loose washes (above).**

PROJECT 1

HALKI, A GREEK ISLAND

Don't be surprised if your paints appear to behave differently on holiday. Watercolours are affected by heat, cold and damp, so you might have to adapt your way of working to accommodate this. In strong sun, the colours slide easily from the brush on to the warm paper. Also, the paint dries quickly, making it easier to apply and control flat areas of colour, but more difficult to work wet-on-wet.

For wet-on-wet effects, you must work rapidly, painting one colour on another before the first colour has time to dry. Alternatively, add a little glycerine to your water to delay the drying time. In a damp climate, the opposite happens and watercolours can remain wet on the paper for hours. To prevent this, add a little alcohol to the colour mixtures.

The artist originally painted this scene on location (see top right). He then used it as a reference to paint the step-by-step in the studio.

YOU WILL NEED

Piece of 300gsm (140lb) Not water-colour paper 36 x 51cm (14 x 20in)

B pencil

Brushes: 19mm (³⁄₄in) flat; No.4 round; rigger

12 watercolours: Antwerp blue; Yellow ochre; Gamboge yellow; Vandyke brown; Cerulean blue; Emerald green; Payne's grey; Ultramarine; Indigo; Vermilion; Cadmium yellow; Cadmium red

1 ▶ Make a pencil drawing Draw the subject in simple lines, using a well-sharpened B pencil. Make sure all the buildings are in the correct position in relation to each other. Take special care with uprights, such as the tower. These should not be leaning!

2 ◀ Paint the sky Using a 19mm (³⁄₄in) flat brush, block in the sky with Antwerp blue. Work in smooth, parallel strokes across the paper.

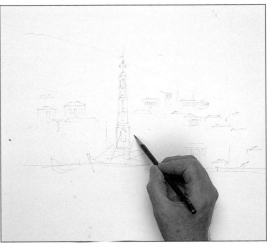

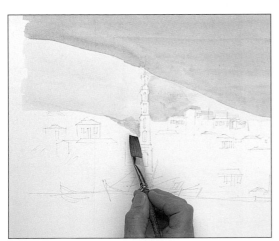

3 ▲ Add the hill Paint the hill as a flat shape using a mixture of yellow ochre and gamboge yellow. Before the paint dries, add the shadows behind the buildings using a diluted mixture of Vandyke brown and cerulean.

DEVELOPING THE PICTURE

Having established the hill and sky as solid blocks of colour, the next stage is to add the trees. These should be painted quickly as loose blobs of colour, so do not be tempted to add detail or overwork the brush strokes.

4 ▶ Paint trees in two tones Change to a No.4 round brush and paint the trees with a mix of emerald green, Payne's grey and ultramarine. Use diluted colour to block in the shape of the foliage, then work into the centre of each shape with a darker tone of the same colour.

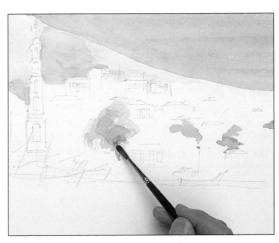

121

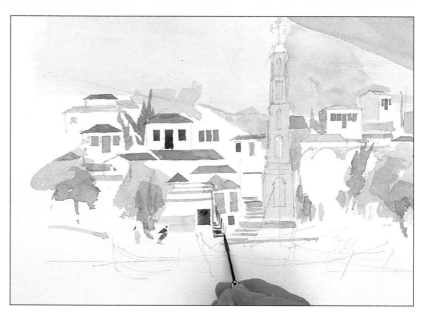

TROUBLE SHOOTER

5 ▲ Continue blocking in With the green used for the trees, paint a few of the windows, doors and steps. Add a little Payne's grey or yellow ochre to this mixture and paint more windows and doors. With a mix of indigo and emerald green, paint the steps by the tower. Block in the tower in a diluted yellow ochre, then paint the roofs in vermilion and cadmium yellow toned down with a little of the green tree mix.

6 ▶ Develop the buildings Dot in the figures under the tree with mixtures of yellow ochre, emerald and vermilion. Use indigo with a touch of emerald green for the small flight of stairs in the foreground.

7 ▲ Add detail to the tower Mix a very dark tone – almost black – from vermilion and emerald green and use this to paint the architectural detail on the tower.

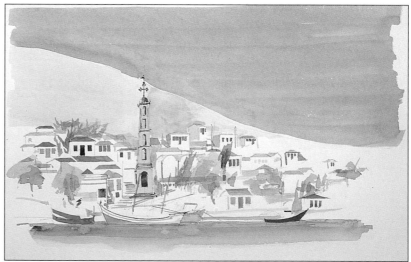

8 ▲ Paint the boats and sea Paint the boats in pure cadmium red and a khaki mixed from emerald and vermilion. Using broad strokes of the 19mm (¾in) flat brush, paint the sea in an emerald green/cerulean blue mix. Add a little Vandyke brown for narrow shadows under the boats.

A FEW STEPS FURTHER

The picture is now almost complete. Allow the paint to dry before adding the final details. Watercolour appears paler as it dries, so you might also want to strengthen some of the tones and colours.

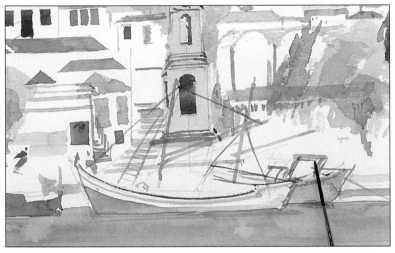

9 ▲ **Add linear detail** Use a rigger brush to paint the rigging and outline of the boat in a greenish-brown mixed from cadmium red and emerald. The long, tapering bristles will enable you to paint the ropes as fine, flowing lines.

10 ▲ **Adjust the tones** Strengthen any colours and tones that have dried too pale. For example, here, the rooftops are darkened in vermilion with a touch of emerald green.

THE FINISHED PICTURE

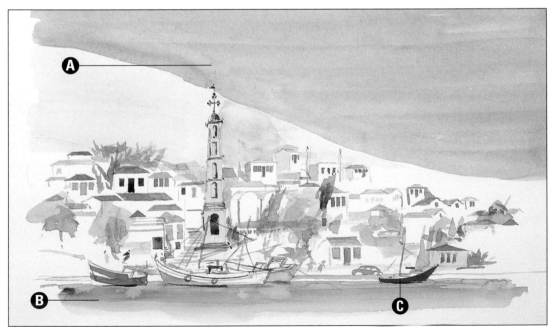

A Flat sky
The bright sky was painted in broad, parallel strokes. The flat colour conveys a sense of stillness, which helps create an impression of heat.

B Water effects
An intense turquoise wash over the sea suggests the translucent quality of real water. Wet-on-wet runs of colour accentuate this watery effect.

C Pure colour
To match the sunny brilliance of the scene, bright paints were used. The boats, for instance, are rendered with unmixed cadmium red.

PROJECT 2

NEAR MORECOMBE BAY, LANCASHIRE

In stark contrast to the sunny Greek island, with its bright colours and cheerful ambience, this coast has a quiet, understated beauty. Apply the paint freely wet-on-wet to capture the damp, windy weather, and limit your paint mixes to a subtle range of greys.

Do not simply mix black and white to obtain your greys. Instead, as our artist has done, just tone down blue, green or yellow with Payne's grey or by adding a little contrasting colour. This helps create 'living' greys, which appear very different when seen next to each other.

Apart from the distant buildings which are painted as dark silhouettes on the horizon, most of the tones in this painting are pale and quite similar to each other. This 'close tones' approach is usually chosen to give subtle or moody effects.

YOU WILL NEED

Piece of 300gsm (140lb) Not watercolour paper 36 x 51cm (14 x 20in)

B pencil

Brushes: 19mm (¾in) flat; Nos.4 and 5 rounds; rigger

8 watercolours: Antwerp blue; Payne's grey; Yellow ochre; Violet; Ultramarine; Emerald green; Burnt sienna; Cadmium yellow

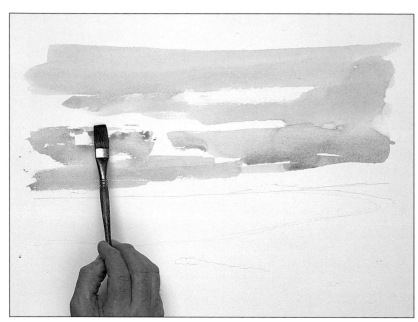

1 ▲ Paint the sky Use a B pencil to draw the main composition, starting with the horizon, which is established as a precise single line. Using a 19mm (¾in) brush, paint the top of the sky in Antwerp blue with some Payne's grey. Add a little yellow ochre and violet towards the horizon. Make short, irregular strokes, leaving patches of white among the areas of paint.

EXPERT ADVICE
Wet-on-wet effects

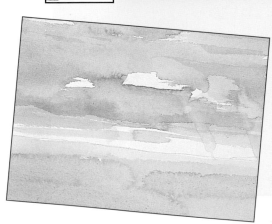

While crisp washes are ideal for simulating the effects of clear Mediterranean light, working wet-on-wet is perfect for the damp English climate. It produces unexpected and spontaneous runs of colour. If you leave these to dry naturally, you will get attractive dark edges where the pigment has collected around the runs (see left).

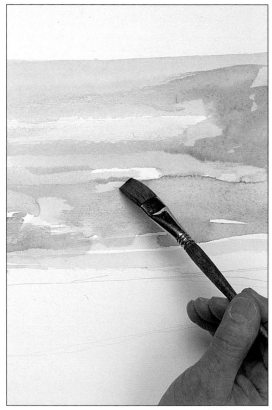

2 ▲ Make swirling clouds Work into the wet sky with Payne's grey mixed with touches of ultramarine and emerald green. Brush a few streaks on the white spaces, then paint some loose, swirling strokes to give a cloudy, windswept effect. Add a little more ultramarine as you paint down towards the horizon.

3 ▼ **Establish the beach** When the sky is thoroughly dry, start
to paint the sand in a very diluted wash of yellow ochre.
Paint darker streaks in mixtures of burnt sienna, with touches
of Payne's grey and violet, allowing the wet streaks to blend
together to create runs of colour.

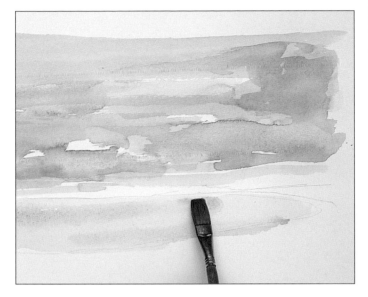

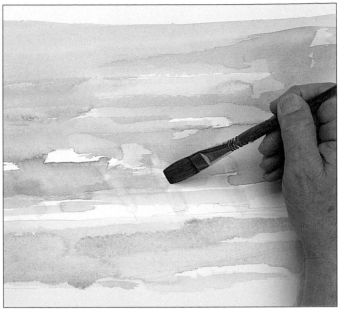

4 ▲ **Add a few rays of light** Dip the brush in clean water and
paint a few broad, diagonal strokes across the sky and
sea. The water will dissolve enough colour to give the
impression of pale rays of light.

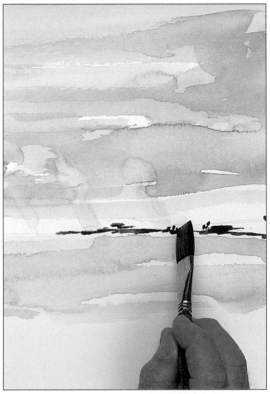

5 ▲ **Dot in the buildings** Mix a cool, dark grey
from Payne's grey with touches of violet and
yellow ochre. Dot in the buildings around the
bay with short vertical and horizontal strokes
using the edge of the flat brush.

Master Strokes

Peter de Wint (1784-1849)
Mountain scene, Westmorland

This watercolour painting by British artist Peter de Wint shows a very different
landscape to the one in the step-by-step, but there are some similarities in the
colour palettes used to depict both scenes. At first glance the mountains may
appear greyish, but look closely and you'll see ochres, greens and pinks.

**Clouds hovering over the
hills have been beautifully
evoked by transparent
washes of grey.**

**The dark rocks form the focal point of the
painting. They also create a strong tonal
contrast which helps differentiate the
foreground from the pale hills beyond.**

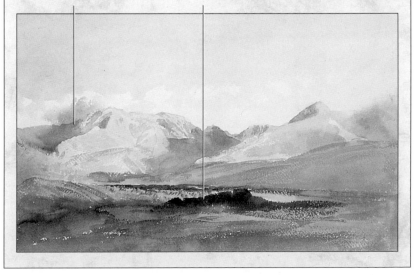

6 ▶ Paint the grass
Change to a No.4 round brush and paint the distant grass in a watery mixture of cadmium yellow with a little ultramarine. The trees in front of the grassy area are painted in a mixture of Payne's grey and cadmium yellow.

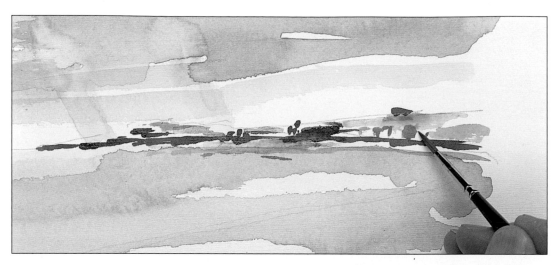

DEVELOPING THE PICTURE

At this point, the sand has been painted simply as flat washes of colour. It needs to be broken up with a few tide marks to give a sense of scale and space to the beach.

7 ▼ Add some tide marks Use the B pencil to indicate the position of the tide marks on the beach in sweeping concentric curves. Draw the curves closer together as they go off into the distance to give the scene a sense of recession and perspective.

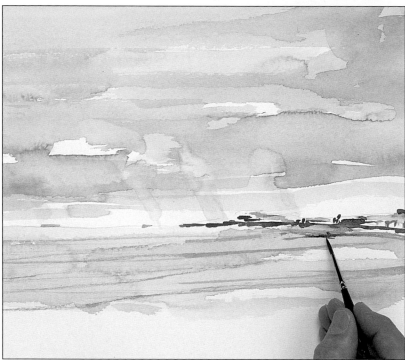

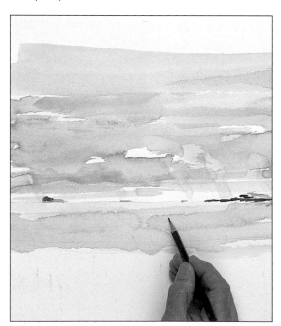

8 ▲ Paint the tide marks With the No.4 brush dipped in a mixture of violet and yellow ochre, paint over the sweeping curves you have drawn on the beach to indicate the tide marks.

9 ▶ Add darker tones Darken the most distant houses with Payne's grey mixed with a little violet and yellow ochre. Mix a very dark green from Payne's grey with a touch of yellow ochre and add the small trees on the right with short jabs of the No.4 brush. Allow the colours to dry.

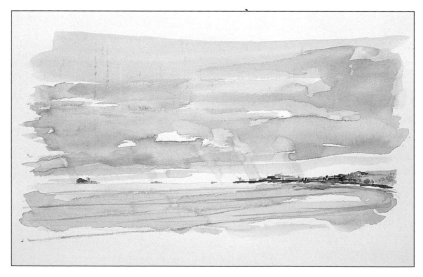

While you are waiting for the paint to dry, stand back and take a good look at your work. At this stage, the painting is virtually finished and needs only one or two small adjustments before it is complete. For example, the bottom edge of the composition looks rather cramped.

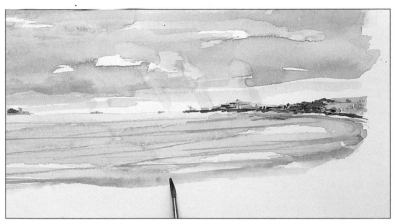

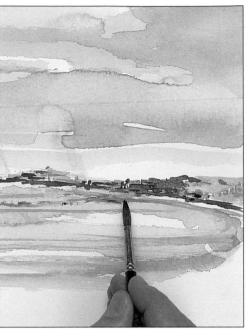

10 ▲ Extend the composition Change to a No.5 round brush and strengthen the lower edge of the painting by extending the curved tide marks on the beach, using a diluted mixture of violet and Payne's grey.

11 ▲ Put in the distant shadows Finally, use a stronger version of the same colour to add a few dark tones to the shadows on the far side of the beach.

THE FINISHED PICTURE

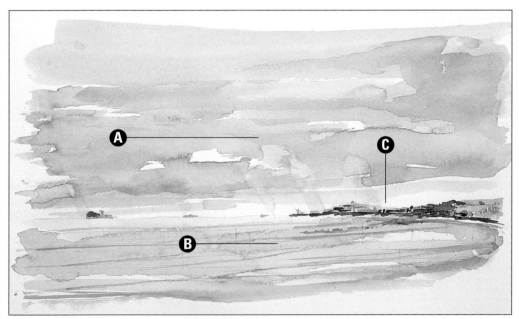

A Swirling sky
The living, moving sky was painted loosely with a large brush. Wet colours were allowed to run into each other to create amorphous shapes of muted blues and greys.

B Greyed-down colours
Local colours, such as the yellow ochre of the sand, were mixed with a little Payne's grey or a contrasting colour to create a range of cool, neutral tones.

C Suggestive brush strokes
There is no detail in the distant trees and buildings. Instead, these are suggested with tiny vertical and horizontal strokes, using the edge of a large, flat brush.

Hand-tinting photographs

Give a black-and-white photograph a suggestion of delicate colour by tinting it with watercolour inks.

Hand-tinting can completely alter the look of a black-and-white photo. You need to choose an image with a high proportion of pale tones as tints do not show up against dark areas. And matt, rather than glossy, prints generally accept the tints best.

As for subject matter, virtually anything goes. You might want to use pale, delicate tints on more ornate subjects – such as flowers or contemplative portraits – while bolder, brasher colours might be more suitable for happy family snapshots. Try experimenting with different colour mixes by ordering reprints of your photo and tinting them in different ways.

Tinting techniques

When applying the tints, make sure you rinse your brush in water and dry it with cotton wool each time you change to a new colour. Remember also to change your water regularly to prevent tainting the subtle tints.

To check you've got the right mix of water and ink, test out your colours on a scrap of paper before starting on the actual print. You can use a piece of cotton wool to absorb excess ink. If you make a serious mistake, soaking the photo should remove the colour.

◀ **The delicate tints on these flowers create a beautiful, muted image.**

YOU WILL NEED

Black-and-white photographic print on fibre-based matt paper

Masking tape

No.2 soft round brush

4 watercolour inks: Scarlet; Process yellow; Royal blue; Grass green

Mixing palette

Jar of water

Cotton wool

1 ▼ Fixing down the photograph Attach the print securely to your work surface, using masking tape. When the diluted ink is applied, the paper is likely to wrinkle, so taping it down will keep the print as flat as possible.

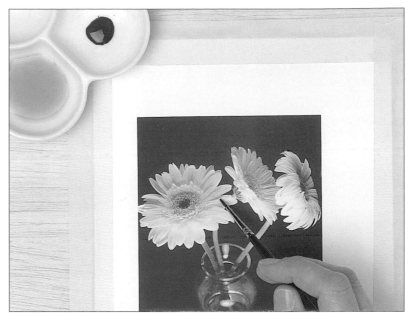

2 ▲ Colour the first flower Dilute some scarlet ink in your palette to a very light pink – a single drop of ink is all you need to create the right shade. Using a No.2 brush, apply a first layer of scarlet to the flower on the left, filling in the colour within the outlines of the petals. Be careful not to make the brush too wet.

3 ▼ Tint the water in the vase Clean your brush, then apply diluted process yellow ink to the flower on the right. Leave the middle flower for the moment to prevent colours running between the two flowers. Clean your brush once more, then add a very faint hint of diluted royal blue to indicate the water in the vase.

EXPERT ADVICE
Diluting coloured inks

To create a diluted mix of a colour, first place a single drop of ink on your palette. Then soak a piece of cotton wool in water and gently and slowly squeeze it over the ink. This gives you greater control over the precise amount of water you use to dilute the ink, and enables you to judge more easily the exact shade of ink you require.

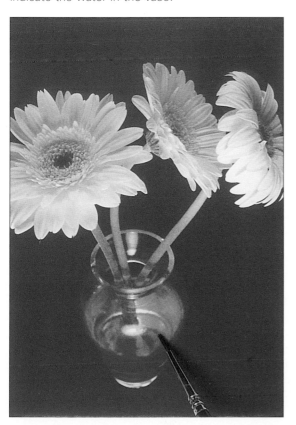

4 ▶ Add a second wash Once the ink has dried, paint on a second layer of each colour. Rinse and dry your brush, then add a wash of royal blue ink to the flower in the centre of the picture. Be careful not to let this colour overlap the ink on the flowers on each side.

5 ◄ **Colour in the flower stems**
Dilute a drop of grass green ink and apply it carefully to the flower stems. When this has dried, add a third layer of royal blue to the water in the vase to build up the depth of colour.

6 ▲ **Deepen the shade of water** Add a drop of process yellow to the diluted royal blue ink already on your palette. Mix the colours with your brush to create a greenish blue shade. Use this to deepen the shade of the water in the vase.

THE FINISHED PICTURE

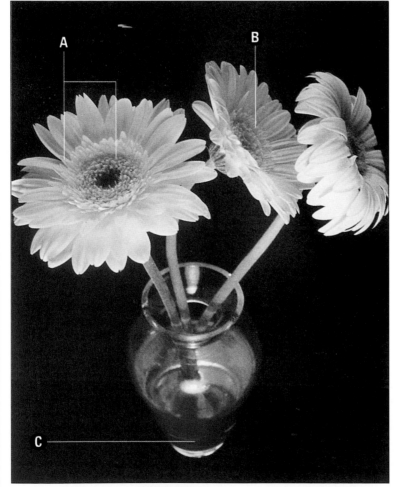

7 ▲ **Fill in the details** Make up a very diluted shade of blue and fill in the centres of the flowers on the left and right. Then mix and apply an equally diluted shade of process yellow for the centre of the middle flower.

A Subtle colours
The watercolour ink was thoroughly diluted to produce soft, pastel colours for the flower petals and stalks.

B Crisp edges
To prevent two shades of ink running together, each colour was allowed to dry thoroughly before a new one was applied.

C Tinting in stages
Deeper tones, such as the dark blue of the water, were built up by painting on more than one layer of ink.

Watercolour crab

Extend your range of watercolour techniques in responding to the challenge presented by the subtle colours and textures of a crab.

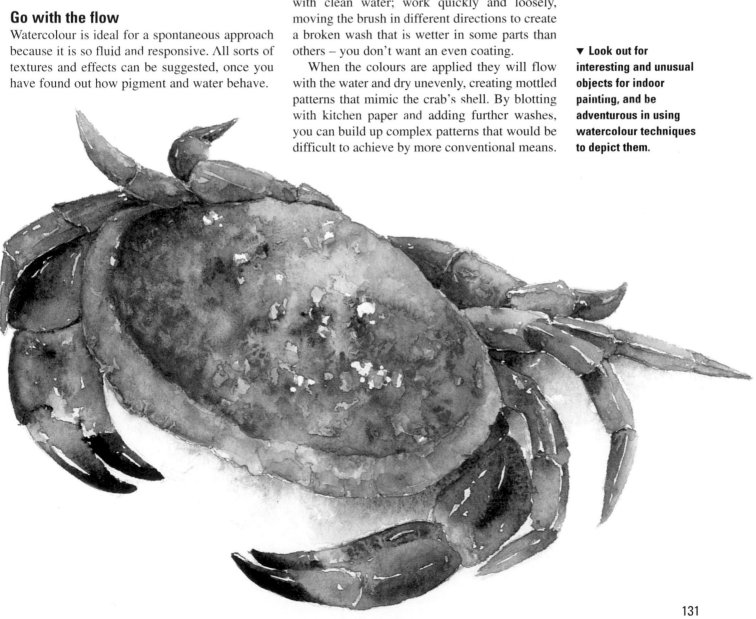

We tend to think of still life as being a group of objects, but a single item, painted in an interesting way, can have just as much impact as a table groaning with fruit and vegetables. The complex forms and unusual textures in this crab provide a means of challenging your watercolour skills to the full. Don't feel inhibited — the idea is not to reproduce the crab in photographic detail but to express the essential qualities of its appearance.

Go with the flow

Watercolour is ideal for a spontaneous approach because it is so fluid and responsive. All sorts of textures and effects can be suggested, once you have found out how pigment and water behave.

Beginners are often afraid of watercolour because they think it is difficult to control. But, as this project shows, the best results are achieved by not controlling the paint too much; often you will find that it does much of the work for you! To paint the crab, wet the paper with clean water; work quickly and loosely, moving the brush in different directions to create a broken wash that is wetter in some parts than others – you don't want an even coating.

When the colours are applied they will flow with the water and dry unevenly, creating mottled patterns that mimic the crab's shell. By blotting with kitchen paper and adding further washes, you can build up complex patterns that would be difficult to achieve by more conventional means.

▼ **Look out for interesting and unusual objects for indoor painting, and be adventurous in using watercolour techniques to depict them.**

FIRST STROKES

1 ▶ Draw the outline
Make a careful outline drawing of the crab using a sharp HB pencil. Don't attempt any shading, but outline the highlighted areas on the shell, some of which will be masked out.

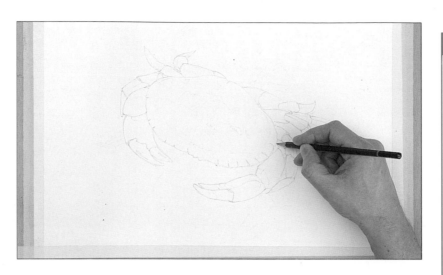

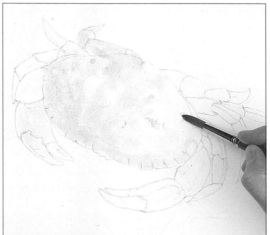

YOU WILL NEED

Sheet of 400gsm+ (140lb+) Not watercolour paper

HB pencil

Small, old watercolour brush for applying masking fluid

Tinted masking fluid

Brushes: Nos. 11, 6 and 2 round

Jar of water

6 watercolours: Raw sienna; Burnt sienna; Cadmium orange; Cadmium red; Burnt umber; French ultramarine

Kitchen paper

Mixing palette or dish

2 ▼ Mask out the highlights Use a very small, old paint brush to apply masking fluid to the small highlights you have outlined on the shell of the crab. Leave to dry.

3 ▲ Apply the underwash Before applying any colour, load a No.11 round brush with clean water and work it over the shape of the crab with fast, random strokes so that some areas are wetter than others. Don't worry if the water goes over the pencil lines – it will add to the unforced effect you are aiming for. Now dip the brush into some undiluted raw sienna and apply it randomly. The paint will flow with the water and create strong tones and lighter ones as it mixes with either damp or dryer areas.

TROUBLE SHOOTER

REMOVING HARD EDGES

If the underwash dries before you have a chance to apply a second wash over it, the second wash will dry with an unwanted hard edge. To avoid this, simply drop some water from the tip of the brush on to the edge where the two colours meet and gently work them together.

4 ▶ Blot with kitchen paper While the surface is still wet, blot some of the highlight areas on the main body of the crab with crumpled kitchen paper, using a press-and-lift motion. This forces the paint into the fibres of the paper, increasing the textural effects on the shell.

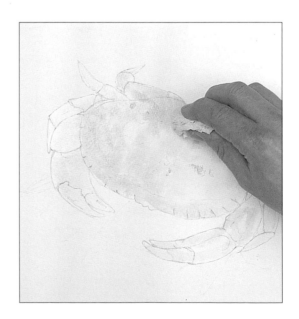

DEVELOPING THE PICTURE

Having completed the underwash, the next stage is to develop the texture and form of the crab using wet-on-wet washes. The idea is to observe your subject carefully and then allow the paint to interpret what you see.

5 ▶ Apply burnt sienna
Working quickly before the underwash dries, apply undiluted burnt sienna around the edge of the crab's body. Just touch the tip of the brush to the paper and let the colour flow on the damp surface.

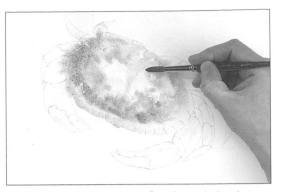

6 ▲ Start to build up form Continue darkening the body with burnt sienna, except for the top and 'pie-crust' edge of the shell, which pick up more light. Touch in some cadmium orange on the top of the shell. The rounded form of the crab is beginning to emerge: the top is pale, darkening as the shell curves away from the light.

7 ▲ Add more colours Carry on building up layers of paint. To suggest the blotched patterning, drip some clean water off the brush to form small pools and then touch in a little undiluted cadmium red, then some burnt sienna. Let the colours bleed into the surrounding wash.

Master Strokes

Pieter Claesz (1597-1660)
Breakfast Still Life with Roemer and a Crab

This painting expresses the subtle details found in commonplace objects. Using a subdued palette with occasional touches of bright colour, Claesz concentrated on depicting light (as on the large glass or *roemer* of the title) and texture. He was one of the most important exponents of the highly popular 'ontbijt', or breakfast piece, which showed a simple meal arrangement.

The detailed reflection of the bread suggests the high shine of the metal plate's surface.

The folds of the tablecloth seem brighter and whiter against the dark wood of the table.

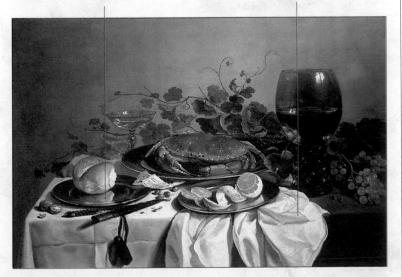

8 ▲ Work on the edge of the shell Using a wad of kitchen paper, blot the outer edge of the shell to lift out some of the paint, creating soft highlights that suggest the raised 'pie-crust' ridges. Leave the painting to dry naturally so that the water and paint settle at their own pace; using a hair-dryer will even out the marks.

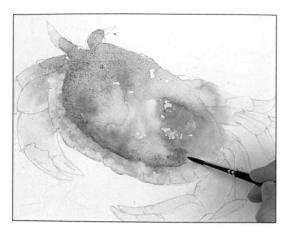

9 ◄ Add definition
Now drop some more water from the brush on to the shell. Use the tip of a No.6 brush to 'draw' a line of raw sienna where the rounded body meets the flat edge of the crab, adding more definition to the shape.

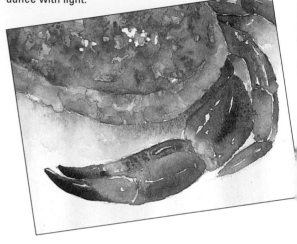
10 ► Paint the darker markings Mix burnt umber with a touch of raw sienna and start to paint the darker markings using a No.2 brush. Make small, fast strokes, skipping the brush over the surface to create a mottled pattern.

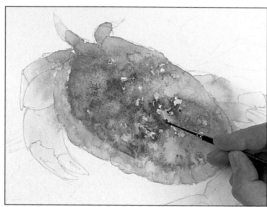

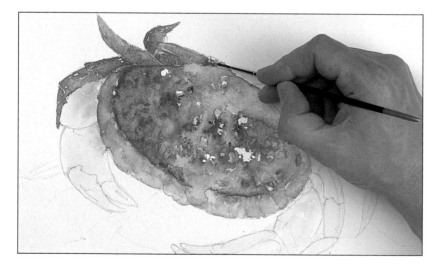

11 ◄ Start painting the feelers Allow the painting to dry completely, then remove the patches of masking fluid by rubbing with your finger to reveal the small, bright highlights on the shell. Now paint the first set of feelers using a slightly diluted wash of burnt sienna applied with the No.2 brush. Don't fill in the shapes completely but use small, broken strokes, allowing tiny patches of the pale underwash to show through and provide highlights. Allow to dry; because you are now working on dry paper, the paint will dry with a crisp, hard edge.

▼ When the paint is dry you can see the interesting textural effects achieved by dropping water and wet pigment into a wet underwash, creating 'cauliflower' blooms that suggest the mottled and uneven surface of the crab's shell.

12 ► Add shadows
Apply a dilute wash of burnt sienna over the feelers. Just before this dries, paint the shadows on the edges of the feelers and between the joints with a mixture of burnt umber and ultramarine. The edges will blend softly into the damp burnt sienna wash.

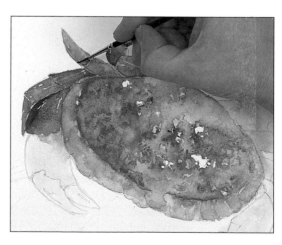

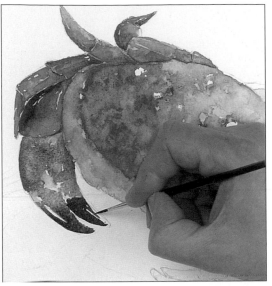

13 ◀ **Paint the claws**
Repeat steps 11 and 12 to paint the first set of claws, this time making the shadows slightly stronger. Darken the mixture with more ultramarine to paint the tips of the claws. As before, use small, broken strokes and allow slivers of the underwash to provide the highlights and reflections.

14 ▼ **Complete the claws and feelers**
Now paint the second set of claws and feelers, using the same method as for the first set. Leave the painting to dry.

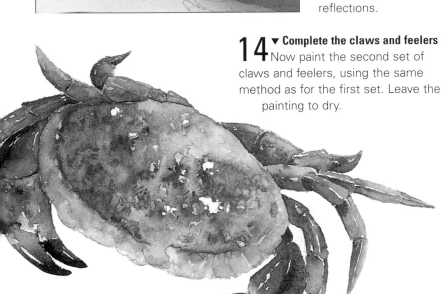

Express yourself
Loosen up

In this version of the same subject, the artist has worked even more loosely than before. He has also used more water: notice how some of the claws and feelers are partially dissolved, giving them an interesting 'lost-and-found' quality.

As well as painting a shadow under the crab, the artist has also suggested a white plate. This is understated so as not to detract attention from the crab, but serves to place it in context.

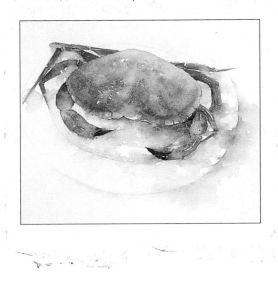

A FEW STEPS FURTHER

You might decide here that your study is complete. Sometimes adding more detail merely results in an overworked picture. But perhaps you feel your picture needs more contrast; you might also wish to add some background shadow to anchor the crab in space.

15 ▶ **Strengthen texture and detail** On the body of the crab, use burnt sienna and the No.6 brush to work up the shell and emphasise form and texture. Again, use small, quick strokes to strengthen the marks already created, particularly round the edges of the shell.

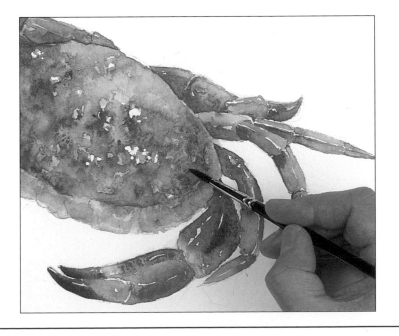

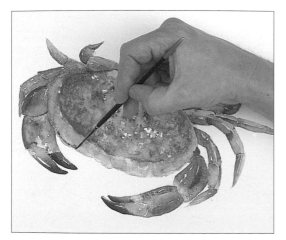

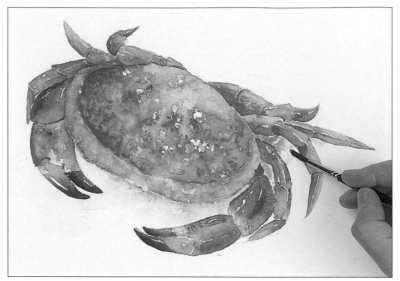

16 ▲ **Add more darks** With the No.2 brush go over some of the shadows on the claws and feelers with a mixture of burnt sienna and ultramarine to make them stand out. Then paint a thin, broken line along the lower edge of the crab to give it more definition. Leave to dry.

17 ▲ **Paint the background shadow** Finally, add shadow beneath the crab for a three-dimensional effect. With the No.6 brush, paint the shadow in raw sienna, overlaid with a pale mix of burnt sienna and ultramarine. Then rinse the brush and drip a little water on to the shadow area; the colour will dissolve into the water and dry with a soft edge.

THE FINISHED PICTURE

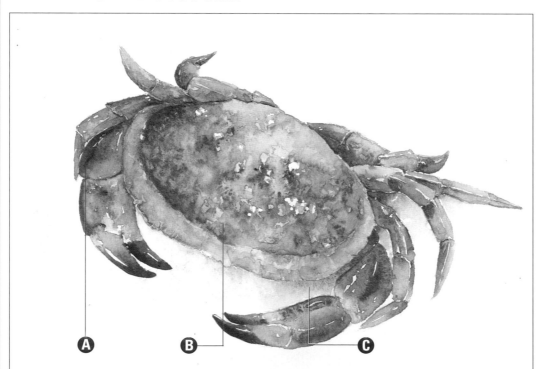

A Rounded forms
The rounded forms of the claws and feelers were suggested with overlaid washes, working from dark to light and leaving the brightest highlights unpainted.

B Mottled patterns
The blotched patterning on the crab's shell was captured perfectly by working wet-on-wet, blotting with kitchen paper and allowing the paint to flow and dry at different rates.

C Softly graded shadow
A touch of shadow helped to anchor the crab in space. The shadow is darkest directly beneath the crab, gradually fading out to nothing. This effect was achieved with a graduated wash.

Street sign in watercolour

Watercolour is the ideal medium to re-create the faded paint and softly merging rust stains on this old and weathered Parisian street sign.

Towns and cities derive much of their character from the details of their architecture. Doors, windows, balconies and decorative brick- and stonework can make lovely painting subjects in themselves, especially when they are old, faded and weathered. Even purely functional objects, such as pillar boxes and signposts, have potential due to their interesting shapes and patterns; moreover, they quite often have a characteristic design which identifies them as belonging to a certain country or era. Take the old metal street sign shown here: it is typical of the elegant Art Nouveau features that still grace many Parisian streets today.

Moving in close

It takes confidence to base an entire composition around one object placed centrally on the paper, but by cropping in close the artist can encourage the viewer to see that object with a fresh eye. It is easy, for example, to pass by a street sign like this one, but when we look at it up close we can appreciate the beauty of its design and the elegance of its lettering – and the fact that it is faded and streaked and rusting with age only adds to its appeal.

When painting architectural details in close-up, it is important to keep your brushwork and colour mixes lively and varied, otherwise there is a danger of your finished picture appearing static. Think about how your subject is lit, too; light coming from one side will create interesting shadows and emphasise form and texture, whereas front lighting tends to have a flattening effect.

▼ Although this is a realistic interpretation of the subject, the artist has not merely copied, but also interpreted it in a personal way, capturing its character through lively brushwork.

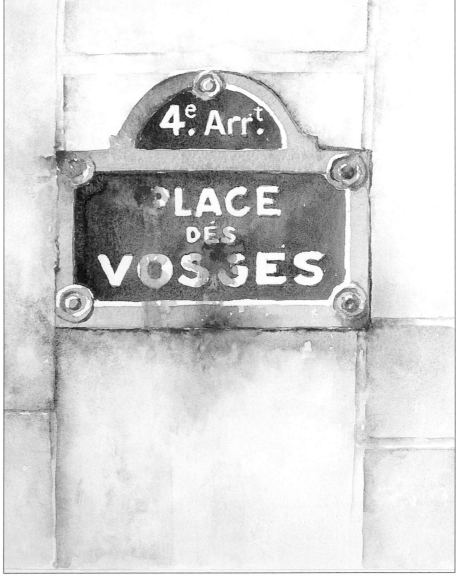

FIRST STROKES

1 ▼ **Draw the design** Make a careful outline drawing of the street sign and its lettering using a sharp pencil (propelling pencils are good since they give clean lines and don't need to be sharpened). Outline the two large rust patches on the main part of the sign and on the green border. Indicate the stone blocks on either side of the sign.

2 ▼ **Mask out the lettering** Use an old paint brush to fill in the lettering with masking fluid, but don't mask out the large rust marks outlined in step 1. Masking fluid tends to leave hard-edged shapes, which is fine for the lettering but not suitable for the ragged, soft-edged shapes of the rust patches. Also mask out the white edges and the highlights on the decorative roundels at the top and corners of the sign. Allow to dry thoroughly.

3 ▲ **Paint the green border** Mix a mid-toned green from olive green and a little Hooker's green and French ultramarine. Using a No.6 round brush, fill in the green border, again working around the outlines of the rust patches. Take care not to lean on any of the masked areas as you work, as the dried masking fluid is quite tacky and might lift off.

4 ▲ **Start to paint the rust patches** While the previous wash is still damp, but not too wet, change to a No.2 brush and paint the rust patches on the green border with burnt sienna. Apply just a tiny drop of colour and let it bleed into the green wash so that it dries with a soft, ragged edge.

5 ▼ Add some dark colour When the burnt sienna base wash has dried off a little, touch in a tiny bit of burnt umber on the outer edge of each rust patch, allowing it to bleed out into the burnt sienna wash.

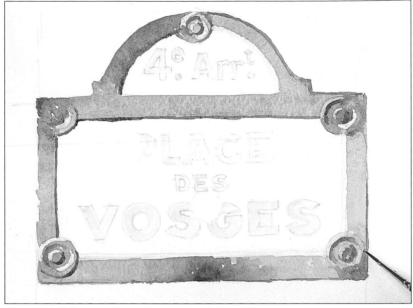

6 ▲ Paint the shadows and outlines Darken the green wash prepared in step 3 by adding a little more French ultramarine to it. Use the tip of the No.2 brush to paint the dark edges of the green border and the shadowed parts of the corner roundels. This helps to give the sign a more three-dimensional appearance. Leave to dry.

Express yourself
Crumbling stonework

By spraying watercolour paint on to watercolour paper using a plant mister spray, you can create a convincing stained wall surface. The artist gradually built up the rusty-looking effect shown below with layers of diluted raw sienna paint followed by layers of burnt sienna. Once these were dry, the drainpipe was painted with a brush; the textures, however, still show through.

7 ▲ Fill in the blue background Prepare a wash of French ultramarine slightly darkened with a drop of burnt umber. Fill in the blue background of the sign using a No.11 brush. To suggest the faded and distressed appearance of the old sign, vary the tone by adding more or less water, leaving some tiny slivers of white to suggest highlights. Gently blot with kitchen paper in places. You can wash over the masked-out lettering, but don't forget to leave gaps for the rust patches to go in later.

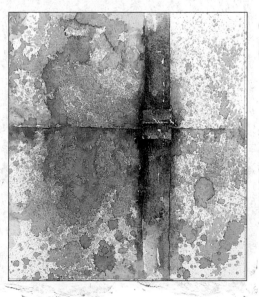

8 ▶ Paint the large rust patches Just before the blue wash dries, change to the No.6 brush to touch in the large rust patches with burnt sienna. Allow the colour to bleed slightly into the surrounding wash.

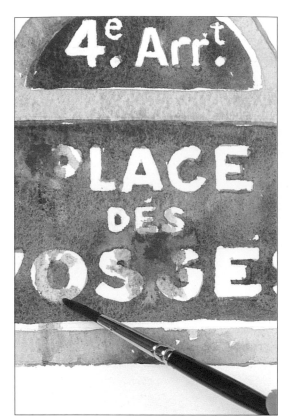

9 ▲ **Remove the masking fluid** Check that the previous washes are completely dry before removing the masking fluid from the lettering by rubbing with your finger. Now add more touches of burnt sienna to show where the rust has bled and run on to some of the white parts of the sign, in particular on the lettering.

TROUBLE SHOOTER

AVOID HARD OUTLINES

When you are painting buildings, beware of using hard outlines to define individual bricks and stones, as the result could look awkward and unnatural. Use a neutral tone – never black – to paint a very thin line along the shadow edge, then dampen your brush with water and run it along the line to soften and break it up.

DEVELOPING THE PICTURE

Now that you have completed the street sign itself, it is time to tackle the surrounding stone wall. Since the sign is the focal point of the picture, the wall should not be too strong in tone and detail, otherwise it will fight with the sign for attention. Begin by indicating the overall colour and tone of the wall, then add a suggestion of texture.

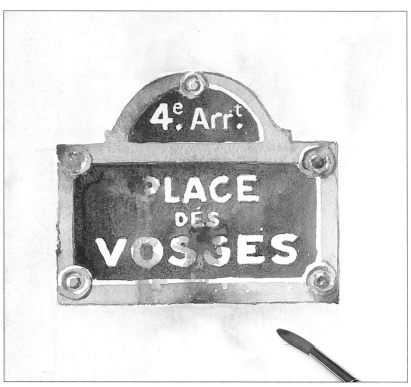

10 ▲ **Apply the underwash** Change to the No.11 brush and use it to wet the entire wall area with clean water. While this dries off a little, prepare a medium-strength wash of raw sienna. Apply this to the wall, using broad, loose strokes worked in a vertical direction. To suggest the streaked and weathered appearance of the stonework, vary the intensity of the wash by adding more pigment or water in some places and leaving other areas white.

11 ▲ **Suggest rust streaks** While the underwash is still wet, change to the No.6 brush and touch in a little burnt sienna on the wall, just beneath the main rust spots on the street sign. Encourage the colour to bleed into the underwash and run downwards to suggest streaks of rust on the wall.

12 ▼ **Start to paint the stone blocks** While the underwash is still damp, build up variations of tone and colour on the wall with random touches of raw sienna, burnt sienna, and a grey mixed from ultramarine and burnt umber. Start to paint the stone blocks to the right of the sign using raw sienna and the grey on your palette, again working wet on wet.

Master Strokes

Nick Harris (b.1948)
Blue Wall and Red Door

In this acrylic painting, the artist has made a feature of the dilapidated house wall. He has defined the cracked surface of the stucco so that it forms an intriguing pattern of hard-edged, irregular shapes – a complete contrast to the softly merging colours of the weathered wall and sign in our step-by-step. The brilliant colours and architectural lines make this a striking image.

Pink-red and green provide strong colour contrasts with the blue of the wall. The blocks of colour offset to the left are balanced by the window at top right.

Fascinated by the patterns that have been created in the cracked surface by age and weathering, the artist has made the wall the main point of interest in the painting.

13 ▲ **Continue adding tone and texture** Paint the stone blocks to the left of the sign using the same technique as before, leaving narrow strips of the pale underwash showing through for the gaps between the blocks. Suggest the weathered surface of the centre part of the wall by applying more wet-on-wet washes and streaks of colour and by blotting with crumpled kitchen paper. This gives a pleasing, granular texture to the paint.

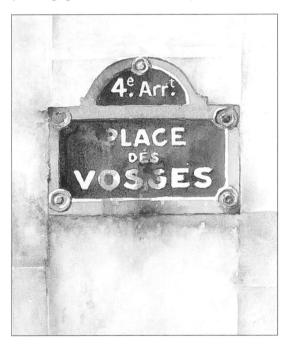

14 ▲ **Finish off the wall** Strengthen the tone of the stone blocks with small overlaid strokes of raw sienna and grey, leaving tiny chinks of the paler underwash showing through to suggest the crumbling surface. Finally, use the same mixture to define the two long horizontal stone blocks above the street sign.

A FEW STEPS FURTHER

At this stage, when the painting is nearly complete, leave it for a while and return to it later with a fresh eye. All it will probably need to finish it off are a few crisply defined touches to bring it into focus.

15 ◄ **Add definition to the street sign** Check that the painting is dry. Mix burnt umber and French ultramarine to make a near-black, and paint a thin, broken line along the right-hand and lower edges of the street sign using the No.2 brush. This gives the sign a little more definition and makes it stand out from the wall slightly.

THE FINISHED PICTURE

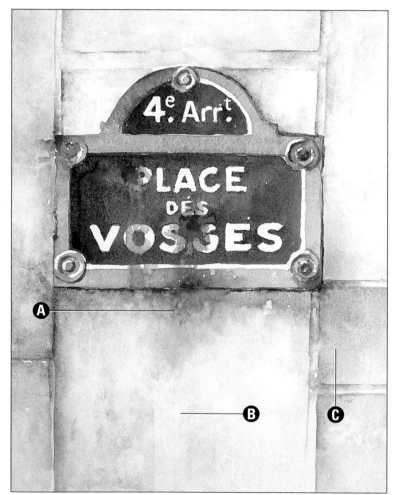

16 ▲ **Strengthen the stonework** Define the shapes of the individual stone blocks by outlining some of their edges, using a slightly stronger solution of the grey mixed earlier. Finally, strengthen the colour of the lower part of the wall with a loose wash of raw sienna.

A Aged effect
The aged quality of the wall and sign were achieved by blotting wet-on-wet washes with kitchen paper.

B Asymmetric design
The space below the street sign is much larger than the space above it. This creates a more interesting composition.

C Neutral background
The wall was painted in pale, neutral tones, with just enough suggestion of texture and form to place the street sign in context.

Introducing mixed media

Some of the most exciting and unexpected effects in painting can be created by combining media. Begin here by exploring watercolour paints and pencils.

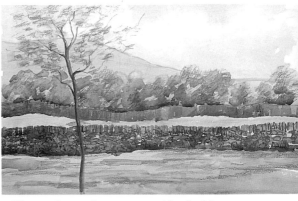

▲ **Watercolour paints were combined with soluble pencils and crayons to create the many textures in this rural landscape. Several different techniques were used; the distant trees, for example, were loosely worked in crayon and partly softened with water, and the foreground tree is a mixture of wash and lightly worked crayon.**

The most important (and most familiar) quality of watercolour paint is the clear, translucent colour it produces. Most early watercolour painters were unwilling to combine it with any other media, in case this quality should be lost, but many contemporary artists have experimented with watercolour and revealed its versatility. With watercolour pencils and crayons, used with paint from tubes, pans or concentrate, you can create an enormous variety of unique effects.

Wet and dry

Apply watercolour paints in thin layers or washes, so that they dry without affecting the texture of the paper (making the fibres fluff up, for example). When the colour is dry, you will be able to work on the painted surface with many other materials, including crayons and drawing pencils.

By using water-soluble pencils and crayons (instead of the more usual non-soluble ones), you have yet another

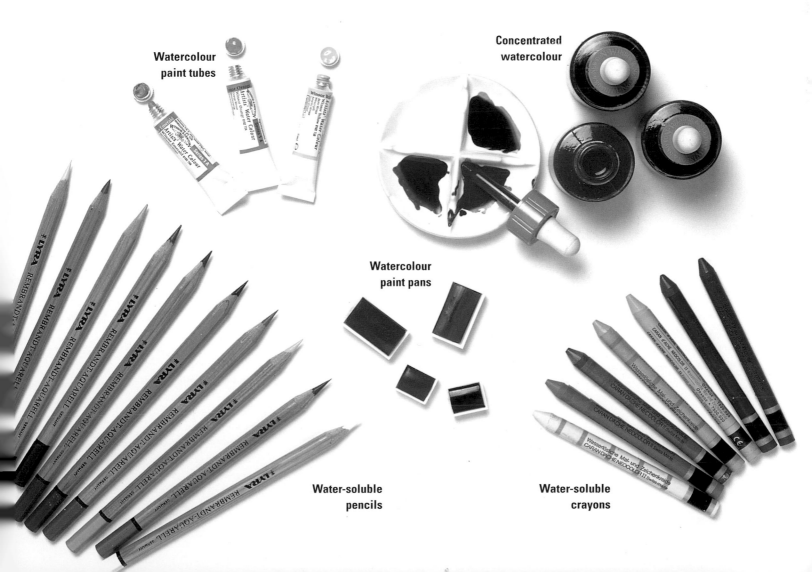

Watercolour paint tubes

Concentrated watercolour

Watercolour paint pans

Water-soluble pencils

Water-soluble crayons

Combining colour and water

◄ **Blending with water** Make rough pencil marks in two colours, then wash them with water, causing them to run together and form a third colour.

► **Drawing on damp paint** Draw water-soluble pencil on to a wash of damp watercolour paint to produce fine, slightly softened lines.

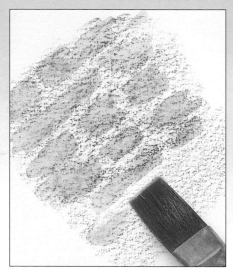

▲ **Crayon washing** Wash graded crayon marks with water, creating an effect similar to a graded watercolour wash.

▲ **Washed patches** Dissolve roughly worked pencil marks with water to form contrasting textured patches.

▲ **Self-colour washing** Overpaint a rough crayon pattern with a similar colour, creating a pattern of softly blended shapes.

advantage: when you have finished the picture – or any one area of the picture – you can then use water or watercolour paint to dissolve and blend the soluble lines into the painted colour.

Lines and washes

A combination of watercolour paint and water-soluble drawing materials allows you to include fine lines, rugged texture, flat wash and blended colour all in the same painting. Try using water-soluble pencils or crayons to draw directly into areas of wet paint. The resulting lines will be blurred and soft, merging gently into the background colour.

In the landscape painting illustrated on page 143, much of the drawing was done in this way, by drawing directly on to wet watercolour washes. Further blending and softening was achieved later using clean water and a soft brush.

When dampened, water-soluble pencils and crayons are brighter and bolder than non-soluble products. Many artists appreciate and exploit this quality. It does mean that the results from soluble drawing materials can be more unpredictable than those you expect from the non-soluble varieties, but this is part of the excitement of experimenting. Also, if the strokes are very heavy, no amount of water will be able to dissolve the lines completely, so the marks will show through the wet colour.

Experiment and discover

Always choose a sturdy, good-quality watercolour paper for mixed media work. The support should be heavy enough to withstand wet watercolour washes without buckling. It should also be tough enough to allow the pencil colours to be blended with a brush – on coarse, poor quality papers, the fibres may be raised by the water.

Mixed media work allows you great scope to experiment and create exciting and unusual effects. As you try out different materials – either singly or in combination – you will become more familiar with their special qualities and the way they behave when combined with other materials.

The water-based materials illustrated here are just the beginning. As you gain more experience, you will be able to add other materials and techniques to your repertoire; always bear in mind that individual taste and originality are all-important when using mixed media.

► **Here, water-soluble crayon was applied to wet colour, forming broad, soft lines which run into the painted background.**

Snow scene in watercolour

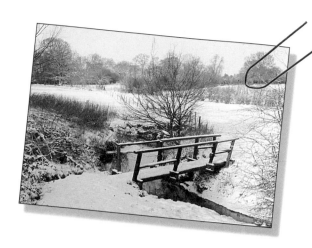

Use a range of watercolour techniques to paint this tranquil landscape under a blanket of snow.

Snow transforms the landscape, softening edges and imposing a tonal harmony. In bright sunshine, its reflective quality gives the landscape a dazzling brilliance, with trees and other features standing out in contrast to the prevailing whiteness.

When painting a snow scene in watercolour, you need to work logically from light to dark, conserving the white of the paper for the snow and applying washes carefully to the surrounding areas. Use masking fluid for details such as the snow on the bridge.

Warm and cool colour contrasts are very evident in snowy landscapes. Shadows are a characteristic blue-lilac colour and were often depicted in winter scenes by Impressionist painters, who understood how they complemented the yellowish orange of the winter sunlight. In this project, the warm browns and oranges of the trees contrast with the stark white snow and the cool, blue shadows, emphasising the chilly conditions.

▼ **Dark, crisp foreground details contrast with softly blended, washed colours in this peaceful winter scene.**

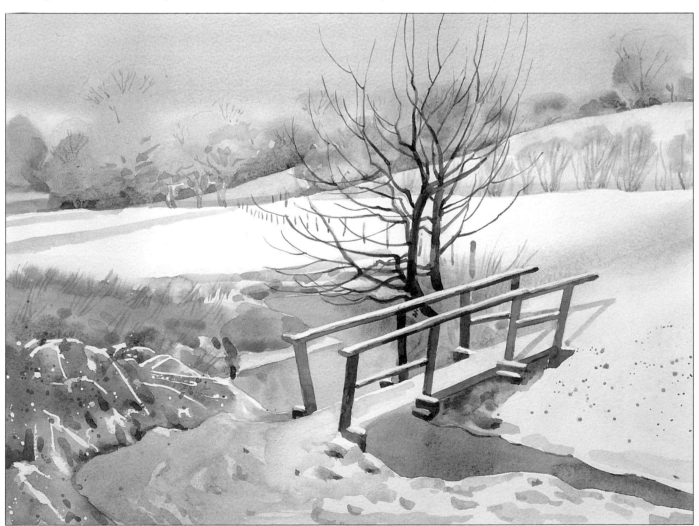

YOU WILL NEED

Stretched sheet of 300gsm (140lb) Not watercolour paper

Masking tape

2B pencil

Brushes: Nos.10, 7 and 4 rounds

Watercolour palette

Masking fluid

Old brush

9 watercolours: Yellow ochre; Winsor blue; Burnt umber; Ultramarine; Cadmium orange; Cadmium red; Raw umber; Raw sienna; Sepia

FIRST STROKES

1 ▶ Draw the landscape To create a white border for the finished picture, stick strips of masking tape around the edge of the stretched paper. Using a 2B pencil, make a drawing of the landscape, leaving the snowy areas white. Work lightly in the background and use crisp, emphatic lines for the bridge and tree in the foreground.

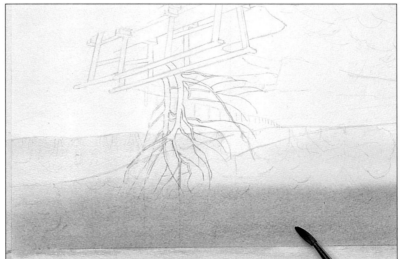

2 ◀ Lay a graduated wash Turn the picture upside down and prop it at a shallow angle (see Expert Advice, page 12). Wet the sky area with a No.10 brush dipped in water. Lay in the area just above the horizon with a yellow ochre wash. Then lay a band of Winsor blue wash under the yellow ochre. The washes will blend to create a soft edge.

▲ Winsor blue, a cool blue, is ideal for painting a chilly, wintry sky. It was allowed to bleed into yellow ochre towards the horizon to create a delicate neutral undertone for the trees.

3 ▲ Indicate the distant trees While the sky is still wet, lay in the shapes of the distant trees, using mixes of burnt umber and ultramarine for the darker trees, and cadmium orange and cadmium red for the orange ones. The paint will bleed, creating soft edges. Leave to dry.

4 ▲ Add darker woodland Use darker versions of the same mixes to paint another layer of trees. Mix Winsor blue with burnt umber or cadmium orange for the darkest areas, working wet on wet. While the area is still wet, apply touches of Winsor blue mixed with ultramarine along the edge of the woodland. Leave to dry.

5 ▲ Spatter on masking fluid Before applying masking fluid to the vegetation on the left, protect the adjacent areas with sheets of paper. Dip an old brush in the masking fluid, then tap it with your finger to deposit droplets and streaks over the area. Leave to dry.

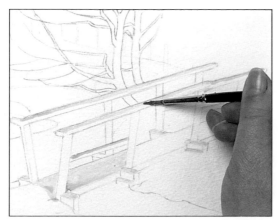

6 ▲ Mask the bridge Paint masking fluid over the walkway of the bridge and the tops of the plinths, then lay a band of masking fluid along each rail. Let the mask dry thoroughly.

DEVELOPING THE PICTURE

With the sky and background established and the snowy details in the foreground masked, you can get on with applying the washes and fine details that will pull the picture together. Because the white of the paper is a positive element rather than simply blank paper, the picture is actually further advanced than would be the case with any other subject.

7 ▶ Lay shadows on the snow Wet the paper where you are going to work. Using a No.7 brush, lay a very dilute wash of cadmium orange over the sunlit snow on the right. While the paper is still wet, lay a dilute wash of ultramarine over the areas of cast shadow. The edges of the orange and blue washes will bleed. Leave to dry naturally.

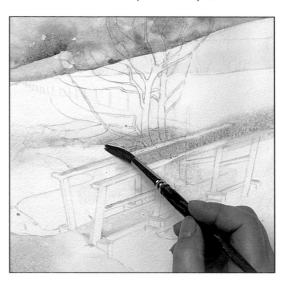

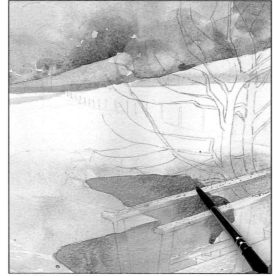

8 ◀ Paint the stream Mix a wash of Winsor blue for the stream and apply it using the No.7 brush. While the blue is still wet, introduce a touch of burnt umber for the reflections of the vegetation beside the stream. Add a touch of cadmium orange here and there.

EXPERT ADVICE
Painting winter trees

In order to paint trees, particularly leafless ones in a winter scene, consider their structure and growth pattern carefully. Use the flat of the brush for the main branches and the tip of the brush for the smaller ones. When you paint towards the end of a branch, the line will naturally become thinner as you complete the stroke, creating a realistic effect.

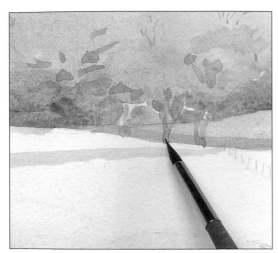

9 ▲ **Add details to the distant trees** Using a No.4 brush with raw umber and a touch of Winsor blue, apply light, delicate brush strokes to suggest the trunks and main branches of the distant trees. Use the very tip of the brush to paint in the smaller branches.

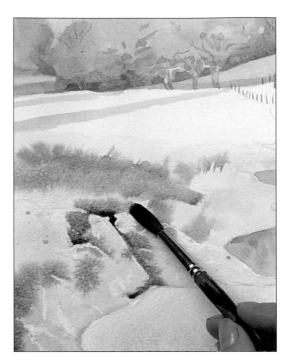

10 ◄ **Add foreground detail** Paint the fence and the hedge on the right with a mix of burnt umber and cadmium orange. Wet the paper on the left, then, with a No.10 brush, use the same wash to paint the vegetation, creating spiky stalks with the brush tip. Add Winsor blue and ultramarine, then dab touches of the raw sienna here and there. Leave to dry.

Master Strokes

Claude Monet (1840-1926)
The Magpie

Monet painted this atmospheric snow scene around 1870, when he had already become interested in working in the Impressionistic style for which he is renowned. The effects of light and shade are one of the main features of the painting.

The white of the snow is broken up by flecks of yellow, suggesting the reflections of winter sunlight glinting from the surface of the snow. The shadows are a pale grey-blue – a cool colour complementing the warmer tones of the bright snow.

The dark shape of the magpie, which stands out distinctively against the snowy landscape, forms the focal point of the painting.

Dabs of yellow and blue with a few touches of pink enliven the surface of the snow in the foreground.

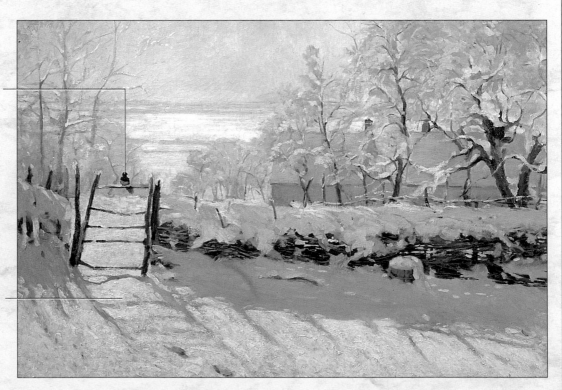

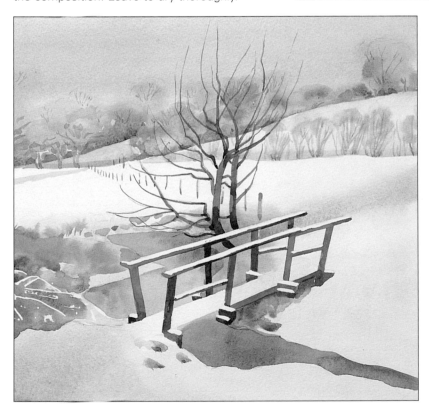

A FEW STEPS FURTHER

The painting is now well established. By contrasting the warm sunlight with the cool shadows on the snow, the artist has captured the sparkling light and chill of the scene. Add more texture in the foreground if you wish.

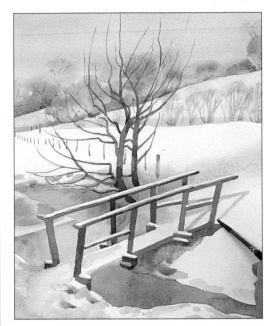

13◀ Add shadows Use the No.4 brush and an ultramarine wash to paint the shadows in the trampled snow in the foreground. With the same wash, paint the crisp shadows cast by the rails of the bridge.

11 ▲ Paint the bridge Change back to the No.4 brush and paint the bridge with sepia. This man-made structure is an important focus in the picture, as its geometric shape contrasts with the soft forms elsewhere in the composition. Leave to dry thoroughly.

12▲ Paint the trees Remove the masking fluid from the bridge and the vegetation on the left by gently rubbing the surface with your fingertips. Then use sepia and the No.4 brush to paint the trees by the bridge. Make them dark and well defined to contrast with the distant trees and create a sense of recession from foreground to background.

Express yourself
Introduce a figure

The watercolour snowscape in the step-by-step has a sense of tranquillity and solitude. By introducing a figure, the artist has created an entirely different mood. The man trudging through the snow suggests a narrative – we wonder where he is going and why. The tree on the left has changed the dynamic of the composition, providing both a counterpoint for the single human figure and another route to lead the eye into the picture.

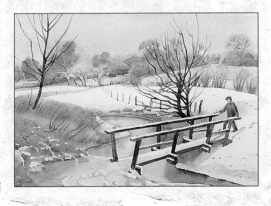

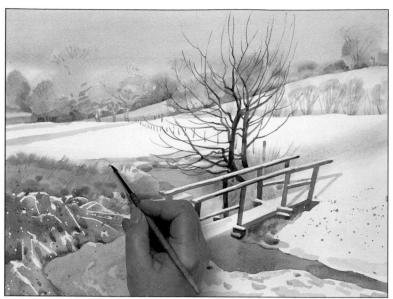

14 ▲ **Add spattered textures** Protect adjacent areas by covering them with sheets of paper. Dip the No.4 brush in the ultramarine wash and spatter colour on the snow by tapping the brush briskly with your forefinger. Load the brush with raw sienna and repeat the process.

15 ▲ **Paint the dry grass** Mix a raw umber wash and, using the tip of the No.4 brush and a firm yet gentle flicking gesture, paint in some tufts of dry grass in the left-hand foreground area.

THE FINISHED PICTURE

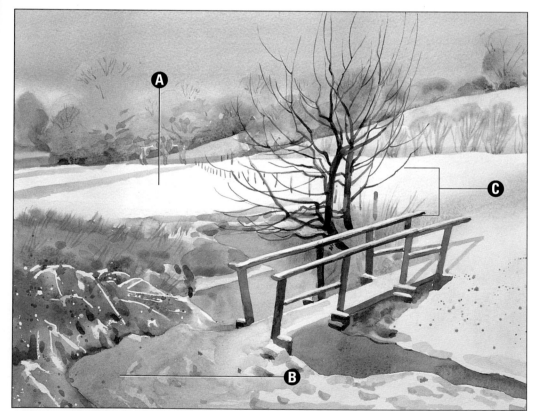

A Snow white paper
The snow is represented by the white of the paper itself, washed in places with yellow ochre and in others with ultramarine.

B Cool shadows
Cool, violet-blue shadows provide a complementary contrast to the orange sunlight of winter.

C Crisp contrast
The dark, crisply painted bridge and trees create a focal point which draws the eye into the painting.

Introducing gouache

An exciting, versatile form of watercolour, gouache can be used to create both delicate, translucent washes and bold, opaque areas of colour.

Gouache is simply an opaque form of watercolour. It is made in exactly the same way as traditional watercolour paint, except that white chalk is added to make it opaque.

Though it has never attained the popularity of watercolours or oils, gouache nevertheless has a long history. Reputedly, it was discovered in the eleventh century by an Italian monk, who added zinc white to his watercolours for illustrating manuscripts. It was also used to paint miniatures from the sixteenth to eighteenth centuries. Some of the best-known artists to have used gouache include Joseph Turner (1775-1851), Edgar Degas (1834-1917), Pablo Picasso (1881-1973) and Henri Matisse (1869-1954).

Sometimes referred to as body colour,

gouache has many of the qualities of pure watercolour, but being opaque it has a character of its own. Like watercolour, gouache flows easily, dries quickly and becomes lighter in colour as it dries. When dry, however, it has a matt, slightly chalky finish quite different from that of translucent watercolour.

Brightness of gouache

Whereas watercolour paint gains its brightness from light reflecting off the white paper beneath it, the brightness of gouache comes mainly from the reflecting power of the pigments in the paint surface itself.

As with traditional watercolours, some colours are permanent, but a few are liable to fade – so avoid using these if you intend to paint for posterity. The degree of permanence is indicated on the label. Also, try to avoid mixing too much white

with a colour, as it can cause fading.

All the papers and boards recommended for pure watercolour are also suitable for gouache. Moreover, with gouache, coloured papers can be used to great effect. If the paint is applied thickly, for example, the colour of the paper is obliterated, but when it is washed on thinly, the paper colour shows through and modifies the colour applied on top. Furthermore, areas of coloured paper can be left unpainted so that the colour becomes part of the painting.

Choosing a coloured paper

If you want to work with coloured paper, always choose good-quality pastel paper or mounting board, which will not fade when exposed to light. Lightweight papers should be stretched, as it is for watercolour painting (see

▼ **If you already work in watercolours, you have all the equipment needed for gouache, except the paints themselves. Instead of white paper, you can try a coloured support.**

Stretching paper, page 52-3).

Watercolour brushes are normally used for gouache, but because the paint has more body than watercolour, you can also use bristle brushes to make textural marks and strokes.

As gouache is an opaque paint, it is a more forgiving medium than watercolour. One layer of colour will conceal another, and light colours can be applied over dark. This makes it ideal for beginners, as mistakes can be corrected and tones modified with ease.

Bold, lively marks

Gouache might not have quite the radiant transparency of pure watercolour, but you can still get subtle washes of paint by diluting it with water. Alternatively, you can use it thick and undiluted to produce an effect similar to oils and acrylics, using bristle brushes to make bold, lively marks and even building up a slight impasto. Thick, near-dry paint can be scuffed and dragged across the paper to create attractive, broken-colour effects with a matt, pastel-like quality.

Flat, saturated colour

Mixed with a little water, gouache has a soft, creamy consistency. It flows smoothly and dries evenly – ideal when you want to emphasise pattern with bright areas of flat, saturated colour. It is equally good for creating fine lines and details. Illustrators are particularly fond of the medium because its bold hues, matt finish and dense covering power make it ideal for reproduction in books and magazines. When it is thinned with more water, gouache takes on a delicate, semi-transparent, milky quality, which is perfect for capturing the effects of clouds, mist and haze in landscapes.

All of these different techniques can be incorporated within a single painting. Areas of wet-in-wet dilute colour can be overlaid with areas of thick, opaque paint, and these variations help to create a lively picture surface.

Mixed media

You can obtain an even wider range of interesting textures and visual effects by mixing gouache with other media. Watercolour and gouache are often used together, the opaque colour being used to add highlights or to scumble clouds over a sky wash, for example. Gouache also combines well with acrylics, egg tempera, pastel and pen-and-ink.

THE EXPRESSIVE, VERSATILE MEDIUM

Like watercolour, gouache can be used thinned with water to attain transparent washes of paint (see the flowers, left). But it also presents you with many other options. For instance, you can also add white to your gouache paints to create opaque colour (see below). This allows you to apply light colours over dark.

The sky sketches (right) show the possibilities of this technique. In the top picture, white is used quite thickly in parts so that the blue and grey underwash is hidden and a 'silver lining' effect is achieved. In the bottom picture, near-dry paint has been 'scuffed' across the underwash to mimic wispy clouds. You can see here how gouache – like acrylics and oils – allows you to create distinct brush strokes.

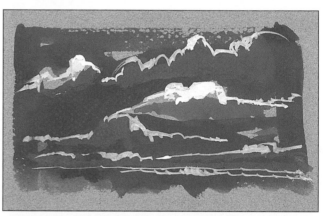

▲ After the sky and grey clouds were loosely washed in, opaque white gouache was added to create silver linings.

▲ **Varying degrees of transparency, from the most transparent (top) to the least (bottom), can be attained by diluting gouache with water.**

▲ Adding white to a gouache colour not only lightens it but makes it more opaque. Here the colour on the left is created by using viridian lake neat; the other two have different amounts of white added.

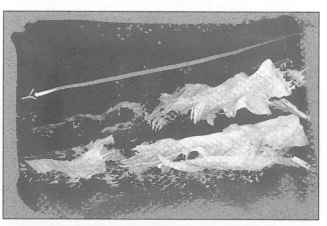

▲ Scrubbing dryish white paint over a blue wash with the side of the brush creates wispy clouds and vapour trails.

House plants in watercolour

This striking, close-up composition of three different conservatory plants shows that you do not need a grand subject or broad view to capture the beauty of nature.

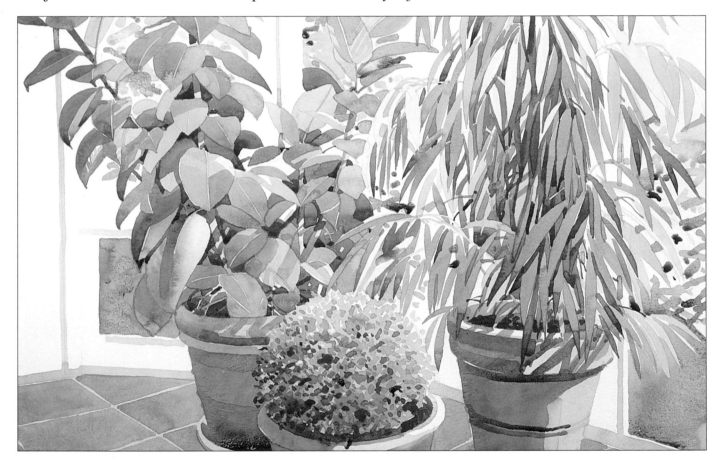

Plants offer a particular challenge to the artist. The variety of forms, colours and textures require close observation and a careful choice of colours.

A painting like this inevitably includes a lot of greens. Although green might appear to be quite a cool, fresh colour, the painting nevertheless manages to evoke the sun-drenched, humid atmosphere of the conservatory.

A range of greens
The trick is to observe the colours to be found in the light and shadowed areas. The artist has captured a wide range of greens, both warm and

cool. Occasionally, he used a wet-on-wet style to let the colours run together and gain smoothly blended tones.

Visual editing
When re-creating a scene such as this, you continually need to edit the still life, simplifying the information from the original into something that can be reproduced. You are not trying to make a botanical rendering. What is important is that your painting looks believable, with an accurate representation of the shapes and light. If the composition needs a bit of help, feel free to rearrange the plants or leaves.

▲ The reds and greens that predominate in this carefully observed study of plants provide an exciting complementary colour contrast.

Piece of 300gsm (140lb) Not watercolour paper 60 x 40cm (24 x 16in)

2B pencil

Brushes: Nos.10, 9, 7, 3, 5, 6 rounds; No.3 flat

Mixing palette or dish

Jar of water

9 watercolours:
Yellow ochre;
Payne's grey;
Cerulean blue;
Lemon yellow;
Indian red;
Burnt umber;
Sap green; Brown madder alizarin;
Ultramarine

Gum arabic

FIRST STROKES

1 ▼ Draw in the pencil outline Use a 2B pencil to sketch the basic picture on to the paper. Pay special attention to the shapes of the leaves and the overall forms of the plants, as they are the main focus of the composition. Close observation at this stage will pay dividends as the painting progresses.

2 ▲ Lay a thin background wash Leaving the highlights and the brighter parts of the composition blank, apply a very thin wash of yellow ochre and Payne's grey over the entire picture using a No.10 round brush. Leave the wash to dry.

3 ▼ Begin adding colour to the leaves Look for the bluish reflections on the leaves and, using a No.9 round brush, apply a very thin mix of cerulean blue to these areas. Use the same colour to block in the rounded plant at the front of the picture, as well as the view through the leaves and out of the window. Leave to dry.

4 ▲ Paint the light areas Add a little lemon yellow to your blue mix to make light green. Apply the paint from top to bottom of each leaf on the large plants. The paint will be most concentrated at the bottom of the leaves, giving the impression of light shining through the paler parts. Develop the rounded plant. The cerulean blue applied in step 3 will show through the green in places, creating a denser colour that contrasts with the translucent blue-lemon mix.

5 ▲ **Block in the floor and pots** Mix a light terracotta colour, adding a lot of Indian red and a little more yellow ochre to the original ochre mix used in step 2. Changing to a No.7 round brush, block in the floor and pots. You will need to use this smaller brush in order to cut in around other areas of colour, as it is important that the terracotta shade does not 'bleed'. Darken the terracotta mix with a little more Indian red and some burnt umber. Apply to the lighter areas of the stems, using a No.3 round brush.

Master Strokes

Mark Gertler (1891-1939)
Agapanthus

This still life of a pot plant in bloom is painted in oils rather than watercolours, giving denser, less translucent colouring than in our watercolour step-by-step project. However, Mark Gertler – a British-Jewish painter, who was influenced by eastern European folk art – has captured the same interplay of light and shade on his subject. The almost black shadow areas at the heart of the plant act as a foil to the light and mid tones, where the foliage catches the light.

The background is plain and unfocused. The band of black at the top enables the beautiful blue of the flowers to sing out.

Both cool blue-greens and warm yellow-greens are apparent on the long, strap-like leaves. The paint is carefully blended wherever the two colours meet along the length of a leaf.

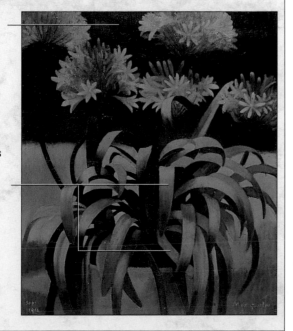

DEVELOPING THE PICTURE

Now that you have put in the palest tones of the leaves, pots and floor tiles, you can begin to build up the medium and dark tones on top. Work wet-in-wet so that the colours run into one another for a natural effect.

6 ▲ **Apply the main leaf colour** Mix sap green and lemon yellow to make a more intense lime green. Using a No.5 round brush, start to develop the detail of the lighter parts of the leaves where the sun catches them. Be very careful to render the shapes accurately.

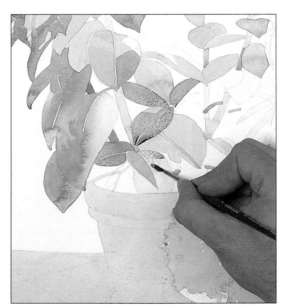

7 ▲ **Introduce the darker areas** Mix lots of sap green with burnt umber and a little Payne's grey for a rich leaf colour. Add some gum arabic to intensify the colour and enable you to re-wet it once dry. Next, mix a dark stem colour with a little brown madder alizarin and lots of burnt umber. Work across the picture, painting the green mix wet-on-wet over the lime green to create the dark leaf areas. Drop brown colour on to the stems as you work across the painting.

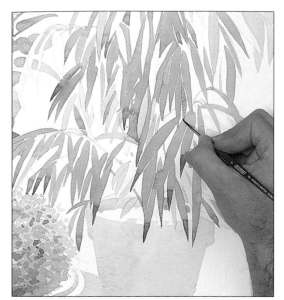

8 ▲ Continue adding definition to the leaves Carry on adding the darker colours to all the plants. On the rounded plant, dab on the colour to show the smaller leaves. This adds density to the plants – until now, the painting has been very light and fresh. This stage takes a long time, but do not rush it, as the effect of the wet-on-wet technique is central to the whole painting. Work methodically across the picture, as you did before.

9 ▲ Add colour to the pots Mix burnt umber, a little yellow ochre and a little Payne's grey to make a medium brown for the soil and the insides of the pots. Apply with a No.6 round brush. Add some Indian red to the mix to warm up the shady side of the pots, paying close attention to where the areas of light fall. The warm colours of the pots contribute to the bright, sunny atmosphere of the painting.

Express yourself
Pattern of leaves

Leaf shapes and the patterns they create are endlessly fascinating. In this pencil drawing, the artist has focused closely on the foliage of a rubber plant so that the leaves fill the paper. The pattern of leaves is more important here than the structure of the plant itself. A hint of tone and texture is achieved by the lines drawn on the foreground leaves.

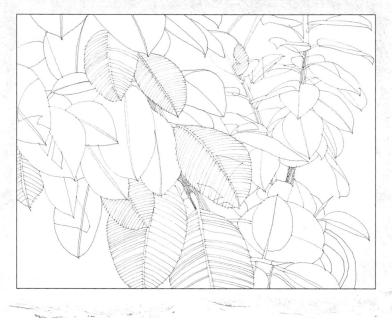

10 ▲ Define the areas of shadow Mix sap green, Payne's grey and just a little burnt umber. Use this for the very dark green leaves and stems. As before, work methodically across the paper, introducing the dark brown colour from step 7 occasionally to add variety – use the colours together wet-on-wet.

11 ▲ **Complete the areas of shadow** Continuing with the dark brown and green mixes, work into all the shadow areas. Stand back and look at your painting. Remember that you are trying to create a believable, evocative picture, not a slavish re-creation of the original, so you can use a bit of artistic licence if necessary. If you feel the painting needs some more areas of shadow, add them, but keep it looking natural.

12 ▲ **Embellish the background** Mix Indian red with a little brown madder alizarin. Block in the floor tiles, using the No.9 round brush – these will make sense of the composition spatially. Add a little ultramarine, and use this mix to add detail to the pots. Make a thin mix of yellow ochre, Payne's grey and brown madder alizarin for the window frames. Paint these in as simple straight lines.

▼ **Adding Payne's grey to the sap green creates a dark green for the shadow areas on the foliage.**

13 ▲ **Finish off the background** Complete the lines that form the window frames – these provide a suggestion of the setting, but do not detract from the main focus of the composition. The painting is now a very believable rendering of plants in a conservatory.

All the main areas of light and shadow are now included, but you can improve the picture further by adding more colours to the shadows and intensifying the background.

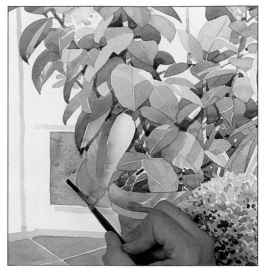

14 ◄ **Sharpen the picture**
Make a more intense mix of the dark green used on the leaves in step 10. This mix should be almost black. Using the No.3 brush, cut in around the leaf shapes, adding more definition and sharpening up the picture. Add further accents to the pots to emphasise the light and dark areas and to strengthen the effect of bright sunlight. Make sure that you have represented all the areas of intense shadow, even the very fine ones. For close work, change to a No.3 flat brush.

15 ▲ **Suggest the background** Mix sap green and cerulean blue. Apply using the No.6 round brush to give a suggestion of foliage outside the conservatory. This increases the sense of depth in the picture and helps the painting to look more complete.

THE FINISHED PICTURE

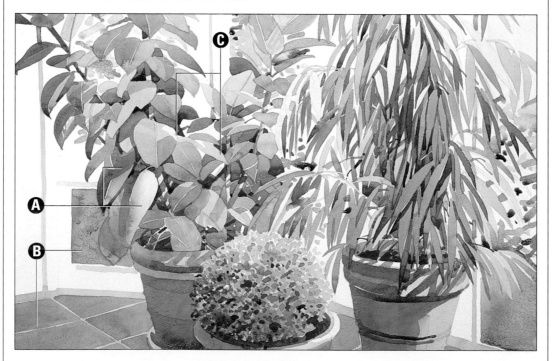

A Wide tonal range
To convey the impression of strong sunlight filtering through the window and plants, a wide range of tones was used, both on the leaves and the pots.

B Simple background
In contrast to the busy subject matter in the foreground of the picture, the background was kept uncluttered – the windows and floor tiles are suggested very simply.

C Dark shadows
The areas of deepest shadow on the plants were painted during the final stages of the picture. The dark colour crisply defines the lighter shapes of the leaves.

Sunny waterside scene

Bring a hot, sunny holiday afternoon alive by boldly applying vivid washes of watercolour.

The clean, bright hues that can be created with watercolour really evoke a sun-soaked, holiday mood in this picture. Large expanses of colour, such as the yellow wall, the blue water and the figures' tanned skin, all help convey the atmosphere of a hot, relaxing afternoon.

Breaking a few rules

When composing a picture, you don't have to feel tied down by conventional rules. Here, the woman basking in the sunshine is looking out of the picture, pulling our eye with it. However, together with the litter-bins on the right, she also guides the eye back into the heart of the picture. We are asked to linger on the man on the path and then move on to the house across the water. In effect, the composition moves our eye in different directions, helping create a lively, engaging picture.

Vary your technique as much as you like to add interest and texture to this casual scene. Work wet-on-wet and with overlaid washes to produce rich colour mixes, such as those on the

central figure, the litter-bins on the right, and the woman's bronzed skin and vest-top.

You could also experiment with a little paint on a very dry brush. This technique is ideal for giving a stippled texture to the trees that form an attractive backdrop to the scene. For fine details, such as the ripples on the water and the slender tree branches, use well-sharpened coloured pencils.

As a reference, the artist used a sketch he made on site (above). Working in his studio on the finished picture gave him more time to think about the composition and colours. He decided to add the man in the centre of the picture as a focal point. He also painted the path and wall in the foreground in yellows and oranges. This helps give an illusion of depth – the warm colours in the foreground leap forward while the blues and greens in the background recede.

▼ **Versatility is the key to creating a picture like this. The vivid hues are rendered with intense washes of watercolour, interesting textures put in with dry brushwork and detail added with coloured pencils.**

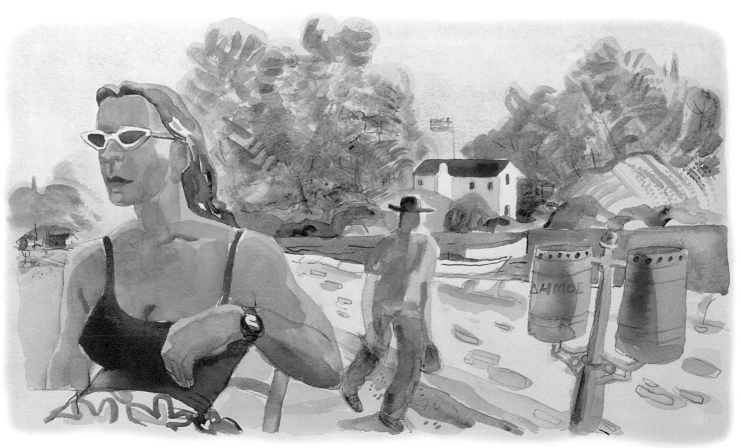

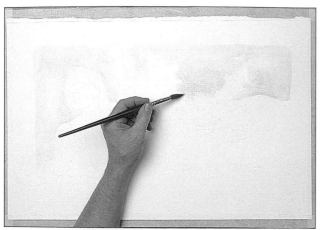

FIRST STROKES

1 ▲ Paint the sky Sketch the scene with a 4B pencil. Wet the sky with a No.12 flat brush and clean water. Drop in cerulean blue watercolour across the wet area and lay a thin wash, using a No.12 round brush.

2 ▶ Add the trees Make a watery mix of olive green, cerulean blue and cadmium yellow. Continuing with the No.12 round brush, lay this in broad areas to represent the line of trees across the back of the scene. Notice how colour variations are created where the green wash overlaps the previous blue wash. Dab off any excess or running wash with kitchen paper.

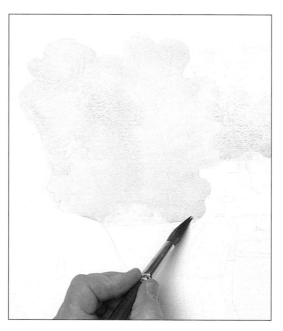

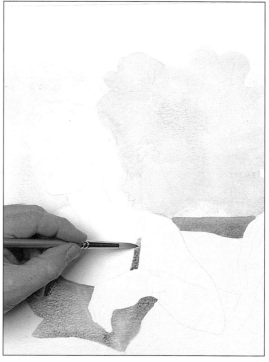

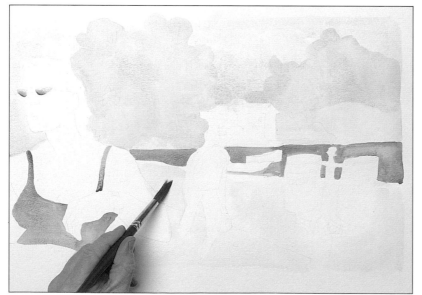

3 ▲ Lay in some strong blues Mix up a fairly bright blue with cerulean blue and cobalt blue. Use a No.4 round brush to paint in the areas of water and also the vest-top of the woman on the left of the picture. Paint wet-on-wet, adding more blue here and there to give the washes some depth and texture.

4 ◀ Wash in the wall Continuing with the blue mix, add the sunglass lenses of the woman. Put in an initial wash for the wall and path behind the woman with the No.12 round brush and a thin wash of cadmium yellow. This instantly warms up the image and helps project the woman forward.

DEVELOPING THE PICTURE

Now that the larger areas of colour are blocked in, the main shapes, such as the figures, the distant house and the litter-bins, have emerged in outline, ready to be filled in.

5 ▼ Block in the main figure Using the No.4 round, block in the woman's skin with a fairly opaque mix of Indian red, titanium white and yellow ochre. Add more Indian red to the mix to paint dark shadows on the woman's right side and under her left arm.

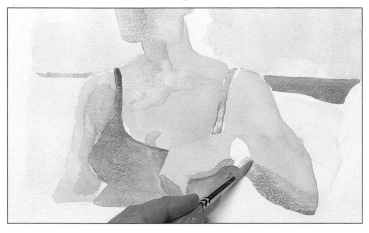

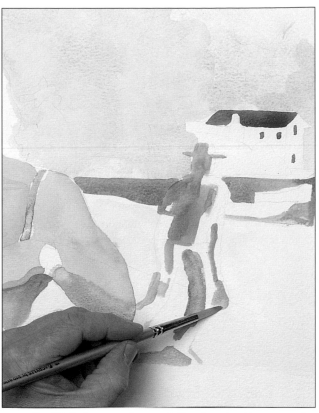

6 ▲ Establish the central area Still using the No.4 round brush, work on the central portion of the picture. Paint dense Indian red on the roof and windows of the building to bring the distance into focus – this will be the darkest colour in the painting and will help you to judge the depth of the tone across the rest of the picture. With the same brush and watery Indian red, sketch in the man in the centre, including his bag. Pick up a little yellow ochre on your brush to lift the colour on his legs.

Express yourself
A line and wash portrait

Here, the image of the woman was sketched boldly with a soft black pencil. Simple washes of black ink were then brushed on, overlapping the pencil lines in some places. Further pencil work was added on top of the thinner ink washes once they had dried.

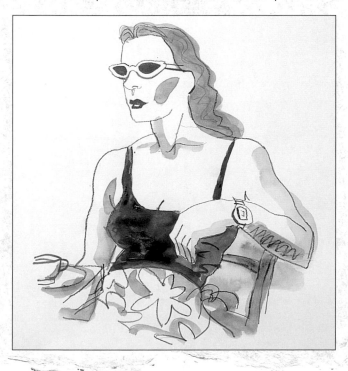

EXPERT ADVICE
Creating light and shade

In an intensely sunny scene like this, it is important to convey a sense of light and shade throughout the picture. To create strong tonal contrast in the backdrop of trees, lay thicker paint over the top of thin colour washes with a dry, flat brush. This also builds up a sense of depth.

7 ▶ Define the foliage
Using a fairly dry No.4 flat brush, paint olive green swirls and dashes across the trees to suggest leaves and branches. Now load a very dry No.4 fan brush with the olive green paint. Dab on curved lines, creating a stippled effect by picking up tiny amounts of dense Indian red from the palette. Change the direction of the brush to vary the curves.

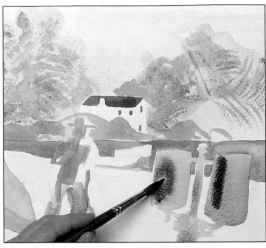

8 ▲ Paint in the litter-bins Mix Winsor blue with a little Indian red to render the rocks behind the man with the No.12 round brush. Paint the litter-bins in permanent rose – first with a light wash, then build up the shadowed sides with a stronger mix. Add touches of the same colour to the man.

9 ▲ Add shadows With the No.4 round brush, and a mix of cerulean blue, ivory black and burnt umber, wash thin shadows on to the building and thicker ones on the rocks. Paint the flag in cerulean blue. Use black with a touch of blue to paint the woman's hair, then wash cadmium yellow over the man and the bins. With watery Indian red and a cerulean blue-black, add shadows on the path. Wash burnt umber shadows on the wall.

10 ▲ Bring up some details With a No.6 round brush, add cerulean blue and black shadowing on the man's bag and left foot, and burnt umber lettering and details on the bins.

TROUBLE SHOOTER

ANCHOR THE ROCKS

If you feel that the middle distance of your picture looks too flat and fades into the far distance, increase the tonal contrast here to build up form. In this painting, the dark bluish-black shadows painted on the rocks anchor this part of the picture within the whole scene.

11 ▲ Develop the figures Use the Nos.1 and 6 rounds for the details. Define the woman's chair with Winsor blue. Use black for her watch-strap and hair, permanent rose for her top and a mix of permanent rose, cerulean blue and black for her sarong. Add Winsor red lips and burnt umber facial features, then put cadmium yellow on her glasses and skirt. Define the man's hat and the boats with black and burnt umber.

12 ▲ **Outline with pencils** Using a No.12 round brush, paint in some stonework on the wall with Naples yellow gouache, outlining it with a purple coloured pencil. Add linear detail across the whole picture with purple and ultramarine coloured pencils.

13 ▲ **Intensify the darks** Mix burnt umber and Winsor red to paint dark shadows across the woman's skin with the No.6 round. Add a wash of ultramarine mixed with ivory black and burnt umber to the rocks, a mix of Winsor green and ivory black to the foliage, and burnt umber and black shadow to the man's face.

Master Strokes

Paul Gauguin (1848-1903)
Tahitian Women on a Beach

This picture was painted in the year Gauguin left France to begin a new life in Tahiti. Compared to the light, airy feel of the painting in the project, it has a solidity and depth that is achieved with the emphatic application of colour. The dark bands of the sea form a decorative device behind the heads of the two women and contrast strongly with the pale yellow sand of the beach.

White foam adds a touch of realism to the sea, which is otherwise highly stylised.

Gauguin is known for flattening space, but this figure's face is subtly modelled in browns and green.

A FEW STEPS FURTHER

Step back and look at your picture to see if it could benefit from a little more depth of tone. A mix of ultramarine and ivory black is useful to deepen shadows without making them appear too harsh. Continue using coloured pencils to put in additional details and return to the fan brush to build up the tree foliage.

14 ◄ **Enrich the detail** Use the purple pencil to define details on elements, such as the litter-bins and the man's body and bag. Wash a mix of ultramarine and ivory black over the man's trousers and add burnt umber shadows along the top of the wall.

15 ▲ **Finish off the foliage** Using the No.4 fan brush, stipple more dry, olive green watercolour across the trees. Turning to the No.4 round brush and a mix of Winsor green and ultramarine, paint in some blue-green shadows at the base of the trees. Draw in fine branches with the purple pencil.

16 ▼ **Deepen the blue-blacks** Take up a mid-green coloured pencil to add the pointed cypress trees emerging from the tree-tops on the far right of the picture. Using the No.4 round brush, add more ultramarine and ivory black on the left of the painting, along the rocks and in the woman's hair.

THE FINISHED PICTURE

A Grainy texture
The grain of the paper shows through the thin colour washes on the woman's vest-top, and helps to suggest the texture of the fabric.

B Unpainted areas
In classic watercolour fashion, white areas such as the boats, the building and the woman's watch-face and sunglass frames were left as exposed white paper.

C Suggesting distance
The blue of the water in the mid ground and the blue-greens of the trees in the background are cool colours that help convey recession in the scene.

Deserted beach corner

Spatter masking fluid and use a subtle combination of watercolor paints to create areas of sand and shingle.

Any corner of a deserted beach offers a wealth of textures, from smooth pebbles scattered over the sand to the patterned grain of weathered wood and the fraying twists of old rope. With a little ingenuity, these diverse surfaces can be recreated in watercolour if you explore different ways of applying the paint.

Sand and pebbles

Spattering is a versatile technique that allows you to create droplets of colour, excellent for the grainy texture of sand with small pebbles on it. To give a sparkling texture to the sand, start by spattering masking fluid (see the feature on pages 44-45) over the white paper. Paint a diluted sand-coloured wash over the dried fluid, then spatter various other colours on top of the wash for the pebbles. When the dried drops of masking

fluid are removed, you will be left with tiny white highlights.

Wet-on-wet

Some of the paint on the wooden barrier and pillar is applied 'wet-on-wet'. In this technique, the colours run together spontaneously, so your colour mixing is done on the paper rather than on the palette. The exact effect can never be entirely anticipated, but the resulting accidental runs of colour usually make it well worth giving up a little control.

▼ Learn to depict rough textures in watercolour with the help of a few tricks of the trade.

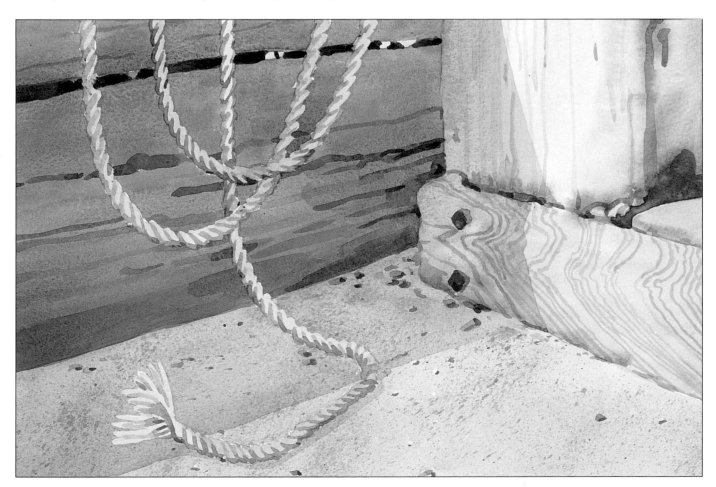

FIRST STROKES

1 ▼ **Start with a light drawing** Make an outline drawing of the subject with a sharp 2B pencil, keeping the lines light and minimal. If the drawing becomes too dark, rub it over lightly with a putty eraser.

3 ▼ **Spatter the masking fluid** Cover the area of the wooden barrier and the pillar with sheets of scrap paper. Then spatter the sand areas with masking fluid by dipping the old paint brush in the masking fluid and flicking the brush at the paper. This area forms the ground of the pebble effect. Wait for the masking fluid to dry, using a hair-dryer to speed up the process if necessary.

5 ▶ **Continue to wash in the initial colours** The base of the pillar is also pale, so paint this in a very dilute wash of burnt umber. While it is still wet, add a little French ultramarine followed by a touch of raw sienna. Allow the colours to run together. When the pillar base is dry, paint the sand in a wash of equal parts cadmium orange and raw sienna, applying it loosely over the masked-out rope. Also paint a few light patches to indicate gaps in the wooden barrier.

2 ▲ **Apply masking fluid to the rope** Before applying watercolour, paint out the rope with masking fluid, using an old brush. When dry, the fluid will form a protective rubbery mask, allowing you to paint over the masked area without affecting the paper underneath.

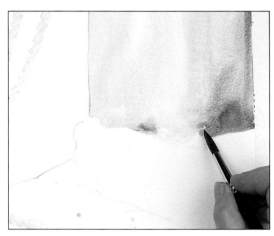

4 ▲ **Apply the first wash of colour** Using a No.10 round brush, wash a very dilute solution of raw sienna over the upright pillar. For the dark patches and the shadows, flood a mixture of French ultramarine and burnt umber into the wet wash. The small rust-coloured patch is cadmium orange applied to the wet colour.

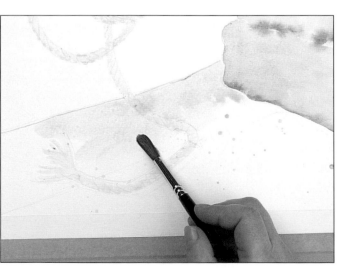

YOU WILL NEED

Sheet of 300gsm (140lb) Not watercolour paper 28 x 37cm (11 x 14½in)

2B pencil

Putty eraser

Masking fluid and old paint brush

Scrap paper

Hair-dryer

Brushes: Nos 10, 7 and 4 rounds

7 watercolours: Raw sienna; French ultramarine; Burnt umber; Cadmium orange; Alizarin crimson; Raw umber; Burnt sienna

Old toothbrush

▲ Earth colours such as the siennas and umbers are ideal to represent the tones of sand and bleached wood.

6 ▶ Paint the barrier with graded colour

For the wooden barrier, mix a purplish-brown from approximately equal parts alizarin crimson, burnt umber and French ultramarine. Gradually add small amounts of alizarin crimson to the mixture as you progress down the shape. Note that alizarin is a strong colour, so use it sparingly.

To give your watercolour a clean edge, stick masking tape around the border of the picture area before you start painting. Take the colour up to and over the masked edge. When the tape is removed you will have a crisp, straight line and the painting can then be framed without using a cardboard mount.

DEVELOPING THE PICTURE

The picture is now covered with washes of thin colour. It is time to work into these pale areas, strengthening the image by developing detail and adding texture.

7 ▶ Paint a shadow on to wet colour

When you have reached the bottom of the barrier, introduce a little French ultramarine into the wet colour to indicate the shadow on the pillar and base. Use the same colour to paint the shadow on the sand.

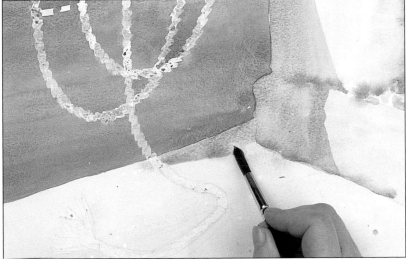

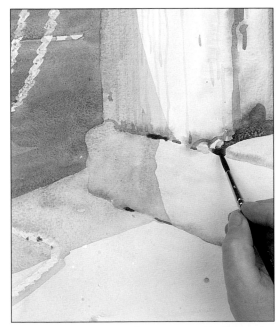

8 ▲ Add more shadow

Change to a No.7 round brush. Using a diluted mixture of equal parts burnt umber and raw umber, paint the wood grain on the pillar and the pebbles at its base. Then paint more shadows into the base of the pillar in burnt umber.

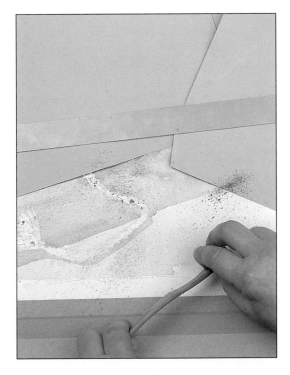

9 ◀ Start to spatter the sand

Reposition the paper mask so that only the sand area is left uncovered. Hold the paper mask in position with something heavy if you think it might move. Using an old toothbrush, spatter the pebbles, firstly with a diluted mixture of burnt umber and French ultramarine, and then with a more concentrated version of the same colour. Work from the same place to give a strong directional feel to the spatters.

10 ▼ **Paint the grain on the barrier** Paint the dark wood grain on the barrier in a mixture of burnt umber and French ultramarine. Add a little alizarin crimson to this mixture and paint the paler grain and a few pale pebbles. Use the tip of the brush to dribble the same colour along the grain pattern to create a more natural effect.

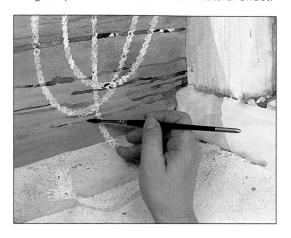

BRUSH PROTECTION

TROUBLE SHOOTER

To avoid ruining your brush when using masking fluid, wet the bristles and rub them against an ordinary bar of soap before dipping them into the masking fluid. The rubbery fluid can then be easily washed off without destroying the brush.

11 ▼ **Develop the metal bolt heads** Paint the rusty bolt heads in cadmium orange, and the rust marks on the pillar base in burnt sienna. Use the tip of the No.7 brush to paint the wood grain on the pillar base in raw umber, applying the colour in wavy parallel lines.

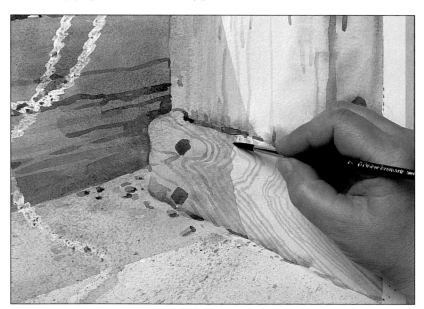

Express yourself
The rope trick

In the main demonstration, the three areas of the painting – the wooden barrier, the pillar and the sandy beach – with their different textures and painting techniques, are visually united by the rope. Its loops bring the three areas into focus as a recognisable subject. You can see the effect of the rope in the version below. Without the rope bringing the three areas together, the relative shapes of the barrier, the pillar and the sand become more important. The painting loses its realism and becomes a composition of rectangular shapes. It takes on an abstract quality, an effect that is enhanced by a reduction in the amount of detail. For the painting to work as an abstract, you need to use colour – in this case, touches of alizarin crimson on all three elements – to create a sense of visual unity.

12 ◄ **Remove the masking fluid** Making sure that the paint is dry and that your finger is clean, remove the masking fluid by rubbing carefully. If it becomes difficult to remove, try using a clean eraser instead.

13▼ **Paint the rope** Using a No.4 brush, soften the sharp white shape of the rope by applying a pale wash of equal parts cadmium orange and French ultramarine.

14▼ **Define the bolt heads** Make the bolt heads stronger, darkening the tone by overpainting them with a little burnt umber.

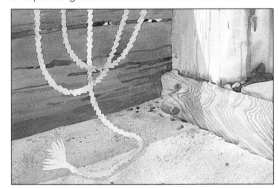

A FEW STEPS FURTHER

At this stage, the painting is almost complete. The composition involves just four main elements – the barrier, the pillar, the sand and the rope. Yet this simple arrangement of shapes has already become a detailed and realistic painting. Now for a few finishing touches.

15▼ **Add shadows to the rope** Starting at the top, work down the rope, painting the shadows in burnt umber mixed with touches of French ultramarine and cadmium orange. Use the tip of the brush and keep the shadows as evenly spaced as possible.

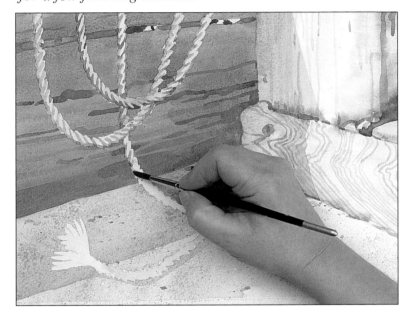

Master Strokes

Ruskin Spear RA (1911-90)
Sea Wall, Cornwall

Like the picture in the demonstration, Spear's painting has a spontaneous feel. He has chosen an unusual viewpoint, with the stones of the wall taking up more than half the picture space. The sombre tones of this area make the sea and clouds in the distance appear much lighter and brighter.

The individual shapes of the stones in the wall have been worked over with a smudgy layer of paint, creating a spontaneous yet weathered feel.

The lobster pots in the foreground are clearly defined, while the figures further away on the beach are much more vague and shadowy, as though melting into the distance.

▲ **Cool Alizarin crimson and French ultramarine make up the picture's pinky-mauve areas, such as the wooden barrier. Raw sienna is a useful neutral tone.**

16 ▼ **Strengthen the dark tones** Still using the No.4 brush, mix burnt umber with a touch of raw umber and use this to strengthen the dark tones on the tops of the bolt heads. Change to the No.7 brush. With a fairly dark mixture of equal parts French ultramarine and raw umber, go over the dark shadows between the wooden boards in the barrier.

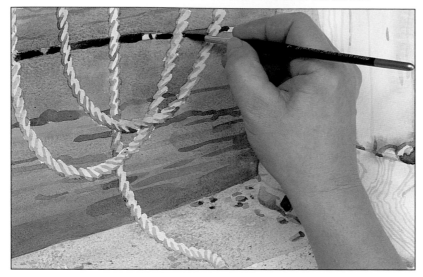

17 ▲ **Add more pebbles** Finally, using the left-over colour mixtures on your palette, dot in a few more pebbles with the tip of the No.7 brush.

THE FINISHED PICTURE

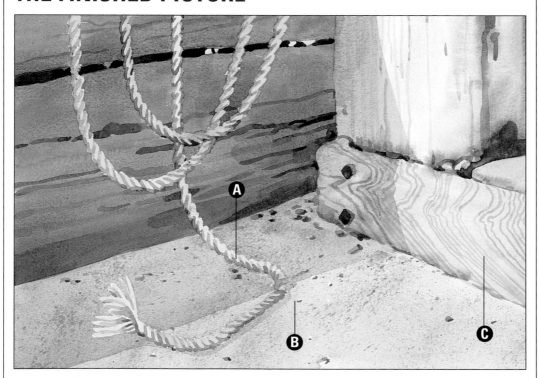

A Masking fluid
Instead of painting around the rope, masking fluid was used to protect this area as a crisp shape, which was then washed with light colour.

B Spattering
Spattered texture can be overdone and is most effective when used only on selected areas. Here it was confined to the small patch of sandy beach.

C Wood grain
A convincing impression of wood grain was created by using the tip of the brush to paint parallel wavy lines, spaced slightly unevenly.

Still life with melon

Try a direct, 'no-drawing' approach to watercolour painting to achieve a bold, spontaneous effect.

For centuries, artists have used fruit and vegetables as an inspiration for still life paintings. Works range from the lavish to the humble, from exotic fruit tumbling off silver salvers to partially peeled potatoes on scrubbed wooden tables.

Whatever your taste, you will find that fruit and vegetables make extremely versatile subjects. Fortunately, they are also easy to get hold of and a quick trip to the local market can set you up with an extraordinary range of shapes, colours and textures with which to compose your picture.

Here, the artist chose a melon for the textural detail of its seeds, a vine of cherry tomatoes to create interesting negative shapes and a lemon and an aubergine for their strong colours and harmonious, curvaceous forms.

Fresh approach

To paint this colourful arrangement, try taking a fresh approach to a classical subject. Apply the watercolour without a preliminary pencil drawing – a bold method that produces equally bold results. Use big brushes to keep your work immediate and lively, and avoid overworking the colours. Although a small brush was used to define the melon seeds, fine lines and details can generally be painted quickly and easily using the tip of a Chinese brush.

▼ **Bold application of watercolour brings out the strong, clear colours of the fruit and makes them stand out from the background.**

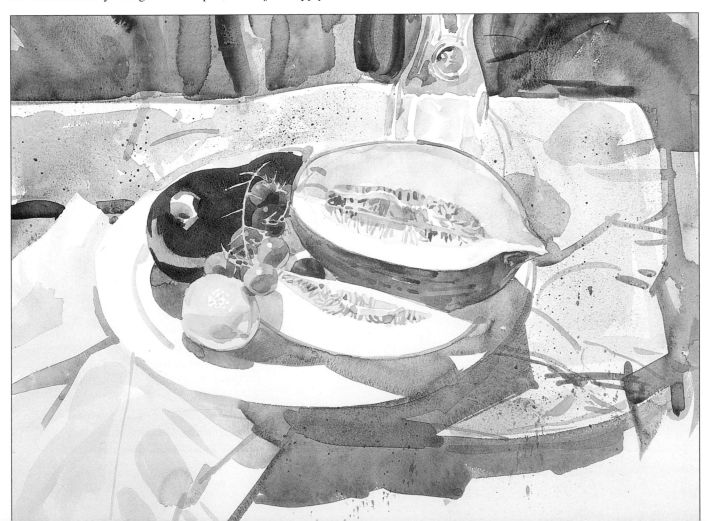

FIRST STEPS

1 ▲ Position the melon Using a Chinese brush, start by boldly blocking in the shapes of the melon flesh in dilute gamboge yellow. Make sure the proportions and positions are correct.

2 ▶ Paint the tomato stalks With the tip of the Chinese brush, paint the main tomato stalk with a mixture of gamboge yellow and Winsor green. Judge the correct position of the stalk by relating it to the painted melon, taking care to leave unpainted spaces for the tomatoes.

3 ▲ Add the lemon Paint the lemon in pure lemon yellow, leaving a patch of white to represent the highlight. Using the tip of the brush, dot in the dappled peel texture on the highlight. Outline the right-hand edge with a stronger lemon yellow mix.

TROUBLE SHOOTER

RESCUING HIGHLIGHTS

Leave unpainted paper for the white highlights on shiny fruit and vegetables. If you forget to do this, move quickly before the paint dries and create a highlight by soaking up the colour with a dry cotton bud.

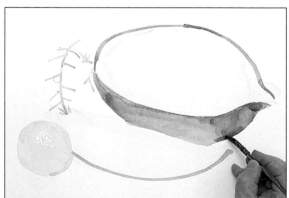

4 ▲ Develop the melon Allow the colours to dry, then outline the melon shapes with a strong mix of Winsor green with a little added ivory black and cadmium orange. Add more water and a little more orange to the mixture and flood this into the centre of the melon half, allowing the colour to bleed into the darker tone.

5 ▼ **Add the melon seeds** Paint the shaded edge of the melon flesh in a mixture of Winsor green and lemon yellow. Add the seeds to the segment of melon in the foreground in gamboge yellow and raw sienna, leaving the pith as an unpainted white shape.

6 ▼ **Paint the tomatoes** Paint a mixture of emerald green and lemon yellow around the edge of the melon. Add three tomatoes in washes of cadmium orange and scarlet lake, leaving highlights unpainted. Paint the half-melon's seeds in mixes of raw sienna, cadmium orange and gamboge yellow.

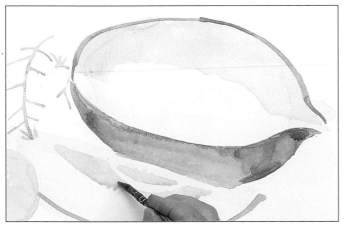

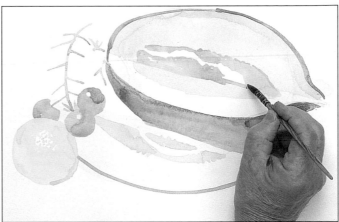

DEVELOP THE PICTURE

You will need to change to a smaller brush to put in some of the detail. However, it is important to keep the painting generally bold and broad.

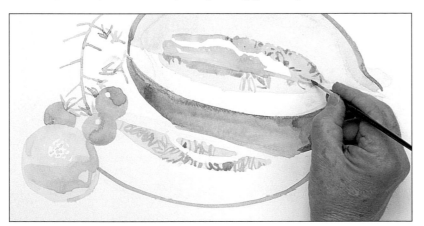

7 ▲ **Add details** Complete the tomato stalks in gamboge yellow and Winsor green. Paint the shadow on the lemon in gamboge yellow with small amounts of viridian and raw sienna. Change to a No.3 soft round brush and define the seeds in mixtures of raw sienna, burnt sienna and raw umber.

8 ▲ **Develop the colours** With the Chinese brush, block in the remaining tomatoes in cadmium orange and cadmium red, painting around the green stalks. Add the dark stripes to the outside of the melon, painting these as broken lines of Winsor green and raw sienna.

Express yourself
Fruit substitute

You can change the emphasis of the still life by substituting one fruit or vegetable for another. In this painting of a similar subject, a watermelon dominates the colour scheme. Its bright pink centre draws the eye more than the pale green flesh of the melon used in the project. The grapes play the same role as the tomatoes in the step-by-step, creating intricate detail and interesting negative shapes. Try, too, altering the background slightly, putting in additional colours and textures.

Master Strokes

Georges Braque (1882-1963)
Still Life with Grapes and Apples

Still life paintings were a favourite subject for the French pioneer of Cubism, Georges Braque. In typical Cubist fashion, he gives us a rather distorted view of everyday objects here. The jug, bowl and plate are starkly divided into black and white halves.

The horizontal and vertical lines of the background and table further divide the picture area into a pattern of straight-edged shapes. This geometric aspect of the painting is softened by the softly rounded edges of the crockery and fruits.

The highlights on the grapes are suggested with pale grey dabs of paint that curve around the fruit.

The green cloth in the foreground echoes the colour of the fabric hanging behind the table, helping to unify the composition.

Textural brush strokes capture the wavy effect of wood grain on the brown table-top.

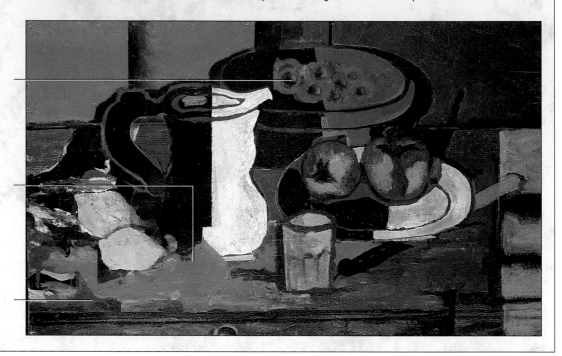

9 ▼ Paint the aubergine Block in the aubergine in Winsor violet with a touch of ivory black and permanent rose, painting carefully around the tomatoes and stems. Leave the jagged highlights unpainted, referring closely to the subject to find their exact shapes.

10 ▲ Block in the shadows Change to a 25mm (1in) soft flat brush and block in the shadows around the fruit and plate in a mixture of Winsor violet, burnt sienna and a little black. Paint the shadows on the white fabric in a diluted version of the same colour. Take the same diluted colour over the highlights on the aubergine.

11 ▼ **Paint the background** Loosely paint the glass bottle with a mix of Winsor violet and burnt umber, leaving the lower half of the bottle unpainted to indicate the pale stone behind. Block in the background and stone with bold strokes, using dark and pale mixtures of raw sienna, ivory black and Winsor violet.

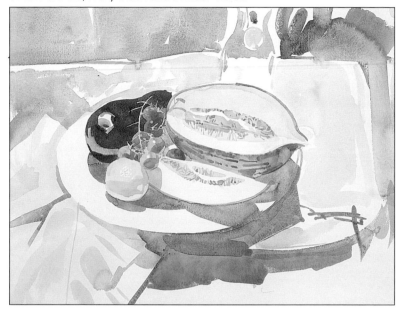

EXPERT ADVICE
Composition check

As you have not made an initial drawing, check your composition as you progress. Choose a support larger than you want the finished picture to be, then cut a card mount. By moving the mount around on the painting from time to time during the early stages, you can choose a suitable composition at any time as work progresses.

A FEW STEPS FURTHER

The watercolour is virtually finished. However, you might wish to add one or two finishing touches before putting down your brushes. For example, the background and the stone are possibly rather too similar in tone and texture.

12 ▲ **Darken the background** Working in bold, broad strokes, strengthen the background with dark washes of burnt umber mixed with ivory black and a little Winsor violet. Use the same mixtures to emphasise the shadow around the right-hand side of the stone.

13 ▲ **Develop dark tones** With the Chinese brush, define the motif and reflections on the bottle in a mix of cobalt blue and ivory black. Paint alizarin crimson shadows on the tomatoes and add a cool shadow to the lemon in a mixture of gamboge yellow, black and ultramarine. Emphasise the melon seeds in mixtures of raw and burnt sienna. Darken the outside of the melon in sap green and black.

14 ▼ Mask the picture
Prepare to add a spattered texture to the surface of the stone by first protecting the rest of the painting with old rags and newspaper. Stick these down with masking tape, positioning the tape carefully so that it protects the edges of the plate, cloth and bottle.

15 ▲ Spatter the stone
To spatter, mix a wash of sap green and burnt sienna. Dip an old toothbrush into the diluted colour and hold the loaded brush a little way above the area to be spattered. Pull the bristles back and flick the colour across the paper, repeating this until the stone is covered with a speckled texture.

THE FINISHED PICTURE

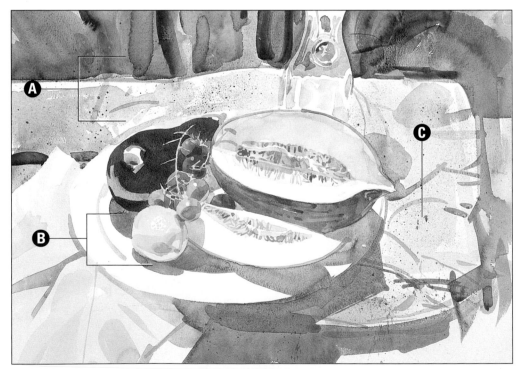

A Muted background
The background was painted in dark, neutral colours which do not compete with the central subjects: the brightly coloured fruit and shiny aubergine.

B Shadow shapes
The artist used cool violet-grey shadows on the plate to reflect curved shapes within the subject and play a positive role in the overall composition.

C Speckled stone
Spattered texture on the stone is light and minimal – just enough to differentiate it from the smooth cloth. It does not detract from the main elements in the composition.

Watercolour mediums

If you would like to experiment with watercolour, try mixing it with some of the special additives that change the character of the paint.

The fluid nature of watercolour means that it is ideal for creating washes of translucent colour and delicate tones. However, this is by no means the end of the story. You can actually change the consistency of watercolour by adding one of several mediums to the paint. In this way, your colours become more versatile and you will be able to invent many different textures and surfaces. For example, watercolour mixed with the appropriate medium can be used with masking tape, painted in stiff peaks and even applied with a knife.

Gum water and gum arabic

Gum water and gum arabic are useful additives that enhance both the colour and texture of watercolour. A little of either medium mixed with the paint will give a rich gloss to the picture

WATERCOLOUR MEDIUMS

Choose a watercolour medium to make the colour thicker or thinner; to improve the flow; to slow down or speed up the drying time; to get a glossy finish; or to paint impasto textures.

- **A** Thickening paste
- **B** Gum water
- **C** Gum arabic
- **D** Glycerine
- **E** Ox gall liquid
- **F** Drying medium

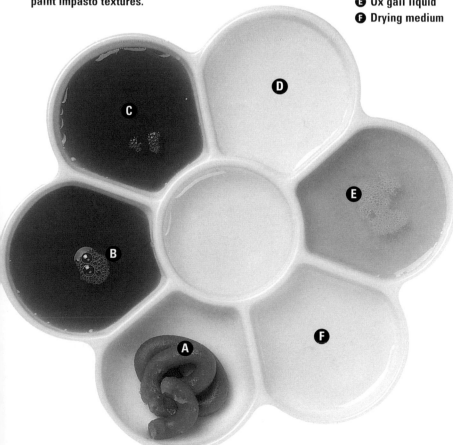

USING GUM ARABIC

To achieve a glossy sheen, add a little gum arabic to the diluted watercolour with a brush, then try the following experiments.

MOTTLED PATTERN

Drops of water applied with a small brush will dissolve dry, thickened colour and disperse the pigment particles to create this attractive mottled texture.

SGRAFFITO

Use a fork or other sharp tool to scratch patterns into wet, thickened colour. The white paper or underlying colour will show through the paint.

SPATTERING

Using a toothbrush, flick clean water on to dry, thickened colour. Wait for a few seconds until the water has had time to dissolve the colour, then blot the excess.

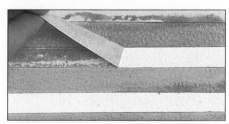

MASKING TAPE

Press strips of tape firmly down on the paper and apply the thickened colour. When the colour is dry, carefully peel back the tape to reveal the crisply painted stripes.

THICKENING PASTE

Stiffer than gum arabic, thickening paste is particularly suitable for impasto watercolour and other highly textured effects. As it is often translucent rather than transparent, too much of the paste can affect the colour of the paint and produce a cloudy effect. Once watercolour paint has been thickened with this medium, it can then be applied with a painting knife as well as with a brush.

MIXING
Blend the paste and colour together well using a stiff brush. If the mixture is too firm for your purpose, add a little water.

IMPASTO
Use the flat blade of a painting knife to apply thick layers of colour and to create wedges of overlapping paint.

SGRAFITTO
Pronounced ridges and other scratched patterns can be made using a fork, comb or other implement on the wet colour.

BRUSH MARKS
Thick colour retains the marks of a stiff brush so experiment with different types of brush stroke – dabs, swirls, and so on.

STIPPLING
Pat the wet colour with the flat blade of a painting knife to create raised peaks of colour in a coarse, stippled effect.

surface. Both mediums can be spattered or sprayed on to an area of dry colour to create a speckled or mottled texture.

Gum arabic is less fluid and more viscous (sticky) than gum water. When watercolour paint is mixed with gum arabic, it can become stiff enough to hold the shape of brush marks. The thickened colour allows you to create other surface textures such as combing or stippling. However, too much gum arabic will make the paint jelly-like and too slippery to be workable.

Thickening paste

For a heavy impasto effect, try adding thickening paste to your watercolours. The resulting mixture can be so stiff that it looks quite unlike traditional watercolour paint – in fact, many purists disapprove of the additive for this reason. However, it is always fun to experiment, and watercolour applied with a painting knife is certainly an intriguing idea. Also, if used discerningly on selected areas of a painting, thickening paste can add textural interest and enhance the surface of the paint without detracting from its more classical qualities.

Thickening paste comes in tubes and looks similar to equivalent mediums made for oil and acrylics. Take care, when purchasing the medium, to buy a product that is made specifically for watercolour.

Flow improvers

Ox gall medium is the best known of the 'flow improvers', which are used to disperse colour evenly, particularly in washes and wet-in-wet techniques. It is a brownish-yellow liquid originally made from the gall bladders of cows and is normally added to the water rather than to the paint. Although still available, real ox gall has generally been replaced by synthetic alternatives.

In addition to ox gall, a number of other proprietary mediums are available to improve the flow of watercolour and to disperse the pigment evenly.

Drying mediums and retarders

If you have ever tried painting wet-in-wet on a very hot day, when the colour dries as soon as it touches the paper, you will appreciate the value of glycerine. A few drops of this heavy, honey-like liquid added to the watercolour will keep your painting moist and workable for considerably longer by delaying the natural drying time of the paint.

Conversely, watercolour paint dries surprisingly slowly in damp and humid conditions. This can be frustrating, especially if you are waiting to apply colour to a dry surface. Happily, you can speed up the drying time by using a proprietary drying medium. Alternatively, a few drops of alcohol added to the paint will also have the same effect.

Ramshackle old building

An old, run-down building is as interesting to paint as a more conventionally 'pretty' subject.

It is natural for artists to want to paint subjects that are attractive and colourful. But it is often a good exercise to paint something that appears to have no appealing qualities at all. To make it successful, you will need to be creative in your use of technique, perhaps altering colours, bringing in distortion and adding textures.

This ruined old shack in the Australian outback offers a good opportunity to test your creativity in watercolour. The building and the surrounding landscape are unremarkable, and even the light is rather grey and flat. However, there are many interesting shapes and textures to explore: the roof and chimneys are slightly askew, the walls are stained and streaked and the paintwork is chipped and peeling.

To bring out the character of the dilapidated building, use a combination of wet-on-dry and wet-in-wet washes, and push the paint around, blotting it to provide tonal variation and texture. You can further exaggerate the tonal contrasts to inject some extra light into the scene.

▼ **The artist has not merely copied the photograph above, but has given this picture life and character through his use of brushwork.**

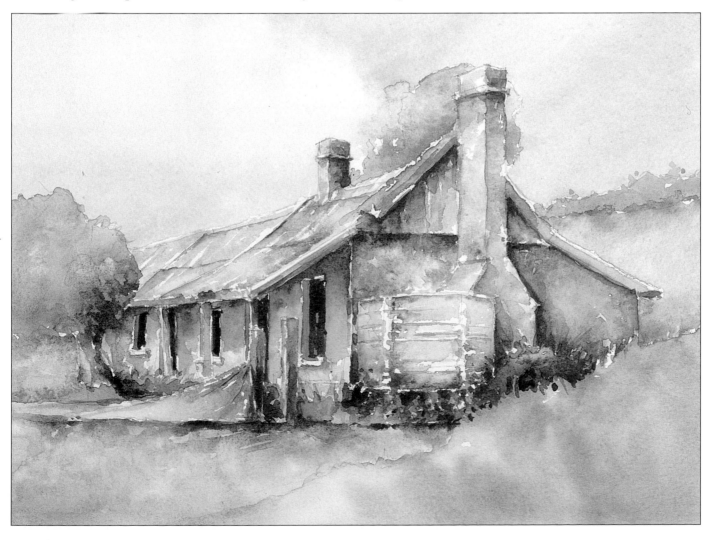

FIRST STROKES

1 ▶ Make a sketch and wet the sky area
Pencil in the shack's outlines, noting the perspective. Indicate the surrounding trees and the foreground. Dip a No.11 brush in clean water and wet the entire sky area, working around the outlines of the roof and treetops. Wait for the surface sheen to dry off the paper before painting the sky. The washes will bleed gently on a damp surface, but if it is too wet, they will run out of control.

2 ▼ Paint the blue sky Mix a wash of cobalt blue for the sky. Working around the large cloud shape, start at the roof and make diagonal brush strokes upwards towards the top of the paper. This lends a feeling of movement to the sky. When the paint dries, the blue will be more intense where the pigment settles at the top of the sheet, graduating to a paler blue towards the bottom of the sky and creating the illusion of the sky receding towards the horizon.

◀ **Cobalt blue, alizarin crimson and raw sienna will give you a range of greys for painting clouds.**

3 ▶ Indicate shadow under the clouds
While the paint is still damp, lift out the fluffy shapes of the clouds by blotting the sky with a crumpled piece of kitchen paper. Mix a purple-grey from cobalt blue with a touch of alizarin crimson. To indicate the base of the clouds, use short zigzag strokes and let them spread softly on the damp paper.

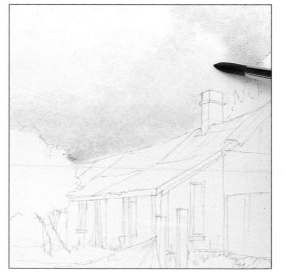

4 ◀ Add highlights to the clouds Drop a tiny amount of weak raw sienna on to the tops of the clouds and allow it to bleed into the damp paper. As it dries, the colour will fade away almost to nothing, just giving a hint of warmth. This gentle gradation from warm to cool suggests the rounded forms of the clouds. Leave to dry.

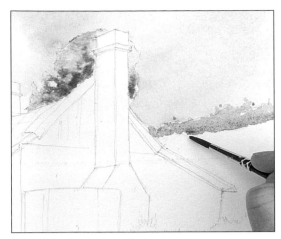

5 ▲ **Paint the foliage** Dampen the tree, using a No.6 brush. Mix olive green and a hint of cobalt blue. Touch spots of this and cadmium yellow on to the damp paper, letting them bleed softly. Add more blue and darken the foliage near the base. Paint the distant hedgerow.

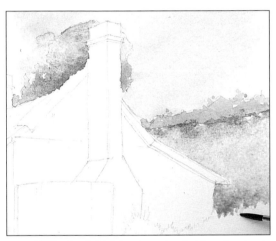

6 ▲ **Fill in the field** Moisten the field and paint it with olive green mixed with a little cadmium yellow and the purple-grey cloud colour on your palette. Add some water here and there so that it dries unevenly. While the wash is still damp, add a little blue to intensify the colour at the edges.

EXPERT ADVICE
Softening edges

Avoid creating hard edges on trees, as this can make them look like cardboard cut-outs. To blend a tree naturally with its surroundings, work on damp paper and let the edges merge into the sky colour, wet-into-wet.

DEVELOPING THE PICTURE

Now that you have blocked in the sky and the distant landscape, it is time to tackle the building. This might look complicated, but by simplifying detail and using a limited palette of colours, it becomes much easier.

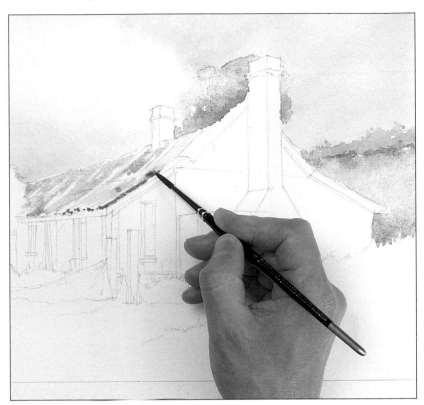

7 ▲ **Paint the roof** Mix a very weak, watery wash of cobalt blue, greyed with a hint of burnt umber. Paint the corrugated iron roof of the shack, using a series of broken lines and allowing plenty of white paper to show through. Suggest the rust stains with pure burnt sienna, letting it bleed softly so that it stains the surface, much as rust does. If the colour looks too strong, break it up a little by blotting with crumpled kitchen paper.

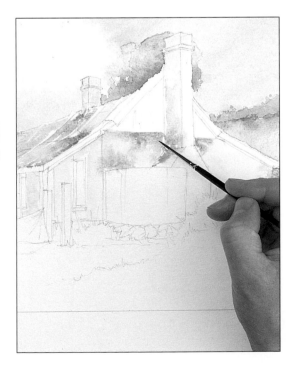

8 ◄ **Start the walls** Paint the concrete walls and chimneys with an underwash of raw sienna. Using broken strokes, vary the tone by adding more or less water, and leave a few tiny flecks of white paper showing. Change to the No.2 brush and use some of the greyish colour left on your palette to suggest stains on the walls. Skip the brush over the paper with tiny strokes and let the colour bleed into the damp underwash.

► Freely applied paint will acquire a pleasing, granular texture if you blot it frequently with a piece of kitchen paper. This technique can also be used to completely remove or re-introduce areas of colour.

Paint a vignette

You don't always have to paint a complete image; sometimes a small soft-edged detail, or vignette, is enough to capture the atmosphere of a place. Concentrate on one area and fade out the edges by softening them with water.

9 ► **Add shadows**
Return to the No.6 brush to develop the shadows under the verandah, using grey graduating to burnt sienna. Mixing cobalt blue and burnt umber, add more grey stains on the wall, then paint the roof triangle. Use burnt sienna for the roof edge.

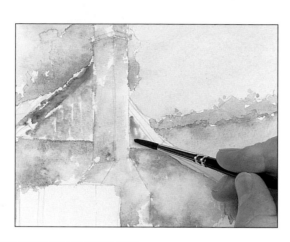

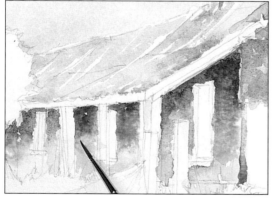

10 ◄ **Develop the textures** Using the No.2 brush, mix cobalt blue and burnt umber to add a dark grey to the chimney. Enrich the end wall with grey, mixed wet-in-wet with burnt sienna. Deepen the verandah shadows with the dark grey mix.

HOW TO DEFINE EDGES IN WATERCOLOUR

TROUBLE SHOOTER

On buildings, it is tempting to define the edge where one plane meets another with a dark line, which looks unnatural. Instead, leave a thin sliver of the underwash showing, as on the edges of the roof and the tank.

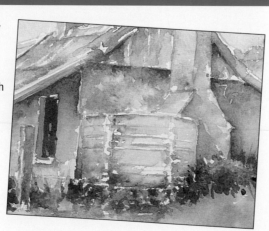

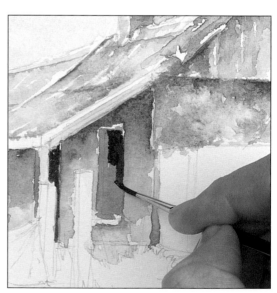

11 ▲ **Work on the roof and windows** Use grey and burnt umber to strengthen the roof colours. Pick up a little burnt sienna on the tip of the brush and emphasise the joints between the corrugated sheets. Fill in the windows with the dark grey mix from step 10, leaving tiny flecks of white to suggest reflections. When dry, use a darker, near-black wash for the shadows on the windows.

12 ▶ Finish the roof and paint the water tank
Continuing with the roof colours from step 11, paint the roof surround and the wooden verandah posts, leaving tiny white highlights to denote the edges (see Trouble Shooter, opposite). Using the same colours as mixed for the roof in step 7, paint the corrugated iron water tank in front of the shack with a series of broken lines. Leave slivers of white paper for the highlights, and suggest stains and rust patches with touches of burnt sienna and near-black.

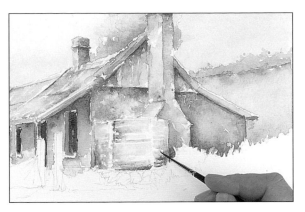

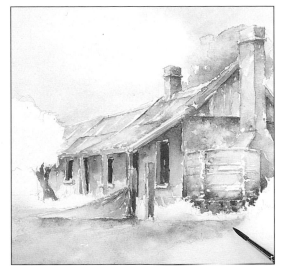

13 ▲ Start work on the foreground Paint the tree trunk on the left with a mix of burnt umber and cobalt blue. Wet the foreground area using the No.11 brush. When this has dried a little, change to the No.6 brush and apply earth tones mixed from burnt umber and raw sienna, plus touches of the grey-brown colour mixed in previous steps. Apply the paint wet-into-wet, pushing it around to create a variety of hues.

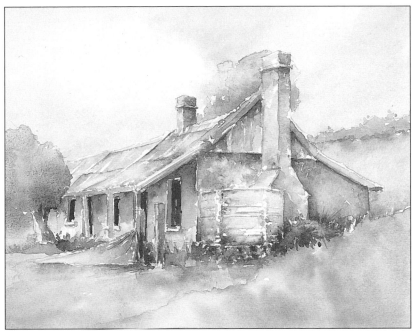

14 ▲ Paint the foreground foliage Mix olive green and cobalt blue for the foliage of the tree on the left, dropping in cadmium yellow at the top. Mix all three colours for the foreground grass. Vary the tone by adding and lifting out colour here and there. Darken the green mix with more blue and suggest tufts of tall grass growing in front of the shack.

Master Strokes

Myles Birket Foster (1825-99)
At the Cottage Door

In contrast to the abandoned and dilapidated country shack in the project, this cottage scene is full of life. The English painter, engraver and book illustrator, Myles Birket Foster, favoured idealised rural views of this type.

The surfaces in the painting are full of textural detail, from the wood grain to the lichen on the tiles.

Flowers and animals in the composition create a warm, homely atmosphere and a sense of permanence.

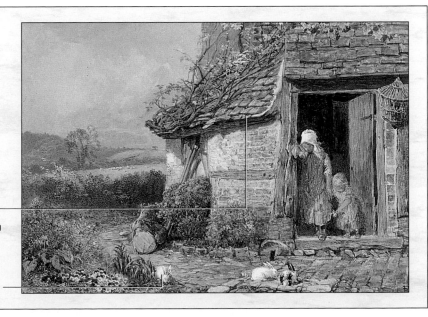

Although the watercolour painting is now more or less complete, the foreground needs just a little fine-tuning. Beware, however, of adding too much extra detail to the picture, as this will prevent the eye from travelling into the painting to the focal point – the shack.

15 ▶ Add some dark touches Darken the green used in step 14 to paint shadows under the left-hand tree canopy. Then, using the No.2 brush and a little of the dark grey-brown mix on your palette, put in shadows in the long grass.

16 ▲ Strengthen the foreground Darken the area under the left-hand tree canopy to outline its shape more clearly. Change to the No.6 brush and add interest to the patch of bare earth with loose mixes of burnt umber and raw sienna, making vertical and diagonal strokes to suggest the ruts in the earth.

THE FINISHED PICTURE

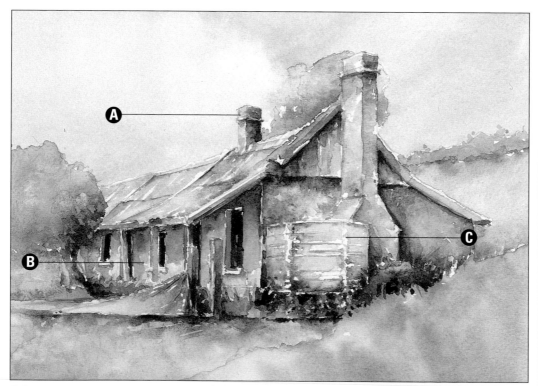

A Strong focal point
The picture is dominated by the shack, which occupies much of the picture space. Viewed from a low angle, its roof line breaks into the sky, creating an interesting shape.

B Limited palette
The picture was painted with a limited range of cool, warm and neutral colours. Because the colour mixes are all made from the same hues, they harmonise well.

C Unpainted areas
Small flecks of white paper can be seen throughout the painting. These not only provide highlights, but also create 'breathing spaces' and lend sparkle to the colours.

Relaxed study in watercolour

Cool blues, mauves, pinks and greys, enlivened with touches of brighter colour, create the right mood for this tranquil study.

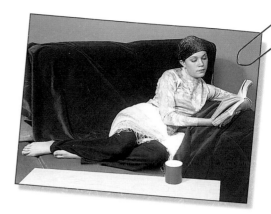

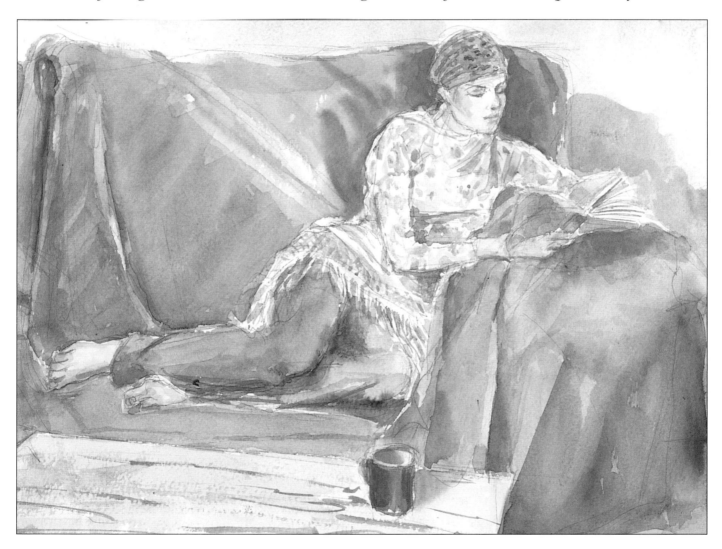

This relaxed study shows off the versatility of the watercolour medium. Working with wet-in-wet washes, colours have drifted into each other to suggest the luxurious texture and the fall of the velvet throws on the sofa.

And these large expanses of colour contrast effectively with the more detailed study of the sitter. Moreover, the warmish pinks and purples of the sofa covers – together with the browns of the table and floor – also play off against the cool colours of the subject's clothes. This contrast helps to focus attention on the sitter. In terms of colour, the picture is further lifted by the lively pattern of blues and yellows on her blouse.

Looking at shape

Understanding how shapes work together is a major part of painting. The woman's pose – half lying, half sitting – creates an interesting, fluid shape. This is set off against the angularly shaped expanses of the velvet throws. The coffee table in the foreground helps lead the eye into the picture.

▲ **Note how most of the detailed work in the painting has been reserved for the sitter and her clothes. The rest of the painting has been completed in relatively loose washes.**

185

FIRST STROKES

1 ▼ **Sketch in the scene** Using a 2B pencil and light but legible strokes, sketch the model and the draped sofa, checking the angles and proportions of the figure. Don't be afraid to erase parts of the drawing with a putty rubber and start again.

YOU WILL NEED

Piece of 300gsm (140lb) Not watercolour paper 28 x 38cm (11 x 15in)

2B pencil

Putty rubber

Brushes: Nos.10, 6 and 2 rounds

15 watercolours: Winsor violet; Naples yellow; Burnt sienna; Purple madder alizarin; Permanent rose; Payne's grey; French ultramarine; Raw sienna; Burnt umber; Sepia; Cerulean blue; Black; Emerald; Raw umber; Cadmium red

2 ▼ **Establish the back-drop** With a No.10 round brush, block in the background throw with light washes of Winsor violet. Now take up a No.6 round and work on some smaller areas. Begin on the face and hands with a very watery Naples yellow and the broad headband with burnt sienna. Throw the model's head forward by adding strong shadows in Winsor violet behind it.

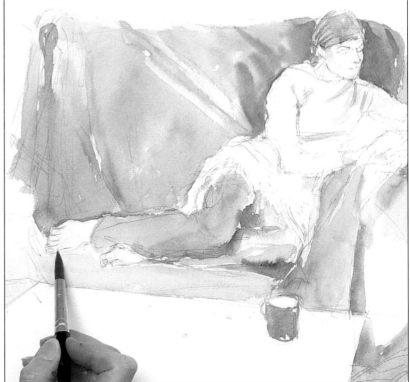

3 ▲ **Fill in the scene** With the No.10 brush, paint the foreground fabric in purple madder alizarin, and deepen the background fabric with mixes of purple madder alizarin and Winsor violet, adding permanent rose highlights. With a wash of Payne's grey and a touch of French ultramarine, paint the trousers, the fringed shawl, and the shadows on the blouse and wall. Use raw sienna over burnt sienna for the sofa, raw sienna on the sitter's headband, Naples yellow for the feet and French ultramarine for the mug.

DEVELOPING THE PICTURE

The main areas of your composition are now blocked in, and the pale and brighter colour registers are established. Progress by working with a range of other colours, right across the picture, using various paint thicknesses and techniques.

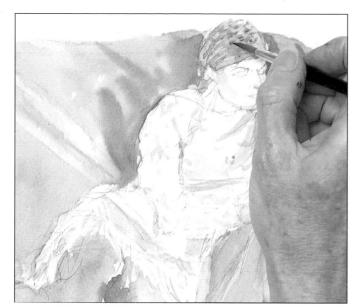

4 ▲ Add upper-body detail Changing to a No.6 round brush, use the tip to pattern the blouse with watery raw sienna. Add a little more Payne's grey on the fringed shawl. Dot in the design on the headband in burnt umber and sepia.

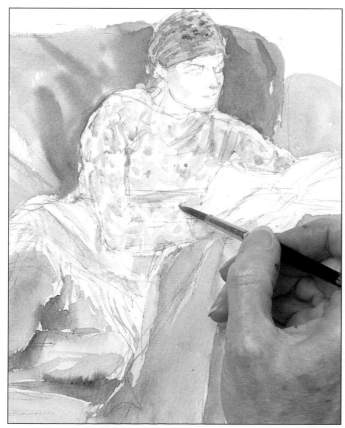

5 ▲ Brighten the blouse Still using the pointed tip of the No.6 brush, lift the whole scene by painting in the blue parts of the blouse pattern with cerulean blue.

◄ **Sepia (top), Winsor violet (bottom right) and purple madder alizarin (left)** have been used extensively in the picture and help to set its overall colour key. They harmonise well with each other, creating an air of calm.

EXPERT ADVICE
Be complementary

By making use of complementary colours – opposites on the colour wheel – in a prominent part of the scene, you can really lift the whole. Here, placing brown-yellow and blue together in the blouse's pattern enhances the colours and brings a bright but balanced element to the picture.

6 ▲ Paint in the book Now bring the model's book into the picture, balancing the right-hand side of the painting. Use the fine tip of the No.6 brush to sketch in an outline of the book cover in watery sepia. Put in the faintest suggestion of the pages in the same colour. Working wet-in-wet, use sepia and Payne's grey to block in the book cover. With a mix of purple madder alizarin and Payne's grey, paint the shadow of the book on the throw.

A different viewpoint

This painting, also in watercolours, creates a different mood to the step-by-step one. The high viewpoint – combined with the curled, sleeping body position – provides a highly original figure study. Note how the model's nightgown is beautifully described by controlled wet-on-wet washes. The contrast in tone here – from the white of the paper to the deep blue shadow in the middle of her curl – really brings out the form of the body. The teapot and cup and saucer in the corner pick up on blue of the nightgown and help balance the composition.

7 ▲ **Work on the large areas** Taking up the No.10 brush, start working up more depth and richness on the two throws. Use purple madder alizarin on both of them, laying thin washes over the dried colour to suggest the texture and sheen of velvet.

8 ▼ **Define the facial features** Now turn your attention to the face. With a No.2 round, start to add some fine detailing with intense sepia paint. Wash a little watery burnt sienna over the lips.

9 ▼ **Intensify the darks** With the No.10 and No.6 brushes, use a mix of cerulean blue and black to define the feet and legs by adding shadows on and between them. Intensify the shadows across the blouse, too. Using the No.10 brush, wash strong Naples yellow across the table as a base colour.

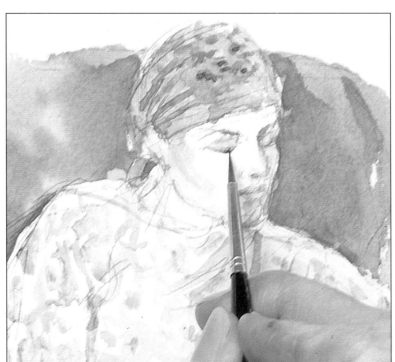

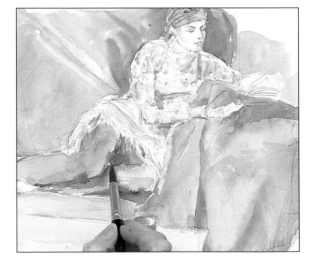

10 ▼ Work on some detail Use the same blue-black mix and the tip of the No.6 brush to define the shawl's fringe, then dot ultramarine along its border. Mix up cerulean and emerald paints and wash this across the wall behind the sofa. Notice how leaving the pencil underdrawing in has created some surface interest and definition.

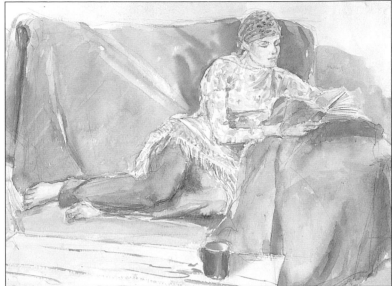

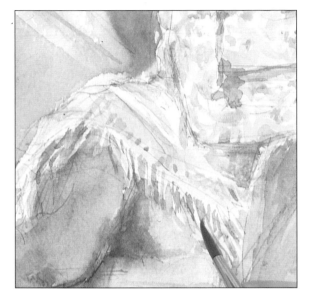

11 ▲ Adding definition With the No.6 round, sweep lines of dry sepia, burnt umber and raw umber across the table to suggest wood grain. Using a 'palette mud' mix of black, burnt umber and ultramarine, strengthen the shadows on the legs and next to the mug. Add sepia to this mix to build up the tone of the book. Paint a little sepia and burnt sienna on the feet and hands, and a touch more detailing on the fringed border of the scarf.

Master Strokes

Paul Gauguin (1848-1903)
Fair-haired Woman on a Sofa

This painting was made in 1884, a year after Gauguin gave up paid employment to become a full-time artist. The viewpoint creates a harmonious composition of horizontals – the outstretched pose of the reclining woman is echoed by the straight lines of the *chaise longue* and the bold, wide band of brown running along the bottom of the wall.

Surrounded by the dark tones of the wall, floors and *chaise longue*, the white dress and pale flesh tones really leap out.

The curved line of the *chaise longue*'s back helps frame and draw attention to the woman's head.

The greyish-browns of the walls and *chaise longue* are picked up in some of the shadow areas of the dress.

A FEW STEPS FURTHER

Now that you have worked hard on bringing up the detail on the reclining figure, even up the balance of the picture by giving a little more attention to the larger expanses of plain colour on the throws and sofa seat.

12 ▶ Finish the drapes Wash some plain water across the throws to give them more drama and depth. Using Winsor violet and the No.6 brush, strengthen the shadows on the background throw. Wash a little cadmium red lightly over the foreground throw.

13 ▲ Bring up the sofa Using the No.10 round, add the final touch by washing watery sepia across the front of the sofa seat. Now the drapes, table and model are all well-balanced, and the central figure retains its solidity, strength and interesting visual detail.

THE FINISHED PICTURE

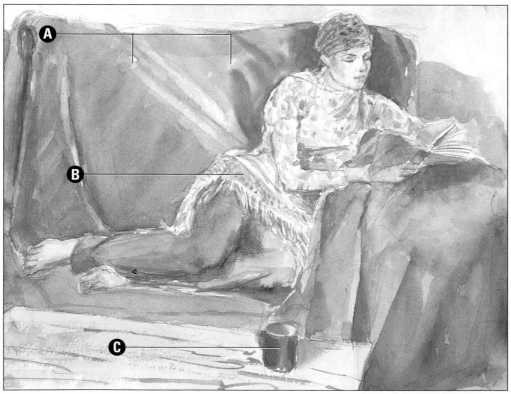

A White highlights
The tiniest flecks of unpainted white paper are sufficient to represent white highlights on the luxurious fabric.

B Central interest
Attention to detail by painting the pattern on the fringed shawl brings a point of interest to the centre of the picture.

C Drawing the viewer in
The artist has placed a strongly coloured object – the mug – in the foreground to help draw the viewer into the picture.

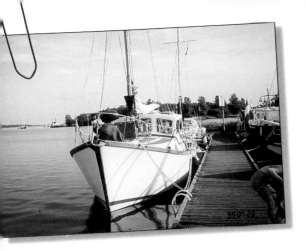

Moored boat

Create this painting of a harbour scene with bold blocks and bands of watercolour.

A white sailing boat is the focal point of this nautical scene. However, the surrounding shapes and colours play an equally important role in the finished painting.

Negative shapes

Before starting work, take a good look at the subject. Forget you are looking at a boat and jetty. Imagine instead that you are seeing an arrangement of shapes and tones – an abstract composition rather than a recognisable subject. Start painting without doing a preliminary pencil drawing. Instead, paint the empty spaces, or negative shapes, around the boat as areas of flat colour. These spaces include the shadows, sky and sea.

Working without guidelines forces you to look hard to see where the shapes and colours fall in relation to each other. However, if you feel you really do need a few initial lines to help you, keep these to an absolute minimum. Sketch in the first few shapes, then abandon the pencil and concentrate on the painting.

It is also important to pay attention to the unpainted white shapes left between the painted areas. These are as much a part of the composition as the painted areas themselves. As the negative shapes are built up, the boat gradually emerges and becomes recognisable. With a few more details, a seemingly abstract design is transformed into a distinguishable seascape complete with jetty and distant trees.

▼ **Bold, crisp washes of watercolour, together with the striking use of exposed white paper, help to capture the feel of a bright, sun-filled harbour scene.**

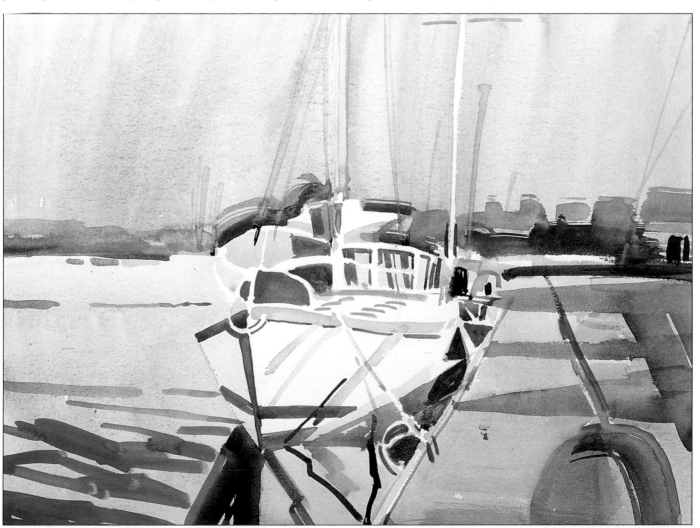

1 ▶ Block in the dark shapes Mix a very dilute wash of ivory black. Using a No.6 round brush, paint the dark shapes on and around the boat, including the background trees, the windows in the cabin, and the shadows on the boat and beside the jetty. When you have blocked these in, the hull will stand out as a clean white shape.

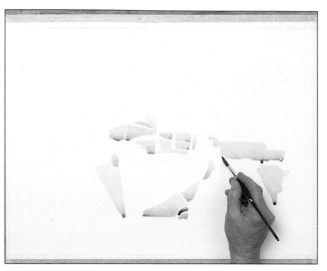

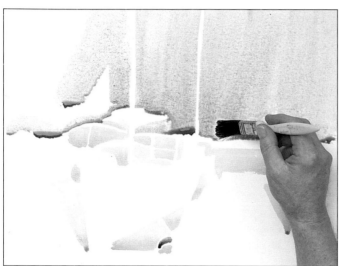

2 ▲ Paint the sky Change to a 25mm (1in) flat brush and paint the sky with a wash of cerulean blue and a touch of alizarin crimson. Leave the masts unpainted – you will find this easier if you apply the colour in vertical strokes rather than horizontal ones. Pick up any runs of colour by squeezing the brush dry and dragging it along the horizon.

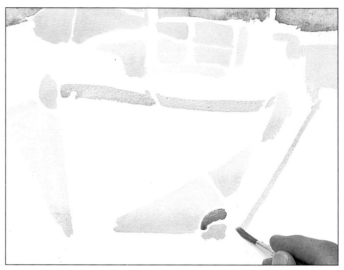

3 ▲ Add the wooden trim With a No.4 round brush, paint the wooden trim around the top of the boat in yellow ochre, remembering to leave white spaces for the mooring ropes. Still using the yellow ochre, paint a narrow line along the edge of the jetty.

▲ **Ultramarine, cerulean and Prussian blue are the main colours used for the sky and the sea.**

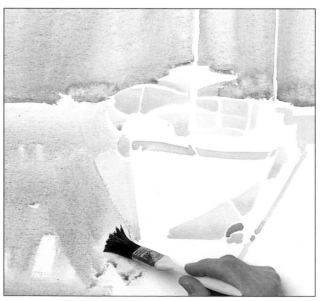

4 ◀ Continue with the blocking in
Paint the masts in yellow ochre, leaving a narrow band of white to represent the light on the main mast. Change to the 25mm (1in) brush and block in the sea with ultramarine blue. The sea should be lighter than the sky, so dilute the colour with plenty of water.

▶ **The bright stripes on the boat are painted in cadmium red, yellow ochre and ultramarine.**

5 ▼ **Add the details** Using the No.4 round brush, paint the foreground rope in burnt umber. Keeping the colour flat and strong, add a stripe to the hull in ultramarine blue. Continuing with the bright colours, paint the sail covers in ultramarine and the lower stripe in cadmium red.

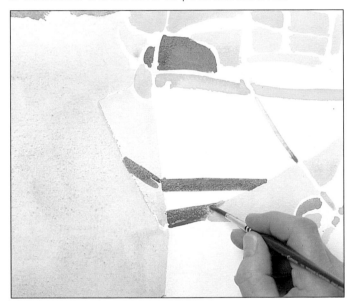

6 ▼ **Paint the hull** Still working in flat bands of colour, paint the trim on the shaded side of the hull and on the prow in burnt umber. Take the brush around the looped rope, using a continuous stroke to create a smooth, curved shape.

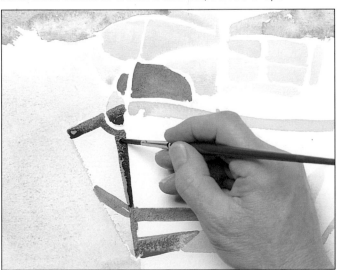

You can create a sense of distance in a picture by painting the background with light, textured brush strokes rather than as solid tone. Here the artist suggests the distant landscape by lightly dragging the background tone across the horizon using just the tips of the bristles.

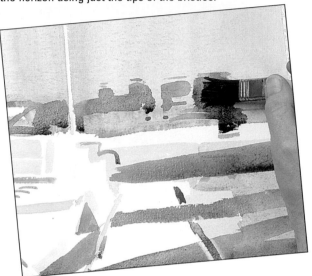

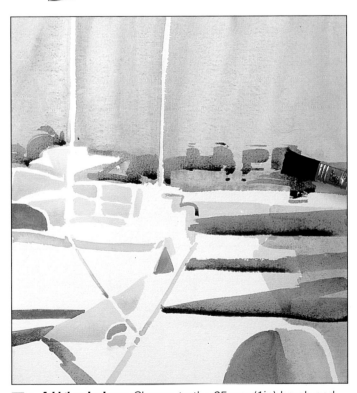

7 ▲ **Add the shadows** Change to the 25mm (1in) brush and paint the mid tones on the right of the jetty in ultramarine. Leave to dry. Add the shadows on the jetty, using a wash of ivory black. Working in loose, horizontal strokes, take the black into the distant landscape and trees. For the streaky texture of the trees, paint with the tips of the bristles only.

DEVELOPING THE PICTURE

Allow the painting to dry and assess the progress so far. The black wash has dried to a paler tone and will need to be strengthened.

8 ▼ Add details and develop tones Add a few more colourful details – yellow ochre in front of the cabin and a line of cadmium red along the jetty. Darken the shadows and background, using the black wash with a little Prussian blue added to it.

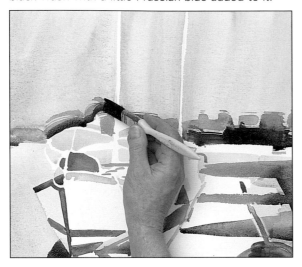

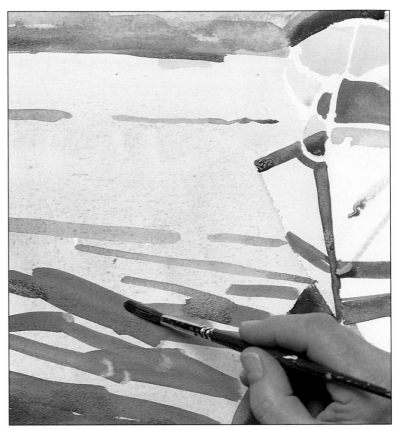

9 ▲ Paint the water Using the No.6 brush, paint the reflections and ripples on the surface of the water in Prussian blue. Use a little artistic licence and concentrate on conveying the shifting, abstract patterns rather than trying to achieve a realistic rendering. Paint these as flat angular shapes to harmonise with the rest of the composition.

Express yourself

Revealing shapes

Having gained enough confidence to work without a pencil line, try an even more abstracted version of a similar subject. Here, the unpainted boats and sails stand out as blocks of white against the negative shapes of the sky and sea. Buoys in bold red and yellow form colourful focal points.

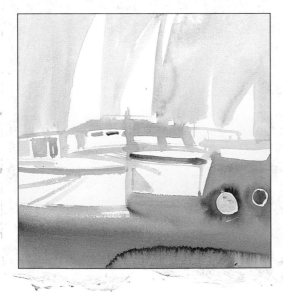

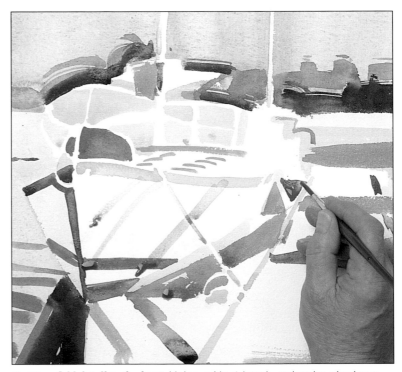

10 ▲ Add detail to the boat Using a No.4 brush, paint the shadows of the ropes on the hull with a watery mix of burnt umber and cerulean blue. Then add the floats and the ropes beside the mast in strong cadmium red.

194

11 ▼ **Paint masts and rigging** Strengthen the main mast with more yellow ochre, using the No.4 brush. Then indicate the masts of the distant boats with ivory black, using the tip of the brush to achieve fine lines. Paint the rigging ropes in the same way.

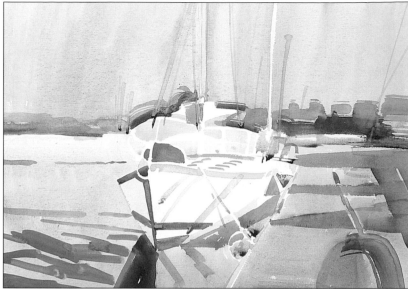

12 ▲ **Complete the jetty** Mix a wash of burnt umber and yellow ochre and use the 25mm (1in) brush to block in the jetty, working in light horizontal strokes to achieve an even effect. As you progress, paint over the cast shadows to warm them up a little. Fill in the shadow between the boat and jetty with a thin black wash.

Master Strokes

Claude Monet (1840-1926)
Argenteuil

In this oil painting by the French Impressionist Monet, the two reddish-brown boats attract the eye with their warm, strong hues set against the cooler blues and greens in the rest of the composition. Unlike the broad, flat areas of colour used for the scene in the step-by-step painting, the water and sky here are built up from spots and dashes of paint that create a lively texture.

The masts create a dramatic vertical element, linking the upper and lower halves of the picture.

The reflections of the boats in the river are worked as broken colour to suggest the rippling of the water.

The picture is now very near completion. As watercolours become lighter when they dry, it is a good idea to rework any earlier colours and tones that now appear pale and faded.

13 ▶ Develop the windows
Using the No.4 brush, darken the windows and hatch with burnt umber. Suggest reflections in the windows by leaving streaks of pale underpainting showing though the darker tone.

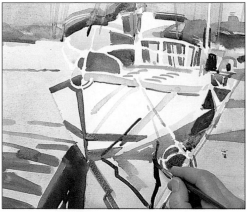

14 ▲ Strengthen dark tones Finally, check the painting for any colours and tones that might need strengthening. For instance, a strong black is used here to emphasise the darkest shadows on the boat and water.

THE FINISHED PICTURE

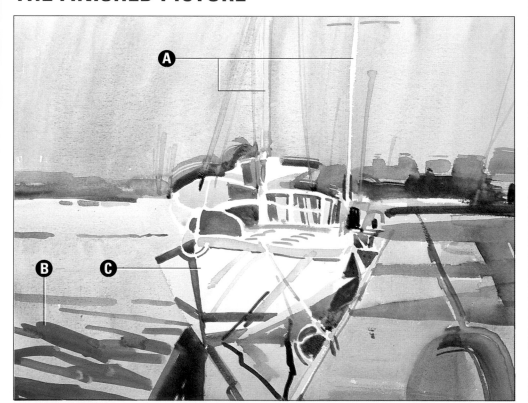

A Negative shapes
The sky plays an important role in this composition – two upright masts divide the sky area into three negative shapes, which echo the shapes of the water, the boat and the jetty.

B Angular reflections
The ripples and reflections on the surface of the water were brushed in as sharp splinters of colour, in keeping with the angular shapes and hard lines in the rest of the painting.

C White paper
The boat is left unpainted, its shape being defined by the water and shadows around it. Its bright whiteness has the effect of making the surrounding colours stand out.

Colours for skies

When you've perfected the sky, your whole landscape will come together – so it's well worth practising to get it right.

Trying to capture the ever-changing moods of the sky seems rather daunting at first – where do you start? The sky changes constantly, as the sun rises and sets and as atmospheric effects such as clouds, rain and mist move across it. But if you watch the sky regularly and make notes, practise using different media and familiarise yourself with colours and techniques, you'll soon have the confidence you need to render skies skilfully and convincingly.

Sky sketches

The great landscape painter John Constable (1776-1837) sketched the sky constantly, working in oils directly from the subject – a process he called 'skying'. On 23 October 1821, Constable wrote to his friend Archdeacon Fisher, emphasising the importance of the sky in landscape painting: 'That landscape painter who does not make his skies a very material part of his composition, neglects to avail himself of one of his greatest aids.... The sky is the source of light in nature, and governs everything.'

Follow Constable's example and study the sky as often as you can. Make notes about the location, time of day, season and weather conditions. This process will help you to understand what you are seeing when on location, and will enable you to reproduce sky effects in your work.

Sky relationships

The sky is the backcloth to the landscape and should relate logically to the rest of the painting. If the sky is bright

▲ This atmospheric sketch in oils, *Sky Study, Clouds,* is the result of one of Constable's numerous 'skying' expeditions. He believed that skies were supremely important, painting them again and again.

blue, the landscape should be sunny. Think about where the sun is and create shadows that are appropriate: small or non-existent if the sun is overhead, long and clearly defined if the sun is lower in the sky. If the sky is overcast and leaden, the tones in the landscape will be muted and shadows absent or indistinct.

Linking sky to landscape

A toned ground laid over the entire support will subtly modify the sky and the landscape and pull the two areas together. If you add tiny dabs of sky

colour to the landscape, as delicate touches or highlights, this will help to mirror the way in which light is constantly reflected from one area to another in nature.

The colour of the sky

The colour and brightness of the sky depends on factors such as the amount of cloud cover, the quantities of dust and water droplets in the air, and the position and strength of the sun. The sky is at its deepest blue between showers of rain, while on a beautiful summer's day it is often bright but not very blue because of the dust particles in the air.

To check the precise colour and tone of the sky, hold something blue or white up to it. You will find that generally the sky is brightest and whitest close to the sun, and that it often becomes paler again as it approaches the horizon.

The way you reproduce the sky will depend very much on the medium you are using and the style of your painting. In a cloudless sky, you need subtle gradations of colour and tone. You can achieve this in watercolour by laying a graduated wash, or in oil by working

▲ **A range of greys mingle with browns in this Constable study; the paint was applied loosely and the ground shows through.**

wet into wet to create subtle blendings. You can create skies of great depth and luminosity by applying layers of glazed and scumbled colour. You can even use a rich impasto, applying and smearing the paint with a knife – *Starry Night* by Vincent Van Gogh demonstrates the truly dramatic potential of impasto.

Special effects

Sunrise, sunset and special effects, such as rainbows, provide colourful spectacles – and each occasion is different. At sunrise and sunset, the sky is suffused with reds, oranges and yellows, which flow gradually into one another.

To describe these subtle transitions, use blending and wet-on-wet techniques. Clouds at sunset create emphatic shapes which are best painted wet-on-dry, or wet-on-damp in watercolour.

In the picture opposite, the artist Eugène Boudin (1824-98) has painted a sunny day on the beach at the seaside resort of Deauville in northern France.

KNOW YOUR SKY COLOURS

Cerulean blue
This warm blue has a slightly greenish tinge, useful near the horizon.

Prussian blue
A cold shade for rainy weather, Prussian blue also contains a hint of green.

French ultramarine
This deep shade is a warm violet-blue, perfect for sunny days.

Cobalt blue
Cobalt blue provides a good balance between warm and cold.

Payne's grey
A blue-grey, ideal for moody skies and storm clouds.

The clouds scudding across the sky give us a sense of the sea breeze.

The sky dominates the composition, occupying almost three-quarters of the canvas. The paint layer consists of thin veils of colour, which have been skimmed over the canvas so that the light itself seems trapped in a delicate web of atmospheric colours. The brush-work is soft, loose and informal, the most solid paint applications being reserved for the deep, intense blue of the sky at its highest point.

Sky moods

Despite the apparent simplicity of the subject, Boudin's painting is pervaded by a marvellous sense of space, light and airiness. If you visualise this sunny scene under a brooding, stormy sky, or gilded by the setting sun, you will see that by simply changing the sky you can create an entirely different picture.

▼ **One of Eugène Boudin's many beach paintings,** *Deauville, 1893*. **You can almost feel the blue sky and bracing air of a breezy day by the seaside.**

MIXTURES AND DILUTIONS

The colours you choose depend on the key of your painting, the effect you are trying to create and the appearance of the sky itself. So, for an intensely blue sky, you could use French ultramarine at the highest point, graduating through pure cobalt blue to cobalt blue muted with vermilion at the horizon.

Mix...

A range of warm greys can be very useful when painting cloudscapes.

Payne's grey + yellow ochre = = warm greys

Add a little vermilion to cobalt blue to create atmospheric muted violets.

vermilion + cobalt blue = = muted violets

...and dilute

Cobalt blue is a very useful sky colour. In watercolour, it can be diluted to create a range of tints. With other media, you can achieve a similar effect by adding white.

varying strengths of cobalt blue watercolour

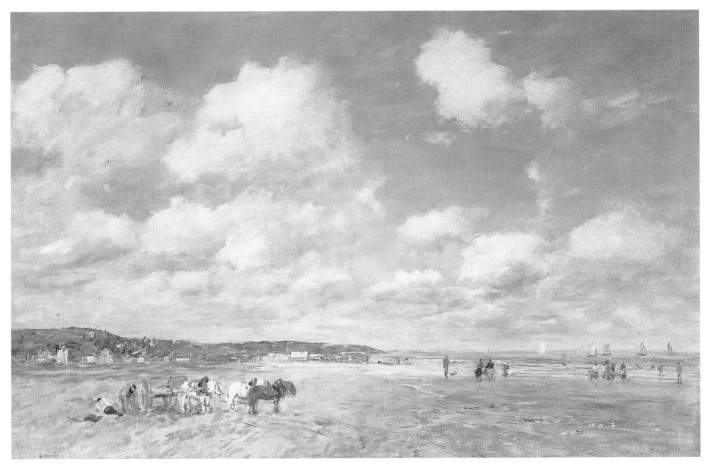

The drama of the sky

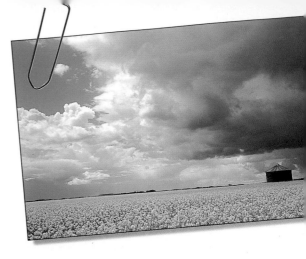

Watercolours aren't usually associated with textural marks. However, by mixing them with ordinary paper glue, you can create thick, exciting brush strokes.

Two hundred years ago, J. M. W. Turner (1775-1851) mixed flour paste with watercolour to paint atmospheric clouds and mists. This landscape has a similar drama, but here the watercolours are mixed with paper glue to make the colour thick and viscous.

Glue delays the drying time of the paint, allowing you to move the colour around on the paper. The thickened paint also retains the brush marks to give a good texture. Alternatively, by adding water to the mixture, the colour can be spread thinly and flatly.

Which glue?

For this technique, use the paste-type, liquid paper glues available at stationers – Gloy is a well-known brand. Water-soluble glues are particularly good – if you make a mistake, you can simply wet the area and wipe the colour away.

For pale colours, use only a touch of paint with the glue – about 5% watercolour is a good starting point. Increase the paint-to-glue ratio for stronger colours. Most of the colours in this image were about 20% paint and 80% glue. However, this is by no means an exact recipe. The best method is to pour some glue next to the colours on your palette and mix the two until you get the desired result.

As creative expression is the name of the game when using glue, the artist took a few liberties with his reference photo, including adding some bright red flowers.

▶ Using watercolour with glue allows you to emphasise the brush strokes – as if you were working in oils or acrylics.

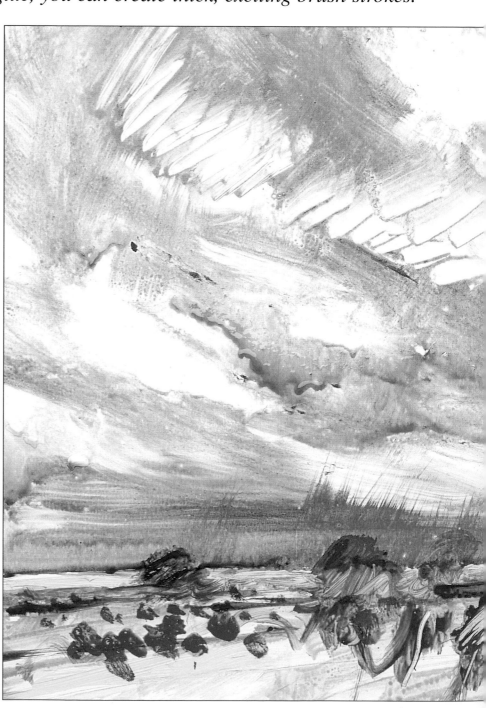

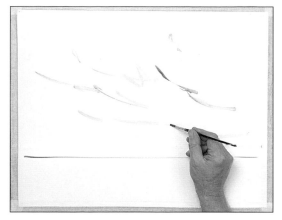

1 ◄ Paint the basic outlines Make a well-diluted wash of cerulean blue and water. Using a No.4 soft round brush, mark the position of the horizon and paint in the main cloud formations.

2 ► Start painting the sky Mix mauve and ultramarine with plenty of glue – the ratio here is about one part colour to four parts glue – then add enough water to make the mixture easy to spread. Using a 25mm (1in) decorator's brush, establish the cloudy sky in free sweeps.

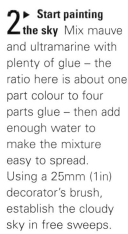

EXPERT ADVICE
Mixing glue and paint

Mix the watercolour paint and glue on a white palette or dish. Against a white background, you can control the strength and transparency of the mixture more easily and assess how dark or pale the colour will appear on the white paper. Note that using glue and watercolour on their own produces a stiff mix, suitable for highly textured work. For general brushwork and washes, dilute the mix with water.

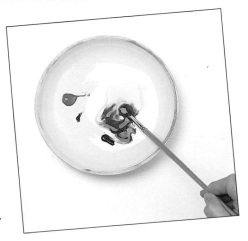

3 ▼ Add pure blue Still working with lively strokes, dip the brush in water and spread the sky colour unevenly across the paper. Mix ultramarine with glue and water and add diagonal streaks across the centre of the sky.

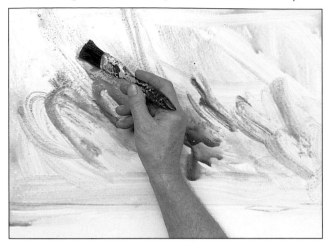

4 ▲ Establish the horizon Start to build up the colour in the lower part of the sky by painting a strong mixture of Prussian blue and glue along the horizon line.

5 ◄ Develop the sky Put a large blob of the Prussian blue and glue mixture in the middle of the sky. Use a crumpled paper tissue to smear the paint upwards and outwards to create an eruption of colour spreading from the centre of the picture.

6 ▲ Use a dry brush Start to manipulate the wet, viscous colour to give a turbulent, windswept effect. Use a dry decorating brush and drag it across the sky to create shafts of diffused sunlight.

7 ◄ Define the clouds Using a clean, dry No.12 stiff flat brush, work further into the wet colour with short, stubby strokes. This reveals the white paper to suggest light on the clouds. If the colour has already begun to dry, simply wet the area with a little clean water before using the dry brush.

CORRECTING MISTAKES

By using water-soluble glue, you can dissolve and remove mistakes even after the painted surface has dried. Here, clean water is applied to dissolve the dry colour before removing it with a brush or tissue.

TROUBLE SHOOTER

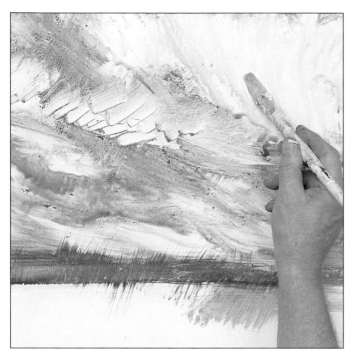

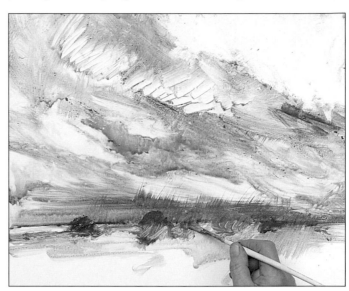

DEVELOP THE PICTURE

Now that the sky is complete, move on to the landscape, painting it in clear, bright colours with lively, textural strokes.

8 ▲ **Remove colour** Wet the top right-hand sky area and use the dry bristles of the No.12 flat brush to wipe off the colour, creating a large white cloud.

9 ▲ **Add the distant landscape** Mix pale green from lemon yellow and a little sap green. Add glue and paint this along the horizon with a No.4 stiff flat brush. Mix a deeper green from ultramarine and lemon yellow and add a few trees.

Master Strokes

Nicolas Roerich (1874-1947)
Skyscape

While Roerich paints the receding hills with flattish colours, he makes the clouds into fully modelled, sculptural forms. Indeed they seem to be more solid than the land. The resulting effect is rather menacing – almost as if we are looking at an alien world.

The brown clouds in the distance take on the appearance of upturned hills – almost as if the landscape is reflected in the sky.

To convey distance, aerial perspective is used – the hills get progressively bluer in the distance.

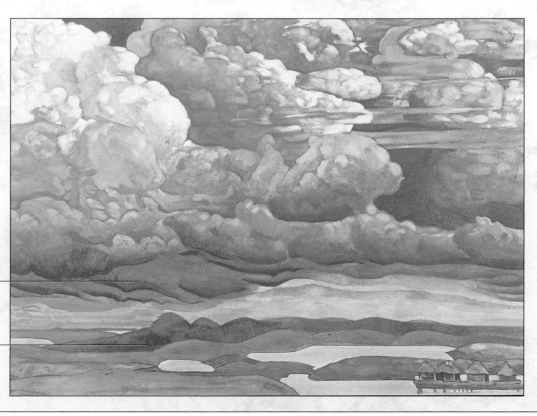

10 ▶ Paint the foreground grass

Make a dilute mix of lemon yellow with a touch of ultramarine to create a light lime green. Using long, sweeping horizontal strokes, paint the grass right across the foreground.

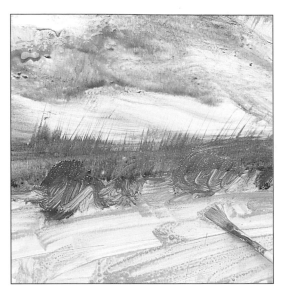

A FEW STEPS FURTHER

As it stands, the painting could be considered complete – a dramatic landscape with a turbulent sky and windswept fields. However, you might wish to add a little more colour, giving an indication of the yellow flowers in the field and perhaps also adding some red ones for variety.

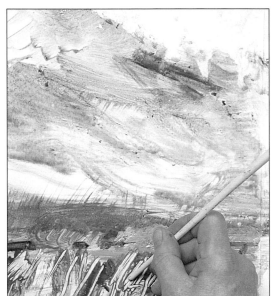

11 ◀ Scratch in some texture

Paint long vertical streaks of grass, using the deep green tree mixture from step 9. While the colour is still wet, use the tip of the brush handle to scratch bold, scribbled texture into the grass.

Express yourself

Washes of watercolour

This sketch shows how different sky effects can be achieved by using watercolours without glue. The loose, stretched-out washes of paint capture the blustery atmosphere in a very immediate way. The dark grey shapes in the distance have been applied wet-in-wet and give the impression of distant trees.

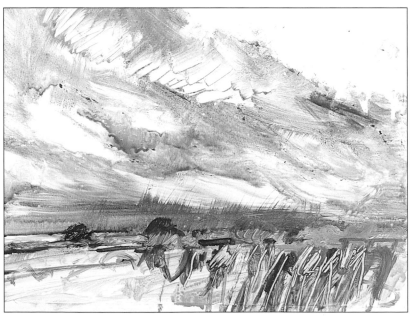

12 ▲ Finish the foreground
Complete scratching back the grass, and allow the painting to dry before moving on to the next stage.

13 ▼ **Paint sunlit fields** Using the No.6 stiff flat brush, mix lemon yellow with a little glue and apply this in broad horizontal strokes to depict light on the fields. Add a few dabs of thick lemon yellow for the flowers.

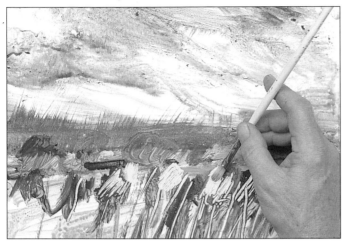

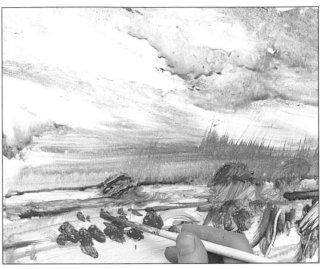

14 ▲ **Add red flowers** Finally, mix cadmium red with a little glue and dot in clusters of poppies to show up against the yellow and green grass.

THE FINISHED PICTURE

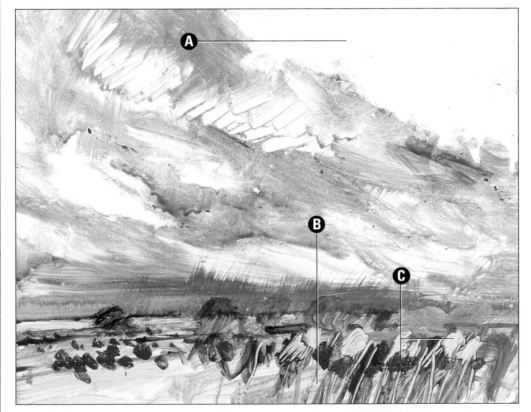

A Revealed white
A dry brush was used to wipe back wet colour in the sky, revealing pale clouds and creating a sense of movement.

B Sgraffiti
Long grasses were scratched into the viscous colour with the tip of the brush handle, creating lively texture in the foreground.

C Pure colour
Many of the colours are used unmixed. For example, the flowers are painted in pure lemon yellow and cadmium red.

Shades of autumn

Focus in closely on this arrangement of shiny, brown horse chestnuts and mottled autumn leaves to explore their colours and textures.

The horse chestnuts in this water-colour look real enough to pick up and put in your pocket, but beware of overworking your painting to get a realistic effect. A lifelike impression does not mean you have to make a slavish copy of what is in front of you.

For a truly naturalistic result, do as our artist did when working on this autumnal arrangement: keep the colours and brushwork as fresh and lively as possible to match the natural freshness of what you are painting. In addition, refer constantly to the subject. In this way, you will pick up subtleties of shape and colour which will be transferred to your painting.

Wet-on-wet

Dramatic runs of colour in the red and green leaves were achieved by working wet-on-wet. Paint was dropped on to wet paper and the colours were allowed to run together and find their own way into the watery shapes.

From the very early stages, the artist encouraged the pigments in the wet colours to separate and form random textures and watermarks. The effect of this separation – or granulation, as it is sometimes called – is noticeable in the slightly dappled texture on the leaves.

The crisp outlines of the husks and horse chestnuts called for a different approach. For these hard edges, it was necessary to work wet-on-dry, which meant first allowing the surrounding colours to dry completely.

▶ **Bold washes on the leaves are balanced by the precise shapes of the chestnuts.**

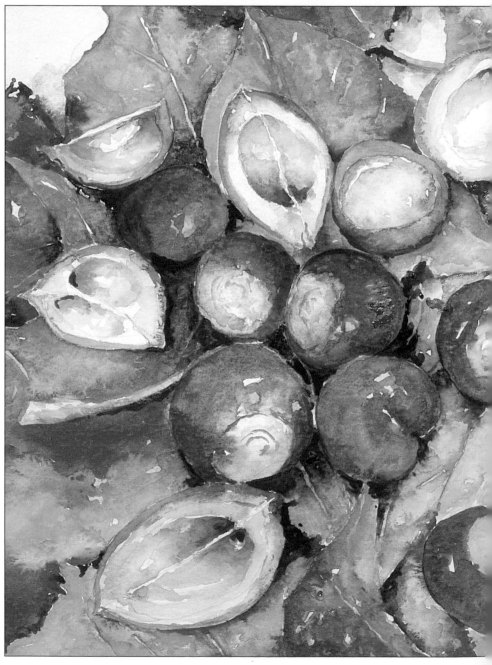

Sheet of 555gsm (260lb) Not watercolour paper 46 x 41cm (18 x 16in)

2B pencil

10 watercolours: Raw sienna; Burnt sienna; Sap green; Cadmium yellow; Scarlet lake;

Cadmium orange; Burnt umber; Ultramarine; Raw umber; Alizarin crimson

Brushes: Nos. 16, 6 and 1 soft rounds

Mixing dish or palette

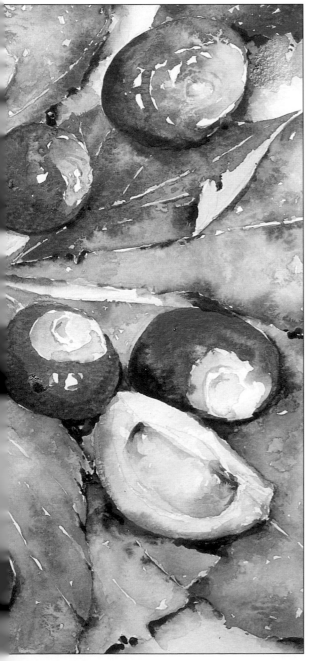

FIRST STEPS

1 ▶ **Make an outline drawing** Using a sharp 2B pencil, make an accurate drawing of the subject. Extend the image right out to the edges of the picture area.

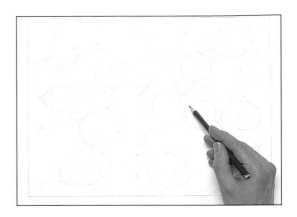

2 ▼ **Paint a wash** Apply a very dilute wash of raw sienna with a No.16 round brush. Take the colour across the whole picture area, but paint around the white husks and the highlights on the horse chestnuts. These should be left as unpainted shapes of white paper.

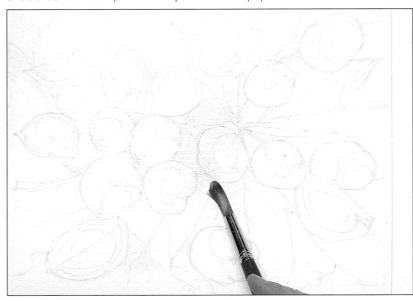

3 ▼ **Paint wet-on-wet leaves** While the raw sienna wash is still slightly damp, change to a No.6 round brush and drop dilute burnt sienna into the reddish areas at the edges of the leaves. The colour should run slightly to form soft edges around the brush strokes.

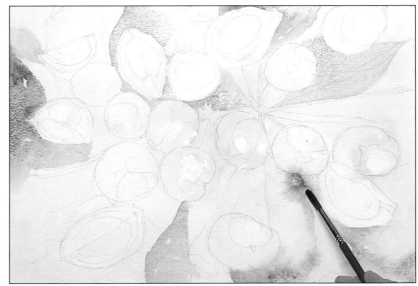

4 ▶ Add the green
Apply sap green with touches of cadmium yellow and raw sienna to the centre of the leaves. As the initial wash begins to dry, change to a No.1 round brush and define the edges of the leaves with burnt sienna.

▲ **Fresh green for the leaves is mixed from raw sienna, sap green and cadmium yellow.**

5 ▶ Strengthen the colour Pick out the brighter reds on the leaves with a dilute mixture of scarlet lake, cadmium orange and burnt sienna. Work around the veins in the leaves, leaving these as unpainted lines of paler undercolour. Paint the shadows in a more concentrated version of the same mixture.

6 ▼ Add detail Returning to the green leaf colour – sap green with cadmium yellow and raw sienna – start to develop the detail in the leaves on the right-hand side of the painting. Paint the darker shadows by dropping small amounts of burnt umber into the wet green, referring constantly to the subject to make sure the colour goes in the correct places.

7 ▼ Add leaf shadows Continue building up the colours and tones on the leaves, adding a little ultramarine to the raw umber for the deepest shadows.

8 ▼ Blend the leaf colours Starting at the top of the painting, continue
to build up the leaves in the basic green and red mixtures. It is impor-
tant to keep the colours damp enough to blend the red and green areas
together and avoid hard edges. If the colours become too dry, you
might need to dampen the area you are working on with a little clean
water to encourage the colours to merge and form soft edges.

EXPERT ADVICE
Granulation effects

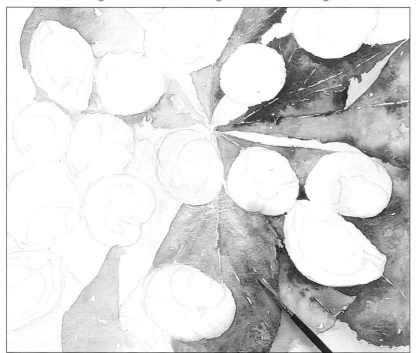

To encourage granulation, drop pure water on to
wet or damp colour. The water lifts the pigments,
which then settle and dry to form characteristic
textures and watermarks.

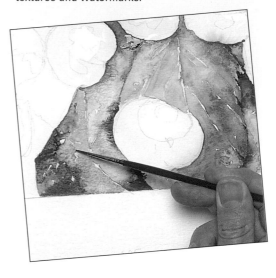

9 ▼ Introduce texture Continue to block in the leaves using
the red and green mixtures. Try to vary the textures and
tones by dropping a little clean water into areas of wet colour
(see Expert Advice).

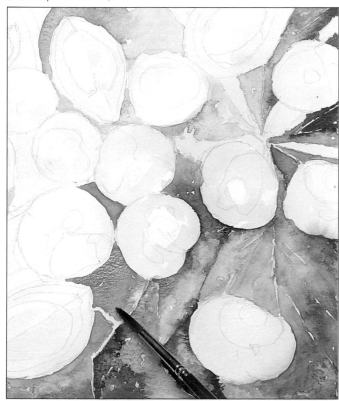

10 ▲ Build up dark tones Paint the deep shadows around
the husks and horse chestnuts in strong mixtures of
sap green, ultramarine and burnt sienna. These dark tones
help to produce a three-dimensional effect, creating a sense
of space in the picture.

11 ▼ Dot in more shadows Continue to develop the light and dark tones on the background leaves. Here, a cluster of red leaves is painted in varying strengths of burnt sienna, alizarin crimson and scarlet lake. Add a little burnt umber and ultramarine to these colours and use this to dab in the dark shadows around the husks and horse chestnuts.

◄ **Earth colours on the horse chestnuts and husks include burnt sienna, raw sienna and burnt umber.**

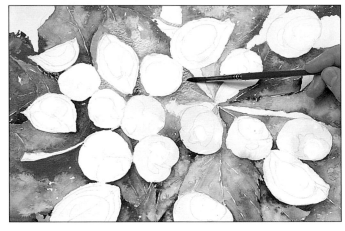

12 ▼ Adjust the tones Using the No.6 round brush, block in any remaining unpainted leaves. Take an overall look at the painting and darken any earlier shadows that might now appear pale compared with the recently painted deep tones. Allow the painting to dry.

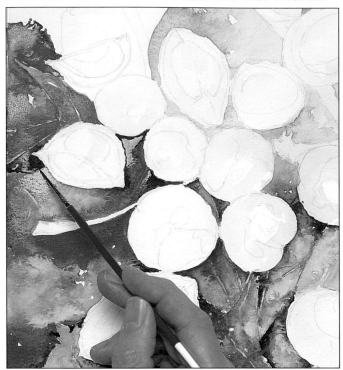

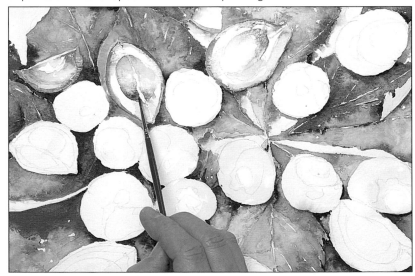

13 ▼ Define the white shapes With the No.1 round brush, touch up any incomplete shadows around the husks and horse chestnuts. Take this opportunity to define the unpainted shapes prior to blocking in the local colours.

DEVELOP THE PICTURE

The background leaves are now established and it is time to block in the rest of the painting. Remember to work around the pithy areas on the husks and the reflections on the horse chestnuts – these will remain as unpainted white shapes in the finished painting.

14 ▲ Start painting the husks Working from the top of the composition, paint the shadows inside the husks in dilute raw sienna. Drop a little burnt sienna into the wet colour and allow this to spread. Build up the shadows and describe the concave shapes in tiny, stippled strokes of burnt sienna. Mix burnt umber, burnt sienna and a little ultramarine and use this for the darkest shadows on the inside of the husks.

15 ▼ **Build up the shadows in the husks** Moving to the husks in the foreground, paint these using an initial wash of cadmium yellow with a touch of raw umber. Build up the shading on the concave curves in small dabs of burnt umber and a little ultramarine. When you have finished painting the husks, allow the picture to dry.

16 ▲ **Paint the horse chestnuts** Start to paint the horse chestnuts, beginning with the cluster at the centre of the composition. Dampen the shapes with clean water, taking the water precisely up to the edges of the fruit, but avoiding the highlights and the pale seed scars. Drop burnt sienna on to the damp area, allowing the colour to run into the wet shape.

Master Strokes

W. S. Goodwin (*fl.*1894-1923)
Odd and Even (Pears)

The pears in this still life have a misshapen appearance that gives character to the arrangement. Their strange forms and blemishes are captured in detail – dark tones help give a sense of the deep hollows, while creamy, white paint captures the light glinting off the curves. As in the step-by-step project, colourful leaves enhance the autumnal feel of the painting. The rich, dark background throws the still life forwards, creating a sense of recession.

Specks of paint dabbed on with the tip of a fine brush build up a dappled effect on the pears.

The reds, golds and browns used for the leaves blend subtly into one another, giving realistic, graduated colour.

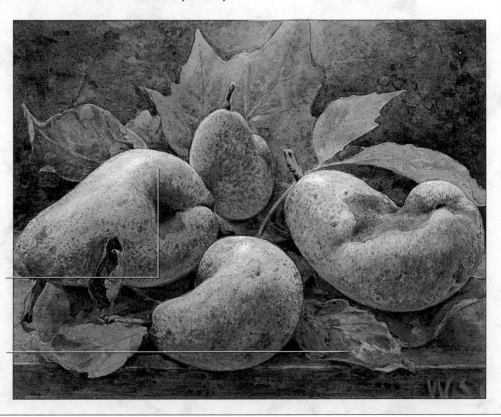

17 ▶ Describe the forms Wait until the flooded colour is almost dry. Use tiny, stippled strokes of burnt sienna to build up the darker areas of colour on the horse chestnuts. Working closely from the subject, take the shadows around the curved forms to emphasise their solidity and roundness.

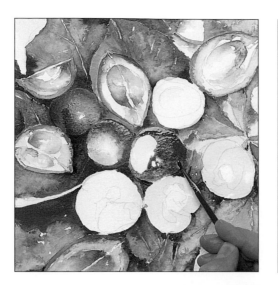

A FEW STEPS FURTHER

The painting is almost complete. However, a little more work on the darker tones and shadows will give a greater sense of depth and make the subject appear even more realistic. Remember, no two shadows are the same, so it is important to work closely from the subject.

18 ▼ Tone down the whites Lightly wash over the pale seed scars with very dilute mixtures of burnt umber and burnt sienna. Leave tiny flecks of white around the scars to separate these areas from the surrounding darker colours.

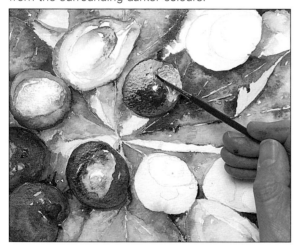

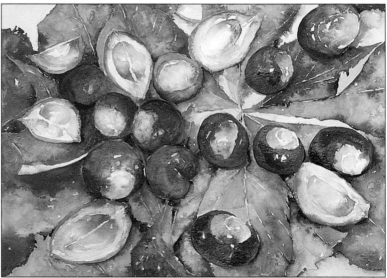

19 ▲ Complete the blocking in Working across the composition, paint the remaining horse chestnuts in burnt sienna and block in any remaining unpainted areas. Allow the work to dry.

Express yourself
Experimental leaves

Before embarking on a complicated composition, why not experiment with wet-on-wet techniques on some simple leaf shapes? Start by making outline drawings of one or two interesting leaves – those beginning to turn red in the autumn have particularly exciting colours. Wet the leaf shapes, leaving the veins and highlights as dry patches. Drop paint on to the damp areas, then watch the colours as they find their own way into the wet shapes, creating a natural-looking, mottled surface.

20 ▼ **Add final shadows** In varying mixtures of sap green, raw umber, raw sienna and ultramarine, add the darkest shadows around the horse chestnuts and the husks.

21 ▲ **Complete the husks** Strengthen the shadows inside the husks in mixtures of raw umber, burnt sienna and raw sienna. Build up the graded tones in tiny dots of colour, blending these to describe the rounded, concave shapes.

THE FINISHED PICTURE

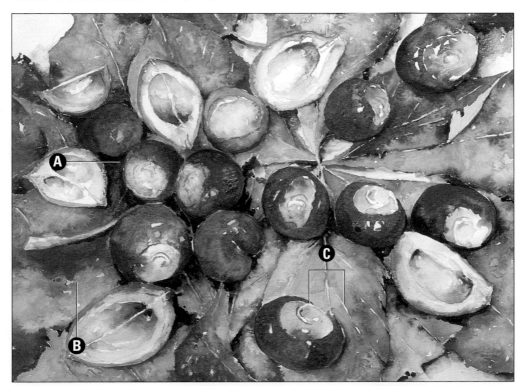

A Dark tones
Deep shadows emphasise the solid forms and create distance between the horse chestnuts and husks and the background leaves.

B Merging colours
Reddish-brown and green mixes were allowed to run into each other to give an effect of autumn leaves on the turn.

C White paper
Leaf veins, highlights on the horse chestnuts and other white areas were left as unpainted patches of paper.

French street in watercolour

Using warm yellows, ochres and crimson, layers of watercolour are built up to create the buildings in this quiet corner of a French town.

Buildings, both old and new, can be fun and challenging to paint.

Looking at the angles

The artist has based her painting on a photograph of the small town of Soubes, near Montpellier in the south of France. The viewer is separated from the scene by the railings running right across the foreground, but the eye is drawn into the picture and down the street by the buildings that sweep in from the right and stretch away to the left.

To capture the angles of the buildings and to achieve a convincing sense of perspective, the artist took time over her preparatory drawing. She sketched in plenty of pencil guidelines running along the buildings towards their respective vanishing points on the hori-zon. She then used these to help her place the windows and doors correctly.

The way in which the paint is used enhances the sense of depth. The build-ings and their architectural features at the end of the street are merely suggest-ed with a light wash of colour, and this blurring helps to create the effect of the scene stretching away into the distance.

Creating a sense of place

The building on the right and the stone wall supporting the railings in the fore-ground have a real sense of solidity in this painting. The artist has created this impression by building up layers of colour. A light wash with a pale Naples yellow lays the foundation, then darker but still warm tones are flooded in as the painting progresses.

Selecting details

The artist has not included every detail of the original scene. Instead, she has looked for the elements that capture the sense of place: the shutters, the railings, the electric cables that snake around the buildings and hang across the street. In fact, in order to emphasise the continen-tal feel even more, she decided to replace the flat balcony railings on the side buildings with more decorative, curved ones.

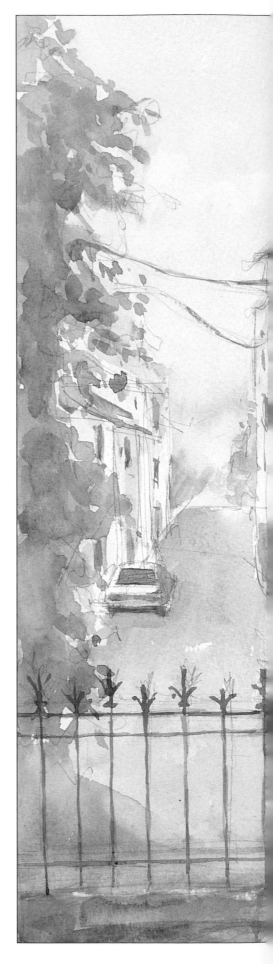

▶ **Wrought-iron railings, colourful shutters and a rounded archway are distinctive architectural features in this painting.**

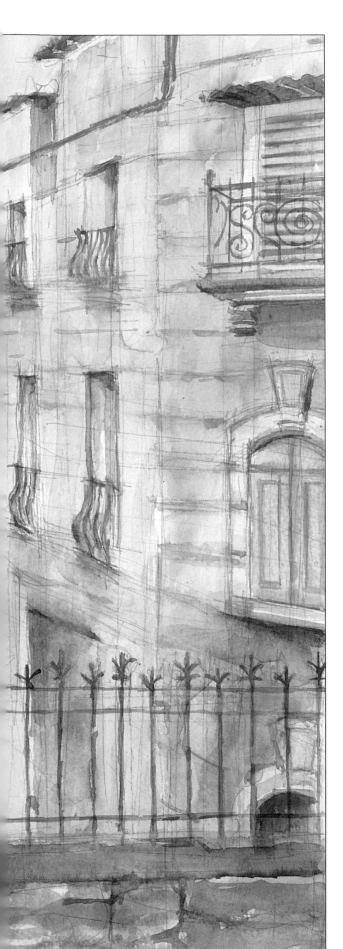

Piece of 300gsm (140lb) watercolour paper 44 x 38cm (17½ x 15in)

Retractable pencil

12 watercolour paints: Naples yellow; Burnt sienna; Alizarin crimson; Payne's grey; Lemon

yellow; Raw sienna; Hooker's green; Cadmium yellow; Cerulean blue; Burnt umber; Cobalt blue; Cadmium orange

Brushes: Nos.10 and 5 rounds

Paper tissue

1 ▶ Sketch the scene
Use a retractable pencil to make a fairly detailed sketch of the scene. Spend some time on getting the perspective right. The building at the front is at an angle and so has a different vanishing point from the buildings next to it. Pencil in perspective lines on the windows of these buildings, with the lines going off towards their vanishing points. You can always rub out these lines later.

2 ◀ Wash over the buildings Using a No.10 round brush, lay a wash of Naples yellow over the front building. Flood in a mix of burnt sienna, alizarin crimson and Payne's grey. Add lemon yellow to this mix to vary the colour.

3 ▶ Block in other areas Wash lemon yellow over the left-hand houses and into the distance. Paint the road with Payne's grey, then continue with this colour along the foreground wall. Rough in the stonework with the Payne's grey and burnt sienna. Add raw sienna to the left-hand buildings and wash it over the tree foliage.

4 ◀ Add building detail Dilute the dark mix from step 2 and use it to add some colour to the building at the front. With burnt sienna and a No.5 round brush, paint in some lines on the stonework up to the corner of the building. This will enhance the sense of perspective. Soften the lines with water if they look too stark.

6 ▲ Paint the shutters Use the No.5 brush and diluted cerulean blue to wash over the shutters on the front building. If the paint drifts, use paper tissue to pick up the excess. Using less diluted paint, add horizontal lines to the top shutter and some detail to the bottom shutters.

5 ▶ Paint the tree Mix Hooker's green with a touch of cadmium yellow. Using the No.10 brush, dilute the mix and paint the foliage of the tree, feeding in more yellow as you work from top to bottom. Add a touch of Payne's grey to the mix and dab wet-on-wet over the foliage. Use diluted Payne's grey to drift a shadow from the bottom of the tree.

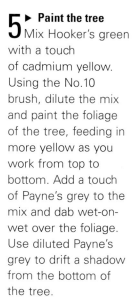

7 ▲ Work on the front building Use burnt sienna, alizarin crimson and Payne's grey to work up the small roof over the top shutter. Use light and dark tones to bring out the detail. Sketch the balcony with the same mix. Build up the stonework and strengthen the shadows around the windows.

Master Strokes

Martiros Sergeevich Sar'Yan (1880-1972)
A Street, Midday, in Constantinople

In this unusual painting, worked in 1910, the effects of perspective and colour in the composition are striking. The rooftops cut into the sky, creating an abstract blue shape that is echoed by the similar orange shape of the road below. Blue and orange, being complementary colours, set up an exciting and vibrant visual effect and make the shadowy buildings on either side of the street appear even darker and more mysterious.

Sunlight catching the rooftops is shown with bands of the orange used for the road, visually linking the top and bottom of the painting.

Robed figures appear as simple dark silhouettes set against the glowing orange of the road. Like the buildings, they are worked in perspective.

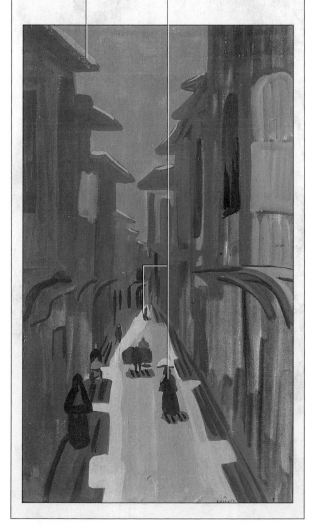

8 ▶ Work on the side buildings Use the dark mix from step 7 with a touch more crimson to paint the roofs along the side buildings. Add highlights with raw sienna. Continuing with the crimson mix, mark in some of the windows along the side buildings – first use a wash, then put in detail and shadow under the balconies with heavier colour. Paint the cables using the same mix.

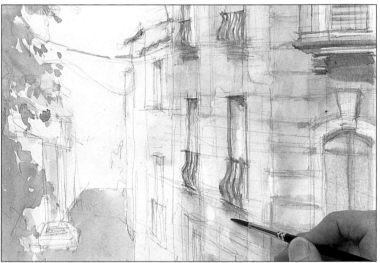

9 ▲ Add architectural detail Use a mix of burnt umber and Payne's grey to paint the balconies. Wash in the door at the bottom with diluted crimson, then dot crimson into the shadows under the balconies to lift the colour here and prevent it looking muddy.

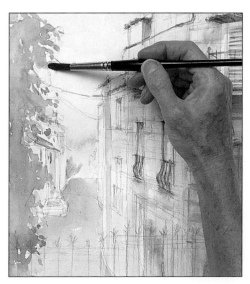

10 ◀ Build up the distance Touch in the roofs of the houses on the left with crimson, adding windows with burnt umber. Strengthen the lemon yellow in the distance. Use the No.10 round brush and a diluted wash of cerulean blue to paint the sky, putting in a touch of cobalt blue where the sky meets the horizon.

11 ▶ Build up detail

Mix Hooker's green with cobalt blue and dot detail into the tree. With Payne's grey and the No.5 brush, paint the base and window of the car. Dilute the Payne's grey to add windows and balconies on the side buildings. Mix Payne's grey and burnt umber to paint the arch at bottom right, using crimson in the archway. Wash raw sienna over the first side building, then add a door and a shadow in crimson.

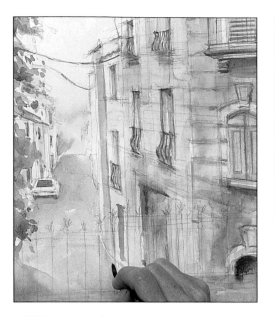

Express yourself
A pale palette

Still using watercolours, the artist worked the scene again, this time with a lighter palette. In this version, the railings in the foreground are white rather than black – this was achieved by painting them with masking fluid, which retained the white paper while the surrounding colours were applied. Being pale, these railings seem less of a barrier to the viewer than the black ones.

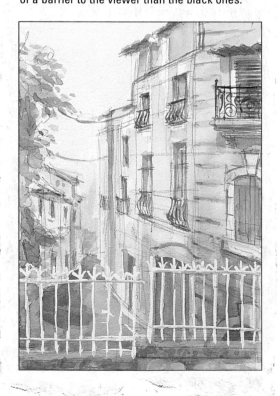

12 ▶ Paint the foreground

Strengthen the crimson door with burnt umber. Use Payne's grey to paint the decorative railings in the foreground. With crimson and raw umber, work on the stone wall below the railings. Add raw sienna to warm up the stones and outline some of them with Payne's grey.

A FEW STEPS FURTHER

The picture is now almost complete, but there is still room for some creative detail on the metalwork of the right-hand balcony. The foreground wall and the railings above it would benefit from stronger treatment, too.

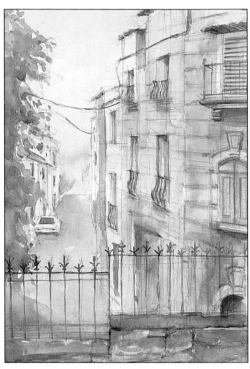

TROUBLE SHOOTER

LIVELY WIRES

When painted in a dark brown shade, the cables appear to sink into the building and look like part of the stonework. Use a bright cadmium orange to help them stand out. The cables hanging across the road are worked in the darker mix.

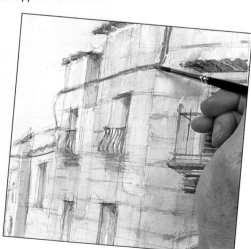

13 ▶ Add details
Mix cobalt blue and Payne's grey to paint a shadow under the car. Wash in a tree at the end of the street with diluted green. Paint Naples yellow along the bottom of the railings. Then strengthen the railings with Payne's grey and the brick wall with the colours from step 12.

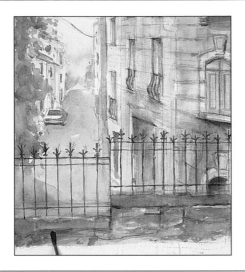

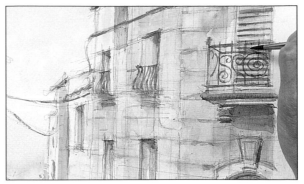

14 ▲ Add the balcony pattern Make a dry mix of burnt umber and crimson and outline the pattern on the top balcony. Finally, flood a little crimson over the wall to strengthen the colour here.

THE FINISHED PICTURE

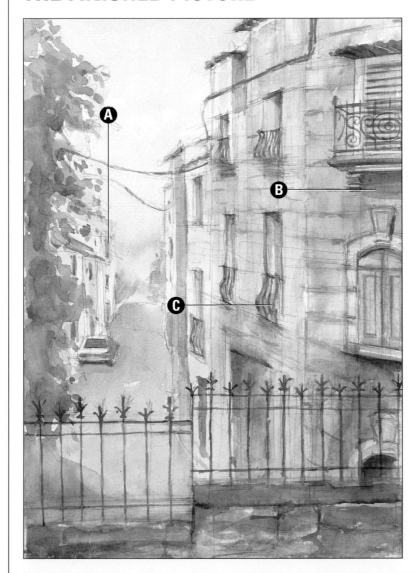

A Aerial perspective
The buildings at the end of the street were painted very roughly and loosely to create the illusion that they are farther away.

B Build up layers
Layers of watercolour were gradually added to the buildings as the painting progressed to create a feeling of architectural solidity.

C Work creatively
The straight balcony railings were changed to curved ones to make them look more decorative. This subtle alteration enhances the continental atmosphere of the painting.

Creating texture in watercolours

Break with convention by adding textural interest to your watercolours with scored and scraped lines.

Bristol board is an unusual surface for watercolour painting – it is not generally recommended because it has a smooth, slippery surface on which washes dry unevenly. However, the technique used for this painting – textural marks are scored into the paper with a knife before washes are applied – is itself unorthodox and Bristol board is the ideal surface for this technique.

Scoring the surface

This still life features objects with a variety of textures and patterns. Such an intricate subject can be difficult to paint without overloading the picture with detail, but the artist has overcome this problem by using the scoring method to suggest detail and texture. The technique is like *sgraffito* in reverse – instead of scratching through a painted area to reveal the white paper beneath, you score the paper to make indents in the surface and then apply colour over it.

This process reveals the more absorbent paper beneath the smooth surface coating of the board, so that the scored lines appear darker than the surrounding washes. The channels made by the knife, and the bumps created by roughing up the surface, become integral parts of the finished painting.

Choice of blade

Almost any type of sharp metal point, such as a penknife, craft knife or scalpel blade, can be used to score the lines, as long as it cuts easily through the board without slipping. A saw-tooth blade dragged across the surface is useful for making hatched and crosshatched lines and for suggesting rough textures. Always be careful when drawing with a sharp instrument – never place your free hand in the path of your drawing hand.

▶ **Chosen for their textural qualities, the objects in this still life make an ideal subject for the scoring technique.**

YOU WILL NEED

Piece of Bristol board
45 x 60 cm (18 x 24in)

Brushes: Nos.4 and 2 soft
rounds; No.10 flat wash
brush

9 watercolours: Ultramarine;
Yellow ochre; Burnt umber;
Ivory black; Sap green;

Viridian; Alizarin crimson;
Cobalt blue; Cadmium yellow

Mixing palette or dish

Jar of water

Saw-tooth blade

Penknife, craft knife or
scalpel blade

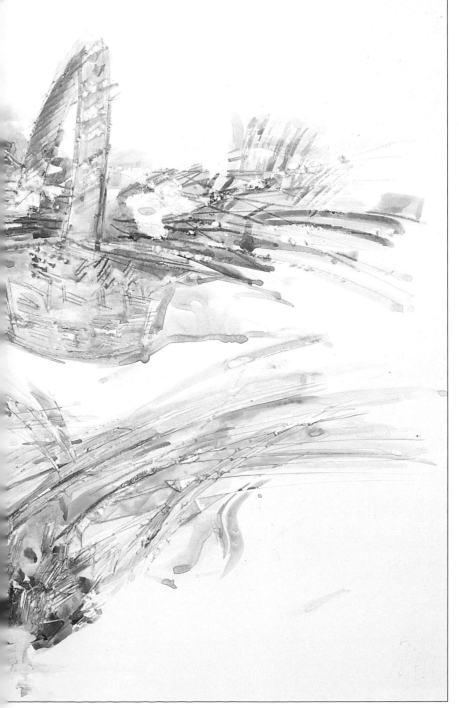

FIRST STROKES

1 ▲ **Draw with a brush** Using a No.4 soft round brush, rough in the main outlines of the still-life group with a dilute wash of ultramarine. Don't worry too much about accuracy – try to express the exuberant lines of the subject.

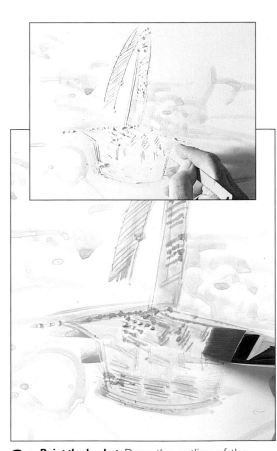

2 ▲ **Paint the basket** Draw the outline of the basket by scoring the surface of the board with the sharp point of a saw-tooth blade. Then suggest the woven pattern of the basket by scoring short, angular lines into the paper, using both the point and the teeth of the blade (see inset).

Then mix a wash of yellow ochre and wash this lightly over the basket with a No.10 wash brush. The paint darkens where it sinks into the indents made by the knife and catches on the roughened paper. Leave to dry.

DEVELOPING THE PICTURE

It can be difficult to see where the scored lines are on the white board, so the best way to proceed is section by section. Score one area of the picture and paint it before moving on to score and paint the next.

3 ▶ Score and paint
Use the blade to score lines that suggest dried flowers and teasels in the basket. Work around the shapes of the white flowers. Mix a wash of burnt umber and sweep it over the dried flowers. Again, the paint darkens where it sinks into the scored marks.

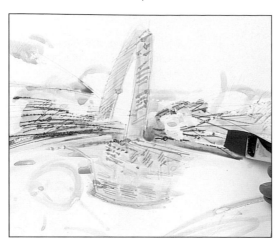

4 ◀ Score the alliums
With a penknife or craft knife, score fine lines at bottom left to show the allium seed-heads. Scratch tiny parallel lines for the seed capsules. Mix a pale wash from ivory black and ultramarine and brush over the seed-heads with the wash brush to reveal the delicate stalks and seeds. Allow to dry.

5 ▼ Work on the corn Now change to a saw-tooth blade. Use the tip and teeth to score a series of short zig-zag lines into the board to suggest the heads of corn lying next to the allium seed-heads. Brush over the lines with a thin wash of yellow ochre to reveal the scored lines.

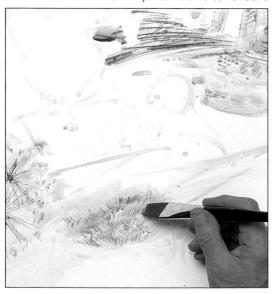

6 ▶ Add the thistle stalks Use the knife to score the long corn and thistle stalks. Suggest the texture of the thistle heads by scoring short parallel lines at varying angles. Paint a thin layer of sap green over the stalks with the wash brush. Go over the darker stalks with a wash of viridian, letting the light and dark greens mix loosely.

KNOW THE SCORE

These examples show the range of textural effects you can achieve with scored marks. Thick lines were made with a saw-tooth blade, finer ones with the tip of a penknife.

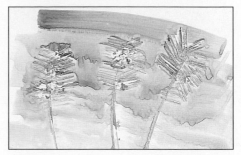

Heads of corn

Basket weave

Dried flowers

7 ▲ Add some purples Paint the red onion in the centre with a purple made from alizarin crimson and cobalt blue, loosely mixed. Let the colour settle in pools of light and dark tone that give form to the onion, and leave a white highlight near the top. Use the same mix to darken the thistle heads.

8 ▲ Paint the jug Lighten the mixture with more water and use the chisel edge of the wash brush to go over the outlines of the blue jug. Bring out its rounded form with overlaid washes of light and dark tone, applied wet-on-wet.

EXPERT ADVICE
Score draw

Why not try using the scoring method to 'draw' the outlines of objects? The scored lines are revealed when colour washes are added, and the contrast of soft washes and fine spidery lines is very pleasing – rather like an etching.

Express yourself
Drawing with a blade

While the scoring technique is used in the step-by-step project to capture intricate detail and texture, it is equally appropriate for simpler, more minimal subject matter. Here, the artist first scored the outlines of the crockery and cutlery, the checks of the tablecloth and the vertical lines in the background. Then he added the washes of watercolour. Finally, when the blue wash was dry, he drew the blade diagonally across it to add a vigorous, lively texture to the background.

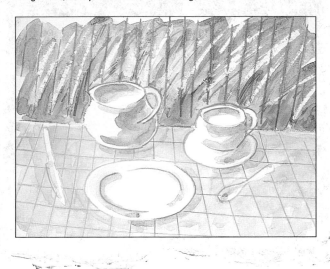

9 ▲ Bring in more details Use ivory black and cobalt blue to add dark lines to the dried flowers in the basket, and to paint the scored teasels and the shadow on the basket handle. Suggest the pink dried flowers with a sweep of alizarin crimson. Paint the cheese with cadmium yellow. Score circular lines for the texture of the broken bread and wash over it with very dilute burnt umber and ivory black.

10 ▲ Strengthen the image Continue to work all over the picture, building up local colour and strengthening the dark areas. Using a mixture of alizarin crimson and burnt umber, add warm shadows to the onion and to the basket and its contents. Strengthen the jug with ultramarine, then paint the chopping board with a loose wash of burnt umber. Use viridian and sap green to add more green stalks in the foreground. Leave to dry.

The painting is now complete, but if you wish you can add just a touch more scratched and painted detail. Resist the temptation to go overboard, though, as you risk losing the spontaneity you have achieved so far.

11 ▶ Scratch back When the washes have dried fully, add texture and highlights to the crusty bread and the skin of the onion by scratching broken lines with the tip of the knife. Then scrape at the unpainted areas left in step 3 to give an impression of the fluffy texture of the white flowers.

Master Strokes

Anonymous Chinese painter (late 1800s)
Basket of Flowers with Cherry Blossoms

In complete contrast to the sketchy, textured treatment of the flowers in the project, this painting, worked on silk, is highly finished and illustrative. The artist has taken great delight in the varied shapes of the flowers and has rendered them skilfully. Look at how the petals of the large purple flowers create a wonderful pattern. Also note the harmonious use of colour – for instance, the way in which the yellow flowers pick up the colour of the vase.

Although the artist is mainly concerned with colour and shape in this picture, subtle darkening of tone on the flowers, foliage and vase helps gives some impression of form.

The flower in the painted design echoes the colour of the red flowers in the vase.

12 ▼ **Add more highlights** In the foreground, use the knife blade to scrape out small patches of colour to suggest the highlights on the thistle heads.

13 ▲ **Add some seeds** Mix burnt umber and a touch of ultramarine and dot in some seeds around the allium heads, using a No.2 round brush. Add a few more in alizarin crimson.

THE FINISHED PICTURE

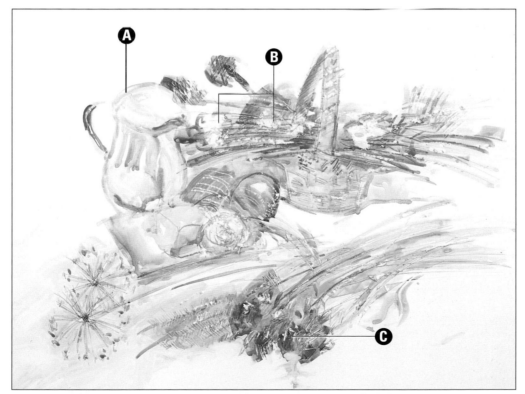

A Lively brushwork
The absence of an initial pencil sketch encouraged freedom and spontaneity in the brushwork.

B Less is more
The white flowers are not really drawn – instead their fluffy texture is registered by scuffing up the paper.

C Surface texture
Scoring and scratching the surface of the board added character to the picture as well as suggesting more detail and texture.

Using resists

Discover the range of textures you can achieve by using watercolours with different masking materials.

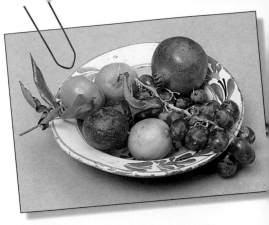

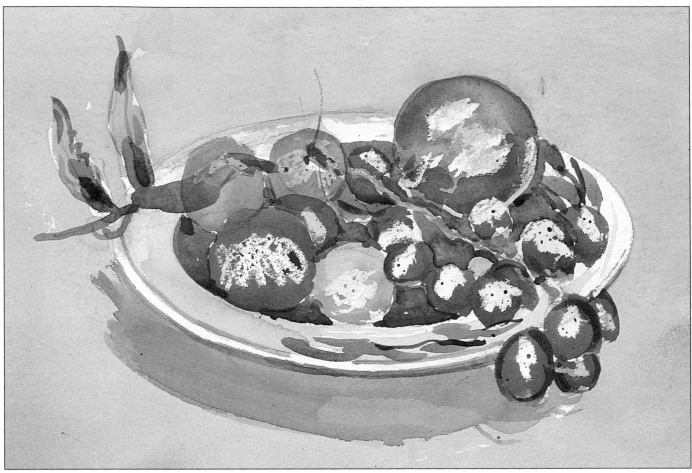

W atercolour paints are unique because they are transparent. The colours contain no white or chalky pigments to make them opaque or cloudy.

For this reason, the most effective watercolour painting is done without the addition of white paint. This means you must plan ahead, leaving areas of white paper unpainted so that they represent highlights and paler tones in the picture.

Mask out the whites

Although white paper is a crucial element in most watercolour painting, you are not restricted to simply leaving certain areas unpainted. In fact, as you might have discovered, it is quite difficult to retain patches of white paper simply by painting around them. Not only do you have to remember where the white areas are, but you also have to take care not to paint over them by mistake.

The trick is to protect, or mask, the white areas before you start painting. In this way, you can work quickly, applying colour freely over the masked areas which will eventually show through the paint as patches of pure white. Any substance that temporarily blocks out the paper is known as a resist.

Masking fluid

For sharply defined shapes with a hard edge, such as the crisp highlight on this shiny, ceramic plate, nothing is more effective than masking fluid. This can be applied to the paper with either a brush

▲ **Masking off areas in this picture has created sparkling highlights and interesting textures.**

or pen, and dries to form a thin, rubbery film. You can then paint over it and rub it off when the colours are dry to reveal the white paper underneath.

Candles and wax crayons

For a textured or linear resist, try using candles, wax crayons or oil pastels. When watercolour is painted over the oily or waxy marks, it forms droplets, which run off the resist area. However, a few drops will usually dry on top of the resist to create an attractive speckled texture. Wax crayons or oil pastels will provide a touch of colour too.

FIRST STEPS

1 ► Draw the still life
Start by making a simple line drawing of the bowl of fruit – a chunky carpenter's pencil will help you to keep the shapes broad and unfussy. Draw the plate as an ellipse and then establish each piece of fruit as an approximate circle. Take the spiky leaves over the edge of the plate to interrupt the elliptical shape.

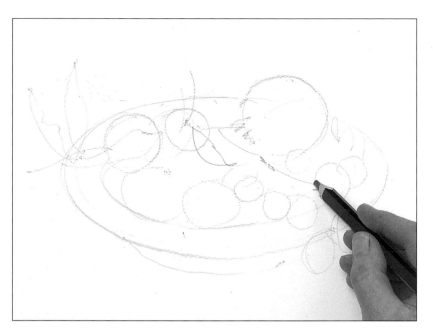

2 ◄ Apply a wash over the background
Using a 38mm (1½in) flat wash brush, paint the table top in a wash of burnt umber mixed with a little cadmium yellow. Apply the colour in broad, rapid strokes, working around the outlines of the bowl and fruit. A few drips and tidemarks will add interest to the flat table area, so don't worry if the paint looks uneven.

EXPERT ADVICE
Removing masking fluid

When removing areas of masking fluid, start rubbing from the centre of the masked shape and work outwards. In this way, the fluid should come away easily without tearing the surface of the paper.

3 ► Mask out the highlights While the wash dries, take the opportunity to mask out some of the highlights on the fruit, using wax crayons. Make loose, sketchy strokes, but indicate the approximate rounded contours of the fruits. Choose a yellow wax crayon for the lime and an orange one for the tangerines and the pomegranate.

227

4 ▼ **Draw reflections with a candle** Continuing with the orange wax crayon, scribble over the highlight area of the pomegranate. Then use a candle to establish the white reflections on the grapes and figs. The colourless wax preserves the whiteness of the paper

5 ▲ **Apply masking fluid** Paint the highlight around the rim of the bowl as a curved line, using masking fluid and an old round brush. Paint another line of fluid across the plate – this will be the grapes' stalk (see step 14).

DEVELOPING THE PICTURE

All the masked highlights have now been established, and it is time to start painting. Remember, the beauty of using resists is that it allows you to paint quite freely as the highlight areas are protected.

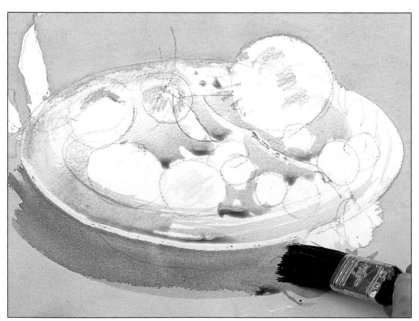

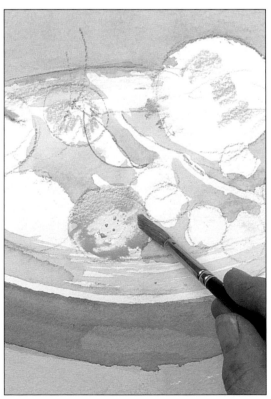

6 ▲ **Apply a wash to the plate** Using the 38mm (1½in) flat brush, paint the plate with a pale grey wash mixed from ivory black with lots of water. Follow the curved shape of the plate and use bold strokes to paint around the grapes and other fruit. Darken the tone of your wash to paint the shadow under the plate.

7 ▲ **Paint the lime** Change to a No.8 round brush to paint the lime in a mixture of lemon yellow and viridian, taking the brush strokes around the shape of the fruit and over the waxy crayon marks.

8 ▼ Continue painting the fruit Using the same technique, paint the tangerines in a mixture of cadmium red and cadmium yellow. Leave a tiny patch of white paper showing through at the centre of each fruit.

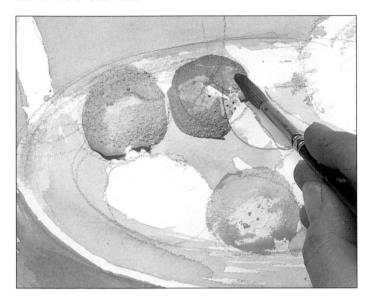

Express yourself
A sketch in wax crayons

The wax crayons used in the painting to mask out highlights on the fruit are an excellent drawing medium in their own right. They are perfect for chunky sketches in which bold line and colour are more important than a detailed rendering. This still life from the artist's sketch book was done using a basic set of 12 wax crayons. The highlights on the fruit are left as plain white paper or filled with lightly applied, smudged colour. The blue shadows on the plate echo the colour of the table.

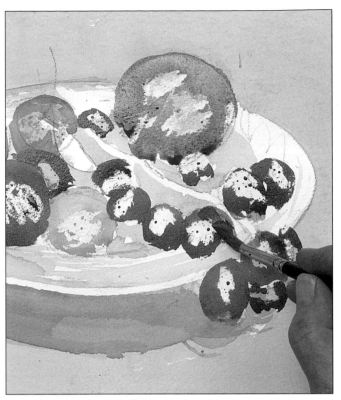

9 ▲ Complete the fruit Paint the pomegranate in alizarin crimson, and the figs and grapes in a mixture of alizarin crimson and ultramarine. You will find that the candle wax resists the colour and shows up on the fruit as white reflected highlights.

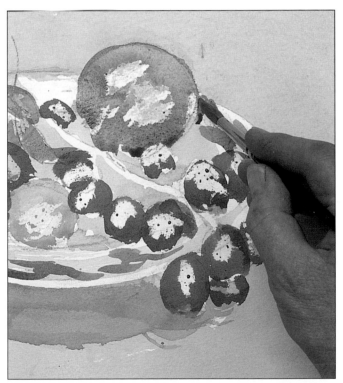

10 ▲ Paint the leaves and plate Using viridian darkened with a little ivory black, paint each leaf as a single brush stroke of colour. Add a few darker shadows by overpainting in a darker tone of the same colour. Use the same green to paint the leaves on the ceramic plate design.

◄ The table top is burnt umber and cadmium yellow; the foliage viridian with a touch of added black; and the plate a diluted wash of ivory black. Note the rough texture created by the candle resist.

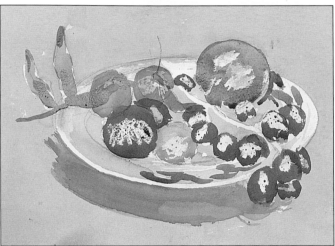

11 ▲ **Complete the bowl** Develop the leaf design on the painted ceramic plate, taking the pattern up to and around the curved shape of the pomegranate.

Local colours and the highlights are now in place. Shadows and dark tones need to be added – particularly on the plate, which looks a little flat at this stage.

12 ▲ **Add the bowl shadow** The shadow on the bowl is painted in a wash of ultramarine and burnt umber – the fruit shows up as lighter shapes against this dark colour. Put the paint on in broad strokes with a No.7 brush, redefining the round shapes. Flood extra colour into the darker areas.

Master Strokes

Jan van Os (1744-1808)
Fruit and Flowers

This lavish display by Jan van Os is typical of Dutch still life painting in the eighteenth century. Rather than being arranged in a formal way, the fruit and flowers spill in profusion across the table top. The light falls in a diagonal band across the centre of the picture from top right to bottom left, making this swathe of fruit stand out from the darker areas around it. In oil paintings, the highlights do not require forward planning as they do with watercolours – the bright reflected light can be added as final touches.

The highlights on the black grapes are restricted to single points of white paint; the green grapes, by contrast, are outlined in white.

Fruit of many different shapes and sizes, from tiny berries to a large melon, add variety and interest to the composition.

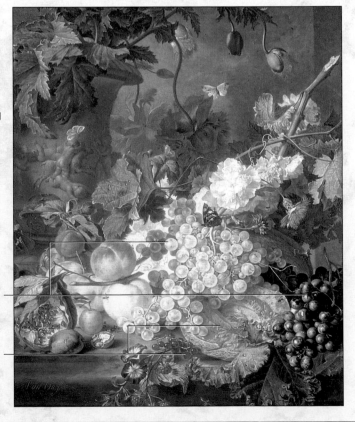

13 ▲ **Add detail to the patterned plate** Complete the rim of the plate in yellow ochre applied with the tip of a No.7 brush. Still using the tip of the brush, add dark green details to the leaves on the fruit and the plate design.

14 ▼ **Complete the grapes** Remove the masking fluid applied to the line of the grapes' stalk in step 5. Then paint the stalk with yellow ochre.

THE FINISHED PICTURE

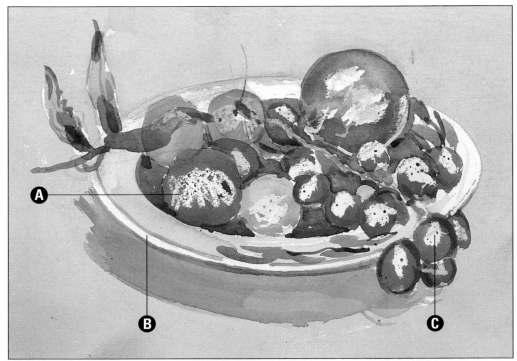

A Textured fruit
Coloured wax crayon was used for the highlights on the citrus fruits. The slightly rough surface of the watercolour paper helped create the texture of the peel.

B Bowl highlight
The sharp linear highlight on the ceramic bowl was achieved with masking fluid, applied in a bold, unbroken line.

C White reflections
The wax from an ordinary household candle was applied in loose, sketchy strokes to create patches of reflected light on the purple grapes and the figs.

Street scene

Streets can be marvellous subjects for a painting as they are full of colour, texture and detail – and usually have human interest, too.

Although it can be very rewarding to paint outdoors, one problem in town is finding somewhere to set up your easel without attracting unwanted attention from curious passers-by.

Working from photographs

This is where photographs and sketches are a boon, allowing you to gather all the information you need easily. You can use them as the basis for a painting

and work on it at your leisure, at home or in your studio.

Attracted by the provincial charm of this row of small shops, the artist photographed each one separately. Back home, he laid out the photos to form a panorama of the street.

He did not slavishly copy the scene but chose to move things around in order to improve the composition. He removed the cars, for example, shuffled

the figures along to make interesting groupings and moved one of the trees so that it filled the patch of sky above the single-storey shop. The artist also deliberately cut out all hints of perspective as he wanted to concentrate on the abstract elements of shape, pattern and colour.

Mood and atmosphere

The overall tonality of the scene has been lightened and the grey sky has

▼ This simple composition of small shop fronts conveys the atmosphere of a quiet town with the residents going about their day-to-day business.

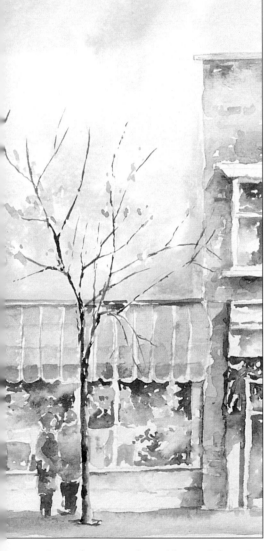

been interpreted as blue, giving the painting a fresh, spring-like mood. In addition, the loose handling of the paint and impressionistic treatment of detail lend character and energy, and there is a feeling of light moving across the buildings. What's more, there is a pleasing contrast between the solid geometric shapes of the buildings and the organic forms of the figures and trees.

▼ YOU WILL NEED

Piece of 300gsm (140lb) Not watercolour paper 60 x 40cm (24 x 16 in)

HB pencil

10 watercolours: Cerulean; Raw sienna; Burnt sienna; Burnt umber; Ultramarine; Permanent rose; Cadmium orange; Lemon yellow; Scarlet lake; Cadmium yellow

3 brushes: Nos.12, 6 and 1 rounds

Paper tissues

Jar of water

Mixing dish or palette

Masking fluid and a small, old paintbrush

FIRST STEPS

1 ▲ **Start with an outline drawing** Using your sketches and photos as references, make a careful outline drawing of the subject, including the lettering on the shop signs, with a sharp HB pencil. Paint out the leaves on the two trees with masking fluid, applied in small flecks with an old brush. Wash the brush out immediately.

2 ▲ **Block in the sky** Dampen the sky area with clean water. Mix a strong wash of cerulean (remember it will dry lighter) and apply it loosely with the No.12 round brush. Let the paint spread and diffuse on the damp paper; this gives a more attractive effect than a flat wash.

3 ◄ **Create white clouds** While the blue wash is still wet, lift out a few soft white clouds using a press-and-lift motion with a piece of crumpled paper tissue. Leave to dry (or use a hair-dryer if you're in a hurry).

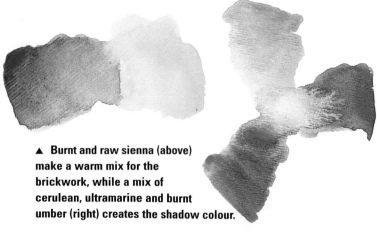

▲ **Burnt and raw sienna (above) make a warm mix for the brickwork, while a mix of cerulean, ultramarine and burnt umber (right) creates the shadow colour.**

4 ▼ **Start painting the walls** Change to the No.6 round brush and paint in the red-brick walls of the buildings with a watery mix of raw sienna and burnt sienna. Vary the tone by adding more or less water. Apply the paint with small, broken brush strokes, leaving flecks of white paper showing.

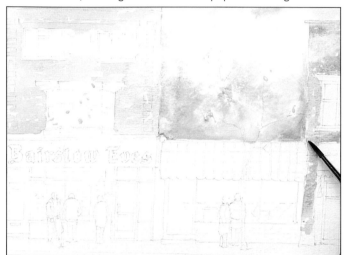

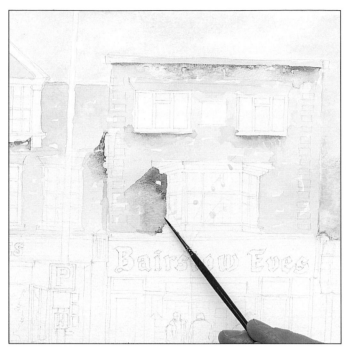

5 ▲ **Put in cast shadows** Darken the wash with some burnt umber and cerulean, plus a little ultramarine to beef it up. While the underwash is still damp, use the No.1 round brush to put in the dark shadows under the eaves and those cast on to the walls by the windows. Start at the dark, inner edge of each shadow and let the colour fade out to nothing.

DEVELOPING THE PAINTING

Now that you have established the light direction and defined the underlying structure of the buildings, you can concentrate on the architectural details and build up tone and texture.

6 ▲ **Put in the window panes** Dilute the mixture from step 5 with more water and put in the lighter cast shadows and suggest the brickwork on the chimneys. Now change the bias of the mix. This time use ultramarine and burnt umber, with just a little cerulean, and start to fill in the dark window panes. Add more water for the lighter tones, and leave tiny flecks of white paper for the reflections.

7 ▼ **Complete the windows** Continue filling in the window panes, carefully observing the light and dark tones. On the bay window in the centre, for instance, the panes are dark on the left and much lighter on the right because they face into the light; add more cerulean to your mix on the light side to suggest reflected light from the sky.

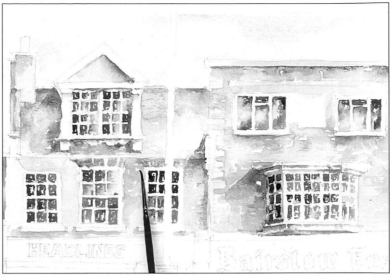

8 ▲ **Add more texture to the walls** Mix a more intense wash of raw sienna and burnt sienna than used in step 4. Using the No.1 brush, suggest the pattern and texture of the brick walls; apply the paint with tiny strokes, bringing out the negative shapes of the decorative stones and allowing the pale underwash to break through for the lighter bricks. Be selective – it is easy to overwork the detail.

EXPERT ADVICE
Painting brickwork

When painting a wall, don't try to build it brick by brick with flat strokes. A few bricks here and there, painted loosely, will give the effect in a more natural way. Put the overall tone in first, leaving chinks of white to suggest highlights. Suggest the dark bricks with darker tones of the same colour, letting the underwash show through to give the mid tone.

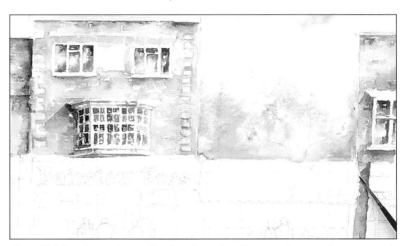

9 ▲ **Finish painting the walls** Continue building up the rough texture of the walls with small strokes. Let the paint do the work for you – the water will carry the pigment so that, as it dries, it forms hard edges that subtly suggest individual bricks. Reinforce the colour in shaded areas with touches of burnt umber.

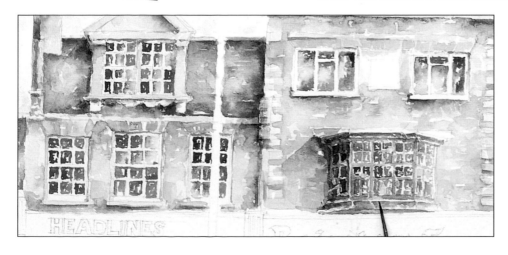

10 ◄ **Continue working on the windows** Use permanent rose and a touch of cadmium orange, diluted to a pale tint, for the pink paintwork around the windows on the left. Paint the dark window frames on the bay window using the shadow colour mixed in step 5. In reality, the frames are black, but dark brown is a more sympathetic colour for a watercolour painting – black looks too stark.

235

11 ▼ **Start painting the shops** Use the No.6 round brush to suggest the baker's shop window on the extreme left with the greys and earths already on your palette. Paint the decorative green stonework next to it with a mix of lemon yellow and ultramarine, darkened with more ultramarine for the shadows. Paint the pink shop front with a wash of permanent rose and a little cadmium orange. Add some of the brick colour to this for the drainpipe.

12 ▲ **Add more detail** Fill in the lettering of the shop sign with dilute raw sienna, varying the strength of tone for a natural effect. Mix ultramarine, cerulean blue and a hint of burnt umber, dilute it well and draw the shadows on the pink shop front and in the doorway.

13 ▲ **Paint the shop window** Change to the No.1 brush and paint the glass in the shop window and door with a mix of ultramarine and cerulean blue, adding burnt umber for the dark tones. Work round the white window frame and leave chinks of white paper for the highlights. Outline the letters on the shop sign with the same colour. Suggest the plants with the lemon/ultramarine mix used earlier.

14 ▲ **Move on to the next shop front** Mix scarlet lake and a touch of cadmium orange to block in the red parts of the next shop front along. Paint the brown door and window frames with light and dark tones of raw sienna, burnt sienna and ultramarine. Use a very dark tone of this mix for the shop sign, then put in the glass windows as before, working around the outlines of the figures.

15 ▶ Paint the florist's shop

Paint the awning with cerulean and ultramarine, varying the tones to define its curved shape. When dry, use the tip of the brush to paint the red stripes with scarlet lake. Paint the flowers with lemon yellow, cadmium orange and scarlet lake. Suggest the window with loose strokes as before. Then paint the far right section with greys and reds.

Master Strokes

Anne Redpath (1895-1965)
Houses, Concarneau

This oil painting, made in 1954, shows a street scene of typical French buildings. Although it is similar in composition to the street in the step-by-step project, the side of each building is visible in perspective, giving the painting more depth. The shadowy dome in the background adds to the feeling of recession. Chiefly composed of greys, the picture has a rainy atmosphere enhanced by the heavy sky. As a result, the few patches of colour – especially the yellow shutters – really sing out.

Fine brushwork depicts decorative wrought-iron balconies.

The leafless tree is painted with great economy. Notice how each branch tapers off to a fine line.

Reflections of the buildings and trees in the pavement suggest a wet day.

Make sure the painting is completely dry before continuing. The row of shops is now complete and all that remains is to paint the details in the foreground, the figures in the street and the trees. Also, you need to remove the masking fluid from the trees – this will leave dots of white paper that you can then paint with a leaf colour.

Express yourself

Sketch a shop

A soft pencil was used for this sketch of just one section of the street. Thumbnail sketches are a useful adjunct to photographs when composing a panoramic view; they help you to edit out superfluous detail and simplify the subject. They also help to define the tonal values that underlie any subject.

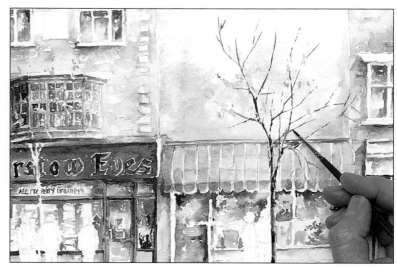

16 ▲ **Start painting the trees** Paint the sapling in front of the florist's shop with burnt umber, adding ultramarine for the darker parts. Skip the brush tip lightly over the paper, making thin, broken lines for the branches. Leave to dry, then rub off the masking fluid. Paint the leaves with a mix of lemon yellow, cerulean and a hint of ultramarine.

17 ▶ **Render the signpost** Paint the other tree in the same way. Then mix a cool grey from ultramarine, cerulean and burnt umber for the signpost, grading the tone to make it appear rounded. Lighten the tone near the top of the post. Paint the sign with the cool grey, cadmium yellow and ultramarine.

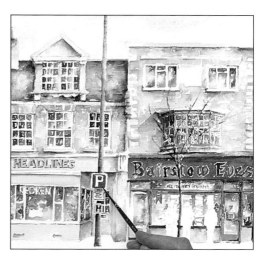

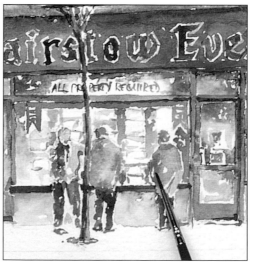

18 ◀ **Paint the figures** Incidental figures should be painted with the minimum of detail. Use some of the greys and earth colours already mixed on your palette to jot in the clothing, leaving tiny flecks of white paper that give movement to the figures. Mix ultramarine and scarlet lake for the woman's purple coat.

19 ▼ **Paint the pavement** To complete the painting, mix two tones of grey from burnt umber, ultramarine, cerulean blue and raw sienna, and paint the pavement with broken brush strokes.

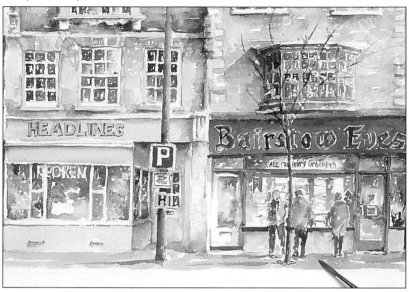

THE FINISHED PICTURE

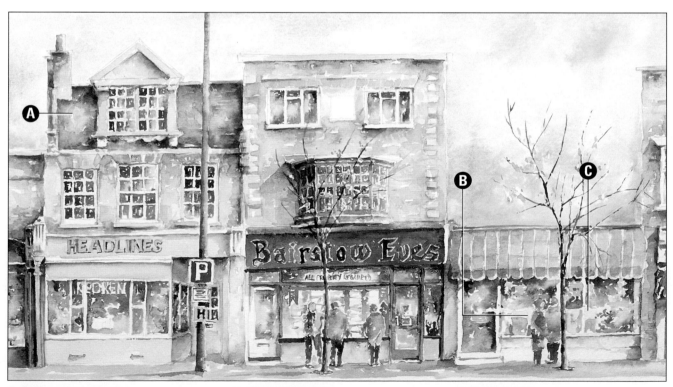

A Spring-like atmosphere
Light tones and colours, and flecks of white paper showing through, give the feel of a crisp, spring morning with sunlight playing on the buildings.

B Minimal figures
The figures were painted with the minimum of detail so that they do not dominate the foreground. Overly precise figures tend to look like cardboard cut-outs.

C Lively detail
The details of the displays in the shop windows, such as the floral arrangements, are hinted at, but not over-defined. This allows the viewer's imagination to play a part.

Children fishing

Family groups at the seaside are a favourite subject with artists. Use watercolours to capture the atmosphere of a bright summer's day beside the sea, with sunshine sparkling on the water.

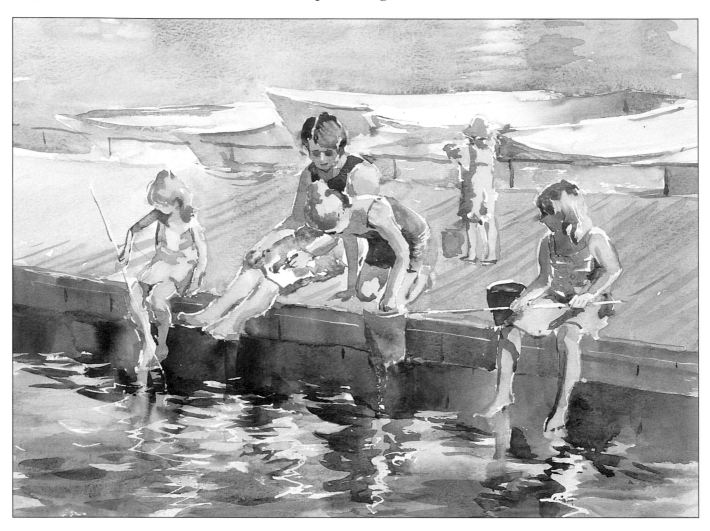

This seaside scene is buzzing with colour and action. In fact, most of the painting is done in just two colours – burnt sienna and cobalt blue. The impression of strong, vivid colours is created by a few well-judged splashes of bright yellow, red and green in the final stages.

The figures, too, are simplified. As a rule, the looser and more decisive you are when painting figures, the fresher and livelier the result will be.

Sketches and photographs

Instead of painting from life, try creating a scene of your own, using any available reference material together with your imagination. The scene shown here is an arrangement of figures and boats taken from photographs and sketches and put together in a colourful composition.

Painting water

Water itself has no colour and is visible only because it reflects its surroundings. Here, the sea reflects the sky, as well as the quay and figures.

It is good idea to paint the water and the children alternately. Every time you apply a new colour to the figures, add a few dabs of the same colour to the reflections. In the water, though, make sure your brushstrokes are looser to give an indication of the ripples.

▲ **The lively highlights on the figures and the water are created by using masking fluid.**

USING SKETCHES AND PHOTOS

Feel free to be selective with your reference material. For example, the figure on the right in the painting was borrowed from the black-and-white sketch of a family fishing (below right). The kneeling figure was also used in the painting, turned around to suit the composition.

A photograph of children fishing might provide you with a general starting point for your composition. From here, you could go on to alter the position of the quay and make any other changes you see fit to create an interesting composition for your painting.

Make a note of local colours on any sketches you do, as shown below left. This will help jog your memory when it comes to choosing colours for the actual painting.

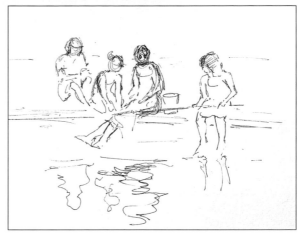

YOU WILL NEED

Piece of 300gsm (140lb) Not water-colour paper 30 x 41cm (12 x 16in)

HB pencil

Masking fluid

Ruling pen

No.6 filbert brush

11 watercolours:
Cobalt blue; Light green; Burnt sienna; Raw umber; Cadmium orange; Cadmium red; Alizarin crimson; Yellow ochre; Prussian blue; Emerald green; Cadmium yellow

White gouache paint

FIRST STROKES

1 ▲ Sketch in the composition Start by drawing the outlines of the figures and other main elements with a sharp HB pencil. Work from sketches and photographs, taking the best elements from each to build up your own composition. Try to draw with fluid lines to capture the movement of the figures and don't make the lines too dark, as they will show through the watercolour.

2 ▲ Mask the highlighted areas Apply masking fluid with a ruling pen on any areas that you want to remain very light in the finished picture – for example, the sunny highlights on the hair and the flickering highlights on the water.

241

3 ▶ Paint the water
Using a No.6 filbert brush, paint the water in a dilute mixture of cobalt blue and a little light green. Wherever the water appears slightly sandy, add a little burnt sienna to this mixture. Paint the water in long horizontal strokes, leaving slivers of white paper showing between the brush strokes to indicate the ripples.

4 ▶ Paint the flesh shadows Mix a deep tan colour from burnt sienna with a touch of raw umber and use this on the shaded side of the figures. Paint with the tip of the brush to create long, tapering shadows down the arms and legs.

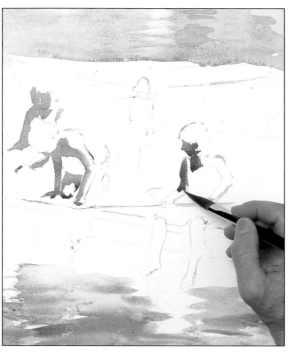

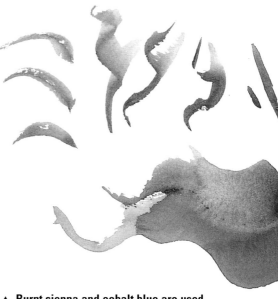

▲ Burnt sienna and cobalt blue are used extensively, forming the main colour theme in the composition.

EXPERT ADVICE
Choosing brushes

Your choice of brushes is a personal one and it is worth experimenting to find out which types suit your particular approach. For example, the filbert recommended for this painting was chosen specifically by the artist, who finds that the obliquely cut bristles are ideal to create both flat colour and sharp detail.

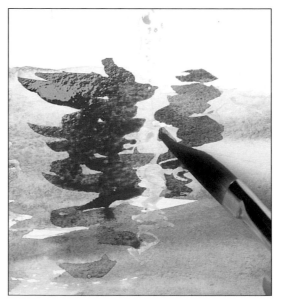

5 ◀ Add colour to the reflections Take the flesh colour into the reflections in the sea, making irregular, wavy strokes with the filbert brush to give the impression of moving water.

DEVELOPING THE PICTURE

In this painting, the splashes of bright colour really catch the eye – namely the orange and yellow outfits, the red bucket and the emerald green fishing net. These local colours should be as bright as you can make them, so use pure colour diluted with a little clean water and applied with a clean brush.

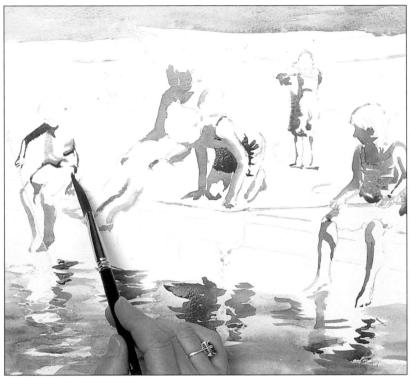

6 ▲ Add splashes of colour Now for some local colour. Paint the swimsuit of the right-hand figure in cobalt blue and the shorts of the kneeling figure in cobalt blue with a touch of burnt sienna. The shadow on the boy's outfit is cadmium orange, and the red swimsuit is cadmium red with a little alizarin crimson. As you use each colour on the figures, take a little of the same colour into the water to help build up the reflections.

7 ▶ Paint the hair shadows The hair shadows on all the figures are painted in a mixture of raw umber and yellow ochre. Vary the proportions of this colour mixture, using more yellow ochre for the blonde heads and more raw umber for the brunettes. Paint the woman's skirt and top in Prussian blue.

Express yourself
Trying out colours

An exploratory colour sketch enables you to work out appropriate paint mixes before starting on the main painting. In this preliminary work, note how the flesh colours, the jetty and the water are observed and painted in detail.

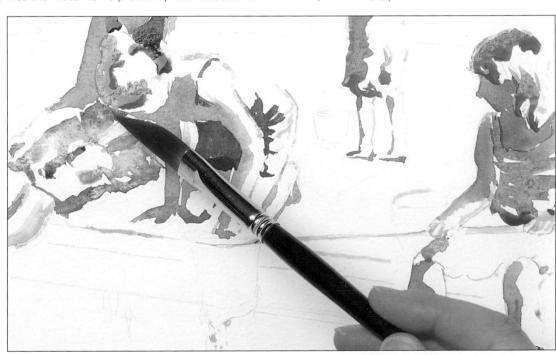

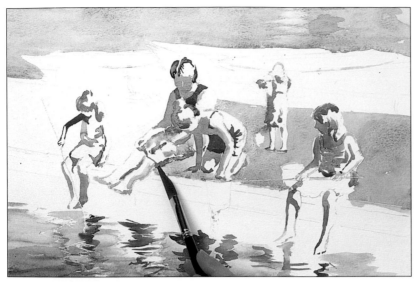

8 ▲ Block in the quay Paint the quay in a pale, dull mauve shade mixed from burnt sienna and cobalt blue. As you paint up to and around the figures, take this opportunity to redefine the contours and outlines.

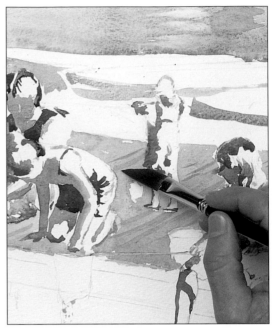

9 ▲ Add the boats and wooden slats Mix a touch more cobalt blue with the basic quay colour and use this to block in the shapes of the boats and to suggest the slats of wood on the quay.

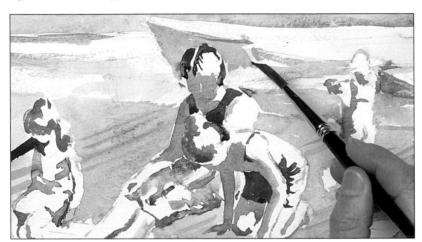

10 ▲ Develop the boats Paint the interiors of the boats in yellow ochre or emerald green, and the rims in emerald green or Prussian blue. The colours should be paler than those used on the figures and in the foreground, yet must be strong enough to show up against the white paper when you remove the masking fluid.

ADDING MORE WHITE

Forgotten to paint out some of the highlights with masking fluid? Don't worry. You can use white gouache to paint any light areas you missed. Here, a few white sparkles are added to the waves in the final stages.

TROUBLE SHOOTER

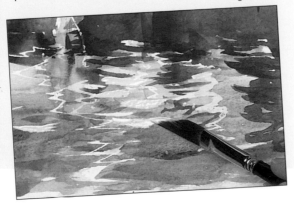

11 ▲ Paint the deep shadow The shadow under the wooden quay is one of the darkest tones in the whole picture, so paint this in a strong mixture of burnt sienna and cobalt blue. Apply the colour in broad, horizontal strokes and also add a few small dabs to the reflections in the water.

12 ▶ Complete the quay Paint the edge of the quay with a mixture of Prussian blue and burnt sienna, keeping the colour slightly paler than the shadow underneath the quay. Add a splash of bright emerald green for the child's fishing net, not forgetting to add the same colour to the reflections in the water.

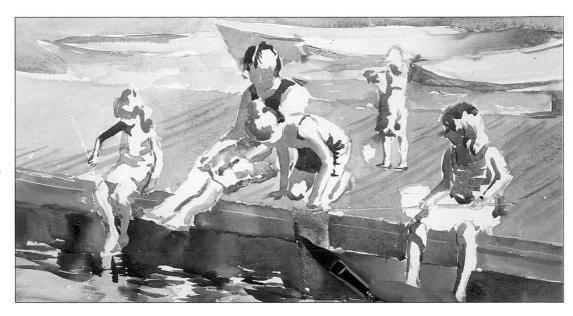

13 ▲ Add more bright splashes For a little more local colour, paint the bucket in cadmium red and the outfit of the standing boy in cadmium yellow. Using a dilute mixture of burnt sienna and yellow ochre, wash in any unpainted hair and skin tones on all the figures.

▼ To do justice to the colours of the buckets, fishing nets and clothes in the bright sunlight, emerald green, cadmium yellow and cadmium red were used.

Master Strokes

Cecilio Pla Y Gallardo (1860-1934)
The Beach

As in our step-by-step painting, this unusual oil painting by Spanish artist, Pla Y Gallardo captures the atmosphere of sun sparkling on water very effectively. He has used heavily textured, horizontal brush strokes for the sea, leaving the buff-coloured canvas to represent the beach. The bathers are depicted in a simple, impressionistic style with vertical brush strokes.

Several pale tints of blue and mauve are blended to provide the luminous look of the sea, which is reflecting the sky and sunlight.

The reflections of the bathers in the sea are indicated with dabs of green paint with the addition of a little flesh colour.

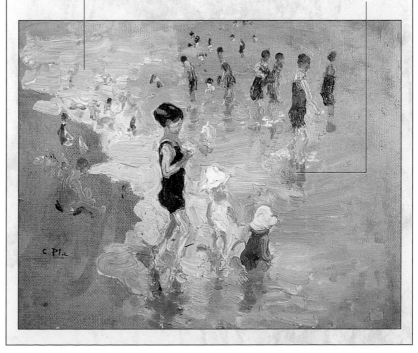

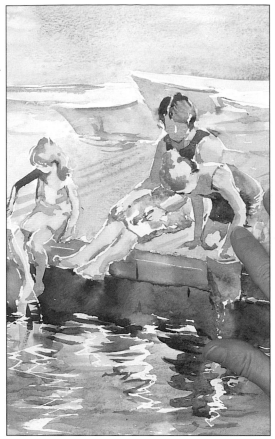

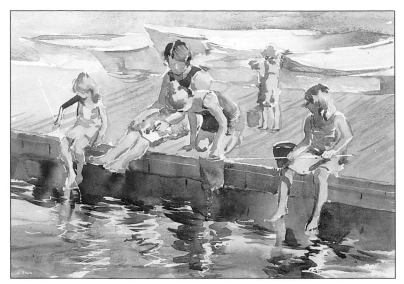

16▲ **Assess the picture** Stand back from your painting to review the overall effect. Adjust the tonal contrast if necessary, remembering that the tones in the distance should be paler. Check that you have not missed out any coloured reflections in the water.

A FEW STEPS FURTHER

Colours are bright and the brushwork lively, evoking the warm sun and fresh air of this seaside scene. Although at this stage the picture could be considered complete, you might want to add a few more details. However, keep these to a minimum – overworking a watercolour in the final stages can reduce the natural spontaneity of the medium.

14▲ **Remove the masking fluid** Paint the dress of the seated figure in pale cadmium red and the vest of the kneeling child in cadmium orange. Allow the paint to dry completely, then rub off the masking fluid with your finger.

15▼ **Soften the white shapes** Mix an extremely dilute wash of cobalt blue and burnt sienna and use this to tone down the stark white areas revealed by removing the masking fluid.

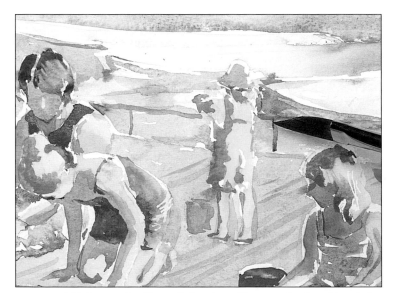

17▲ **Add the metal railings** Paint the railings at the far side of the quay in burnt sienna, keeping these sharp and clearly defined to contrast with the pale, hazier shapes of the boats behind.

18 ▶ Make final adjustments

Finally, you might need to soften some of the hard edges between the pale and dark flesh tones with a little clean water, dabbing off excess colour with a tissue. You could also give the woman a pair of sunglasses to protect her eyes from the strong sunlight! Using the end of your brush, simply draw the glasses with a mix of Prussian blue and cadmium red.

THE FINISHED PICTURE

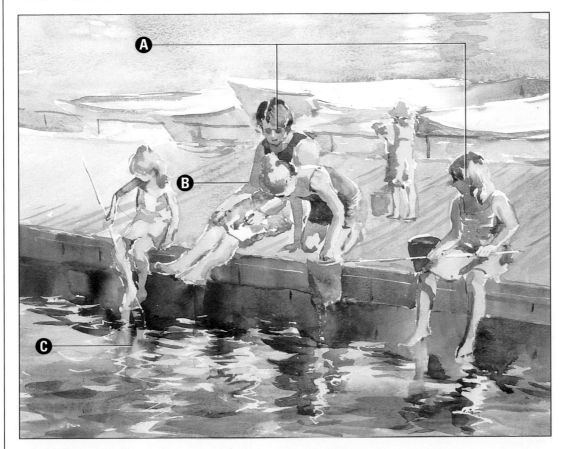

A Selected elements
The figures, boats and jetty were selected from different photos and drawings. These separate elements were adapted to make the most satisfactory composition.

B Simplified colour
Flesh shadows on the figures were all painted quickly at the same time in burnt sienna mixed with a little raw umber.

C Lively reflections
Reflected colours were built up gradually as the painting progressed, with a little of each colour used elsewhere in the picture being added to the reflected patterns in the water.

The drama of white water

Use watercolours to capture the excitement of a river rushing over rocks.

Moving water is a compelling subject but, at first sight, you might wonder how you can possibly convey the turbulence of a rushing river or the energy and excitement of rapids or a waterfall.

The elements of swiftly flowing water that need special attention are its movement, transparency and reflections, all of which can be portrayed with careful observation and the right techniques. To depict moving water effectively, you need to simplify by focusing on the main patterns and shapes being created by the flow. (Working from a photo is helpful as these patterns are frozen.)

Preserve the highlights

Working wet-on-wet with a broad wash brush is the best technique for suggesting areas of flat, undisturbed water, while wet-on-dry with broken brush strokes best describes turbulent areas of waves or spray. Avoid overlaying too many washes as the colours will become muddy.

Masking fluid is an invaluable tool as it allows you to highlight the tops of ripples, the glints of sunlight on still water or the spray thrown up by falling water. You are then free to work on the surrounding darker tones without having to worry about preserving these highlights.

In contrast to the drama of the water, the artist added a peaceful backdrop of autumnal trees. Their darker tones help guide the eye into the centre of the image.

▶ **To capture a fast-flowing river in watercolour, the unpainted areas are as important as the painted ones.**

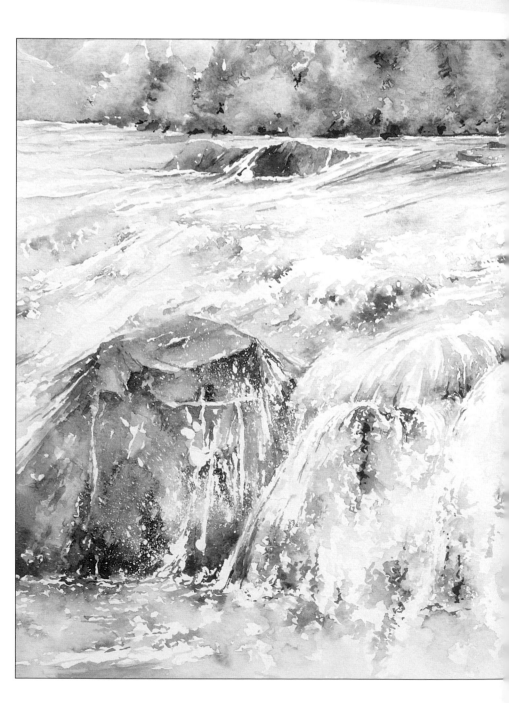

FIRST STROKES

1 ▲ **Make a sketch and apply masking fluid** Lightly draw the main shapes with a 2B pencil, looking at the main thrust of the water. Dip the toothbrush into the masking fluid and flick it on to the paper, starting in the centre and moving up to the left and right. Remove any unwanted blobs of fluid by blotting them with kitchen paper.

2 ▲ **Paint the sky and hills** Use a wash of pure ultramarine watercolour to touch in the areas of sky with a No.8 brush. Add a little burnt umber and alizarin crimson to the ultramarine, and brush on to dry paper to represent the distant hills.

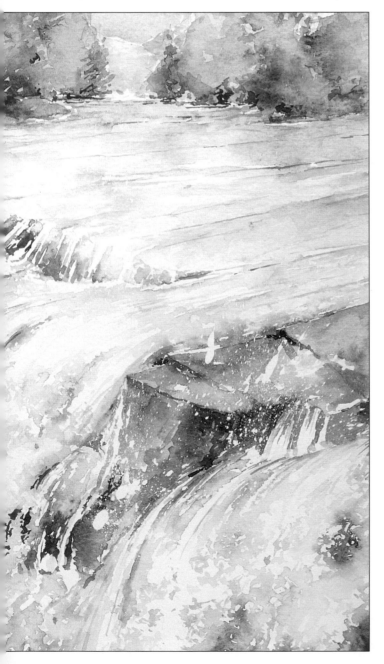

◄ The underwash for the trees was mixed from sap green, ultramarine and a touch of raw sienna.

3 ► Paint the trees wet-on-wet
Now dampen the paper with a
No.16 brush – a damp surface
rather than a wet one gives you
more control over the paint. Return
to the No.8 brush and mix sap
green, ultramarine and a touch of
raw sienna to create an underwash
for the trees, laying it on more
thickly towards the bottom. Create
form in the trees using the same
wash with less water added, then
drop some yellow ochre on to the
foliage to give it colour.

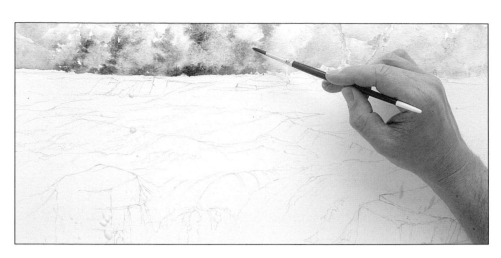

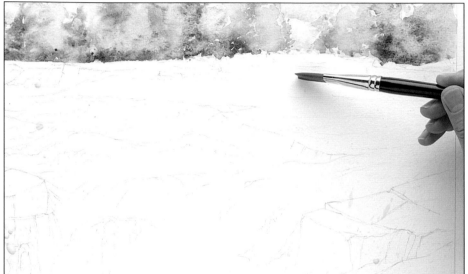

4 ◄ Continue to build form in the trees
Load cadmium orange on to your
brush and flick it over the trees to
create an autumnal effect. Repeat this
technique with burnt sienna, working
into the dots of paint with a clean,
wet brush. Load the wash brush with
water and brush it across the far
water, using the chisel edge.

DEVELOPING THE PICTURE

Now begin to develop the water,
using various effects to convey
movement and reflections. Leave
plenty of highlights of white paper
showing to represent foam and spray.

EXPERT ADVICE
Painting reflections

When painting reflections, you need to create a
sense of depth while retaining the horizontal plane of
the water. Dilute the mix of sap green and ultramarine
used to paint the trees, and make horizontal brush
strokes spaced slightly apart. If objects are reflected
in moving water, slight undulations in your brush
strokes will help to indicate ripples.

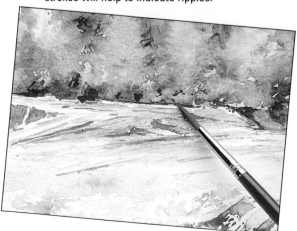

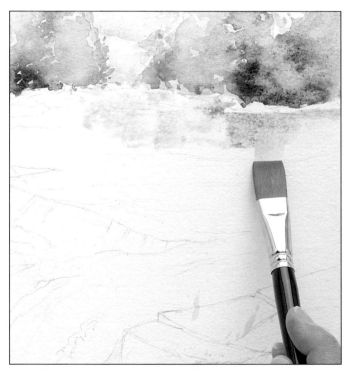

5 ▲ Show trees reflected in water Continuing with the wash
brush, use downward strokes to paint the mix of sap
green, ultramarine and raw sienna (see step 3) on the water.

6 ▶ Begin to paint the rocks Add well-diluted ultramarine to this mix and begin to wash in the water. Drop in some cadmium orange to suggest more reflections. With the No.8 brush, begin to paint rocks with a light wash of ultramarine and burnt umber, adding a touch of yellow ochre.

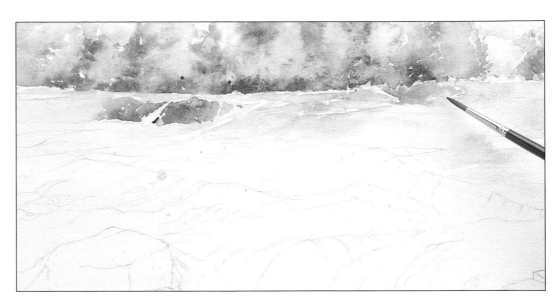

7 ◀ Work detail into the trees Add some detail to the trees using a No.1 brush, dipping back into the green wash from step 3 and working your way across the painting from left to right. Now pull some of the foliage colours into the water, painting thin horizontal lines, and then working over them with clean water in order to diffuse the marks.

▲ **Burnt umber, ultramarine and yellow ochre were mixed in varying proportions to create the colours of the rocks.**

8 ▲ Develop the rocks Start to work detail on to the rocks with the same mix of ultramarine, burnt umber and yellow ochre that you used in step 6. Use broken brush strokes to allow the underwash to show through and leave flashes of paper reserved to reinforce the notion of water pouring over the rocks. Diffuse your marks with clean water.

9 ▼ **Indicate turbulent water** Using a wash of sap green and ultramarine, suggest the rushing movement of the water around the distant rocks with broken lines. Use a circular motion with the brush to make irregular marks that recreate the particularly turbulent water, adding a little yellow ochre in places. Again, diffuse the marks with clean water.

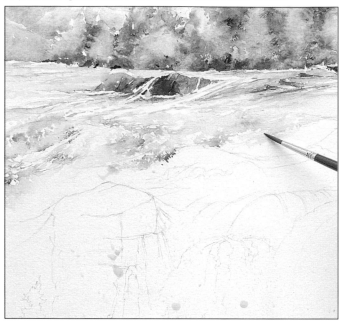

Express yourself
White water

This study of moving water was drawn with water-soluble pencils, and utilises the technique of reserving white paper to suggest water. By drawing rapidly, the artist was able to capture the essence of the shapes of the rocks as well as the direction of the water.

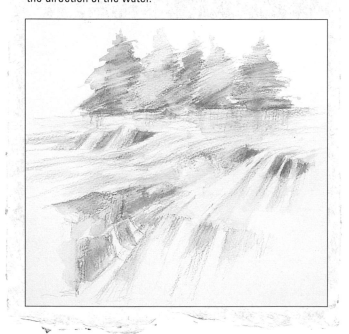

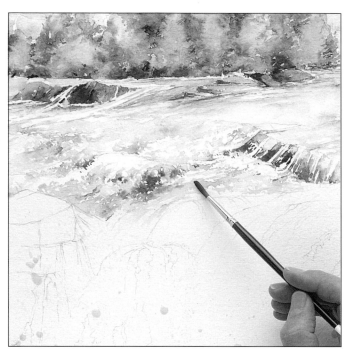

10 ▲ **Move to the middle ground** Work across to the middle ground in the same way. Paint more rocks with a mix of burnt umber, ultramarine and yellow ochre, using diagonal or rounded strokes and leaving some white paper showing to represent the running or foaming water. In front of these rocks, lay in a pale underwash of ultramarine and burnt umber on to dry paper, adding yellow ochre in places. Using the No.1 brush, begin to add detail with broken vertical lines.

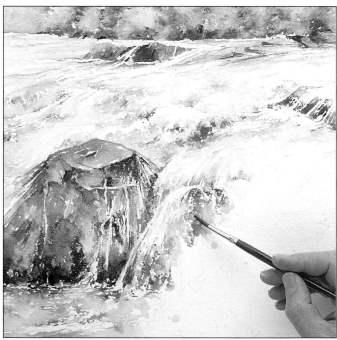

11 ▲ **Start the foreground rocks** Pool your washes together to paint the water in the bottom left-hand corner. Paint the large left-hand rock, adding more ultramarine as you move towards the bottom. Leave white paper showing – broken lines suggest the direction and speed of the water, while dots and short strokes show splashes of falling water. Change to the No.1 brush to work in some detail with a stronger wash.

12▼ **Paint the foreground water** For the foreground water, mix washes of yellow ochre and sap green, and burnt umber and ultramarine in varying strengths. Use the No.1 brush in small, circular motions to indicate the river's turbulence, or in downward strokes to suggest falling water.

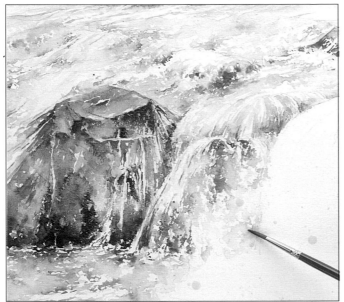

13▲ **Complete the rocks** Continue working across the tumbling foreground water, using the same strokes as in step 12. Then paint the right-hand rock, using the same technique as described in step 11.

Master Strokes

Frederick Edwin Church (1826-1900)
Niagara Falls

An American landscape painter, Frederick Church specialised in paintings of spectacular natural scenery. This vista of Niagara Falls is a wonderful example of how a painter treats water at its wildest. A vast cloud of spray occupies most of the centre of the picture, echoed by a smaller cloud behind it. The rich turquoise water of the river is veined in white, conjuring up a feeling of churning movement.

Tiny figures are shown gazing at the waterfall from a viewing platform. They are used to give a sense of the awesome scale of the scene.

To convey the spray at the bottom of the waterfall, smoothed-out areas of paint have been used. Compare this to the precise strokes used for the foaming water at the top of the fall.

14 ▼ **Remove the masking fluid** Complete the water in the foreground and allow the paper to dry thoroughly. Now rub off the flecks of masking fluid with a putty rubber.

15 ▲ **Fine tune the detail** With the masking fluid removed, you will have a clearer idea of how your finished painting will look. The whiteness of the paper is revealed and the original pencil sketch is rubbed out.

A FEW STEPS FURTHER

The painting now gives a superb impression of agitated water. All that is needed is some definition in the trees and details on the surface of the water.

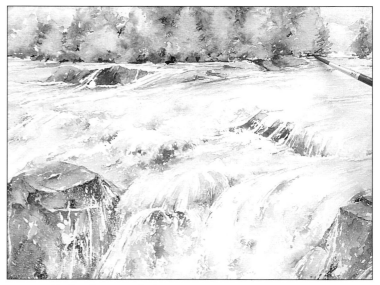

16 ▲ **Define the trees** Pick out shadows and define the shapes of the trees with a mix of ultramarine and sap green, using the No.1 brush. Horizontal lines of the same wash but diluted suggest reflections in the water.

LEAVE THE PAPER TO DRY

Wait until the fibres of your paper are completely dry before you attempt to remove masking fluid with a putty rubber. Even if the paper appears to be dry to the touch, the fibres might still be damp, and rubbing masking fluid from damp paper will take off the top layer of the paper. You can use a hair-dryer to speed up the drying process.

17 ▼ **Develop the area of flowing water** Using some of the previous mixes, reinforce the notion of moving water with broken lines diffused with clean water.

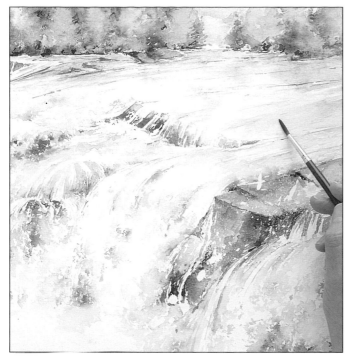

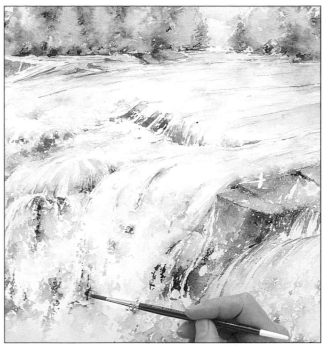

18 ▲ **Strengthen the foreground** Finally, show glimpses of the rocks through the foaming water by dabbing on some of the burnt umber and ultramarine mix, using the No.1 brush.

THE FINISHED PICTURE

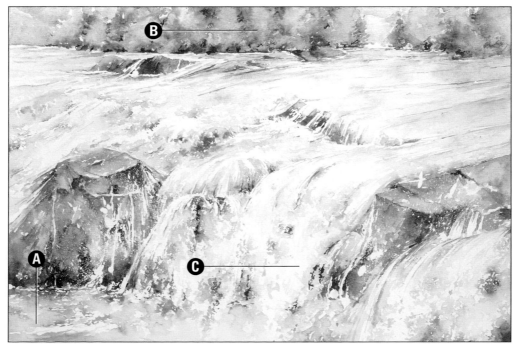

A Visual balance
Deep, strong colours in the corners provide visual balance and prevent the painting from appearing to fade away at the edges.

B Merging colours
The trees in the distance were painted wet-on-wet so that the colours merged softly, avoiding hard edges.

C Reserving paper
Moving water can appear to be largely white in colour, so allow the unpainted paper to do some of the work for you.

Contributing Artists

Harold Bartram: 120–124, 125(tl,tr,bl), 126, 127;

Chris Bramley: 9(tl,tr);

Ken Cox: 159–162, 163(tl,cl,b), 164;

Sharon Finmark: 185-188, 189(tl,tr), 190, 214-216, 217(tl,cr,br), 218, 219;

Michael Grimsdale: 29(l), 30, 31, 32(tr,cr,br), 33, 34;

Lavinia Hamer: 62-65, 66(tl,tr,br) 67, 114-117, 118(tl,tr,br), 119, 145-147, 148(tl,ct), 149, 150, 165-168, 169(tl,cl,cr), 170;

Xiaoeng Huang: 106-108, 109(bl,br), 110-113;

Wendy Jelbert: 23, 24, 25(t,c,bl), 26-28, 240–244, 245(t,cl), 246, 247;

John Raynes: 171-173, 174(bl,br), 175,176;

Tom Robb: 84-86, 87(tl,tr,cr), 88, 89, 98–101, 102(t), 103, 191-194, 195(tl,tr) 196, 200(b), 201, 202, 203(tl,tr), 204, 205, 220-223, 224(tl,tr), 225-229, 230(tl,tr), 231;

Ian Sidaway: 70-72, 73(tl,bl,br), 74, 75, 153, 154, 155(t,tr,br), 156-158;

Adrian Smith: 92-94, 95(tl,tr), 96, 97, 143(t), 144;

Hazel Soan: 46, 47, 48(tl,ct,br), 49-51;

Tig Sutton: 11–12, 13 (tl,tr,cr), 14-17, 38-41, 42(t,cr,br), 43, 54-57, 58(tl,cl,cr), 59, 78-80, 81(tl,tr), 82, 83;

Richard Taylor: 18, 19, 20(ct,tr,c), 21, 22, 131, 132, 133 (t,r), 134-140, 141(tl,tr,br), 142, 179-182, 183(t,cl,cr), 184, 206-210, 211(tl,tr), 212, 213, 232- 236, 237(t), 238, 239, 248-252, 253(tl,tr), 254, 255;

Picture Credits